J.M.W. Turner and the Subject of History is an in-depth consideration of the artist's complex response to the challenge of creating history paintings in the early nineteenth century.

Structured around the linked themes of making and unmaking, of creation and destruction, this book examines how Turner's history paintings reveal changing notions of individual and collective identity at a time when the British Empire was simultaneously developing and fragmenting. Turner similarly emerges as a conflicted subject, one whose artistic modernism emerged out of a desire to both continue and exceed his eighteenth-century aesthetic background by responding to the altered political and historical circumstances of the nineteenth century.

Leo Costello is an Assistant Professor in the Department of Art History at Rice University, USA.

In every possible way, this book is for Sarah, Jamie and Connor

J.M.W. Turner and the Subject of History

Leo Costello

ASHGATE

Published by
Ashgate Publishing Limited
Wey Court East
Union Road
Farnham
Surrey, GU9 7PT
England

Ashgate Publishing Company
Suite 420
101 Cherry Street
Burlington
VT 05401-4405
USA

www.ashgate.com

British Library Cataloguing in Publication Data
Costello, Leo.
 J.M.W. Turner and the subject of history.
 1. Turner, J. M. W. (Joseph Mallord William), 1775-1851--
 Criticism and interpretation. 2. History in art.
 I. Title II. Turner, J. M. W. (Joseph Mallord William),
 1775-1851.
 759.2-dc23

 ISBN: 978-0-7546-6922-7 (hbk)

Library of Congress Cataloging-in-Publication Data
Costello, Leo.
 J.M.W. Turner and the subject of history / by Leo Costello.
 p. cm.
 Includes bibliographical references and index.
 ISBN 978-0-7546-6922-7 (hardcover) 1. Turner, J. M. W.
 (Joseph Mallord William), 1775-1851--Criticism and interpretation. 2.
 History in art. 3. Art and history--Great Britain. I. Turner, J. M. W.
 (Joseph Mallord William), 1775-1851. II. Title.
 ND497.T8C75 2012
 759.2--dc23

 2011033880

Printed and bound in Great Britain by the
MPG Books Group, UK.

Contents

List of illustrations

cm). © Tate, London, 2011.

11 Joseph Mallord William Turner, *The Field of Waterloo*, 1818, oil on canvas, 58 x 94 in. (147.3 x 239 cm). © Tate, London, 2011.

12 Joseph Mallord William Turner, *The Field of Waterloo*, detail, 1818, oil on canvas, 58 x 94 in. (147.3 x 239 cm). © Tate, London, 2011.

13 Joseph Mallord William Turner, *Disaster at Sea* (also known as *The Wreck of the Amphitrite*), c. 1833–35, 67.5 x 86.75 in. (171.5 x 220.5 cm). © Tate, London, 2011.

14 Joseph Mallord William Turner, *Disaster at Sea* (also known as *The Wreck of the Amphitrite*), detail, c. 1833–35, 67.5 x 86.75 in. (171.5 x 220.5 cm). © Tate, London, 2011.

15 William Parrott, *J.M.W. Turner on the Varnishing Day at the Royal Academy*, 1846. Oil on canvas, 9.9 x 9 in. (25.1 x 22.9 cm). Collection of the Guild of St George, Museums Sheffield.

16 Joseph Mallord William Turner, *Venice, the Bridge of Sighs*, 1840, oil on canvas, 27 x 36 in. (68.6 x 91.4 cm). © Tate, London, 2011.

17 William Marlow, *Capriccio: St Paul's and a Venetian Canal*, c. 1795–7, oil on canvas, 51 x 41 in. (129.5 x 104.1 cm). © Tate, London, 2011.

18 Joseph Mallord William Turner, *Venice, Storm at Sunset*, 1840, watercolour and bodycolour with pen and red ink and scratching out on paper, 8.75 x 12.6 in. (22.2 x 32.0 cm). Fitzwilliam Museum, Cambridge, UK. © Fitzwilliam Museum, Cambridge.

19 Joseph Mallord Turner, *Venice from the Laguna*, c. 1840, Watercolour, pen and ink and scraping on paper, 8.75 x 12.6 in. (22.1 x 32 cm). National Gallery of Scotland.

20 Joseph Mallord William Turner, *Going to the Ball (San Martino)*, 1846, oil

on canvas, 24.25 x 36.4 in. (61.6 x 92.4 cm). © Tate, London, 2011.

21 Joseph Mallord William Turner, *The Zitelle, Santa Maria della Salute, the Campanile and San Giorgio Maggiore, from the Canale della Grazia*, 1840, pencil and watercolor, with details added using a pen dipped in watercolor, 9.6 x 12 in. (24.3 x 30.5 cm). TB CCCXVI 19. © Tate, London, 2011.

22 Joseph Mallord William Turner, *Venice: Looking across the Lagoon at sunset*, 1840, watercolor, 9.6 x 12 in. (24.4 x 30.4 cm). TB CCCXVI 25. © Tate, London, 2011.

23 Joseph Mallord William Turner, *An Open Expanse of Water on the Lagoon, near Venice*, ca. 1840, watercolor, 9.75 x 12.1 in. (24.8 x 30.7 cm). TB CCCLXIV 332. © Tate, London, 2011.

24 Joseph Mallord William Turner, *Reclining Nude on a Bed*, c. 1840, watercolor and bodycolor on on textured grey wove paper, 8.5 x 11.25 in. (21.6 x 28.4 cm). TB CCCXVIII 17. © Tate, London, 2011.

25 Joseph Mallord William Turner, *St Benedetto, looking towards Fusina*, 1843, oil on canvas, 24.5 x 36.5 in. (62.2 x 92.7 cm). © Tate, London, 2011.

26 Joseph Mallord William Turner, *Orange Sunset over the Lagoon*, 1840, bodycolor on grey paper, 7.25 x 11 in. (18.5 x 28 cm). Tate TB CCCXVIII 18. © Tate, London, 2011.

27 Joseph Mallord William Turner, *Venice at Sunrise from the Hotel Europa with the Campanile of San Marco*, 1840, watercolor, 7.75 x 11 in. (19.8 x 28 cm). TB CCCLXIV 106. © Tate, London, 2011.

28 Joseph Mallord Turner, *Capriccio with San Giorgio Maggiore, Venice*, c. 1840, watercolor and graphite on off-white wove paper, unframed, 22.5 x 29 cm. National Gallery of Ireland. Photo © National Gallery of Ireland.

1.13 Joseph Mallord William Turner, *Diagram of Ship Positions at the Battle of Trafalgar*, from the "Nelson" sketchbook, 1805, pencil on paper, 4.5 x 7.25 in. (11.4 x 18.4 cm). TB LXXXIX 24a. © Tate, London, 2011.

1.14 Joseph Mallord William Turner, *Yarmouth Sands*, 1827, watercolor and bodycolor on blue paper, 7.25 x 9.6 in. (18.5 x 24.5 cm). Fitzwilliam Museum, Cambridge, UK. © Fitzwilliam Museum, Cambridge.

1.15 Benjamin West, *The Death of Nelson*, 1806, oil on canvas, 71.9 x 97.4 in. (182.5 x 247.5 cm). Courtesy National Museums Liverpool.

1.16 Joseph Mallord William Turner, *Three Views of the Stern of a Man-of-War, and a Ship under Full Canvas*, from the "Nelson" sketchbook, 1805, pencil on paper, 4.5 x 7.25 in. (11.4 x 18.4 cm). TB LXXXIX 11. © Tate, London, 2011.

1.17 Joseph Mallord William Turner, *Diagram of Ship Positions and Notes on the Battle of Trafalgar*, from the "Nelson" sketchbook, 1805, pencil on paper, 4.5 x 7.25 in. (11.4 x 18.4 cm). TB LXXXIX 10v. © Tate, London, 2011.

1.18 Joseph Mallord William Turner, *Studies of a Marine's Uniform*, from the "Nelson" sketchbook, 1805, pencil on paper, 7.25 x 4.5 in. (18.4 x 11.4 cm). TB LXXXIX 4. © Tate, London, 2011.

1.19 Joseph Mallord William Turner, *Sailors and Marines*, from the "Nelson" sketchbook, 1805, pencil on paper, 4.5 x 7.25 in. (11.4 x 18.4 cm). TB LXXXIX 15. © Tate, London, 2011.

1.20 Joseph Mallord William Turner, *Marines, a Seaman and a Separate Sketch of a Man's Face*, from the "Nelson" sketchbook, 1805, pencil on paper, 4.5 x 7.25 in. (11.4 x 18.4 cm). TB LXXXIX 17. © Tate, London, 2011.

1.21 Joseph Mallord William Turner, *The "Victory" from Quarterdeck to Poop*, 1805, Pen and ink, pencil and watercolour on paper, 16.7 x 22.2 in. (42.4 x 56.5 cm). TB CXXI S. Turner © Tate, London, 2011.

1.22 Philippe-Jacques de Loutherbourg, *The Battle of the First of June, 1794*, 1795, oil on canvas, 104.9 x 147 in. (266.5 x 373.5 cm). National Maritime Museum. © National Maritime Museum, Greenwich, London.

1.23 Philippe-Jacques de Loutherbourg, *The Battle of Camperdown*, 1799, oil on canvas, 60 x 84.3 in. (152.4 x 214 cm). © Tate, London, 2011.

2 "The Conception of a swamp'd world": Destruction and Creation in Painting/History

2.1 Joseph Mallord William Turner, *Fishermen Upon a Lee-shore in Squally Weather*, 1802, oil on canvas. Southampton City Art Gallery, Hampshire, UK/ The Bridgeman Art Library.

2.2 Joseph Mallord William Turner, *Calais Pier, with French Poissards preparing for Sea: an English Packet arriving*, 1803, oil on canvas, 67.75 x 94.5 in. (172 x 240 cm). National Gallery, London, Turner Bequest, 1856. Credit: © The National Gallery, London.

2.3 Philip James de Loutherbourg, *An avalanche or ice fall, on the alps, near the Scheideck, in the Valley of Lauterbrunnen*, exh. 1804, oil on canvas, 106.75 x 157.5 in. (271 x 400.1 cm). Petworth House, The Egremont Collection (acquired in lieu of tax by H.M.Treasury in 1957 and subsequently transferred to the National Trust). © NTPL/Derrick E. Witty.

2.4 Nicolas Poussin, *Winter, or The Flood*, 1660–4, oil on canvas, 46.5 x 63 in. (118 x 160 cm). Louvre, Paris, France. Photo credit: Scala/Art Resource, NY.

2.5 Joseph Mallord William Turner, *List of subscribers*, c. 1806–7, and *Two Ships, one Sinking, and a Lifeboat: Arithmetic*, from the "Shipwreck (I)" sketchbook, c. 1805, 4.6 x 14.6 in. (11.8 x 37 cm). TB LXXXVII 2–3. © Tate, London, 2011.

2.22 Joseph Mallord William Turner, *Peace – Burial at Sea*, 1842, oil on canvas, 34.25 x 34.125 in. (87 x 86.7 cm). © Tate, London, 2011.

2.23 Joseph Mallord William Turner, *War – The Exile and the Rock Limpet*, 1842 oil on canvas, 31.25 x 31.25 in. (79.4 x 79.4 cm). © Tate, London, 2011.

2.24 Joseph Mallord William Turner, *The Decline of the Carthaginian Empire*, 1817, detail, oil on canvas, 67 x 94 in. (170.2 x 238.8 cm). © Tate, London, 2011.

2.25 Joseph Mallord William Turner, *The Deluge*, c. 1805, oil on canvas, 56.25 x 92.75 in. (142.9 x 235.6 cm). © Tate, London, 2011.

2.26 Theodore Géricault, *The Raft of the Medusa*, 1819, oil on canvas, 193.3 x 282.3 in. (491 cm x 716 cm). Louvre, Paris, France. Photo credit: Scala/Art Resource, NY.

3 "This cross-fire of colours": Turner and the Varnishing Days

3.1 Joseph Mallord William Turner, *Snow Storm: Hannibal and his Army Crossing the Alps*, 1812, oil on canvas, 57.5 x 93.5 in. (146 x 237.5 cm). © Tate, London, 2011.

3.2 Joseph Mallord William Turner, *Childe Harold's Pilgrimage – Italy*, 1832, oil on canvas, 56 x 97.75 in. (142.2 x 248.3 cm). © Tate, London, 2011.

4 "In Venice now": History, Nature, and the Body of the Subject

4.1 Joseph Mallord William Turner, *Venice, from the Porch of the Madonna della Salute*, ca. 1835, oil on canvas, 36 x 48.125 in. (99.4 x 122.2 cm). Bequest of Cornelius Vanderbilt, 1899 (99.31). The Metropolitan Museum of Art, NY. © The Metropolitan Museum of Art/Art Resource, NY.

4.2 Joseph Mallord William Turner, *The Sun of Venice Going to Sea*, 1842, oil on canvas, 24.25 x 36.25 in. (61.6 x 92.1 cm). © Tate, London, 2011.

4.3 Joseph Mallord William Turner, *The Dogana, San Giorgio, Citella, from the Steps of the Europa*, 1842, oil on canvas, 24.25 x 36.5 in (61.6 x 82.7cm). © Tate, London, 2011.

4.4 Joseph Mallord William Turner, *Venice: The Dogana and San Giorgio Maggiore*, 1834, oil on canvas, 36 x 48 in. (91.5 x 122 cm). Widener Collection, Image courtesy National Gallery of Art, Washington.

4.5 Joseph Mallord William Turner, *Keelman Heaving in Coals by Moonlight*, 1835, oil on canvas, 36.375 x 48.375 in. (92.3 x 122.8 cm). Widener Collection, Image courtesy National Gallery of Art, Washington.

4.6 Joseph Mallord William Turner, *The Campo Santo, Venice*, 1842, oil on canvas, 24 ½ x 36 ½ in. (61.25 x 91.25 cm), Toledo Museum of Art (Toledo, Ohio), Gift of Edward Drummond Libbey, 1926.63. Photo Credit: Photography Incorporated, Toledo.

4.7 Joseph Mallord William Turner, *Mortlake Terrace*, 1827, oil on canvas, 36.25 x 48.125 in. (92.1 x 122.2 cm). Andrew W. Mellon Collection, Image courtesy National Gallery of Art, Washington.

4.8 Joseph Mallord William Turner, *Appulia in Search of Appulus*, 1814, oil on canvas, 58.5 x 95 in. (148.5 x 241 cm). © Tate, London, 2011.

4.9 Joseph Mallord William Turner, *Approach to Venice*, 1844, oil on canvas, 24.375 x 37 in. (62 x 94 cm). Andrew W. Mellon Collection, Image courtesy National Gallery of Art, Washington.

4.10 Richard Parkes Bonington, *The Piazzetta, Venice*, 1827, oil on canvas, 18 x 14.75 in. (45.7 x 37.5 cm). © Tate, London, 2011.

4.11 Joseph Mallord William Turner, *Storm at Venice*, 1840, watercolor, 8.6 x 12.5 in. (21.9 x 31.8 cm). British Museum, London. © Trustees of the British Museum.

4.30 Joseph Mallord William Turner, *Sketches for "Music at East Cowes Castle" and "Two Women and a Letter"*, from "Seine and Paris" sketchbook, 1832, pencil on paper, 6.9 x 4.6 in. (17.4 x 11.7 cm). TB CCLIV 24. © Tate, London, 2011.

4.31 Joseph Mallord William Turner, *What You Will!*, 1822, oil on canvas, 19 x 20.9 in. (48.3 x 53.1 cm). Sterling and Francine Clark Art Institute, Williamstown, USA/The Bridgeman Art Library.

4.32 Joseph Mallord William Turner, *Boccaccio Relating the Tale of the Bird-Cage*, 1830, oil on canvas, 48 x 35.4 in. (121.9 x 89.9 cm). © Tate, London, 2011.

4.33 Joseph Mallord William Turner, *England – Richmond Hill on the Prince Regent's Birthday*, 1819, oil on canvas, 70.9 x 131.7 in. (180 x 334.6 cm). © Tate, London, 2011.

4.34 Thomas Cole, *The Course of Empire: The Arcadian or Pastoral State*, 1836, oil on canvas, 39.75 x 6.75 in. (99.7 x 160.7 cm). Collection of the New-York Historical Society.

4.35 Thomas Cole, *The Course of Empire: Consummation of Empire*, 1836, oil on canvas, 51.25 x 76 in. (130.2 x 193 cm). Collection of the New-York Historical Society.

4.36 Thomas Cole, *Autumn Twilight, View of Corway Peak [Mount Chocorua], New Hampshire*, 1834, oil on canvas. 13.75 x 19.5 in. (34.9 x 49.5 cm). Collection of the New-York Historical Society.

4.37 Thomas Cole, *View on the Catskill, Early Autumn*, 1836–7, oil on canvas, 39 x 63 in. (99.1 x 160 cm). Gift in memory of Jonathan Stuges by his children, 1895 (95.13.3), The Metropolitan Museum of Art, NY. © The Metropolitan Museum of Art/Art Resource, NY.

4.38 Joseph Mallord William Turner, *Borthwick Castle*, watercolor, 1818, watercolor and scratching-out, 7 x 10.375 in. (17.8 x 26.4 cm). Indianapolis Museum of Art. Gift in memory of Dr.

and Mrs. Hugo O. Pantzer by their children.

4.39 Joseph Mallord William Turner, *St. Mawes, Cornwall*, ca. 1823, Watercolor and scraping out, 5 5/8 x 8 5/8 inches (14.3 x 21.9 cm). Yale Center for British Art, Paul Mellon Collection.

4.40 Joseph Mallord William Turner, *The Bridge of Meulan*, c. 1833, gouache and watercolor on paper, 5.6 x 7.6 in. (14.2 x 19.3 cm). © Tate, London, 2011.

4.41 Joseph Mallord William Turner, *Storm at the Mouth of the Grand Canal, Venice, Looking towards the Piazzetta and San Giorgio Maggiore*, c. 1840, watercolour and bodycolour, with details added using a pen dipped in watercolour, on off-white wove paper, unframed, 21.8 x 31.9 cm. National Gallery of Ireland. Photo © National Gallery of Ireland.

4.42 Joseph Mallord William Turner, *Santa Maria Della Salute from the Bacino*, 1840, pencil and watercolor, 9.6 x 12.1 in. (24.4 x 30.7 cm). TB CCCXVI 37. © Tate, London, 2011.

4.43 Joseph Mallord William Turner, *Santa Maria della Salute, the Campanile of San Marco, the Doge's Palace and San Giorgio Maggiore, from the Giudecca Canal*, 1840, watercolor, 9.6 x 12.1 in. (24.5 x 30.8 cm). TB CCCXVI 8. © Tate, London, 2011.

4.44 Joseph Mallord William Turner, *Ducal Palace, Dogana, with part of San Giorgio, Venice*, 1841, oil on canvas, 25 x 36.6 in. (63.5 x 93 cm). Allen Memorial Art Museum, Oberlin College, Ohio, Mrs. F.F. Prentiss Bequest, 1994.

5 *The Slave Ship*: Painting/ Abolition/History

5.1 Joseph Mallord William Turner, *Rockets and Blue Lights (Close at Hand) to Warn Steamboats of Shoal Water*, 1840, oil on canvas, 36.3 x 48.1 in. (92.2 x 122.2 cm). Sterling and Francine Clark Art Institute, Williamstown, USA/ The Bridgeman Art Library.

Acknowledgements

It is a great pleasure to look back over the development of this book and think of the many people who have contributed to it in so many ways. Research for this project has been supported at Rice University by the President's Research Fund, and funds from the School of Humanities under the auspices of Deans Gary Wihl, Allen Matusow and Nicholas Shumway. I have also been generously supported by funds from the Department of Art History under the chairmanship of Joseph Manca, Diane Wolfthal and Linda Neagley. I benefitted immensely from a junior leave at Rice, as well as a teaching release provided by the Humanities Research Center at Rice. The Humanities Research Center also provided for undergraduate research assistants and I am grateful to Katherine Miller, Sarah Mitchell and Marie Stitt for their contributions. Illustrations were supported by a Publication Grant from the Paul Mellon Centre for Studies in British Art, for which I am immensely grateful.

I am extremely thankful for the efficiency and intelligence of the staff at the British Library especially in the Rare Books and Manuscripts Rooms. Mark Pomeroy at the Royal Academy Archives provided help and expert knowledge in researching the chapter on the Varnishing Days. Julia Beaumont-Jones and the staff at the Print Study Room at Tate Britain were wonderfully generous in letting me look at works on paper and Turner's sketchbooks, which was absolutely crucial to this project. I have been assisted at Rice by the staff in the Woodson Research Center and librarian Jet Prendeville. Also at Rice, Lucinda Cannady and Anita Cantu have provided expert administrative support and Mark Pompelia, Kelley Vernon and Andrew Taylor have helped with images. I am grateful to the many institutions and individuals who provided illustrations for this book. Many of them also waived or reduced fees, which made a tremendous difference. At Tate Images, Gudrun Muller was extremely helpful and efficient in dealing with my large request.

This project was nurtured in its early stages at Bryn Mawr College by Christiane Hertel, whose example continues to guide me. I am grateful to her and the other members of the History of Art Department at Bryn Mawr for their mentorship. Portions of this book have been given in numerous conferences over the years and I would like to thank the organizers of these

events for these opportunities to develop and share my work, which have been of inestimable value. I am particularly grateful for the opportunity to participate in the *Turner and the Masters* scholars' event, which came as I was finishing the first draft of the manuscript. Draft versions of Chapters 2 and 4 were read in undergraduate seminars at Rice and I am thankful to the participants of those classes for their feedback and energy. Portions of Chapter 3 appeared as "'This cross-fire of colours': J.M.W. Turner and the Varnishing Days Reconsidered," *British Art Journal*, 10/1 (Spring 2010): 56–68, and I thank editor Robin Simon for permission to reproduce them here. Portions of Chapter 5 appeared as "Turner's *Slave-ship*: Towards a Dialectical History Painting," in Brycchan Carey, Markman Ellis and Sarah Salih (eds), *Discourses of Slavery and Abolition: Britain and Its Colonies 1660–1838* (Basingstoke and New York: Palgrave McMillan, 2004): 209–22 and I am grateful to Palgrave MacMillan and the editors for their permission to reproduce.

Many friends and colleagues have contributed so much to this book with responses to portions of the text, and support and encouragement throughout its development. I thank especially my colleagues in the Department of Art History at Rice. Other colleagues and friends whose generosity and encouragement have helped this project come to fruition are: Irene Brooke, Alexis Castor, Nancy and Chris Glaister, Kate Grandjouan, Anne Helmreich, Andrew Hemingway, Scott Hook, Melina Kervandjian, William Louis-Dreyfus, Kathleen Jameson, Sarah Lepinski, Helena Michie, Susan and Don Nalezyty, Emily Neff, Kathleen Nicholson, Michael Parillo, Robert S. Patten, Caroline Quenemoen, Leslie Scattone, Alan Wallach, Kaylin Weber and Emily Wilkinson. Also, two people deserve particular recognition here. Marcia Brennan has read more of this text than anyone and it would not have taken the form it has without the extraordinary scholarly interchange that we have enjoyed over the years, and without her constant support. Ian Warrell at the Tate has been a model of generosity since I first came to the Tate as a doctoral student some years ago. He has provided assistance in every possible way to make this project a reality and shared his extraordinary expertise. I cannot thank him enough. I am also extremely grateful to the anonymous readers for Ashgate Press. They provided searching, intelligent, constructive reviews and the book is immeasurably improved for their responses. I have also benefitted immensely from the intelligence and expertise of Andrea Pearson in copy-editing the text. I am grateful to the staff at Ashgate for their skill and efficiency, especially desk editor Kevin Selmes, and Meredith Norwich, whose support and belief in this project have been crucial. So much of what may be good in this book is due to these many people; any errors, mistakes or omissions are mine alone.

My parents, Lawrence and Mary, have taught me most of what I know about being a good student and never faltered in their support for my long path to this result. My family—Costellos, Kielts, Kressins and Lewerenzes—have all shown extraordinary patience with what must have seemed at times an endless process and I thank them deeply. My children, Jamie and Connor,

have endured my absences both physical and mental, while researching and writing this book, and have constantly inspired me with their intelligence and creativity. Finally, without my wife, Sarah, this book simply would not exist. She has read or listened to portions of this text both critically and supportively over the years, and has helped me shape and refine ideas throughout this process. But most of all, her steadfast faith in this project, and in me, have sustained me at every turn and in every way.

Leo Costello, November 22, 2011

Introduction

Throughout his long working life, J.M.W. Turner constantly responded to the changing world around him by painting scenes of contemporary history. Despite the shared interests of the pictures in this category, they have yet to be studied as a group.[1] This is perhaps because their critical reception has been dramatically uneven. *The Fighting Temeraire tugged to its Last Berth*, for instance, was one of Turner's most successful paintings from the moment it was exhibited, and the two pictures of *The Burning of the Houses of Lords and Commons*, while controversial during his lifetime, have come as much as any paintings to stand for the artist's reputation as a Romantic genius. But pictures such as *The Battle of Trafalgar* and *The Field of Waterloo* were largely ignored during Turner's lifetime and have been marginalized within the artist's oeuvre since his death in 1851. By approaching them as a set, I will demonstrate in Turner's work a complex and ambivalent elaboration of changing notions of individual subjectivity in an age of developing and fragmenting nationhood, thus considerably nuancing our sense of the importance of history within his overall artistic project.

The goals of this book do not relate to Turner alone, however. In the first place, I am not concerned with redeeming a group of previously understudied paintings by transporting them from relative obscurity to some seemingly appropriate place in a canon, however conceived. Nor am I seeking merely to add another facet to our understanding of an already established master. Rather, it is my contention that by studying Turner's paintings of contemporary history, we can arrive at a more complex view of numerous intersecting issues, both aesthetic and socio-historical, which I take to be crucial to the early nineteenth century. They concern the challenge of producing history paintings during a period in which the individual as a subject—of history, of the state, and of empire—was rapidly changing. Turner's paintings need to be seen as very sophisticated, if not always completely coherent, responses to these shifting historical dynamics and to their attendant complexities in representation. The Turner who emerges from this study is a conflicted, contradictory, ambivalent subject, a site of compelling and provocative

heterogeneity rather than cohesion and unity. Such a view aptly mirrors and complicates both Turner's art and the period it represents.

A similar hybridity informs my approach to Turner's depictions of history. As the title of this book indicates, my interest in Turner is primarily with history paintings, rather than landscapes. However, it will be readily apparent that my definition of what constitutes this history painting with Turner is rather broad and that drawing a categorical line between the genres is by no means simple. Certainly my use of the phrase "contemporary history painting" registers an expanded field of reference, speaking as it does to pictures of subjects beyond the scenes of classical antiquity and elevating moral subject matter that the eighteenth century traditionally understood to define the genre of history painting. The trace of those resonances in the modified genre of contemporary history painting is useful because I will indeed attempt to show that Turner sought to adapt many of the goals of history painting to a wider range of subjects, including pictures that would appear to be more appropriately classed as land- or seascapes. This is to say that not all of the pictures I consider will be overtly concerned with a particular episode from recent history. Thus, while the applicability of the phrase "contemporary history painting" for the *Trafalgar* and *Waterloo* pictures is evident enough, I will also be looking in depth at a number of pictures whose status as history paintings, for Turner's contemporaries or modern viewers, is less immediately clear, such as *The Shipwreck* (1805) and *Bridge of Sighs, Ducal Palace and Customs House, Venice: Canaletti Painting* (1833). In the first place, then, I will be building on the work of a number of scholars who have discussed Turner's ongoing attempts to elevate the genre of landscape to address the moral and narrative imperatives of history painting.[2] In doing so, my concern will be less with a conscious program and more with the various ways in which ideas of progress, decline and empire informed Turner's picture-making. As I will show, pictures like *Waterloo*, for instance, or a number of the Venice paintings, take in part as their subject the very movement back and forth between landscape and history painting. As such, these pictures instantiate the complex ways in which the distinction between landscape and history painting becomes un-decidable as they productively destabilize and extend the very notion of history painting in complex and compelling ways.

It is not my goal, therefore, to argue that pictures like *The Shipwreck* or the *Bridge of Sighs, Ducal Palace* should be understood or reclassified as exclusively, or even primarily, history paintings in the traditional sense. Rather, I will demonstrate that, however classified, these pictures, and others, are significantly concerned with issues of history and that these issues informed Turner's pictorial choices. This last point is important. It means that in my account, many of Turner's pictures are both about history and are influenced by it in ways that may not directly concern the literal depiction of historical events. As such, in this study Turner will appear at times as an individual artistic agent elaborating specific themes and creating particular effects. But I also wish to delineate the effects of a broader historical moment

on the aesthetic choices that Turner made and suggest that his own sense of artistic subjectivity emerged in part out of a negotiation with history and history painting. At one level, of course, the movement from history painting to landscape as the repository of significant moral content is a part of a larger shift in the early nineteenth century to a privatized, bourgeois cultural model. But this does not account for the particular form this shift takes in Turner's work. In attempting to do so I will see artistic change as embedded within a set of historical conditions that provide a particular range of possibilities out of which individual agents like Turner make choices. Thus, I will be particularly interested in Turner's own ambivalent response to the loss of history painting as it had been traditionally practiced as a locus of significant pictorial statements. Indeed, one of the basic premises of this book is that Turner took quite seriously the legacy of history painting, but was also extremely sensitive to the changes that made modifications to that legacy necessary. Elements of Turner's painting that rejected history painting may seem familiar to modern viewers, such his attention to the tactile quality of paint and its expressive qualities, for instance. But these need to be understood in part as the products of a complex negotiation with the less familiar aspects of narrative and literary content taken from history painting, rather than a simple rejection of them. I will therefore portray Turner as a deeply ambivalent artistic figure, one split between aesthetic modes and whose destruction of certain traditions emerged, paradoxically, out of his very desire to continue them. It is, I believe, most appropriate and productive to highlight these kinds of paradoxes rather to suppress them in the interests of creating a coherent subject "Turner."

The Subject

The status of the term "subject" is therefore important here. At the first level, its use in the title is meant to signal an awareness of the approach taken by Andrew Wilton and Kathleen Nicholson, as well as John Gage, Eric Shanes, and others, in acknowledging the importance of subject matter and history to Turner's ongoing artistic project. I will seek to continue this work by revealing how fully questions of history were integrated into the creative process for Turner, rather than seeing them as a gloss or a superficial addition.[3] The use of the term "subject" in this regard was current during Turner's lifetime. But it was mobilized at times in connection with the complaint that his pictures actually lacked a subject, or even, to shift the emphasis slightly, that they took lack, absence, or nothingness, *as* their subject and this also needs to be accounted for. The literary critic William Hazlitt, a contemporary of Turner, touched on exactly this idea when he famously—and somewhat contemptuously— characterized Turner's work as "pictures of nothing and very like." Hazlitt also complained that Turner's paintings were "representations not so properly of the objects of nature as of the medium through which they are seen." In suggesting that there is a loss of solid form by the phrase "pictures of

nothing," Hazlitt implies that there is a refiguring of the subject of the picture, so that it is less about what is being seen and more about how it is being seen. While Hazlitt is referring to the atmospheric effects that seemed to obscure the ostensible subject of Turner's pictures, it also suggests that the picture is about precisely the process by which the subject was lost or, crucially, re-formed: in the same review of 1816, Hazlitt had concluded of Turner's works, "They are the triumph of the knowledge of the artist, and the power of the pencil over the barrenness of the subject."[4]

Hazlitt was, in fact, not alone in making this claim. A decade before, John Landseer, in one of the most perceptive accounts written by any critic during Turner's lifetime, argued for something similar. He did not write primarily about Turner's depiction of atmosphere, although he does touch on it. Instead, he focused—with much greater approval than Hazlitt—on Turner's ability to alter the "subject" of the picture.[5] Landseer writes,

We had not imagined that any *View of Margate*, under any circumstances, would have made a picture of so much importance as that which Mr. Turner has painted of the subject: but, by introducing a rising sun and a rough sea; by keeping the town of Margate itself in a morning mist from which the pier is emerging; and by treating the cliffs as a bold promontory in shade, he has produced a grand picture.

Landseer suggests, then, that a "grand" picture can be created not only irrespective of its "subject," but even in spite of it. As Landseer would have been aware, academic theorists like Sir Joshua Reynolds had used the term "grand" to refer to the highest kind of painting, which was addressed to the mind rather than the senses. Speaking of the "grand style," Reynolds said that "The great end of art is to strike the imagination."[6] This is precisely what Landseer credits Turner with when he calls him "a master of the *philosophy* of his art." "To this," Landseer continues, "we are much indebted for the perfect unities of time and place, and the consequent totality of impressive truth, with which his works generally affect the mind." The ideas of "perfect unities" and "consequent totality"—both conveying a sense of wholeness—were linked for both Landseer and Reynolds to the ability of the artist to transcend observed nature and to "generally" (i.e. in a manner that moves beyond specificity) "affect the mind." In this regard, these phrases represent a linkage between the detail and the whole, because the artist's transformation moves from a specific individual vision to something general, something shared, and something capable of unifying its viewers. Landseer continues to link Turner's ability to transform the appearance of individual objects with his ability to elevate the (non-)subject of the picture: "The detail of the town and cliffs, being lost at the early hour which is represented, in the mistiness of the morning, and only the bolder forms being discernible, Margate acquires a grandeur we should look in vain for at any other time and under any other circumstances." Landseer concludes that

…Mr. Turner delights to paint to the imagination: and sometimes he apparently paints with a view to calling up distant, but still associated, trains of ideas. The classic scholar who shall contemplate this picture, forgetting modern Margate, will probably be led to think of the temple of Minerva on the promontory of Sunium, which no Grecian mariner presumed to pass without an offering or a prayer.[7]

Landseer's use of the terms "imagination," "mind," and "grand," all recall the academic theory espoused by Reynolds, as does his invocation of universality by means of the classical reference. But the key difference relates to the subject of the picture itself. Reynolds had stressed the importance of an ennobling narrative. Of the grand style he wrote that "…no subject can be proper that is not generally interesting. It ought to be either some eminent instance of heroick action, or heroick suffering. There must be something either in the action, or in the object, in which men are universally concerned, and which powerfully strikes upon publick sympathy."[8] Subjects, he continues, should be taken from classical antiquity rather than modern times because of their universal rather than specific appeal. This is not to ignore the importance of stylistic questions and "central form" to Reynolds, nor to disregard his later admittance of local custom in painting.[9] Indeed, Reynolds himself placed greater emphasis on stylistic questions than had earlier writers on aesthetics, including the earlier Earl of Shaftesbury, in part because the *Discourses* were addressed primarily to artists, rather than connoisseurs.[10] But whether or not one wishes to argue that Reynolds's emphasis on the painter's ability to unite the formal elements of the picture and transcend natural particularity prepared the way for accounts like Landseer's, the point is that a shift has occurred with regard to the "subject" of painting. Turner, according to Landseer, is directly in the center of that shift, in which the artist-as-subject at some level replaces the subject matter as the term capable of uniting detail and whole. We might also think here of Constable's roughly contemporaneous statement that "it is the business of the painter…to make something out of nothing."[11] Here Constable registers the same reversal in priorities expressed by Landseer, in which a painting's capacity to appeal to the imagination depends less on the subject itself and more on the distance traveled in the picture from its humble source material. Hazlitt, too, as Kathleen Nicholson points out, came to embrace this position, writing a few years later that, in painting, "There is a continual creation out of nothing going on…"[12]

Clearly, this idea is related to the notion that in modern painting the two kinds of subjects I have described are reversed, so that subject matter recedes as individual subjectivity emerges. The point here is not to retell this story, but rather to tie the issues of Turner's subjects and subjectivity to broader questions of historical representation. In particular, I will show that the "subject" of many of Turner's works that relate to history painting was indeed the very process of obscuring, or even destruction. Turner was, as I see it, increasingly aware that both history and painting were characterized by the dynamics of formation, disintegration, and reformation. Simply stated, part

of the goal of history painting for Turner was to find visual equivalents for those inter-linked processes. Creativity thus became a partially destructive process, one that required Turner to demolish elements of an artistic past he held dear. This was, then, a necessarily ambivalent project for the artist.

Another crucial element of "subject," then, is an exploration of the emergence of artistic subjectivity in the face of history: subjectivity, in my account, emerges for Turner not as a rejection of history in painting and the Academy, as Ruskin characterized it, but partly through them.[13] As an emblem of this we might look briefly at a picture I will discuss in detail below, *Bridge of Sighs, Ducal Palace and Custom-House, Venice: Canaletti Painting* (1833, Plate 1), which stages the scene of the painting as a confrontation between the individual painter and a city, Venice, which had powerful literary and historical resonances. If we recall Landseer's account, in which the modern city of Margate is transformed into a source of contemplation, then we can see the act of the artist as calling these associations forth from the scene. Turner's Canaletto (detail, Plate 2), in part a surrogate for himself, as we will see, is distanced from the buildings by the lagoon, but also tied to this larger entity as its opposite pole within the pictorial space, visually connected by the gondolas in the middle space. What I wish to suggest is that while the painter takes Venice as his subject, he also comes into being as a subject, in Landseer's terms, in the face of it, in the process of representing it. As a result, while Turner's work clearly marks an emergence of the artist as a liberated, independent subject, that emergence takes place through the negotiation with elements exterior to the self, elements it is both tied to and separated from. An extensive body of literature on the emergence of the modern "self" in this period characterizes selfhood as based on a sense of a coherent and independent inner existence rather than on ideas of rank, appearance, or behavior.[14] While this concept implies a subject who is thereby liberated from various disciplinary boundaries, both secular and spiritual, we should note that at the same time the term "subject" can refer to someone who owes allegiance to, or is dominated by, some larger power, as for instance when the social reformer and philosopher Jeremy Bentham refers in this period to "the sacrifice made…of the interest and comfort of the *subject-many*, to the overgrown felicity of the *ruling few*…"[15] Indeed, what interests me is precisely the manner in which Turner's own sense of artistic selfhood was formed by the process of interacting with larger social networks. The dual sense of liberation and alienation produced by modernity affected Turner keenly. Here Dror Wahrman's work on the development of identity in relation to emerging notions of selfhood in eighteenth-century England is relevant. For Wahrman, identity encompasses two contradictory impulses: the unique individuality of a person and the pursuit of commonalities that signify placement within a group. The one is based on difference and the other on its erasure.[16]

This is another way of saying, then, that the subject "Turner" appears in this book both as an individual agent and as a figure whose artistic development took place within a set of broader discursive networks that did not merely

influence aesthetic decisions and also did not determine them, but were the very material out of which they were made. This should clearly indicate my interest in thinking of Turner as embedded within his cultural milieu, rather than as a transcendent Romantic genius. At the same time, however, I do not intend to dispense with an investigation of the artist as an individual agent.[17]

Turner and the Social History of Art

In elaborating this idea of a dual subject, one both independent and contingent, I will employ a social history of art to assess the ways in which these elements emerged from Turner's particular interaction with the artistic and political world of his lifetime. My interest in maintaining the category of "Turner" as a particular area of study, moreover, is based in a belief in the importance of historical investigation that focuses on the specific complexities of individual experience as a means of resisting the homogenizing tendency of capitalism. Indeed, a crucial part of capitalism's development and the formation of the state, according to studies by Phillip Corrigan and Derek Sayer, as well as Foucault, is the extent to which the developing state totalizes subjects' experiences, even as it isolates them as individuals, so that a set of normative modes of behavior can be established and policed even as the state seems to be the guarantor of individual "liberty."[18] My approach to Turner here is rooted in a desire to allow history to resist this totalizing process with respect to individual subjectivity. It will be clear, for instance, that I am skeptical of the value of art historical binaries such as a modern/ pre-modern, especially for an artist as complex and multi-faceted as Turner. Similarly, I take a view of historical change in the early nineteenth century that emphasizes the contested, complex nature of Britain's transformation from an oligarchic, aristocratic nation to a democratic, bourgeois one. This process was by no means completed by the 1832 Reform Bill, nor even desired by many of its architects. Indeed, I see the elaboration of individual experience as a necessary means of preserving the complexity of subject formation and class identification within this larger framework of historical change, which cannot be reduced to convenient political binaries like democratic/aristocratic.[19]

Perhaps surprisingly, there has yet to be a large-scale study of Turner from a social-historical perspective. Scholars have produced valuable shorter works that adopt this approach, many of which I will cite throughout this book. But the question of why a social history of Turner's art on the scale of John Barrell's and Ann Bermingham's important studies of John Constable has not been undertaken is difficult to answer.[20] Part of the reason must lie in the difficulty of placing Turner politically, whereas Constable's conservative politics are fairly easily established. There is very little correspondence that details Turner's political views, and the evidence of the pictures is complex.[21] Also significant is the fact that much of the social history of art, as it is applied to English painting, has been primarily concerned with landscape and

questions of the natural. Though related, Turner's work is not easily included in these categories as a whole because it is explicitly concerned with issues beyond landscape to an extent that Constable's is not.[22] This fact is another part of the reason for this book's focus on history rather than landscape.

A social history of Turner's work, therefore, must address a different set of issues, some of which I have described already. But it is not only a question of which issues are brought to bear, but also how they are conceived as relating to the artist and his work. It is not my goal to elaborate a context of ideological issues around the work of Turner-as-subject, which would ultimately maintain some distinction between matters that are properly conceived as inherent to his paintings and the exterior conditions that may inform it. Rather, it is my aim to show that such a separation into binary terms of text/context is not possible, and thus to demonstrate how issues of class outlook and historical representation were a part of the very formation of subjectivity for Turner.

Turner, Nation, and Empire

Another important aspect of this study is that it brings to bear a social history that considers developments outside of the British Isles. Two terms require particular explanation in this regard: "empire" and "nation." Scholarship has increasingly explored the manner in which depictions of colonial subjects and non-English populations played a role in British conceptions of empire and its meanings and consequences.[23] My account, therefore, introduces the issue of empire centrally into an understanding of Turner's depictions of history. In pictures such as the two versions of *The Battle of Trafalgar*, *The Field of Waterloo*, and his depictions of the rise and fall of Carthage, that reference will be direct, but in others, such as *The Shipwreck* and *The Wreck of the Amphitrite*, it will not. In both cases, though, I am less concerned with a literal iconography of empire than with seeing painting as a site for the metaphorical elaboration of issues of empire on multiple levels. Of particular interest is the development of both imperial and national identity as a "fragmented and fragmenting process" to borrow the phrase of Kathleen Wilson,[24] and at the same time as a consolidating force, as described by Linda Colley.[25] The pursuit and achievement of imperial expansion, not only overseas but also in the incorporation of Scotland and later Ireland, was a means of consolidating ideas and opinions about both English and British identities. But expansionism also produced unprecedented changes that challenged the very viability of notions of a unified national identity. It is my conviction that the two spheres of activity, imperial center and periphery, cannot be separated in treating representations of nationhood and empire. This will become most clear in the final chapter on *The Slave Ship*. For now I will simply note that the effects of empire as it expanded and contracted, formed and disintegrated, will be considered at the formal and thematic levels in a number of Turner's paintings.

In doing so, Turner's many seascapes assume a particular prominence in my study. In considering the importance of the sea for Turner in relation to issues of national and imperial identity, the work of scholars who have discussed the significance of maritime imagery as something coherent and unified in imagining empire is especially important. Geoff Quilley, for instance, suggests that "the pictorial image of navigation and the sea functioned in…imagining the nation in eighteenth-century Britain, giving visual form to a growing sense of political, economic, and cultural community, but simultaneously stimulating its growth."[26] For Quilley, the nation is not something "fixed and objective," but is instead constructed discursively. Works of art, therefore, do not merely reflect some given sense of national or imperial identity but are themselves one place in which that identity can be formed. Thus, Quilley demonstrates how eighteenth-century images of the Thames functioned to accommodate a vision of England as a commercial nation into a harmonious whole with religious and political symbols of its pictorial past.[27] At a time of dramatic political and economic change, when empire was both constructing and destroying identity, pictures became a site where an illusory wholeness, at least for a time in the eighteenth century, could be metaphorically produced. In saying that Turner took the legacy of eighteenth-century history painting seriously, I mean to suggest that he sought to similarly produce that kind of unifying pictorial statement, the need for which if anything increased with war, imperial growth and political division in the nineteenth century. The chapters that follow will argue that these same factors, however, made creating pictorial unity around history more and more difficult. Part of the poignancy, and complexity, of Turner's pictures emerges from his ambivalence around this position. The sea therefore becomes a site of instability in representation. For Turner, it became a way to investigate the formal means to explore both the formation of empire—enabling goods to travel to and from the center, as well as the source of its military strength—but also to how empire could be pictured as a process of radical disintegration.

One final thing should be stressed here: this book is not a survey. It is not my goal to account for every Turner painting that touches on the question of history, nor am I seeking to explain the artist's entire oeuvre by means of my characterization of certain paintings. I am offering here a set of precisely aimed interpretive essays that consider certain specific themes and issues in depth. As a result, I will look at some paintings at great length while others are mentioned only quickly or not at all. This is not to imply a judgment or re-ordering of priority in Turner's oeuvre, but merely reflects which pictures are most useful to my characterization of Turner. This characterization, finally, is not intended to serve as a master narrative or trope. If I discover its presence and influence in a wide variety of pictures by Turner this is to be taken as a sign of its importance certainly, but not as an indication that this is the only or even the dominant issue in all of his pictures.

The book proceeds in roughly chronological fashion. The first chapter is focused primarily on a single painting from early in Turner's career, his

first picture of *The Battle of Trafalgar* (1806–8). This picture is a richly complex reaction to both history and the tradition of history painting, as I will show by considering Turner's relationship to contemporary history painting in England, which, if it did not begin with Benjamin West's *Death of General Wolfe*, certainly gained powerful cultural influence with it. In seeking, I will argue, to continue in the tradition of West, John Singleton Copley, and other artists who used the depiction of contemporary events to forge a pictorial visual unity for an increasingly heterogeneous viewing public, Turner destroyed that tradition by undoing the very compositional and symbolic mechanisms that had enabled it to function in the first place. At stake in this destruction will be not only a sense of the artist's relation to the past, but also to a more broadly framed set of questions about representation: not only how events could be represented in paintings, but how the nation was to be represented politically, who could be seen to act politically, and who could be made into what kind of political subject.

The second chapter is less concerned with an individual painting than with a particular theme, one that was already present in *Trafalgar*: Turner's awareness of a problem in representation, namely that any kind of viable painting of history increasingly needed to take into account patterns of decay, destruction, and disintegration. Thus, where meaning coalesces in his paintings, we will see that it often does so only after passing through a stage of decomposition. This was a particular challenge in the genre of history painting, which emphasized above all compositional unity and narrative coherence. The problem for Turner was to refigure or reformulate the terms of unity, composition, and coherence to account for the pressing cultural significance of disunity, decomposition, and disintegration. In investigating this, I will look at a series of pictures beginning with *The Shipwreck* from 1805 and continuing through the teens and twenties, looking in detail at *The Field of Waterloo* (1818) before ending with an unfinished picture, *The Wreck of the Amphitrite*, formerly known as the *Disaster at Sea* (1833–5).

The third chapter spends very little time looking at pictures themselves, and focuses instead on their production and on critical reactions to that production. In particular, I consider Turner's use of the Varnishing Days, when he would complete paintings from minimal beginnings during the few days before the exhibitions at the Royal Academy and the British Institution. For a notoriously secretive painter and person, this was an astonishingly public proclamation of his ability as a "magician" with paint. I will use Turner's Varnishing Days practice, and various responses to it, to consider issues of individuality and collectivity within the RA. I will show that these were a primary means for Turner to assert his own status as Britain's leading artist, "the great lion of the day," as he called himself.[28] But we will see that this assertion of individual creative power inspired not only admiration but also condemnation from a variety of political viewpoints, and that it became one forum for questions of individuality to be discussed in Reform-era Britain. This chapter will also pick up the theme of destruction and tradition from the previous chapters,

for I will show that the Varnishing Days became another means by which Turner destroyed tradition, as well as his fellow painters in the Academy, by asserting his own prominence. But we will also see that Turner himself was ambivalent about this project: he also cared deeply about the Academy and his predecessors and colleagues, and saw the Varnishing Days as a means of maintaining contact with a collective body and the tradition it represented.

The fourth chapter picks up with a group of paintings, this time the Venetian pictures of the 1830s and early 1840s. Here I return to the notion of history as a falling away, or decaying, but in this case it is a slow process of decline. I will take account of the literary references prompted by Turner's paintings of Venice, and the long tradition of historical comparisons between Venice and Britain. But I will also investigate his pursuit of paint as a means of creating an emotional equivalent to the experience of a given site or location. For Turner, as the example above suggests, Venice became a site for exploring linked questions of artistic and historical subjectivity. In particular, I will show that he was interested in the physical, sensual relationship of the artist to the external world. That relationship produced a very different kind of pictorial subject than the model of history painting that Turner had inherited, one that is essentially private, specific, and embodied, where the traditional subject of history painting had been public, ideal, and physically absent.

The final chapter returns again to the study of a single painting, *The Slave Ship*. While this work has been the subject of an enormous body of literature since its appearance at the Royal Academy exhibition of 1840, I offer a reading that differs from previous analyses, one that stresses the complexity of the picture's response to issues of slavery and abolition in Britain. In particular, I allow the picture a radical disunity and anachronism. It is my argument that Turner was aware that the issues raised by slavery were not ones that permitted clear pictorial solutions. Rather, the painting prompts the viewer to be skeptical of any such solutions. In the end, the picture not only suggests that history painting can no longer be practiced in the nineteenth century, but it also undermines the moral basis of history painting as a whole or, put slightly differently, any attempt to paint history whole.

Endnotes

1 William Rodner's important book, *J.M.W. Turner: Romantic Painter of the Industrial Revolution* (Berkeley and London: University of California Press, 1997) considers Turner's work in relation to industrialism, and so necessarily discusses many of his pictures of contemporary subjects. There are also many important studies of individual paintings and themes which I will also cite throughout this text. A number of these were undertaken by John McCoubrey, but never brought together into a collected group. See: "Parliament on Fire: Turner's Burnings," *Art in America*, 72/11 (December 1984): pp. 112–25; "War and Peace in 1842: Turner, Haydon and Wilkie," *Turner Studies*, 4/2 (1984): pp. 2–7; "Time's Railway: Turner and the Great Western," *Turner Studies*, 6/1 (1986): pp. 33–39; "'The Hero of A Hundred Fights': Turner, Schiller and Wellington," *Turner Studies*, 10/2 (1990): pp. 7–11; "Turner's *Slave Ship*: Abolition, Ruskin and Reception," *Word and Image*, 14/4 (October/December 1998): pp. 319–53. Another title central to any consideration of Turner and history is Gerald Finley's *Angel in the Sun: Turner's Vision of History* (Montreal: McGill-Queen's University Press, 1997). Over a series of studies, Eric Shanes has also explored Turner's reactions to a wide range of contemporary issues and events. See, for instance, Shanes, *Picturesque Views in England and Wales* (London: Chatto and Windus, 1980), pp. 37–40; "Dissent in Somerset House:

Opposition to the Political *Status-quo* within the Royal Academy around 1800," *Turner Studies*, 10/2 (1990): pp. 40–6; *Turner's England, 1810–38* (London: Cassell, 1990), pp. 190, 198–9, 220–5; *Turner's Human Landscape* (London, Heinemann), p. 325; *Turner: The Great Watercolours*, exhibition catalog (London: Royal Academy of Arts, 2000), pp. 213–4. Also see David Solkin's important discussion of how Turner's rural scenes register broader anxieties over modernity and socio-political change in the early nineteenth century in *Painting out of the Ordinary: Modernity and the Art of Everyday Life in Early Nineteenth-Century Britain* (New Haven and London: Yale University Press, for the Paul Mellon Centre for Studies in British Art, 2008), pp. 244–6.

2 Andrew Wilton, *Turner and the Sublime*, exhibition catalog (London: British Museum Publications for The Art Gallery of Ontario, The Yale Center for British Art and the Trustees of the British Museum, 1980), pp. 67–102; Jerrold Ziff, "Turner's First Quotations: An Examination of Intentions," *Turner Studies*, 2/1 (1982): pp. 2–11; Kathleen Nicholson, *Turner's Classical Landscape: Myth and Meaning* (Princeton: Princeton University Press, 1990); Gillian Forrester, *Turner's "Drawing Book": The Liber Studiorum*, exhibition catalog (London: Tate Gallery, 1996).

3 For a fascinating, complex account of Turner which does nonetheless view verbal structures as superimposed onto essentially visual works see Ronald Paulson, *Literary Landscape: Turner and Constable*, (London and New Haven: Yale University Press, 1982), pp. 63–103.

4 William Hazlitt, "On Imitation," *The Examiner*, no. 30 (18 February, 1816): pp. 108–9.

5 Kathleen Nicholson importantly nuances our understanding of Hazlitt and his overall view of Turner in tracing this phrase through earlier reviews in her 2009 Pantzer Lecture to the Turner Society, subsequently published in the *Turner Society News*, May 19, 2010.

6 Sir Joshua Reynolds, *Discourses on Art*, Robert Wark (ed.), (New Haven and London: Yale University Press, 1975), Discourse IV: ll. 15, 82, pp. 57, 59.

7 John Landseer, "Mr. Turner's Gallery," in *The Review of Publications on Art*, v. 1, (London: printed by John Tyler; published by Samuel Tipper, 1808), pp. 158–9 (emphasis original).

8 Sir Joshua Reynolds, *Discourses on Art*, Robert Wark (ed.), (New Haven and London: Yale University Press, for the Paul Mellon Centre for Studies in British Art, 1975), Discourse IV: ll. 19–23, p. 57.

9 On these aspects of Reynolds see John Barrell, *The Political Theory of Painting from Reynolds to Hazlitt: "The Body of the Public"* (New Haven and London: Yale University Press, 1986), pp. 136–58.

10 For Hemingway's important critique of Barrell's account of Reynolds in particular, see "The Political Theory of Painting without the Politics," *Art History*, 10/3 (September 1987): pp. 381–95.

11 C.R. Leslie, *Memoirs of the Life of John Constable, Esq., R.A., composed chiefly of his letters*, 2nd ed., (London: Longman, Brown, Green and Longmans, 1845), p. 135.

12 Nicholson, Pantzer Lecture, 2009.

13 John Ruskin, *Notes on the Turner Collection at Marlborough House* (London: Smith, Elder & Co., 1857).

14 An important account of this in philosophical terms is Charles Taylor's *Sources of the Self: The Making of Modern Identity* (Cambridge, MA: Harvard University Press, 1989).

15 Jeremy Bentham, *Plan of Parliamentary Reform, in the Form of a Catechism, with Reasons for Each Article: With an Introduction showing the Necessity of Radical, and the Inadequacy of Moderate, Reform* (1817), in *The Works of Jeremy Bentham* (11 vols, Edinburgh: William Tate, 1839), v. 10: p. 442 (emphases original).

16 Dror Wahrmann, *The Making of the Modern Self: Identity and Culture in Eighteenth-Century England* (New Haven and London: Yale University Press, 2004), pp. xii, ff.

17 The discourse of genius has shown remarkable tenacity with respect to Turner. Exceptions include Sam Smiles's important book, *J.M.W. Turner: The Making of a Modern Artist* (Manchester and New York: Manchester University Press, 2007), which considers the various institutional, personal, and national discursive investments that have produced a particular kind of reputation for Turner since his death. Smiles abandons the Promethean artist-subject for the absented Foucauldian author-function, but does so with reference to Turner's posthumous reputation. Andrew Hemingway has also departed from the standard biographical approach to the artist in considering Turner's Thames river imagery within the larger context of the various resonances of landscape painting in a context of contemporary urban viewership in *Landscape Imagery and Urban Culture in Early Nineteenth-century Britain* (Cambridge and New York: Cambridge University Press, 1992), pp. 224–45. The notion of the subject "Turner" as a critical construction embedded within a socio-cultural framework also figures centrally in K. Dian Kriz's important exploration of the development of the "genius" landscape painter as a part of nationalistic discourses at the

beginning of the nineteenth century, *The Idea of the English Landscape Painter: Genius as Alibi in the Early Nineteenth Century* (New Haven and London: Yale University Press, 1995).

18 Phillip Corrigan and Derek Sayer, *The Great Arch: English State Formation as Cultural Revolution*, (Oxford: Blackwell, 1985), pp. 8–10; Michel Foucault, "The Subject and Power," *Critical Inquiry*, 8/4 (Summer, 1982): pp. 777–795.

19 For an important discussion of the complexity of the 1832 Reform Bill with respect to class, see E.P. Thompson, "The Peculiarities of the English," in *The Poverty of Theory & Other Essays* (London: Merlin Press, 1978), pp. 48–55.

20 John Barrell, *The Dark Side of the Landscape: The Rural Poor in English Painting, 1730–1840* (Cambridge: Cambridge University Press, 1980), pp. 131–63; Ann Bermingham, *Landscape and Ideology: The English Rustic Tradition, 1740–1860* (Berkeley and Los Angeles: University of California Press, 1986), pp. 87–155.

21 In "Turner's Slave ship," John McCoubrey argues for Turner's political progressivism and on the balance this is convincing, but it does not provide us with a baseline of analysis in the way that Constable's well-documented country Toryism has done.

22 An important study in connecting Turner's landscape to Turner's conception of history and the British nation is Stephen Daniels, *Fields of Vision: Landscape Imagery and Identity in England and the United States* (Cambridge: Polity Press, 1993), pp. 112–45. See also, David Blayney Brown, "Rule Britannia? Patriotism, Progress and the Picturesque in Turner's Britain," in Michael Lloyd (ed.), *Turner* (Canberra: National Gallery of Australia, 1996), pp. 48–72; Elizabeth Helsinger, "Turner and the Representation of England," in W.J.T. Mitchell (ed.), *Landscape and Power*, 2nd ed., (Chicago: University of Chicago Press, 2002), pp. 103–126; and Michele Miller, "J. M. W. Turner's *Ploughing Up Turnips, Near Slough*: the Cultivation of Cultural Dissent," *Art Bulletin*, 77 (December 1995): pp. 572–83.

23 See for instance, Tim Barringer, Geoff Quilley and Douglas Fordham (eds), *Art and the British Empire* (Manchester and New York: Manchester University Press, 2007). Important works bringing these issues to bear in Turner studies include: Paul Gilroy, "Art of Darkness, Black Art and the Problem of Belonging in England," *Third Text*, 4/10 (1990): pp. 45–52, Marcus Wood, *Blind Memory: Visual Representations of Slavery in England and America, 1780–1865* (Manchester: Manchester University Press, 2000), pp. 56–58, ff., and K. Dian Kriz, "Dido Versus the Pirates: Turner's Carthaginian Paintings and the Sublimation of Colonial Desire," *Oxford Art Journal*, 18 (1995): pp. 116–32.

24 Kathleen Wilson, *The Island Race: Englishness, Empire and Gender in the Eighteenth Century* (London and New York: Routledge, 2003), p. 4.

25 Linda Colley, *Britons: Forging the Nation, 1707–1837*, 2nd ed. (New Haven and London: Yale University Press, 2005).

26 Geoff Quilley, "'All ocean is her own': the image of the sea and the identity of the maritime nation in eighteenth-century British art," in Geoffrey Cubitt (ed.), *Imagining Nations* (Manchester and New York: Manchester University Press, 1998), p. 132. See also Eleanor Hughes, "Ships of the 'line': marine paintings at the Royal Academy exhibition of 1784," in Barringer, Quilley and Fordham, *Art and the British Empire*, pp. 139–52. Both Quilley and Hughes are reacting to Benedict Anderson's famous *Imagined Communities*, (London and New York: Verso, 1983). See also Quilley, "Missing the Boat: the Place of the Maritime in the History of British Visual Culture," *Visual Culture in Britain*, 1/2 (Summer 2000): pp. 79–92.

27 Quilley, "'All ocean is her own'," pp. 140–5.

28 Walter Thornbury, *The Life of J.M.W. Turner, RA, Founded on Letters and Papers furnished by his Friends and Fellow-Academicians* (London: Chatto & Windus), p. 239.

"A great and dreadful sea-fight":
The Battle of Trafalgar (1806–8) and the End of
Contemporary History Painting

In 1806 Turner exhibited *The Battle of Trafalgar, as Seen from the Mizen Starboard Shrouds of the Victory* (1806–8, Plate 3) at his own gallery in Harley St. He had begun exhibiting work in this venue two years earlier as a means of further enhancing his reputation and potential sales.[1] Turner then reworked this large picture, and showed it again in 1808 at the annual exhibition of the British Institution. This was not Turner's first painting of contemporary history, nor even of a Nelsonic sea-battle. He had shown *The Battle of the Nile, at 10 o'clock, when the L'Orient blew up, from the Station of the Gun Boats between the Battery and the Castle of Aboukir* (B&J 10, present whereabouts unknown) at the Royal Academy in 1798, but that picture had fared poorly with the critics and in the intervening period Turner had concentrated on academic history paintings and seascapes as he consolidated his standing in the Royal Academy. Throughout the late eighteenth century, a number of writers on the arts had been deeply concerned with the question of how to memorialize military heroes, and this question came to the fore with Admiral Nelson's death at Trafalgar. In 1807, the first number of the periodical *The Artist*, edited by Prince Hoare and associated with a number of Royal Academicians, had called for a government-commissioned painting of Trafalgar. Noting that it would also "be in remembrance of the signal glory of Lord Nelson," the journal suggested that such a commission should be the result of a public competition. "If consistent with dignity of the state," *The Artist* asked, "would not such a commission call forth the talents of the painter and tend to the honor of the country and the arts?"[2] But Turner and a number of other artists, including Benjamin West, had already taken up the challenge on their own initiative. In doing so, West and Turner addressed a number of issues around the depiction of national heroes that had been developing since the middle of the last century.

After seeing it at the British Institution, the engraver John Landseer wrote the only extended contemporary response to Turner's *Trafalgar*. Together with a subsequent, lengthy review that Landseer wrote of Turner's exhibition at his gallery in 1808, this account constitutes one of the most sophisticated

and complex sustained critical responses to Turner before Ruskin. Landseer's commentary on *Trafalgar* is worth considering at some length here, for it lays out what I take to be the key issues of contemporary history painting as it had been practiced over the previous forty years. This is to argue a little against the grain, however, because we should note that Landseer begins by asserting the newness of Turner's picture, calling it "in every sense of the word, the *first* picture of the kind that has ever, to our knowledge, been exhibited."[3] This is an intriguing claim. But how seriously can we take it? In the first place, the very emphasis on innovation was, paradoxically, itself an established aspect of contemporary history painting. Even more, Landseer surely knew that Turner was reprising established elements of contemporary history painting, and death-of-the-hero pictures specifically: the central group, with the body of the felled Admiral Nelson in the arms of his comrades, was an overt reference to this tradition and to its most well-known expression, Benjamin West's *Death of General Wolfe* (1770, Figure 1.1).[4] Indeed, Landseer goes on to list the key elements of the genre: the combination of facticity, or apparent facticity, with the formal and narrative elements of epic or grand style history painting; the ability to communicate a powerful message to viewers; and the pictorial expression of the relationship of the individual hero to the events taking place around him. Landseer writes:

It might not be improper, as this picture is new in its kind, to call it a *British epic picture*. It was the practice of Homer and the great epic poets, in *their* pictures, to detail the exploits or sufferings of their heroes, and to generalise or suggest the rest of the battle, or other accompaniment, and Mr. Turner, in the picture before us, has detailed the death of *his* hero, while he has suggested the whole of a great naval victory, which we believe has never before been successfully accomplished, if it has been before attempted, in a *single* picture.

1.1 Benjamin West, *The Death of General Wolfe*, 1770, oil on canvas, 60.1 x 84.4 in. (152.6 x 214.5 cm). National Gallery of Canada. Transfer from the Canadian War Memorials, 1921 (Gift of the 2nd Duke of Westminster, England, 1918). Photo © NGC.

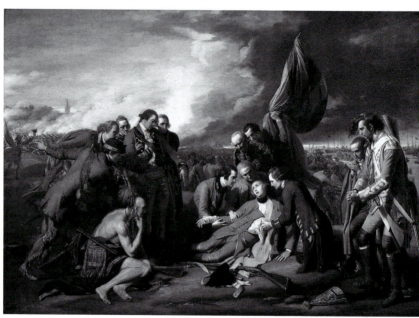

The painter has supposed himself looking forward from the mizzen starboard shrouds, along the main-deck of Nelson's ship, which is closely engaged with the Redoubtable; and while he has brought together all of those leading *facts* which mark the battle of Trafalgar, and the death of our noble and gallant Admiral, he has either painted or suggested all those circumstances of a great and dreadful sea-fight, which shall rouse the hearts of his countrymen to deeds of naval heroism, or melt them with pity.[5]

Landseer emphasizes a balance between the depiction of the scope of a large-scale naval battle and a narrative focus on the individual death of Nelson.

This chapter examines the aesthetic and historical significance of the terms Landseer lays out. I will pay particular attention to the combination of "the death of *his* hero" and "the whole of a great naval victory." Landseer's phrasing here is curious, because while it acknowledges that Nelson's death was itself a fact of the battle, his slight separation of that death from the other facts of "the whole...victory" suggests that it was a truth of a different order, a fact that needed to be treated differently in pictorial terms. In the first section of this chapter, we will see that that was indeed the case, as I will describe Turner's means of dealing with those two pictorial orders in detail, comparing his treatment, Landseer's claim notwithstanding, to previous works in the death-of-the-hero genre by West and Copley. Having noted that Turner's picture continues to include both orders of representation, but alters their pictorial relationship, I will then assess this alteration in terms of their political relevance in a period of dramatic social change in Britain. In what will become a recurrent theme of this book, finally, I will conclude by arguing that in seeking to continue the tradition of contemporary history painting, Turner partially destroyed it. In assessing the significance of pictorial structure, I will pay particular attention to the balance sought in contemporary history paintings between detail and whole, revealing how Turner then formed an altered means for expressing the position of the individual before society. We can then say that he created this altered history painting out of the literal and figurative wreckage of the tradition of contemporary history painting inherited from the eighteenth century, which he discovered he could only continue by means of destruction.

"The Whole of a Great Naval Victory"

As we have seen, Landseer credits Turner with depicting both "the whole of a great naval victory" and the "death of our noble and gallant Admiral" Nelson, but acknowledges that they belong to separate orders of representation. A first glance at *Trafalgar* is likely to suggest the dominance of the battle as a "whole," since the group around the fallen Nelson (detail, Plate 4) seems dwarfed by the scale of the surrounding battle and lost amidst the overall sense of bursting, violent energy, "all the circumstances of a great and dreadful sea-fight." I would like to both confirm and undermine this initial response. Certainly,

there can be little question that in *Trafalgar*, Turner has dramatically increased the scale and complexity of the battle as compared with West's *Death of General Wolfe*. In the earlier picture, the battle functioned in essence as background to the figures, placed in the far distance. Only the figure at left, coming with the news of French surrender, directly connects the main figural group to this distant scene. As such, because this allows the viewer to see that Wolfe died at the moment of victory, the battle plays a supporting role to the figural group, lending poignancy to the General's death, which is the structural and thematic focus of the picture. If we look at pictures that followed *Wolfe* in the death-of-the-hero tradition of contemporary history painting, such as John Singleton Copley's *The Death of the Earl of Chatham* (1779, Figure 1.2) and *The Death of Major Peirson, 6 January 1781* (1783, Figure 1.3), one sees there also an

1.2 John Singleton Copley, *The Collapse of the Earl of Chatham in the House of Lords, 7 July 1778*, 1779–80, oil on canvas, 90 x 121 in. (228.6 x 307.3 cm). © Tate, London, 2011.

expanded drive for detail and greater pictorial complexity. Both pictures were prepared with numerous portrait sittings for the figures and include extensive details of their respective settings. The result is that in both paintings there is a greater sense of equivalence between the main figural groups and the surrounding scenes. In both cases, Copley incorporates a mass of detail into which he embeds the hero's death.

Against this background, two things are evident. First, that Turner has visibly adopted the conventions of the death-of-the-hero group from West and Copley. Nelson and his attendants form a distinct collective sign on the

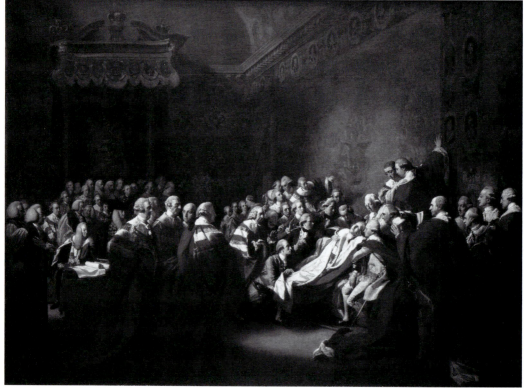

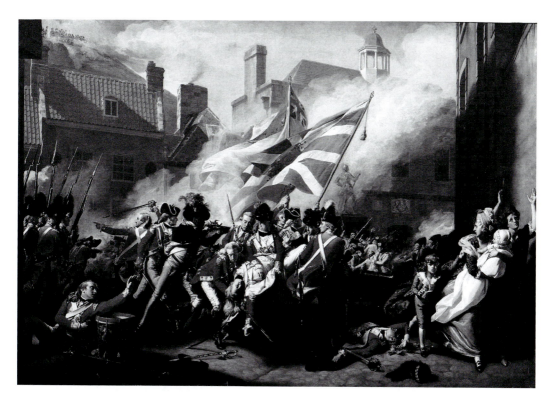

canvas. They are separated on three sides from the surrounding figures and are subtly highlighted by a slight shift in lighting which catches the curved line of the white of Nelson's uniform and distinguishes these figures from the darker groups around them. Turner does not quote West or Copley directly but the overall comportment of the figures around the hero—some supporting him, some looking on—is unmistakably similar. Turner's interest in this kind of figural group is not in doubt. During the peace of Amiens in 1802, he had traveled to Paris and made a detailed copy (Figure 1.4) of Titian's *Entombment of Christ*, which includes a group mourning the dead Christ that is similar to the group around Wolfe.[6] Although the Nelson group includes more figures than Titian's, the basic balance of the group is similar, and the figure immediately behind and to the left of Nelson who looks back up at the French sniper clearly evokes the St. John in the Titian copy. Closer to us, on the deck of the *Victory*, figures present Nelson with the French colors, a reference both to *Wolfe* and to reports that Nelson had died at the moment of victory. A drawing in his "Nelson" sketchbook of a group surrounding the wounded Lieutenant John Pasco, which carefully notes the identities of each of the figures, also shows Turner exploring a Wolfe-type figural group (Figure 1.5). Turner planned, but apparently did not complete, a key for the picture that would have assisted viewers in making those identifications (Figure 1.6), much as Copley had done with *The Death of the Earl of Chatham*.

1.3 John Singleton Copley, *The Death of Major Peirson, 6 January 1781*, 1783, oil on canvas, 99 x 144 in. (251.5 x 365.8 cm). © Tate, London, 2011.

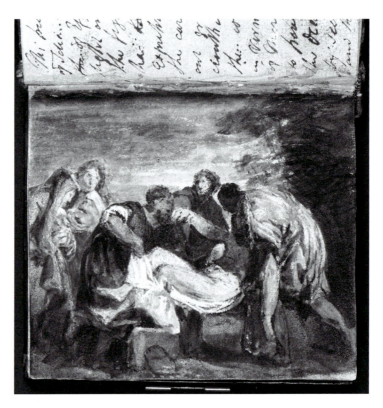

1.4 Joseph Mallord William Turner, *copy of Titian's "Entombment of Christ"*, from the "Studies in the Louvre" sketchbook, 1802, pencil and watercolor on paper, 4.5 x 5.1 in. (11.4 x 12.9 cm). TB LXXII 32. © Tate, London, 20

1.5 Joseph Mallord William Turner, *The "Temeraire", and a Group Surrounding the Wounded Lieutenant Pasco*, fro the "Nelson" sketchbook, 1805, pencil on paper, 4.5 x 7.25 in. (11.4 x 18.4 cm). TB LXXXIX 13. © Tate, London, 20

1.6 Joseph Mallord William Turner, Key to *"The Battle of Trafalgar"*, 1806, pencil and ink and watercolor on paper, 7.3 x 9.2 in. (18.6 x 23.4 cm). TB CXXI K. © Tate, London, 2011.

But the other defining aspect of the picture is that this reference, while included, is made almost comically small in comparison to the rest of the battle, which threatens to overwhelm it entirely. Turner, who took titles seriously, directed his audience to this aspect of the picture, with the long title that refers to details of the battle rather than the death of the hero. However much Copley had reduced his heroes in relation to the scale of the scene around them, there could have been little doubt as to their overall importance and centrality to the picture. This is hardly the case in *Trafalgar*, where Nelson's death appears almost anecdotal compared to the overall sweep of the battle. Turner conveys the overwhelming scale and chaos of the engagement through the soaring masts and intertwined sails that fill the upper two-thirds of the painting and dwarf the individual human participants. Turner seems to have placed many of the smaller figures to highlight this shift in scale. Note for instance the way that he silhouettes the figures behind Nelson, towards the *Victory*'s bow, against a broad sweep of smoke, and does the same with the figures at the right on the deck of the French *Redoubtable*, isolating them against the massive stern of a distant man'o'war. The masts of the ships are so closely entangled, and the smoke from gunfire so thick, that it is frequently difficult to connect the masts and sails to particular ships below. In this manner, Turner placed his diminutive figures against the background of a specific moment that was recognized as unprecedented in naval warfare, when four ships, the *Victory*, the French *Redoubtable*, the British *Temeraire*, and the French *Le Fougeaux* were fighting broadside to broadside in the midst of a major battle.[7] Turner clearly

chose a point of maximum intensity and destructive energy, one that would lend itself to extreme compositional complexity.

In so doing, Turner captured something of the essential violence of Nelsonic battle. As Adam Nicolson has vividly described, the "Nelson touch" was based on the ability of a warship to create a maximum degree of violence, chaos, and destruction, out of which Nelson was certain that superior British aggressiveness and firepower would prevail. At Trafalgar and elsewhere, Nelson's use of two lines of British ships that intersected the French line at a perpendicular angle, allowing his captains to engage the French on their leeward side, meant that rather than the orderly progression of two carefully controlled parallel lines of battle, Trafalgar would be a scene of isolated, intimate and intensely violent close engagements. By adapting this method from Admiral Howe, Nelson, as Nicolson describes it, "*dared* to recreate the mêlée which 150 years previously the invention of the line of battle had been designed to avoid."[8] Interestingly, Nicolson connects this form of battle to Romantic aesthetics in its emphasis on immediacy, its dispensation with politeness and ceremony, its focus on the activity of a multiplicity of common men, and above all in its desire to seek out a kind of elemental, brutal confrontation with the raw experience of life and death.[9]

This complexity was the subject of Turner's most finished sketch for the picture (Figure 1.7). Large portions of the sheet are filled with rapid marks of the pencil which signify smoke, air, sails and ropes. Although the Nelson group appears at the bottom right of the overall sheet, in the sketch, even more than in the finished work, it seems that it is merely glimpsed as a part of a larger sweeping motion of the eye, just one incident among many. Opposite to this sketch in his "Nelson" notebook, Turner appears to have tried to balance the figures and the overall sweep of battle in terms closer to West's and Copley's (Figure 1.8). We see the *Victory* more obliquely in this version. Turner has preserved much more of the off-white color of the sheet so that the group bringing Nelson down from the quarterdeck stands out more clearly. But it was the recto version (Figure 1.7) to which Turner ultimately adhered more closely in the finished painting (he reworked it after its original exhibition at his gallery in 1806). Whereas much of Copley's preparatory work (for instance, Figure 1.9) for *The Death of Major Peirson* had already included the details of the figural group, with the battle in the background to be filled in later, for Turner the battle took priority. Much of the intensity of the recto sketch is present in the final painting, which captures the flux and chaos of the battle at a particular moment, with forms caught seemingly by accident rather than by design. On all sides the frame cuts off the scene arbitrarily. For instance, on both the right and left of the image Turner shows only a part of a sail, with the rest out of view. Also, in the lower left hand corner, the arm of the sailor working at the damaged mast is abruptly terminated by the frame. In another instant the details of these areas might be very different.

1.7 Joseph Mallord William Turner, *Study for "The Battle of Trafalgar, as Seen from the Mizen Starboard Shrouds of the Victory"*, from the "Nelson" sketchbook, 1805, pencil on paper, 4.5 x 7.25 in. (11.4 x 18.4 cm).TB LXXXIX 26. © Tate, London, 2011.

1.8 Study for *"The Battle of Trafalgar, as Seen from the Mizen Starboard Shrouds of the Victory"*, from the "Nelson" sketchbook, 1805, pencil on paper, 4.5 x 7.25 in. (11.4 x 18.4 cm).TB LXXXIX 26a. © Tate, London, 2011.

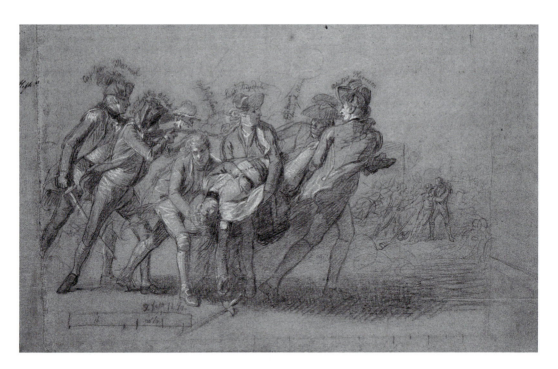

1.9 John Singleton Copley, *Sketch for "The Death of Major Peirson"*, c. 1783, drawing, 14 x 22.6 in. (35.6 x 57.5 cm). © Tate, London, 2011.

The intensity and confusion of battle is also conveyed by an even greater narrative complexity than *Wolfe* or even *The Death of Major Peirson*. While Turner reprises the theme of the hero dying at the moment of victory from those pictures, he also depicts at least six different groups engaged in separate activities on the deck of the *Victory*. We might first notice the group closest to our eye level, at the first crosstree of the *Victory's* main mast, working vigorously to secure the falling yardarm and sail. Following the mast down we see the Nelson group, which is connected to the group at the bottom left of the painting by the figure who leans on the deck and looks at the fallen Admiral. But the part of this group in the extreme corner of the picture is not concerned with Nelson at all, and is instead trying to secure the mizzen mast, which tilts ominously out of the picture frame. All along the starboard railing, to our right, are sailors and Marines engaged with the French, some visible only as silhouettes through the smoke, possibly preparing to board or defending against boarding. Correspondingly, the sense of movement in *Trafalgar* is also greatly expanded, even compared to *Peirson* in which the battle is markedly more dynamic than *Wolfe*. Copley's composition is marked by a series of right-leaning diagonal lines that give the British a sense of inexorable force and inevitability as they advance toward victory. Copley imparts a sense of the chaos and confusion of battle in the crowded, smoky scene and Emily Neff has astutely described a "dramatic multiplicity" in *Peirson*, which violated academic rules of unified composition.[10] The hero's death is spatially centered, as in *Wolfe*, but, as Neff describes, Copley introduces another layer of narrative in the detail of the black servant who shoots Peirson's killer.

In *Trafalgar*, Turner expanded this pictorial and narrative complexity even further and inscribed it in the picture's formal structure. While *Peirson* is dominated by a left to right motion, *Trafalgar* is structured around a series of carefully positioned, crossed lines that create a sense of chaotic movement in multiple directions. The masts and yardarms form a series of horizontal crosses, many of which are tilted slightly to the diagonal to emphasize the rolling of the ships and the damage caused by cannon fire. Even more pervasive are a series of diagonal crosses. The center-left of the painting is dominated by a large X formed by the shroud lines of the main mast of the *Victory*. This shape is then repeated throughout the image, in at least five different intersections of shroud lines to the right of the *Victory* and above the decks of the *Redoubtable* and the other ships. It is also repeated on the smallest scale in the white X's formed by the white straps of the Marines' uniforms. This compositional theme of crossed lines is highly appropriate to a representation of the battle of Trafalgar, in which, as we have seen the action was famously defined by the intersection of perpendicular lines of ships.[11] Unlike the dominant left to right movement of Copley's painting, Turner's *Trafalgar* is structured on the basis of constant back and forth motion, which elaborates a battle scene in which the two sides are closely entangled in numerous engagements, the outcomes of which may be suggested but are not yet clear. This sense of entanglement dominates most of the picture, even as the French colors, which are presented to the dying Nelson, speak of British victory.

Turner's adaptation of the scene of retaliation in Copley's *Peirson* also contributes to the formal and narrative complexity of *Trafalgar*. Turner shows Marines along the starboard rail of the *Victory* (detail, Plate 4) pointing and firing at the French snipers in the mizzen top of the *Redoubtable* (detail, Figure 1.10), where we see smoke coming from a musket pointing down at Nelson. This refers to a story, circulated after the battle, in which Marines under the orders of Second Lieutenant Lewis Roteley and Midshipman John Pollard, infuriated by Nelson's wounding, had cleared the French ship's mizzen top within five minutes of the fatal shot.[12] In his planned key, Turner identified the figure gesturing to the French mizzen tops not as Roteley or Pollard but as Captain Charles Adair, who commanded the *Victory*'s Marines from the quarterdeck near Nelson. Adair had in fact been killed minutes before Nelson, by the same intense French musketry.[13] This scene of retaliation creates another criss-crossing movement for the eye: from Nelson, down to the Marines along the starboard rail, up to the top of the *Redoubtable* and, following the flash of the musket, back down to Nelson.

In short then, if *Wolfe, Chatham, Peirson* and *Trafalgar* all include the death of a hero and the whole of a victory, to paraphrase Landseer, then it would seem that Turner has reversed their priority. Where West had made the dying Wolfe the dominant element in the picture, for Turner Nelson appears to have been overwhelmed by the events taking place around him. Given this, we might wonder about Turner's intentions in including him at all. Where so much of the rest of the painting is confidently painted the handling here is of a

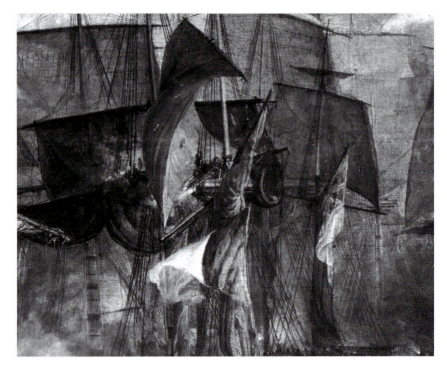

1.10 Joseph Mallord William Turner, *The Battle of Trafalgar, as Seen from the Mizzen Shrouds of the Victory*, 1806–8, detail, oil on canvas, 67.25 x 94 in. (171 x 239 cm). © Tate, London, 2011.

different order, uncertain and awkward. Inevitably, questions about Turner's difficulty with painting figures arise, as they did for his contemporaries.[14] Certainly, other than Landseer, critics were not impressed with the picture and paid particular attention to the figures. Joseph Farington reports on 3 June 1806: "Turner's I went to & saw His picture of the Battle of Trafalgar. It appeared to me to be a very crude, unfinished performance, the figures miserably bad…"[15] Robert Hunt, in *The Examiner*, expressed much the same view, though more satirically: "Turner's *Death of Nelson* is a spirited piece of shipping and effect; but we do not recollect that all the men were *murdered* on board NELSON'S ship."[16] The two parts of the sentence split the painting along the terms I described with Landseer: the overall scene and the figures. But Hunt's use of the term "shipping" makes it clear that the praise in the first clause is ironic: a willful downgrading of the picture from a subject of national significance to a mere commercial scene. This registers the degree to which the narrative of the hero no longer dominates the picture. Without a fully elaborated figural group, Hunt cannot see the ships as men-o'-war, nor can he see the smoke from the battle as anything but "effect." In his final blow Hunt suggests that Turner destroys the heroes rather than preserves them, which, as we shall see below, was one of the key goals of contemporary history painting.

The inclusion of the Nelson group also created narrative problems for Turner's exposition of the "whole battle." If we look again at the musket fire in the French mizzen top and the gesturing Marine, for instance, it becomes clear that we are simultaneously seeing the wounding shot and the order for

retaliation. These details confuse the position of Nelson, because they indicate that we are seeing Nelson both when he was wounded and afterwards. As Turner would have known from published reports, Nelson and Captain Hardy of the *Victory* had been pacing fore and aft along the quarterdeck during the battle, remaining amidships to avoid the recoiling 12–pounder guns to either side. They had just turned aft at the main hatch (a figure to the right of the Nelson group in Turner's picture is standing on the ladder that led down the hatch) when Nelson was wounded.[17] Thus Nelson is facing the correct direction. The artist's sketchbook for the picture shows him diagramming the position of the figures on the deck of the *Victory* (Figure 1.11) and the positions of the ships around Nelson's flagship (Figures 1.12 and 1.13). But even as the muzzle flashes in the French top, Nelson has already turned and fallen. Turner is evidently being pulled in two directions here: to elaborate Nelson's death with respect to previous depictions of wounded heroes on the one hand and the inclusion of extensive and accurate details of the overall event on the other. Even the mainmast, which so dwarfs Nelson, simultaneously forms a powerful stabilizing vertical, just left of center, which draws the eye downward to the Nelson group.

It is clear enough that Turner is citing the overall format of the heroic group from *Wolfe* and *Peirson*. But given the problems it created, how are we to explain its presence? One might well imagine the Nelson group as parody, a means of critiquing the work of West and Copley and so establishing the superiority of his modern marine painting over the tradition of West and Copley. There may be critique at some level, but none of the responses I have cited seem to find any parody at all and Hunt's sarcasm turns, in fact, on the assumption that Turner painted the figures in earnest. Turner's own preparations suggest that they were no afterthought either. In addition to the sketches we have seen, we know that Turner travelled to Sheerness to see the *Victory* as soon as it returned to England with Nelson's body in December 1805.[18] His execution of the *Battle of the Nile* suggests an early interest in Nelson's career, something confirmed by the fact that he returned to the subject of Trafalgar either directly or indirectly in three major works: his second painting of the battle (1824, Plate 5), which I will discuss below, *The Fighting Temeraire* (1839, Figure 2.19) and in the 1827 watercolor, *Yarmouth Sands* (Figure 1.14). As Eric Shanes has ingeniously shown, the latter work depicts a group of figures enacting the battle on a beach underneath a monument to Nelson.[19] Turner also executed pictures of Napoleon and Wellington in the 1840s, further suggestive of an ongoing, very genuine interest in military heroes.[20] On the basis of this evidence, I think no serious account of the picture can fail to address the presence of the Nelson group, with particular attention to its relationship to the examples of West and Copley. It is to that project that this chapter now turns.

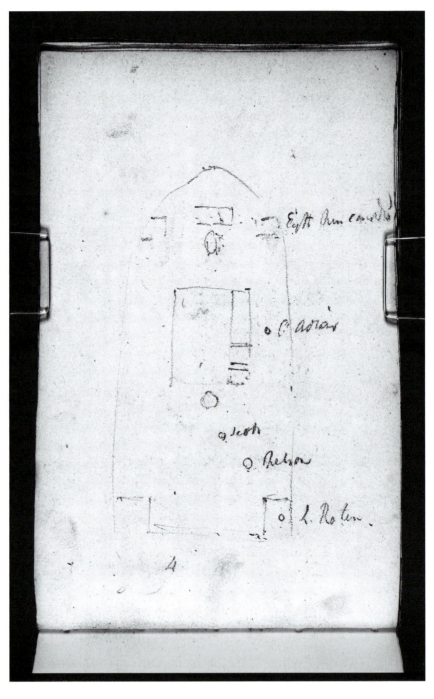

1.11 Joseph Mallord William Turner, *Diagram of the Quarterdeck of the "Victory" with Positions of Nelson and Othe* *at the Battle of Trafalgar*, from the "Nelson" sketchbook, 1805, pencil on paper, 7.25 x 4.5 in. (18.4 x 11.4 cm). TB LXXXIX 19a. © Tate, London, 2011.

1.12　Joseph Mallord William Turner, *Study for "The Battle of Trafalgar, as Seen from the Mizzen Shrouds of the Victory"*, from the "Nelson" sketchbook, 1805, pencil on paper, 4.5 x 7.25 in. (11.4 x 18.4 cm). TB LXXXIX 20a. © Tate, London, 2011.

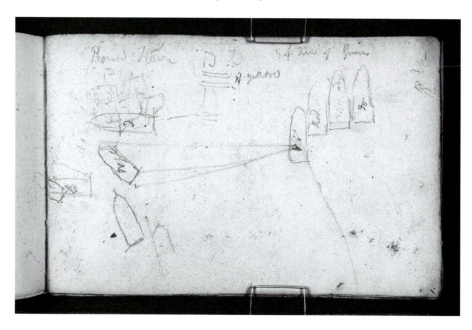

1.13　Joseph Mallord William Turner, *Diagram of Ship Positions at the Battle of Trafalgar*, from the "Nelson" sketchbook, 1805, pencil on paper, 4.5 x 7.25 in. (11.4 x 18.4 cm). TB LXXXIX 24a. © Tate, London, 2011.

1.14 Joseph Mallord William Turner, *Yarmouth Sands*, 1827, watercolor and bodycolor on blue paper, 7.25 x 9.6 in. (18.5 x 24.5 cm). Fitzwilliam Museum, Cambridge, UK. © Fitzwilliam Museum, Cambridge.

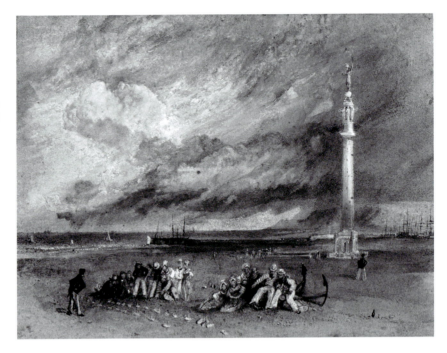

"The Death of our Noble and Gallant Admiral"

To begin this, it will be necessary to have a more detailed sense of the audiences that were addressed by contemporary history painting and the terms in which this address took place. As we have seen contemporary history paintings in essence combined two modes of address, one concerned with the details of the scene as a whole, the other with the elaboration of a significant individual experience within that scene. I would like to connect these two modes to different kinds of publics in the late-eighteenth and early-nineteenth centuries. Even more, I will argue that the way the two modes were mobilized and combined in contemporary history painting provided a means of reacting to issues of political representation in this period. At stake in this hybrid genre, I am suggesting, were questions of the political makeup and future of the nation at a time of tremendous change and instability. Contemporary history painting both responded to this situation and helped shape it by giving it visual form.

Connecting contemporary history painting to political publics in the eighteenth century is not new. West himself, via his biographer Galt, was at pains later in his career to place his use of contemporary details in *The Death of General Wolfe* in terms of a progressive political movement. Having related the initial concerns of Sir Joshua Reynolds about this innovation, Galt reports that upon seeing the final picture Reynolds responded: "Mr. West has conquered...; and I foresee that this picture will not only become one of the most popular, but occasion a revolution in the art."[21] Galt's biography, written half a century later, has long been understood as a product of West's calculated effort to

craft his own reputation in the last years of his life. Whatever the accuracy of the story, however, the important issue is that Galt and West sought to refer aesthetic matters to political ones, tying West's pictorial choices in 1770 to the political revolutions that were soon to follow. These terms were picked up in one of the foundational treatments of the genre of contemporary history paintings, Edgar Wind's essay of 1938. Wind accepts the idea of West's painting as revolutionary, and also ties it directly to emerging political democracy by writing, "Thus, the final breach with the Academic rules of history painting was produced by an impact of democratic ideas proclaimed by a group of American artists."[22] Wind discusses the setting of the picture in colonial North America as a key to creating an intermediate position between "realism," meaning the inclusion of apparently factual material, and grand tragedy. Wind also ties these representations of "mitigated realism" to the development of democratic challenges to authority: "Their intermediate position rendered them more palatable, but also more dangerous to the academic hierarchy than a truly radical attempt at reform; for they veiled the distinction between the old and the new, and bridged the gulf between the conservative and the revolutionary party."[23]

This interpretation of the genre has held considerable sway in art history, but I would like to revise it here to suggest there is a profoundly conservative aspect to contemporary history painting. This has been acknowledged by David Solkin, who also considers *Wolfe* within the overall scope of political change in the eighteenth century but, importantly, sees the painting as a holdover of an increasingly obsolete elite culture. For Solkin, the picture marks the destruction of the idea of heroic public sacrifice in favor of new, private virtues of "sympathetic humanity." Solkin suggests that while the painting accounts for new conceptions of the constitution of the body politic, it ultimately seeks to keep that new public passive, as witnesses to events rather than actors in them.[24] But Solkin ultimately sees *Wolfe* as "the end of an era," because academic painting would subsequently choose to address a primarily elite audience. Solkin thus concludes that *Wolfe* was "an isolated attempt to mediate between academic doctrines and popular taste."[25] Solkin's point about the Academy's need to cleave to an elite audience is well taken, and I do ultimately agree that the demands of the new public, based in larger political movements as he notes, meant that any balance between addressing these audiences was to prove untenable in the long-term. I think, however, that the continuation of the death-of-the-hero genre by Copley and Turner indicates that each sought to achieve this same mediation described by Solkin. However right Solkin may be in the long run, the incompatibility of the aesthetic modes and the publics they addressed was not immediately consolidated or apparent.

Indeed, it is precisely my point that the presence of the Nelson group and its reference to the Wolfe/Chatham/Peirson tradition is to be explained as a result of Turner's continued effort to include the dual levels of signification that had made West's painting so successful. To understand this, we must look further

into these two modes and the results of their interaction in contemporary history painting. The first is the factual, or purportedly factual, aspect, which Landseer identified with the phrase "those leading *facts* which mark the battle of Trafalgar." This mode dominates the sections of the painting that concern the battle as a whole, but is also present in the figures themselves, in the details in uniforms and identities. In short, this mode concerns the artist's desire to appear accurate and precise in the representation of historical events. Again, this was not new to Turner's picture. Landseer's terms echo those earlier used by Benjamin West. Discussing *The Death of General Wolfe*, West claimed to want to act as a "historian," to record "the facts of the transaction" and "mark the date, the place, and the parties engaged in the event."[26] I would like to refer to this aspect of contemporary history painting as its "informative" quality. In doing so, I mean to connect it to the development of newly active, informed political publics in the eighteenth century, as Jürgen Habermas has described.[27] Information held both practical and symbolic importance in the development of a new public in the eighteenth century, one that was increasingly able to exercise independent political thought. As described by Habermas, the growth of the press was determined in large part by the need for an economy increasingly based on long-term trade to be supplied with reliable information from abroad. On the basis of this information, then, intelligent decisions could be made and subsequently circulated, with cities becoming centers for dissemination.[28] By including aspects of the setting, dress, and personnel, West's picture and others acknowledged this newly informed, politicized public.

Consistent with this idea, one of the defining aspects of contemporary history paintings is that they attracted, or could attract, a large and diverse audience. Crowds flocked to see West's *Wolfe* at the RA in 1770 and Copley exhibited both *Chatham* and *Pierson* in private galleries designed to attract a large audience. George III was given a private viewing on the day before *Peirson* was exhibited to the public and apparently returned early from his morning ride in his eagerness to view it. The *Morning Herald* reported the next day that, "His Majesty continued examining it with the minutest attention for near three hours, and in commenting upon its various excellencies, in point of *design, character, composition and colouring* expressed himself in the highest terms of approbation."[29] The King is described as paying particular attention to the informative aspects of the picture and the fact that he came to see it in the public venue, albeit under special circumstances, and that it was deemed important to report the King's approval in the press, all indicate the importance of the larger viewing public for Copley in 1784.

The second mode, which Landseer calls "epic," pre-dated the informational, but its importance in contemporary history paintings needs to be understood as a reaction in part to the growth of the pre-Revolutionary public. The term "epic" signifies a relationship to the grand style of academic history painting as defined by writers such as the Earl of Shaftesbury, Sir Joshua Reynolds, and James Barry. This mode pertains specifically to the

figural groups in contemporary history painting, which reprise the elevated themes and idealized narratives espoused by traditional history painting. Epic painting was addressed to the mind of the elite beholder. It organized the informative aspects of the scene, allowing them to speak to timeless—or apparently timeless—values, even as they appear in the specific temporal and geographical situation established by the informational mode. It refers to both thematic elements—West's well-known adaptation of the iconography of Christian sacrifice—and stylistic ones, namely the use of a carefully controlled linear structure.

A key difference in the two modes is that the informative aspect of contemporary history painting was, by nature, conducive to innovation because it required artists to come to grips with a new set of characters and circumstances for each picture. The epic mode, on the other hand, represented timeless values and permanence, precisely those things which were not subject to change; hence, the stability of the Christian iconography of sacrifice that we see recurring in Wolfe/Peirson/Chatham/Nelson groups. West's success was precisely the result of his ability to allow the timeless themes of loyalty and self-sacrifice to organize the temporal details of time and place. This is to say something close to Wind's "mitigated realism" but to reverse the terms to suggest that it was not the old that veiled the new here, but rather the other way around. Specifically, I mean that *Wolfe* and the pictures of the military hero introduced the informative language of the new public into pictures which reframed the elite male agent as the locus of history.

To see this, we need to be particularly attentive to the role of the individual male subject in both pictorial and political representation. As we have seen, in *Trafalgar* Turner no longer gave the death of that subject the kind of formal or narrative status in relation to the whole that it had in *Wolfe*. It is significant to note that West's picture had emerged at a time when the elite male subject as a political figure was facing unprecedented threats. In addition to the growth of the new public described by Habermas, John Barrell has discussed how the growing diversification of manufacture and economy in the eighteenth century fundamentally undermined the civic humanist notion that a single, land-owning leisured individual could possibly grasp the whole of society.[30] Thus, the very notion of the individual aristocratic male as a political agent was being undermined by the same growth that helped produce the new extra-parliamentary political public. As Barrell discusses, much eighteenth-century thought held that while commercial growth could contribute to the civilizing progress of a nation, the same elements would increasingly privatize the state, leading each of its members to take a narrow, self-interested view rather than a broad, disinterested one. The result of this loss of the disinterested elite subject would be a breaking apart of society, a development marked most significantly by the growth of the middle classes. With this societal shift came increasing calls for the reform of representative government. While Thomas Paine could mock the British system's claims to representation in *The Rights of Man*, noting for instance that while the

borough of Old Sarum, comprised of "not three houses," sent two Members to Parliament, Manchester, a city of sixty thousand, sent none, his opponents, notably Burke, sought to reinstitute the significance of the elite male subject in a very different conception of representation.[31] Burke objected to the idea of proportionate representation because it would place power in the hands of the middling classes, who, in his estimation, were driven only by their own interests. The patrician elite must be entrusted with the decisions of the state, Burke thought, because they would act in the interests of the whole rather than serving their own needs. He therefore favored virtual representation, or trusteeship, in which the middle classes were represented through Britain's territorial communities. Manchester's lack of direct representation was not of concern in this model because it was virtually represented by constituencies with similar interests.[32] Later, Burke characterizes the nation in terms of the relationship of individuals to revered predecessors:

Always acting as if in the presence of canonized forefathers, the spirit of freedom, leading in itself to misrule and excess, is tempered with an awful gravity. This idea of a liberal descent inspires us with a sense of habitual native dignity, which prevents that upstart insolence almost inevitably disgracing those who are the first acquirers of any distinction. By this means our liberty becomes a noble freedom. It carries an imposing and majestic aspect. It has a pedigree and illustrating ancestors. It has its bearings and its ensigns armorial. It has its gallery of portraits; its monumental inscriptions; its records, evidence, titles. We procure reverence to our civil institutions on the principle upon which nature teaches us to revere individual men.[33]

Thus, Burke supported the patrician male elite's ability to form the nation of disparate parts into a whole. Yet as we have seen, the increasing diversification of society made that task seemingly impossible.

At stake in the loss of such individuals for Burke, moreover, was the fate of the state as a whole. Such thought can be identified in views about the separation of the professions, which, according to the Scottish Enlightenment philosopher Adam Ferguson, served "in some measure, to break the bands of society…and to withdraw individuals from the common scene of occupation, on which the sentiments of the heart, and the mind, are most happily employed." Ferguson uses the language of composition to suggest a falling away from unity into an assemblage of individual parts:

Under the *distinction* of callings, by which the members of polished society are separated from each other, every individual is supposed to possess his species of talent, or his peculiar skill, in which the others are confessedly ignorant; and society is made to consist of parts, of which none is animated with the spirit of society itself.[34]

The loss of such transcendent individuals in turn could lead to the decline of the state. Ferguson wrote,

If we would find the causes of final corruption, we must examine those
revolutions of state that remove or with-hold the objects of every ingenious study,
or liberal pursuit; that deprive the citizen of occasions to act as the member of a
public; that crush his spirit, that debase his sentiments, and disqualify his mind
for affairs.[35]

The loss of the ability of the elite male subject to create unity in a homogenous
society—to be the part that could effectively stand for the whole—prompted
concerns over the broader fate of the state.

If the diversification of society threatened the extinction of the elite male
subject, the Reform movement more directly undermined it by increasingly
fostering skepticism about the disinterested claims of the aristocracy to
serve the general good, claims which Reformers saw as masking blatant self-
interest. Paine, as just one example, wrote specifically against Burke's account
of the disinterested elite:

Many things in the English government appear to me to be the reverse of what
they ought to be, and of what they are said to be. The Parliament, imperfectly
and capriciously elected as it is, is nevertheless *supposed* to hold the national
purse in *trust* for the nation: but in the manner in which an English parliament is
constructed, it is like a man being both mortgager and mortgagee.[36]

As a result of these critiques, the elite had to attempt to represent itself as
able to sustain individual control over the nation by making the interests of
that elite individual appear to be synonymous with those of the nation as a
whole.[37]

While *Wolfe*, as we have seen, has been associated with a progressive
adoption of the values of a new, broader political public, we can account for
its politics very differently if we see the picture as a response to this situation,
as belonging to it. That fact that West used Wolfe's individual sacrifice to
carry the burden of narrative and symbolic meaning in the painting is highly
significant given its appearance in this period, when the power of the elite
male subject was increasingly eroded. Depictions of military heroes offered
a means to re-inscribe that power in a format that seemed to adopt the
informational language of the expanded political public, making the individual
appear to be "animated with the spirit of society itself," in Ferguson's terms.
By maintaining the individual male subject as the primary agent of history,
West's picture offered a metaphorized vision of a society and body politic
that is oriented around, as Burke put it, the reverence of individual men. This
re-inscription came at a time when not only was the state being pulled apart,
but when the linkage between individual elite subject and the state in other
discourses was being undermined. Look again at the pairing of Wolfe and
the metaphorical crucifix of the British flag. West aligns the two on a vertical
axis in the center of the picture, so that they form a thematic *contrapposto*:
the empire's rise in North America, symbolized by the erect flag, is possible
because of the individual's fall. The sacrifice of the single, male, elite subject is
judged to be of equivalent scale to the nation's growth.

This was particularly significant because of the role that military heroes played in creating and maintaining an idea of a virtuous nation in the midst of victory. Wolfe's death, for instance, served not only as an expression of cultural values of valor and self-sacrifice but also allowed for a national expression of noble grief as a mark of humility amidst riches. The *London Magazine* seemed to prophetically call for such a hero in the months before Wolfe's demise. In the preface to the 1759 volume that year was summed up as "[having] far exceeded our most sanguine Hopes; for the Glory of Great Britain may now be justly said to extend from the Southern to the Northern Pole."[38] That year the journal also printed also printed an excerpt from Edward Wortley Montagu's *Reflections on the Rise and Fall of the Ancient Republicks* that suggested just how closely entwined the thinking about British dominion and empire was with concerns about its demise. Notably, Montagu stressed the importance of the objects of a society's emulation as evidence of its overall virtue:

There is no mark which so surely indicates the reigning manners of a people at different periods, as that quality or turn of mind, which happens to be the reigning object of public applause…if the object of applause be praise-worthy, the example of the great will have a due influence upon the inferior classes; if frivolous or vicious, the whole body of the people will take the same cast, and be quickly infected by the contagion. There cannot therefore be a more certain criterion, by which we may form our judgment of the national virtue or national degeneracy of any people, in any period of their existence, than from those characters, which are the most distinguished in every period of their respective histories.[39]

Montagu describes a model for the diffusion of virtue from the individual to the whole of the nation, based on the valuation of the individual elite subject in history. Crucially, it is not just the characters who distinguish themselves in history, but those who they nation chooses to memorialize and exalt. Wolfe's death thus occupied a place for which the national imagination was well-prepared. Tom McNairn has also shown that the grief of the nation was understood to be an expression of humility that had been learned in part from the general and his men. A number of poems contrasted the personal grief of wife and fiancée to the noble, public mourning of the nation, so that the same figure could also speak across gender divisions.[40]

But there is still another aspect of this to consider: that in painting the hero, the artist himself could play the role of the unifying subject and this points to the importance of pictorial representation. We can begin by noting that Turner's use of the Wolfe/Peirson/Christ grouping acknowledges something that Nelson himself understood: that at some level he was acting out a part, one based on the already established archetype of the hero who dies in the midst of battle. As Adam Nicolson points out, Nelson wrote frequently of his awareness that England demanded a massive, violent sea victory, and also understood that for that victory to be complete he would need to die in the process.[41] According to the surgeon on the *Victory*, William Beatty, who authored one of the earliest eyewitness accounts of Nelson's death, Nelson

spoke so frequently with Captain Hardy of the *Victory* about dying in battle that it was "a favorite topic of conversation with him."[42] Even more, Nelson seems to have also been aware of the role of visual imagery in creating that archetype and desirous of being similarly documented. John Galt, West's biographer, relates the story of West sitting next to Nelson at an honorary dinner shortly before the latter left England for the last time:

> The admiral complimented the painter on his *Death of Wolfe* and asked why he had produced no more pictures like it. "Because, my lord," West said, "there are no more subjects." He said he feared that Nelson's fearless courage might produce another such scene, and "if it should, I shall certainly avail myself of it." "Will you, Mr. West?" Nelson said. "Then I hope I shall die in the next battle."[43]

Galt's biography is notoriously unreliable, but it is clear that Nelson knew the *Wolfe* print very well and the story accords with other accounts of Nelson's ongoing obsession with dying in battle.[44]

Indeed, Nelson seems to have been determined to put himself in maximum danger that day.[45] Nelson's plan for the two British lines to intersect the French at right angles meant that the first ship in each line would be exposed to intense fire on approach, before it could respond, and would be on the lee side of the French and Spanish fleet without support for some time after it pierced the line. According to Beatty, before the battle began Nelson had been persuaded to reduce sail on the *Victory* as she approached the Combined Fleet. This would have allowed the *Temeraire* and *Royal Sovereign* to lead so that Nelson would be less endangered. When the confrontation began, however, as the ships approached the enemy Nelson refused to do so, claiming it would have delayed the much-sought battle. He thus deliberately placed himself in the greatest degree of peril.[46] Undoubtedly, Nelson's decision was tactical: he wanted to limit any possibility of ships from the Combined Fleet escaping back to their port. But is there not also reason to think that Nelson was placing himself in the best possible position to be martyred and even may have imagined himself assuming the form of Wolfe?[47] Consistent with the Christian framework of sacrifice, there is also a biblical aspect to this idea, since Wolfe/Nelson assumes an Old Testament/New Testament structure of pre-figuration and redemption.[48] Nelson seems to have been well aware that he was following a kind of script, playing a particular role that demanded his death. Even in this, he was presaged by Wolfe, who, according to McNairn, seems to have relished the notion of a heroic death.[49]

I emphasize this because it suggests that at some level representation had come to precede and even determine history. Later in life, West claimed that it was he who created Wolfe's fame through the painting. James Northcote complained that West talked incessantly about "my Wolfe, my Wolfe," and that "He thought Wolfe owed all his fame to the picture: It was he who had immortalized Wolfe, not Wolfe who had immortalized him."[50] But West was not alone in sensing an increased importance for the role of painters in documenting the actions of the heroes. The poet William Hayley, for instance,

in an ode to the painter Joseph Wright of Derby, spoke of the necessity of the artist's act of recording the deeds of the military hero. Discussing the Siege of Gibraltar, Hayley praised the rescue of enemy soldiers from the wreck of the floating batteries as a mark of Britain's magnanimity in victory in terms similar to those we saw with Wolfe. Hayley used this opportunity to connect Britain to the great empires of antiquity. But, he continues:

> Alas what deeds, where virtue reign'd,
> Have in oblivious darkness died,
> When painting by Goths enchain'd
> No life-securing tints supplied?
> Of all thy powers, enchanting art!
> Thou deemest this the dearest part
> To guard the rights of valour, and afford
> Surviving luster to the Hero's sword.[51]

In this formulation, the artist is a counterpart of sorts to the hero, tasked with recording the hero's acts with "life-securing tints." Without the painter, in other words, the deed itself would go unknown, so that representation takes on some of the importance of the historical acts themselves; the history painter becomes literally the maker of history in addition to the military hero. That West's artistic ambition took on something of this form is evident in a letter that dates to the same year *Wolfe* was exhibited: "The Exhibitions hear have drove men to pursue defirent departments in the art of pinting – amongst which I have undertaken to whele the club of Hercules – in plain English I have embarked on Historical painting [sic]."[52] By transforming his instrument from the paintbrush into the club of Hercules, West figures himself as a subject of history, the individual who labors mightily to *make* history.[53]

Another result of this shift towards the importance of representation is that just as the military hero had, the painter becomes capable of the kind of unifying ability that seemed to be eroding in this period. As McNairn notes, Hayley was concerned with the lack of British artists available to depict military heroes. In his lengthy "Essay on Painting," Hayley lamented the absence of native artists to paint Sir Philip Sidney and took the opportunity to "Bid English pencils to honour English Worth."[54] To understand the urgency of this call, we can remember that according to Montagu, a nation's character was to be judged by the individuals it chose to honor. For Britain to fail to produce sufficient admiration for her heroes would therefore be a sign of a more general lack of virtue. Later, in his discourses to the Academy as its President, West linked the importance of the artist's role in recording and preserving the deeds of the hero to the public function of painting in the development of empire: the Greeks, West says, regarded the arts as

their public records, as the means of perpetuating all public fame, all private honour, and all valuable instruction. The professors of them were considered as public characters who watched over the events that were passing, and who had in their hands the power of embodying them for ever. And is not this still the

case with the artists of every country, how varied soever may be its maxims, or its system of action, from those of Greece? Is the artist not indeed that watchmen who observes the great incidents of his time, and rescues them from oblivion?[55]

In this account, the artist occupies a privileged and crucial place as the connection between the hero and the state, ensuring posterity for the virtue of the former and the growth and visibility of virtue in the latter. West also contended that painting could preserve events "for ever" whereas sculpture might not: there was considerable concern over the deterioration of monuments to Wolfe, even those of stone, in the years after his death.[56] Painting, then, had a better chance of forestalling not only the decay of the individual's reputation but also, by preserving virtue, that of the empire itself. As such, the work of painters was to be considered alongside that of poets and historians such as Edward Gibbon as a means of maintaining the moral rigor of the empire and thus averting its decline. To cite but one example, Hayley wrote of the *Decline of the Roman Empire*, "Thy gorgeous fabric, plann'd with wise delay / Shall baffle foes more savage than the Turk. / As ages multiply its fame shall rise, / And earth must perish ere its splendor dies."[57] For Hayley, the role of the painter in these circumstances was to provide a consolidating force, to create societal consensus. Hayley draws a parallel of sorts between military might and artistic accomplishment in his commentary on Wright's *Siege of Gibraltar*:

> Rival of Greece, in arms, in arts
> Tho' deem'd in her declining days,
> Britain yet boasts unnumber'd hearts,
> Who keenly paint for public praise;
> Her battles yet are firmly fought
> By chiefs with Spartan courage fraught:
> Her painters with Athenian zeal unite
> To trace the glories of the prosp'rous fight,
> And gild th' embattl'd scene with Art's immortal light.[58]

Not only does Hayley propose a complementary connection between arms and arts, but with the phrase "Her painters with Athenian zeal unite," he highlights this consensus with reference to the active citizenry of ancient Greece. In an age that felt that the centripetal pull of the division of labor and of party faction and strife could lead to the downfall of empire, the importance of the painter's role in this conception cannot be over estimated.

In reprising the imagery of *Wolfe* and *Peirson*, Turner may well have imagined himself reprising this central role for the artist in making history as well. This also helps to explain the urgency of the call for British painters to commemorate the victory and the death of Nelson. Interestingly, these appeals were also voiced in *The Artist*, which was begun out of a concern that the patronage of foreign masters by connoisseurs was vitiating the public spirit and impoverishing British artists. Not surprisingly, then, in the years 1808–9, the journal argued for the importance of having British painters

document the battle and the death of Nelson, a concern voiced within a larger dialogue on the appropriate means of commemorating the event. While there is no reason to think that Turner was in any way involved in the production of *The Artist*, there is much to suggest that he would have been sympathetic to many of the views expressed there. Turner shared the journal's aversion to connoisseurs in addition to his primary interest in the practical matters of painting, as Barry Venning notes.[59]

As I noted at the beginning of this chapter, in 1807, *The Artist* had called for a government-commissioned painting of Trafalgar. We should note that these demands spoke to the kind of emulation and transference of virtue from part to whole that was crucial in the development of history painting, in which the virtue of the hero was re-inscribed by the painter, and reflected in turn on the nation. The ongoing interest in seeking a connection between painter and hero was made explicit in a letter to the editor, signed simply "An Englishman," which *The Artist* printed to reiterate its previously stated position. This is of particular importance in the context of the ongoing growth of the extra-parliamentary public, as it indicates an increasing awareness that the opinions of elite cultural arbiters like Prince Hoare would gain authority with reference to the public's own views. The letter begins by lamenting that sculptures of Nelson are often not seen "and are, perhaps, by a great mass of the people scarcely known to exist," which points again to the importance of that larger public, as well as to the predominance of the painter over the sculptor for such projects. The anonymous writer then argues for government support for a painting of the great battle. The content of the argument is important, for it invokes the same mutually reinforcing a cycle of detail and whole that I have described. Such a painting, the author states,

would…reflect the highest honour on our national character. The labours of the Painter, thus directed and thus patronised, would, while they contributed to the gratification and improvement of society, display a bright and refined example of beneficence. The Painter, like The Hero, pants for fame, and, under the requisite encouragement, would be enabled not only to ensure it to himself, by the exercise of his talents, but, like the Hero, to impart it to his country.[60]

The connection between hero and painter, emphasized in the capitalization of each term, is thus constituted as a primary goal and echoes Hayley's language ("…unnumber'd hearts, / Who keenly paint for public praise;"). Turner, there is every reason to believe, would have sought exactly the kind of conjunction between personal success and national glory described here. Turner's picture had already been exhibited at his gallery by this point, so he did not undertake the picture specifically to answer *The Artist*'s call. But such ideas about the connections between hero/painter/state were clearly current in circles close to Turner at this stage in his career and *The Artist*'s call and Turner's own pictures need to be seen as linked responses to these ideas.

I noted above that in *The Death of General Wolfe*, West established an equivalence between the state and the individual. As we return to Turner's

treatment of Nelson, we should note that verbal representations of the battle maintained this dual focus on the individual and whole. In reporting the events, for instance, *The Times* judged Nelson's death to be of equal importance to the battle itself. *The Times'* first headline about Trafalgar, on 6 November, read "Glorious and Decisive Victory over the Combined Fleet and the Death of Lord Nelson." This perfectly expresses the way the event was reported in the weeks to follow. Indeed, *The Times* set the tenor of the entire discourse on that first day of reporting by saying, "We know not whether we should mourn or rejoice." Nelson was at first reported to have been felled "by almost the last shot that was fired by the French" but it soon became clear that he had been shot much earlier and died before the battle was finished. By November 7, however, *The Times* was reporting that he had died in the very moments that victory had been secured. By also characterizing him as thinking of his country even in his last moments, Nelson was immediately incorporated into the category of military heroes, including Wolfe, that had been created over the past fifty years, and Trafalgar was cast as a bittersweet event, a crucial victory purchased at the tremendous cost of Britain's dearest son. It is revealing of the extraordinary stature of Nelson, as well as the importance of the military hero in British culture at this time, that the death of one individual could warrant so much attention in the midst of what was already recognized as the most important naval battle for Britain since the defeat of the Spanish Armada.

The Times shared the desire that I have described in contemporary history paintings to organize the information it provided into an interpretation that offered a story with a moral. In addition to the theme of Nelson's sacrifice for Britain, *The Times* used the events and Nelson's death to suggest that there was, and should be, a unified British opinion that transcended class difference. On the first day it reported news of the battle, the newspaper prominently featured a story about an ordinary seaman who cheerfully accepted amputation because he felt it would make him more like Nelson, who had lost an arm. Upon hearing of Nelson's death while the amputation was underway, the seaman reportedly said: "Good God! I would rather the shot have taken off my head, and spared his life."[61] Though apparently anecdotal, the story emphasizes the qualities of loyalty to superiors as well as the importance of emulating their bravery and sacrifice to the nation, while letting Nelson's death stand as the central narrative aspect of the battle.

With all of these resonances, it is hardly surprising that Turner sought to forge a link to the death-of-the-hero paintings by West and Copley. But it does make the fact that he allowed the Nelson group to be so completely overwhelmed by the battle as a whole all the more striking. When we think of this in terms of an increasingly dominant informative mode, however, it is possible to see Turner as being pulled in two directions, while attempting to achieve the kind of balance between the two modes that West and Copley had done. This notion of a split address is suggested not just by the awkward mix of modes on the canvas that we have noted, but also by the picture's exhibition history. Although we have only the sketch for a key to the picture,

the fact that Turner was planning to include this level of detail suggests a connection with Copley and West who had also used keys to their informative pictures. The planning of a key also suggests that Turner may have intended for the picture to reach a large audience by means of a print.[62] By exhibiting the picture in his own gallery, Turner may have sought to build a potential list of subscribers for the eventual print, as he did successfully in these years with *The Shipwreck* (1805, Plate 7), which I will discuss in the next chapter. Even so, however, Turner's gallery was a relatively small venue that was designed to allow a more direct, controlled appeal to potential patrons than the crowded space of the RA. The British Institution, where Turner subsequently showed the picture, was similarly geared to elite audiences. Founded in 1805 by wealthy connoisseurs and cultural arbiters such as Sir George Beaumont, J.J. Angerstein and Sir Charles Long, precisely the kind of patrons Turner would have hoped to attract at his gallery. Indeed, Linda Colley has discussed the degree to which the BI was a primary means of maintaining elite cultural control over the expanding public and Ann Pullan characterizes the BI as a site of struggle in the uneasy relations between patrician and bourgeois culture.[63]

All of this places the picture in the midst of those relations and gives added significance to Turner's decision to give emphasis to the informative aspects of the picture. "Information" and its political importance had continued to grow in the years around *Trafalgar*. By the early nineteenth century, the availability of political information was linked by reformers to the protection of English liberties, defined precisely as the right to exercise political subjectivity free from absolutist direction. Jeremy Bentham's 1817 *Plan of Parliamentary Reform*, written in the wake of Waterloo, followed other reformers such as Thomas Paine and William Cobbett in finding the seeds of moral dissolution present in the continuation of the economic policies and conservative politics of Burke and William Pitt the Younger. Bentham used the term "information" to describe a situation in France in which only official propaganda was permitted to circulate: "In France, on the subject of their common interests, no longer can any information be received through the channel of any newspaper, other than those which are not only instruments, but avowed instruments in the hands of the ruling despotism." Bentham describes a similar practice emerging in Britain, with the two governments as partners in the "subjection" of their people.[64] The effective circulation of information was tied, therefore, to the effective function of English liberty and the presence of an informed public, the public to whom Bentham and other reformers had appealed in earnest since the 1780s.

This aspect of the term "information" was familiar to artists. *The Artist*, as I have noted, was published by Prince Hoare with the explicit goal of counteracting the influence of connoisseurs and non-professional arbiters of artistic taste.[65] Hoare was one of a number of early nineteenth-century figures who attempted to forward the high-minded public goals of the Academy, in continuation of the ideas of Shaftesbury, Reynolds, and Barry. In its opening number Hoare described connoisseurs as false authorities who misled the

public in their own self interest. From the perspective of the artists, and perhaps especially those academicians who contributed to the journal, the connoisseurs were only interested in maintaining the value of their own collections of foreign art by keeping prices for these artists high while depressing those of British artists. In response, *The Artist* appealed directly to the public by providing a forum for learning about art and its practice directly from the artists themselves. Importantly, Turner's fellow Academician and painter James Northcote framed this appeal in terms of circulating information from reliable, knowledgeable sources to a public capable of forming independent judgments: "It will, I trust, be considered as a laudable desire that while I endeavor to open to my country the present streams of information which the age affords, I may, by declaring their sources, enable the public to form a standard, by which to appreciate the value of what is here presented."[66] This call was repeated in a letter printed in the journal in support of the call for a commissioned painting. The anonymous writer begins by lamenting that sculptures are not seen, or even known to exist by "a great mass of the people." The writer then goes on to point specifically to the value of accuracy in painting addressed to a knowledgeable public: "The historical work of the painter, possessing the advantage of representing, distinctly, the exact and living actions of the hero, forcibly arrests the attention; and, being intelligible to every capacity by its resemblance to real life, has the power of affording the most desirable evidence of facts."[67]

It is with this notion of an appeal to a broadened, and broadening, public that we can understand the expansion of the informative aspects of contemporary history painting in Turner's *Trafalgar* that I have described. This expansion is visible also in West's own version of the subject, *The Death of Nelson* (1806, Figure 1.15). Ann Abrams has argued for a development in West's later work similar to what I have described with Turner in which the scope and importance of historical events gains greater significance in relation to the individual scene.[68] Certainly this is visible in his Nelson picture. Compared to *Wolfe*, we can immediately see that West includes a far greater profusion of detail in the large number of figures and ancillary scenes that take place around Nelson on the *Victory*. While he relegates the larger battle itself to the background as he had done with *Wolfe*, West includes a far greater sense of tumult and activity in his Trafalgar picture than characterizes fighting in the background of the earlier painting. The equal clarity of focus and linearity with which he depicts these figures, moreover, causes them to vie with the Nelson group for the viewer's attention, which is diffused across the canvas. West seems to have tried to cope with this difficulty by heightening the difference in the scale between the foreground and background groups, but this produces a sudden, awkward shift in the size of the figures and the further difficulty that the partially horizontal Nelson appears smaller than the standing figures to either side of him.

1.15 Benjamin West, *The Death of Nelson*, 1806, oil on canvas, 71.9 x 97.4 in. (182.5 x 247.5 cm). Courtesy National Museums Liverpool.

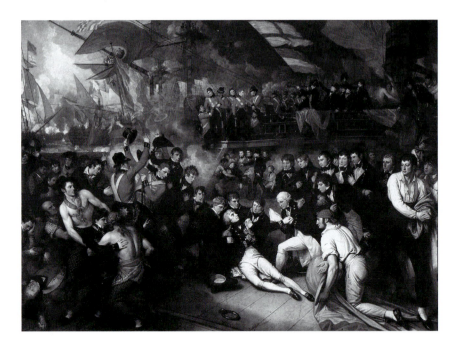

But it is significant that Turner places his viewer very differently than West does. In West's Nelson picture, we are in a position analogous to the viewer of *Wolfe*: we are placed more or less on a level with the figures and little seems to block our access to them. This viewpoint is at once involved closely in the scene by proximity, but also fictionalized and abstracted. It is not the position of any specific participant in the scene but rather that of a generalized viewer. Turner, on the other hand, places us very specifically, high above the decks of the *Victory*, looking at Nelson obliquely and a distance. The singularity of this position as well as the linked desire for immediacy, is indicated in the specificity of the title "…*as seen from the Mizzen shrouds*…" His earlier Nelsonic painting was similarly precise both in regards to time and place: *The Battle of the Nile, at 10 o'clock, when the L'Orient blew up, from the Station of the Gun Boats between the Battery and the Castle of Aboukir*. This choice signals a particular situation for the artist/viewer with respect to some idea of "real" space and time, acknowledging at once the uniqueness of that position and the possibility for other viewpoints, none more privileged than the others, so that it is at once isolated and collective.

In this regard, we should also be attentive to Landseer's use of the possessive "his" before "hero," meaning "Turner's hero Nelson." This phrasing conveys a distinctly different sense than if he had written "England's hero" or "*the* hero," as we saw in the letter to *The Artist* above, for "*his* hero" gives to the relationship between Turner and Nelson a distinctly personal quality. On the one hand, this suggests a direct relationship, pointing to the intensity of Turner's feelings for Nelson and his sacrifice. On the other hand, it isolates that experience, making it private rather than public and shared. Where West's *Wolfe* had been based on a public outpouring of emotion contiguous

with the event itself, it also positioned the artist as the communicator of shared values. By contrast, Landseer casts Turner's painting as an individual reaction: Turner's relationship to "his hero," while intense, is closer to a modern experience marked by distance and absence. Rather than diminishing the importance of Nelson in the picture, the distancing of the group heightens this sense of alienation.

Turner's distancing of Nelson and his men marks a crucial difference from earlier contemporary history paintings that commemorated military heroes, one that hinged in part on the artist's access to the key historical players. Considerable access had been granted to Joseph Wilton, for instance, who executed the Wolfe monument in Westminster Abbey. Wilton studied the stone cistern in which Wolfe's body was transported back to England so that he could attempt a death mask, although the face proved too much deteriorated.[69] Copley had traded on such access in *The Death of Chatham* (Figure 1.2), which, with its many life portraits of peers and details of the interior of the House of Lords, opened to viewers a scene that was secret to the public just a decade before, when Parliament was still closed to reporting. Copley could also claim to have the details of his account of the Siege of Gibraltar directly from Sir Roger Curtis, who had led the rescue of the enemy sailors from the floating batteries, and from General Eliot, the commander of the garrison, and Colonel John Drinkwater, who became the unofficial chronicler of the siege, as John Bonehill notes.[70]

Turner's access to the Trafalgar scene was by comparison limited. He spent no more than an afternoon on board the *Victory* when it returned to Sheerness, during which time he sketched the ship and talked with the boatswain.[71] Notes Turner made in his sketchbook, including "After the S[anta] T[rinidad] passed some other ship with a White Lion Head raked the Victory," have an undeniable immediacy, but one based on an immersion in the scene rather than on a comprehensive understanding of the overall battle. Note for instance the vagueness of "some other ship." Indeed, the "Nelson" sketchbook is filled with fragmentary details: portions of the exterior of ships seen from the side or astern (Figure 1.16), drawings of uniforms and flags (Figure 1.17), and renderings of anonymous soldiers and marines (Figures 1.18, 1.19 and 1.20). Many of these details, to which Turner did have direct access, are more delineated and fully articulated than the Nelson group as it appears in the final picture (Plate 4), or the sketch of the group around Pasco (Figure 1.5). For the Pasco sketch, Turner indicated a number of details about the figures, such as their eye color. Turner clearly felt that this information was a crucial part of contemporary history painting, but such detail seems far from possible in the final picture. Unlike his predecessors, however, he simply did not have access to the key historical players. Where the anonymous figures of Marines and sailors were vivid and present to Turner, Nelson and the battle were not. The Nelson group thus represents a different order of representation entirely, something Turner worked up from the memory of previous paintings to be inserted into the historical picture he was preparing.

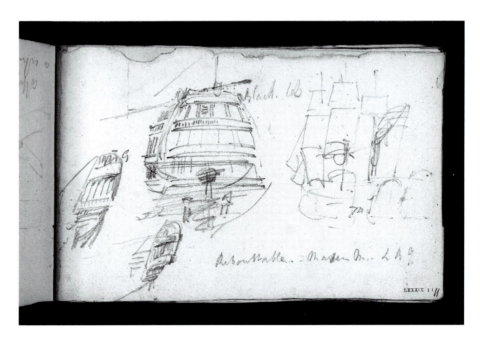

1.16 Joseph Mallord William Turner, *Three Views of the Stern of a Man-of-War, and a Ship under Full Canvas*, from "Nelson" sketchbook, 1805, pencil on paper, 4.5 x 7.25 in. (11.4 x 18.4 cm). TB LXXXIX 11. © Tate, London, 201

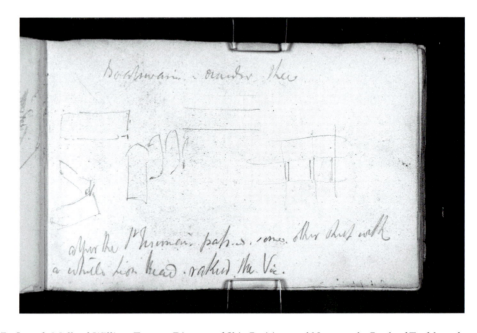

1.17 Joseph Mallord William Turner, *Diagram of Ship Positions and Notes on the Battle of Trafalgar*, from the "Nelson" sketchbook, 1805, pencil on paper, 4.5 x 7.25 in. (11.4 x 18.4 cm). TB LXXXIX 10v. © Tate, London, 20

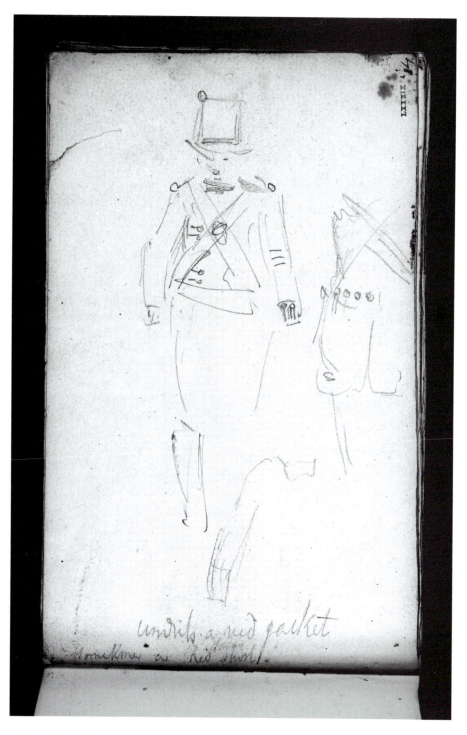

1.18 Joseph Mallord William Turner, *Studies of a Marine's Uniform,* from the "Nelson" sketchbook, 1805, pencil on paper, 7.25 x 4.5 in. (18.4 x 11.4 cm). TB LXXXIX 4. © Tate, London, 2011.

1.19 Joseph Mallord William Turner, *Sailors and Marines*, from the "Nelson" sketchbook, 1805, pencil on paper 4.5 x 7.25 in. (11.4 x 18.4 cm). TB LXXXIX 15. © Tate, London, 2011.

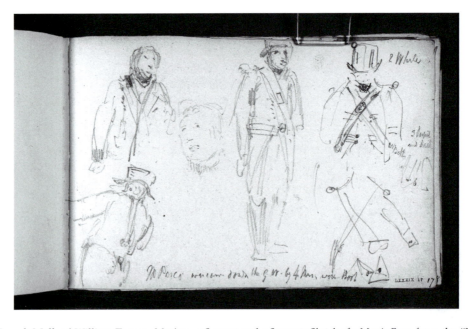

1.20 Joseph Mallord William Turner, *Marines, a Seaman and a Separate Sketch of a Man's Face*, from the "Nelson" sketchbook, 1805, pencil on paper, 4.5 x 7.25 in. (11.4 x 18.4 cm). TB LXXXIX 17. © Tate, London, 2011.

This sense of distance from the Nelson group is present as well in Turner's watercolor of the quarterdeck of the *Victory* (Figure 1.21). Turner notes such details as "Rail shot away during action" and "Splinter hitting marks in pencil / 9 inches thick." These comments, and the pervasive sense of stillness—the huge expanse of empty white deck, the hollow space behind the wheel, the hatch that opens like a grave—where once there had been such noise and action, suggest an artist searching for some connection to a distant event and a distant figure, one that can only be glimpsed in the imagination. This is much closer to a model of battle tourism that would be increasingly common in the nineteenth century, in which travelers would visit sites of conflict, such as Waterloo, to search for a physical fragment or sign of battle.[72]

Even as he sought to maintain the balance between modes, then, Turner's approach to his subject, meaning here both Nelson and the battle, was more akin to that of a member of the extra-parliamentary audience of Copley's commissioned pictures rather than that of Copley himself. Paradoxically, it is the very lack of access, the very different sense of the possibilities of the representation of history—of subjectivity—that gives rise to the poetics of the picture. What emerges in *Trafalgar* is the presence of a fundamentally altered subject position in relation to history and its representation. Where previous paintings had been based on the elaboration of a shared experience,

1.21 Joseph Mallord William Turner, *The "Victory" from Quarterdeck to Poop*, 1805, Pen and ink, pencil and watercolour on paper, 16.7 x 22.2 in. (42.4 x 56.5 cm). TB CXXI S. Turner © Tate, London, 2011.

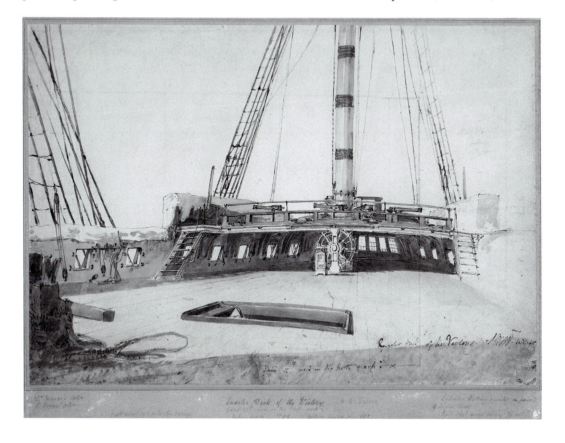

of consensus, Turner's picture emerges from an isolated, single viewpoint. Turner almost certainly felt this as in part a loss, especially when faced with negative reactions. But one also senses the excitement and sense of artistic liberation in the sketches for the picture, in the rapid motion of the pencil, just as one senses the opposite in Turner's lack of commitment to drawing the Nelson group. If Turner is in one sense alienated from tradition, from Nelson, and ultimately from the kind of connection to the state offered by the earlier model of the contemporary history painter he is also liberated by this break and joined to a larger political public from which he draws energy.

To understand this different historical subjectivity, then, we need to look at another representational system. If West's painting depicts a Burkean model of trusteeship representation, then Turner's picture is much closer to Bentham's notion of society as formed by the interaction of large groups of individuals. For Bentham, the prominence of one individual (monarchy) or a few individuals (aristocracy) served merely to enable those "ruling-few," as he puts it, to exploit the "subject-many" for their own benefit. In this way, aristocracy or monarchy works contrary to the "universal interest," against the principles of Utilitarianism and the production of the greatest happiness for the greatest number.[73] At its core, then, this model is opposed to the notion of using the individual as the representational basis of the nation. By contrast, Bentham's plan for reform was based on microcosmic, or proportionate, representation, in which the various and even most minute interests and passions of society, represented in this case by Parliament, would be precisely replicated. By making the interests of the governors exactly coincident with those of the governed, corruption and exploitation would become superfluous.[74] This marks a crucial difference from trusteeship, because it relies upon no single individual to maintain views beyond his or her own interests. It is thus a system born of and addressed to the greater complexity of society described by Ferguson and others.

Turner registers these changes in society and representation in *Trafalgar* by depicting a historical event as a vast scene comprised of individual actions that minimizes distinctions of importance as registered by scale. To be clear, I am not suggesting that Turner consciously set out to create a Benthamite vision of Trafalgar, but that his depiction responded broadly to the kinds of changes in notions of political participation that are evident in the representational theories of Bentham and other Reformers. The development of a complex, industrialized economy, in combination with an expanding reform movement, meant that the metaphorical representation of the dominant individual that had been so effective for West no longer had the same currency for Turner. This is to say: changes in ideas about political representation did not determine the nature and form of aesthetic representation any more than did the continuing progress of the division of labor. But both of these developments affected the possibilities for an aesthetic representation that wanted to remain viable and current in a changing political and social environment. This meant that contemporary history painting, the success of which hinged precisely on a

sensitivity to the shifting dynamics of elite and extra-parliamentary publics, could register them in subtle and exact terms. In 1806, Turner was working with the same basic terms as West had in 1770: the individual actor as political force (the "hero" in Landseer's terms) on the one hand and the larger political sphere on the other (Landseer's "whole of a great naval victory") on the other. For West, the progress of the extra-parliamentary public so derided by Burke was such that it could be contained fairly effectively by the individual. That public had assumed a greater prominence and political force by 1806 and it is this relative shift in importance that Turner registers so powerfully in *Trafalgar*. Interestingly, Elizabeth Helsinger has argued convincingly that Turner's later work in the picturesque involved a similarly political alteration of some of its formal conventions. Discussing Turner's watercolors for the *Picturesque Views of England and Wales* series in the 1820s, Helsinger begins by comparing the cultural superiority she sees implied by the picturesque to the status and property requirements that determined Parliamentary participation in pre-Reform England. She then suggests that by altering certain formal conventions which enacted that superiority, Turner acknowledged the increasing claims of non-elite groups to the right to participate directly in the government of England. For instance, by refusing to merge the figures into the scene in the manner advocated by the picturesque writers, she suggests that Turner declined to allow the elite viewer absolute possession of the landscape. Also, by altering the point of view of the image, according to Helsinger, Turner offers a range of implied viewers, and thus pictorially portrays the English landscape as contested ground in precisely that time when its government was contested. Ultimately, she suggests that in the increasingly conflicted society of early nineteenth-century England, Turner's contested imagery denied the kind of unity typically posited by the picturesque, based in the control by the upper classes.[75]

Epilogue: Creators of Destruction

Several conclusions can be drawn from the above discussion, which have significance for the overall argument of this book. In the first place, I would emphasize the fact that in *Trafalgar* Turner isolated the confrontation between the individual in history and the scope of historical events as a whole. Seen this way the diminution of the Nelson group acquires still greater meaning. That is, rather than appearing as a vestige of a increasingly obsolete style of painting, or as an afterthought by a Romantic artist, the insignificance of the Nelson group can be seen as a structural element in its contrast with the size of the picture and the event as a whole. We will see throughout Turner's career that this structure is repeated both thematically and formally in a structure of his historical pictures, which will continue also to consider the relationship of individuals, often artists, to the larger scope of history. As such, *Trafalgar* also offers an opportunity to very subtly gauge Turner's relationship to

eighteenth-century traditions on the one hand and his sensitivity to larger issues in visual representation more generally. If the painting seems to confirm Turner's distance from artists like West, we can also note that separation was by no means absolute at this stage in his career. If the picture at first glance may appear to be predicated on the notion of visibly exceeding its precedents, further investigation reveals that Turner in part sought to continue the tradition of those precedents. At the same time, however, his choice to emphasize innovation was driven by a sensitivity to the capacity of visual representation to represent an altered set of circumstances. This choice, in the end, amounted to a destruction of the very tradition that Turner at least partially sought to continue.

This linkage of creativity and innovation to destruction will recur constantly in my account of Turner's history painting. We can see a similarly ambivalent relationship to the past in Turner's second version of the subject, *The Battle of Trafalgar, 21 October 1805* (Plate 5), painted much later, in 1823–4. Thanks to the influence of Turner's friend Sir Thomas Lawrence, by then President of the Royal Academy, Turner was commissioned by George IV to paint the subject as one of a series of battle scenes to decorate St. James's Palace, which also included Philippe-Jacques de Loutherbourg's *The Battle of the First of June, 1794* (1795; Figure 1.22). This was a period in which Turner actively sought royal favor, having exhibited *England – Richmond Hill on the Prince Regent's Birthday* (Figure 4.33) as an appeal to the Prince Regent in 1819, and undertaken a series of pictures of the progress of George IV in Edinburgh.[76] The second *Trafalgar* was a failure in this regard and was removed to the Royal Naval Hospital in Greenwich soon after it was installed.[77] It is interesting to compare this picture to his earlier version. In this case, Turner was working under an official commission and as a part of a series, which required him to interact even more directly with a tradition of naval battle painting. In these circumstances, Turner reverted to a more conservative means of composition that attempted to counteract some of the sense of history overwhelming the individual from the first picture. In the 1823–4 *Trafalgar* Nelson does not appear, but the chaos of battle is pushed far into the background, to allow us to focus on a group of figures struggling in a lifeboat in the foreground. Turner clearly adopted this structure from de Loutherbourg, and must clearly have meant for the viewer to compare the pictures. In *The Battle of the First of June, 1794* and *The Battle of Camperdown* (1794; Figure 1.23) de Loutherbourg had used a foreground group to maintain a human scale, both literally and metaphorically, within an image of a massive naval conflict. In both pictures, this group elaborates the human element of the drama. This is the visual equivalent of *The Times's* strategy of relaying individual accounts of the battle to provide the story with a sense of pathos. Turner's figures express the humanity of the British forces as they pull each other out of the water, but also the exultation of victory, as sailors on the right of the boat raise their arms in triumph. Such actions point to the elements of honor and glory that were central to British identity as it was formed through the wars of the last century. What this approach offered

Turner was a different means to keep the individual human actor, albeit an anonymous one, in the forefront of history and to encompass a more complete view of the event. Nelson himself is referred to here not only because of the prominence given to the *Victory*, but through his own words: the *Victory* flies his famous signal "England expects every man to do his duty," and Nelson's motto "*Palmam qui meruit ferat*," (Let whoever earns the palm bear it), floats on the surface of the water in the left foreground. In a sense it is as though Nelson is already bodily absent but spiritually presiding over the scene.

But lacking this identifiable figure in the picture, Turner's attempt to simplify the subject and capture human interest is pulled toward a jumble of anonymity. Turner multiplies the number of figures in the foreground boat and suggests numerous others in the distance. While the figures in de Loutherbourg's picture look both to the battle and the struggling sailors in the water, Turner's glances shoot in every direction, in a manner that replicates the tumbling masts in the background. In the end, he succeeded in complicating rather than unifying the scene. Captain Hardy, who had been next to Nelson on the *Victory*, seems to have been reacting to this when he compared the picture to a "street scene" rather than a battle, and here we might recall Robert Hunt's use of the term "shipping" for the earlier version. Both accounts reduce the scene to something mundane. One senses certainly that Turner wanted to bring a greater sense of flux and complexity into the scene, compared with his predecessor. Furthermore, Turner's picture seems to expressly highlight the insufficiency of scale in de Loutherbourg's picture, which maintains its narrative coherence in part by making the figures seem impossibly large compared to the ships behind. As a result de Loutherbourg's battle looks tame and even absurd, and his entire pictorial structure with it. Even when working on an official commission and next to the work of a predecessor, Turner seems to have been more inclined to undo that tradition.[78] Given the history of artists identifying with military heroes, moreover, is it not possible that the citation of Nelson's motto points to a declaration of artistic competition?

This in turn needs to be understood in the context of growing ambivalence in these years over the role of the individual as an historical actor. On the one hand, we have seen that the elite male subject could act as a unifying force in the nation. On the other hand, the growing emphasis on individual accomplishment and prowess increasingly seemed to threaten the stability of the social hierarchy, by serving its own interests rather than those of the state. If any literary figure can stand for the enduring belief in the importance of the aristocracy as the guardians of social order, it is the snobbish, rank-obsessed Sir Walter Elliott in Jane Austen's *Persuasion*. When asked about the navy, Sir Walter admits its utility but complains about it "as the means of bringing persons of obscure birth into undue distinction."[79] Sir Walter's reservations both encapsulate the issues I have discussed in this chapter and point ahead to the next. On the one hand, I have described how the individual—the military hero, or the painter—could become a site for the creation of a set of unified

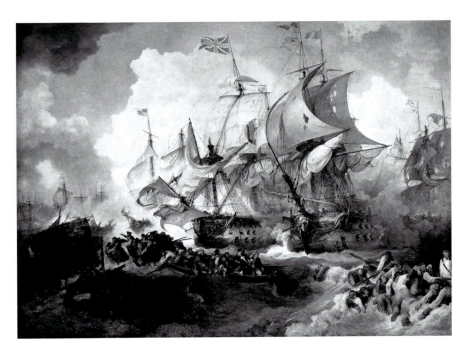

1.22 Philippe-Jacques de Loutherbourg, *The Battle of the First of June, 1794*, 1795, oil on canvas, 104.9 x 147 in. (266.5 x 373.5 cm). National Maritime Museum. © National Maritime Museum, Greenwich, London.

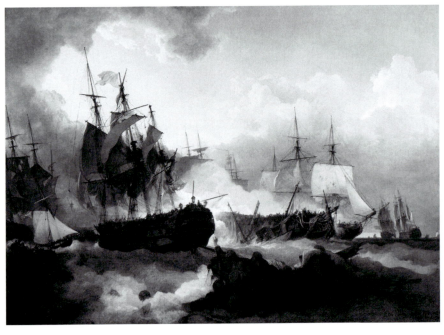

1.23 Philippe-Jacques de Loutherbourg, *The Battle of Camperdown*, 1799, oil on canvas, 60 x 84.3 in. (152.4 x 214 cm). © Tate, London, 2011.

values that could stand for the whole in a time of growing fragmentation. But for this to be successful, the individual element's "utility" to the whole must remain primary. If the individual achieves "undue distinction," Sir Walter fears, then it will no longer maintain the social order but threaten its destruction: it may cease to serve the whole by becoming a whole unto itself. Accounts of Nelson's funeral procession and various commemorations of his death, as discussed by Colin White, betray a concern over the potentially disruptive quality of lower class behavior in the streets.[80] Here the veneration of the individual military hero threatens the stability of the social order, rather than preserving it. As Emily Neff has noted this destructive quality was present already in Copley's modifications of pictorial elements and strategies of exhibition, which appeared to some as threateningly insubordinate and self interested. She connects this to the insubordinate behavior of Peirson himself, whose heroism was produced by his refusal to obey a command to surrender.[81]

This same sense of a dangerous social mobility, political activity, and popularity was undoubtedly a part of the reception of Turner's work, which often betrayed an awareness of his low birth. For both the military hero and the artist who commemorated him, furthermore, creation and destruction could be ambivalently linked. Just as Nelson had brought unparalleled violence to bear as a means to create a secure English state, so too for Turner in his paintings of *Trafalgar*, did the artist need to produce a picture of destruction and outdo his predecessors in the process. Such a figure could hope to bolster societal unity on the one hand, but also threatened to overwhelm it with his sheer individual force. Also, if Wolfe and Nelson were to create new futures for Britain and its empire, they had to do so not merely by means of their own destruction but by bringing that destruction to the empire's Others, be they the Catholic French or the non-white populations they suppressed. But this power of destruction could not be exclusively directed towards the enemies of the state. As Adam Nicolson wonderfully illustrates, part of Nelson's success arose from his ability to balance two kinds of heroism that fit precisely into the tension between individual ambition and the creation of consensus that I have described. This two-pronged heroism is close to my account of Turner's career. On the one hand, the Achillean, or Homeric, hero is "ragingly" individual, burning and destroying in a manner that is necessarily uncontrollable. This is the Turner familiar to us in the discourse of modernism, valued for his destruction of Academic painting. The Virgilian hero, on the other hand, "serves the state" rather than himself; as such, his use of violence is controlled and limited. "He conforms and conserves," Nicolson says, "where Achilles dislocates and destroys." This is a less familiar Turner, the one who deeply revered Sir Joshua Reynolds and whose allegiance to the RA lasted a lifetime. Nicolson suggests that only an awareness of these two modes, the "Trafalgar amalgam" he calls it, accounts for the combination of love of country and honor and the unbridled, apocalyptic violence that was

Nelson's particular legacy, and I would suggest a similar awareness may help us understand some of the apparent contradictions of Turner's career.[82]

Part of the accomplishment of *Trafalgar* is its thundering realization of the dual quality of Nelsonic battle, exemplified in its vivid mix of innovation and destruction. We will see in the next chapter how this duality becomes a common theme with Turner. Not only does Turner posit a kind of subjectivity based on representing scenes of absolute destruction and chaos, but he also engages in the destruction of the tradition of history painting which he had inherited. I noted above that the structure of the death-of-the-hero painting featured a conservative element, namely, the figural group, and an innovative element of the surrounding informational details and immediacy of battle. We can see this combination now in terms of David Solkin's discussion of the need to adapt public virtues of disinterest to a commercial market. That is, by incorporating an element that accommodates individual innovation and ambition within the overall structure of shared universal values, the genre was ideally suited to creating consensus within a complex, privatized society. The destructive capacity of the individual could thus be harnessed and directed towards approved goals. In the one mode, the artist abdicates individual expression, making reference to timeless, shared values, while in the other, the artist paints in a way that would be noticeably different from any picture that had come before. Another way to characterize the balance achieved by West and maintained, with difficulty, by Copley is the control of the latter mode by the former. By calling this a "British epic picture," invoking the language of history painting, Landseer attempted to attribute a similar combination of novelty and tradition and Turner's decision to maintain the presence of the Nelson group indicates finally his desire to balance these terms of innovation. As we have seen, however, other viewers were unconvinced. Ultimately, with the Nelson group minimized and not imposed on the structure of the picture as a dominant compositional force, the private values of innovation seem to have won the day here. Thus, even as Turner tried to continue the genre of the death-of-the-hero, in a fundamental way he destroyed its basic tenets.

This destruction works formally as well, for *Trafalgar* actually inverts the structure of *Wolfe*. In the latter picture the moment of individual death has a kind of gravitational pull, gathering the various gazes and lines of the picture towards its center. The *Victory* occupies a similarly central position on the canvas in *Trafalgar*, but here Turner transforms it into an agent of destructive power that plunges into the center of the canvas and inaugurates the chaotic fragmentation of battle. The painting realizes this splitting, centrifugal energy vividly, with ships that are visible only in parts. The bursting smoke from the *Victory's* starboard guns, for instance, cuts away the stern of the *Redoubtable* from the rest of the ship. In this regard, Hunt's jocular dismissal of the figures as "murdered" registers something profound about the picture's relation to the tradition of contemporary history painting. It is as though those paintings have been split apart, ripped open and left as fragments. We will see this comparison of Turner's painting to a violent, even deadly act repeated often

in the chapters that follow. But here it was entirely appropriate to the nature of the subject. Turner harnessed the violent power of the battle itself to link creativity to destruction, and not for the last time.

Thus, at stake in Turner's destruction of the tenets of contemporary history painting were a set of very delicate balances of detail and whole, of individual and state. The next two chapters explore the degree to which Turner saw himself, and was increasingly recognized, as an agent of destruction, both of artistic norms and social conventions. We will repeatedly encounter a tension between a desire to "serve the state" and a desire for individual achievement and recognition in Turner's work, especially as it relates to history. Paradoxically, as in *Trafalgar*, that destruction will exist alongside a desire to uphold those norms and traditions.

Endnotes

1 See Luke Hermann, "Turner's Gallery and Exhibitions," in Evelyn Joll, Martin Butlin and Luke Hermann (eds), *The Oxford Companion to J.M.W. Turner* (Oxford and New York: Oxford University Press, 2001), pp. 349–50.

2 "The Shade of Nelson," *The Artist* (March 14, 1807): p. 15.

3 John Landseer, "Exhibition at the British Institution," in *The Review of Publications on Art* v. 1, (London: printed by John Tyler, Rathbone Place, for the Authors; and published by Samuel Tipper, 37, Leadenhall Street, 1808), p. 83 (emphasis original).

4 Landseer was an engraver and advocate for the status of engravers and so certainly would have been familiar with the engravings after *Wolfe*. For a discussion of Landseer and his relationship to Turner see Luke Hermann, "Landseer, John (1769–1852)," in Butlin, Joll, and Hermann, *Oxford Companion to J.M.W. Turner*, pp. 160–1 and Hermann, "John Landseer on Turner: Reviews of Exhibits in 1808, 1839 and 1840," *Turner Studies*, 7/1 (Summer 1987): pp. 26–33 and 7/2 (Winter 1987): pp. 21–8.

5 Landseer, "British Institution," p. 83 (emphases original).

6 TB LXXI, p. 32.

7 William Beatty, *The Death of Lord Nelson* (London: T. Cadell and W. Davies, 1807), p. 35.

8 Adam Nicolson, *Seize the Fire: Heroism, Duty and the Battle of Trafalgar* (New York: HarperCollins, 2005), p. 182.

9 Nicolson, *Seize the Fire*, pp.182–3, 192–201, 209–38.

10 Emily Neff, "The History Theater: Production and Spectatorship in Copley's *The Death of Major Peirson*," in Neff (ed.), *John Singleton Copley in England*, exhibition catalog (London: Merrell Holberton for the Museum of Fine Arts, Houston, 1995), pp. 78–81.

11 Gerald Finley, in *Angel in the Sun: Turner's Vision of History* (Montreal and London: McGill-Queen's University Press, 1999), p. 102, suggests that it is the moment of the crossing of the two lines which we see here, but this does not account for the fact that Turner shows Nelson already wounded, when that occurred about a half-hour after the lines crossed. Finley also notes the connection to West and Copley and Turner's use of the Christian hero pose from West, but sees the *Trafalgar* as more "primarily factual" than *Wolfe* or *Peirson*.

12 Tim Clayton and Phil Craig, *Trafalgar: The Men, The Battle, The Storm* (London: Hodder and Stoughton, 2004), pp. 204–5.

13 Beatty, *Death of Nelson*, p. 33.

14 For important discussions of Turner and figuration, see: Andrew Wilton, "Sublime or Ridiculous?: Turner and the Historical Figure," *New Literary History*, XVI/2 (Winter 1985): pp. 344–373; David Gervais, "Figures in Turner's Landscapes," *The Cambridge Quarterly*, 14/1 (Summer 1985): pp. 20–50; Ann Chumbly and Ian Warrell, *Turner and the Human Figure: Studies of Contemporary Life*, exhibition catalog (London: Tate Publishing, 1989).

15 Kathryn Cave (ed.), *The Diary of Joseph Farington* (16 vols, New Haven and London: Yale University Press for the Paul Mellon Centre for Studies in British Art, 1979), v. VII, p. 2710.

16 Robert Hunt, "British Institution," *The Examiner*, 6 (February 7, 1808): p. 94.

17 Beatty, *Death of Nelson*, p. 37. See also Mark Adkin, *The Trafalgar Companion* (London: Aurum Press, 2000), p. 14.

18 James Hamilton, *Turner: A Life* (New York: Random House, 2003), p. 109.

19 Eric Shanes, *Turner's England, 1810–38* (London: Cassell, 1990), pp. 158–9.

20 See Nicholas Alfrey, "Turner and the Cult of Heroes," *Turner Studies*, 8/2 (1988): pp. 33–44; John McCoubrey, "The Hero of A Hundred Fights: Turner, Schiller and Wellington," *Turner Studies*, 10/2 (1990): pp. 7–11; Finley, *Angel in the Sun*, pp. 94–113.

21 John Galt, *The Life, Studies and Works of Benjamin West, Esq. President of the Royal Academy of London* (2 vols, London and Edinburgh: T. Cadell and W. Davies and W. Blackwood, 1820), v. 2, pp. 49–50.

22 Edgar Wind, "The Revolution of History Painting," *Journal of the Warburg and Courtauld Institutes*, 2/2 (October 1938): p. 126.

23 Wind, "Revolution of History Painting," p. 117.

24 David Solkin, *Painting for Money: The Visual Arts and the Public Sphere in Eighteenth-Century Britain* (New Haven and London: Yale University Press for the Paul Mellon Centre for Studies in British Art, 1992), pp. 212–3. Martin Myrone (*Bodybuilding: Reforming Masculinities in British Art, 1750–1810* (New Haven and London: Yale University Press for the Paul Mellon Centre for Studies in British Art, 2005) follows Solkin's argument and considers *Wolfe* as a compromise between the new modes of sympathy and the epic mode of heroization. Myrone importantly further places the picture within the context of a crisis of masculine identity and debates over the appropriate form of heroism in the middle of the eighteenth century, convincingly arguing that West's *Wolfe* offered a well-calibrated heroic imperial subject behind whom all Britons could unite (pp. 108–120).

25 Solkin, *Painting for Money*, pp. 272–3.

26 Galt, *Life of Benjamin West*, v. 2, pp. 48–9.

27 Jürgen Habermas, *The Structural Transformation of the Public Sphere: An Inquiry into a Category of Bourgeois Society*, trans. Thomas Burger (Cambridge, MA: MIT Press, 1989), p. 66.

28 Habermas, *Structural Transformation*, pp. 16–21.

29 Cited in Jules Prown, *John Singleton Copley* (2 vols, Cambridge, MA: published for the National Gallery of Art, Washington by Harvard University Press, 1966), v. 2, p. 307.

30 John Barrell, *English Literature in History, 1730–80: An Equal, Wide Survey* (New York: St. Martin's Press, 1983), pp. 13–50, ff.

31 Thomas Paine, *Rights of Man* (Mineola, NY: Dover Publications, 1999, original, London: J.S. Jordan, 1791), p. 35.

32 This summary is indebted to David Judge, *Representation: Theory and practice in Britain* (London and New York: Routledge, 1999), pp. 47–52.

33 Edmund Burke, *Reflections on the Revolution in France* (Mineola, NY: Dover Publications, 2006 original, London: J. Dodsley, 1790), p. 32.

34 Adam Ferguson, *An Essay on the History of Civil Society* (Cambridge and New York: Cambridge University Press, 1995, original, Dublin: Boulter Grierson, 1767), p. 218.

35 Adam Ferguson, *Essay on the History of Civil Society*, pp. 213–4.

36 Paine, *Rights of Man*, p. 37 (emphases original).

37 Linda Colley, *Britons: Forging the Nation, 1707–1837*, 2nd ed., (New Haven and London: Yale University Press, 2005), pp. 155–93.

38 *London Magazine, or, Gentleman's Monthly Intelligencer*, XXVIII (January 1759): unpaginated.

39 *London Magazine, or, Gentleman's Monthly Intelligencer*, XXVIII (March 1759): pp. 136–7.

40 Tom McNairn, *Behold the Hero: General Wolfe and the Arts in the Eighteenth Century* (Montreal: McGill-Queen's University Press, 1997), pp. 14–5, 43–4.

41 Nicolson, *Seize the Fire*, pp. 251–2.

42 Beatty, *Death of Nelson*, p. 69.

43 Galt, *Life of Benjamin West*, p. 149.

44 For an important account of the Galt biography, see Susan Rather, "Benjamin West, John Galt, and the Biography of 1816," *The Art Bulletin*, 86/2 (June 2004): pp. 324–345.

45 Nicolson, *Seize the Fire*, pp. 91–2.

46 Beatty, *Death of Nelson*, pp. 29–30.

47 As Edgar Vincent notes in his biography, the codicil that Nelson wrote to his will just before that battle and his comment to another officer that "I shall never speak to you again," have been interpreted by many as indications that Nelson intended to die that day. Vincent is more inclined to consider them as the instinctively theatrical gestures of a man in a highly charged emotional state (*Nelson: Love and Fame* (New Haven and London: Yale University Press, 2003), p. 573). Intentions are obviously impossible to determine, but my point remains that at some level Nelson was aware that he was playing a part that was already written.

48 Tom McNairn does not put it in biblical terms, but he certainly sees Wolfe's death as developing into a prototype, as well as one that had itself been prefigured by the deaths of ancient generals. He notes, for instance, the King commissioned the *Death of Epaminondas* to go with his copy of *Wolfe*, reflecting a generally held connection between the two generals (McNairn, *Behold the Hero*, pp. 177–8.)

49 McNairn, *Behold the Hero*, p. 33.

50 McNairn, *Behold the Hero*, p. 162.

51 William Hayley, "Ode to Mr. Wright, of Derby," in Hayley, *Poems and Plays* (6 vols, London: T. Cadell, 1785), v. 1, pp. 143–4.

52 "Letter from Benjamin West," *Journal of the Archives of American Art*, 4/1 (January 1964): p. 12.

53 Martin Myrone's work (*Bodybuilding*) considers the pictorial depiction and performance of heroism in detail. He notes the importance of the creation of heroic images as central to ideas of masculine artistic achievement, saying for instance, "Painters and sculptors were encouraged to believe that, by creating heroic images like those of the acknowledged masters of art from antiquity and sixteenth-century Italy, they could reap material rewards and contribute to a flourishing national culture. They could become, like Phidias and Michelangelo, heroic in their own person – giants in their fields, acclaimed in the present day, commemorated in future eras." (pp. 2–3).

54 William Hayley, *On Painting, in Two Epistles to Mr. Romney*, 3rd ed. (London: J. Dodsley, 1781), l. 436, p. 49.

55 Galt, *Life of Benjamin West*, pp. 88–9.

56 McNairn, *Behold the Hero*, pp. 86–8.

57 Hayley, "Sonnet to Edward Gibbon, Esq.," in *Poems and Plays*, v. 1, p. 160.

58 Hayley, "Ode to Wright of Derby," in *Poems and Plays*, v. 1, p. 144.

59 Barry Venning, "Turner's Annotated Books: Opie's 'Lectures on Painting' and Shee's 'Elements of Art'," (II), *Turner Studies*, 2/2 (1983): pp. 42–4.

60 *The Artist*, 5 (April 11, 1807): pp. 12–3.

61 *The Times*, London, November 6, 1805: p. 1, column d.

62 In this regard, it is especially interesting that John Gage raised the possibility that Turner may have exhibited a version of *The Battle of the Nile* as a public spectacle along the lines of the panorama or de Loutherbourg's *Eidophusikon* (John Gage, "Turner and the Picturesque," *Burlington Magazine*, 107 (1965): pp. 23–5). See also, Martin Butlin and Evelyn Joll, *The Paintings of J.M.W. Turner*, 2nd edition, (2 vols., New Haven and London: Yale University Press, 1984), text volume, pp. 7–8.

63 Colley, *Britons*, p. 176; Ann Pullan, "Public goods or private interests? The British Institution in the early nineteenth century," in Andrew Hemingway and William Vaughan (eds), *Art in Bourgeois Society, 1790–1850* (Cambridge: Cambridge University Press, 1998), pp. 30–1.

64 Jeremy Bentham, *Plan of Parliamentary Reform in the Form of a Catechism, with reasons for each article: with an Introduction showing the necessity of radical, and the inadequacy of moderate, Reform*, in *The Works of Jeremy Bentham* (11 vols., Edinburgh: William Tait, London: Simpkin, Marshall & Co., and Dublin: John Cumming, 1838), v. X, 436.

65 Andrew Hemingway, *Landscape Imagery and Urban culture in Early Nineteenth-Century Britain* (Cambridge and New York: Cambridge University Press, 1992), pp. 138–9.

66 James Northcote, "The Progress of the Arts in Great Britain," *The Artist*, 2 (March 21, 1807): pp. 14–5.

67 Letter to the editor, *The Artist*, 5 (April 11, 1807): pp. 12–3.

68 Anne Uhry Abrams, *The Valiant Hero: Benjamin West and Grand-Style History Painting* (Washington, DC: Smithsonian Institution Press, 1985), pp. 191–196.

69 McNairn, *Behold the Hero*, pp. 62–3. For more on the Wilton monument see Joan Coutu, "Legitimating the British empire: the monument to General Wolfe in Westminster Abbey," in John Bonehill and Geoff Quilley (eds), *Conflicting Visions: War and Visual Culture in Britain and France c. 1700–1830* (Aldershot and Burlington, VT: Ashgate Press, 2005), pp. 61–83.

70 John Bonehill, "Exhibiting war: John Singleton Copley's *The Siege of Gibraltar* and the staging of history," in Bonehill and Quilley (eds), *Conflicting Visions*, pp. 146–7.

71 David Blayney Brown of Tate Britain was kind enough to share with me the suggestion that the sketch of the position of the ship that appears in the "Nelson" sketchbook may in fact have been by the hand of the boatswain. This will be included in the upcoming catalog of the Turner Bequest, an extraordinary undertaking that promises to shed much new light on this painting and many others.

72 I will return to this in the next chapter. See Stuart Semmel, "Reading the Tangible Past: British Tourism, Collecting and Memory after Waterloo," *Representations*, 69 (Winter, 2000): pp. 9–37.

73 Bentham, *Plan of Parliamentary Reform*, pp. 438–43.

74 For a discussion of Bentham's views within proportionate representational theory more generally see Judge, *Representation*, pp. 23–6.

75 Elizabeth Helsinger, "Turner and the Representation of England," in W.J.T. Mitchell (ed.), *Landscape and Power* (Chicago: University of Chicago Press, 1994), pp. 106–119.

76 See Gerald Finley, *Turner and George the Fourth in Edinburgh*, exhibition catalog (London: Tate Gallery in association with Edinburgh University Press, 1981).

77 See Andrew Wilton, *Turner in his Time* (London and New York: Thames and Hudson, 2007, updated edition of 1987 original), pp. 144–5 and Anthony Bailey, *Standing in the Sun: A Life of J.M.W. Turner* (London: Sinclair-Stevenson, 1997), pp. 236–8.

78 I am grateful to Geoffrey Quilley for sharing his insight into Turner's later *Trafalgar* picture and its relation to de Loutherbourg during the Turner and Master's scholar's event in 2010. Quilley's own response to the 1824 *Trafalgar* will appear in his important forthcoming book on naval history paintings.

79 Jane Austen, *Persuasion* (New York: Pantheon Books, 1933), p. 18.

80 Colin White, "'His dirge our groans - his monument our praise': Official and Popular Commemoration of Nelson in 1805/6," in Holger Hoock (ed.), *History, Commemoration and National Preoccupation: Trafalgar, 1805–2005* (Oxford and New York: Oxford University Press, 2007), pp. 36–8.

81 Neff, "The History Theater," pp. 157–66.

82 Nicolson, *Seize the Fire*, pp. xx, 6–7. The development of Nelson as the Homeric/Virgilian male hero also needs to be understood within the development of masculine identity in the period after 1780, in which gender roles became polarized as a part of the larger movement towards modern notions of selfhood. See Dror Wahrman, *The Making of the Modern Self: Identity and Culture in Eighteenth-Century England* (New Haven and London: Yale University Press, 2004). This is explored with great subtlety in relation to the arts in Myrone, *Bodybuilding*. Myrone argues that "an emphatic, hyperbolic gender identity is produced in these years that is entirely, and knowingly, unstable." Thus Myrone is particularly interested in the ambivalence produced by the efforts of artists like James Barry, Henry Fuseli and William Blake to produce what he calls "impossible bodies" to define heroic masculinity (p. 12).

"The Conception of a swamp'd world": Destruction and Creation in Painting/History

This chapter picks up where the previous one left off: with Turner as a painter of destruction. But it also works backwards in part, filling in Turner's awareness of a set of issues relevant to the status of history painting in the first years of the nineteenth century, and seeking to explain in part how the depiction of destruction became so urgent for the artist. It is my contention that Turner recognized fragmentation and disintegration as both the basis and the goal of his project in the early nineteenth century. In considering Turner's pictures of destruction across his career, I will necessarily address the related issue of empire, which many of these pictures concern either directly or indirectly. For a people as historically self-reflexive as the British in the eighteenth century, empire was a necessarily anxious, if lucrative, affair that provoked considerable discussion in a wide range of forms and forums. It was in 1763, at the very point when British dominion in North America had been consummated, that the historian Edward Gibbon decided to embark upon writing *The Decline and Fall of the Roman Empire*. As much as Britain's continued march to empire was fueled by a sense of a divine purpose for a just Protestant land,[1] that very success prompted widespread concern over the fate of the nation. In the first place, the British saw themselves in many ways as the heirs to the great civilizations of the past. James Thomson's rather ponderous poem of 1734, *Liberty*, describes the progress of the eponymous allegorical figure from ancient Greece and Rome, to Renaissance Italy, and finally to modern Britain. Each of these shifts resulted from a decline, a waning of liberty, as the civilization was enervated by the effects of luxury, materialism, fractiousness, and vice. Of Rome, for instance, Thomson writes,

> Thus luxury, dissension, a mixed rage.
> Of boundless pleasure and of boundless wealth,
> Want wishing change, and waste-repairing war,
> Rapine for ever lost to peaceful toil,
> Guilt unatoned, profuse of blood revenge,
> Corruption all avowed, and lawless force.
> Each heightening each, alternate shook the state.[2]

With massive riches pouring into Britain from both east and west, there was great concern that the same fate must inevitably await Britain as well. We have already seen aspects of this dynamic in play while exploring the importance of the sacrifice of General James Wolfe, whose death Benjamin West depicted in the midst of what the *Royal Magazine* called the "inexhaustible source of wealth" in the British dominions of the New World.[3]

Even during the years of imperial success in North America, fears over the effects of commercial success and the influx of Eastern goods caused a concern with redefining a masculine British subject to resist the enervation of luxury.[4] Additionally, because the governing of non-Western peoples in Asia and Africa was deemed necessary to an extent that it had not been in North America, concern grew about the corrupting effects of absolute power for a nation that defined itself, and justified its expansion, in terms of the propagation of liberty.[5] Scottish Enlightenment philosopher Adam Ferguson expressed these fears pithily, writing of the danger to the nation of "the perpetual enlargement of territory." Ferguson continued, "In the progress of conquest, those who are subdued are said to have lost their liberties; but from the history of mankind, to conquer, or to be conquered, has appeared, in effect, the same."[6] After the Napoleonic wars, *The Monthly Magazine* espoused a new form of colonialist policy, encouraging the establishment of a "more mild and beneficent form of government" as a means of subduing piracy on the Barbary coast, enforced by a "well-disciplined European army, directed by a Wellington." By spreading the principles of the English constitution rather than violating them as in the case of the "wanton attack on the French people, for the pretended crime of choosing their own emperor and form of government," the worst effects of autocratic rule, the journal argued, could be avoided.[7] Notable here is the need for empire to stem from English liberty rather than contradict it, and the emphasis on discipline, provided by the rational control of a single male subject ("directed by a Wellington"). By these means not only would empire increase, but British identity would be confirmed internally. After Waterloo, then, as after Quebec, there were widespread fears about what imperial power might mean for the moral fiber of the state.[8] These fears had a long history in patterns of thought on imperial decline. As J.G.A. Pocock discusses, the line of civic humanist thinking that informed the milieu around Gibbon and others held that empire was built through the unity of military and civic virtue. At the very height of the empire's achievement, however, that connection was severed, thus sowing the seeds for decline. The achievement of peace allowed commerce and the arts to flourish, leading to a further enervation of the public spirit.[9] With this reference to a "well-disciplined" army *The Monthly Magazine* pointed to the need to continue employing such a force for the moral good of the nation, not just material gain in the colonies.

In short, I am suggesting that British empire was considered to be a dynamic, fluid process in which rise and fall were implicated, folded back into, and embedded within each other. Turner's interest in the stages of empire has been

discussed by a number of scholars since the 1980s and I want to expand upon these studies by taking the interpenetration of rise and decline into account, to show that only such a model is adequate to understanding both Turner's pictures that relate to empire and his revisions of history painting. [10] I use this model of mutually inflected rise and fall to be attentive to particular qualities of both Turner's pictorial spaces and surfaces and to his understanding of the process of history. Indeed, in both cases, I will show that there is a dynamic formal and thematic element at work in Turner's treatment of history that is best understood as a dialectical process of forming and un-forming, of coming together and falling apart.

That being said, another purpose of this chapter is to give the question of decline, disintegration, and destruction the focus that it demands in Turner's work. In doing so, I am perhaps in part responding to Ruskin's reported charge to Walter Thornbury as he undertook a biography of Turner: "Don't try to mask the dark side."[11] It is my position that destruction was a dominant concern for Turner in depicting history, that it can be seen as a primary structuring, or better, de-structuring agent in his work. This chapter therefore begins with a discussion of the practice and theory of eighteenth-century history painting, as primarily concerned with pictorial and imperial building and with resisting decline. Turner inherited a belief in the importance of history painting and its ability to communicate lofty ideas, but painted at a time when historical awareness was fundamentally different from the period in which this theory was developed. For Turner, history could no longer be imagined primarily as a coming together toward unity and climax, but was instead to be understood as a falling away. Thus, where meaning coalesces for Turner, it will do so only, paradoxically, as the product of this dissolution. For Turner in the early nineteenth century, ideas could be spoken of perhaps best by a process of un-saying.

History Painting and Decline

Turner, who was accepted as a student at the Royal Academy in 1789, was well-versed in the academic theory of the eighteenth century. This discourse, which was geared primarily towards establishing working methods for painting, necessarily touched on a set of moralistic concerns that placed it within the realm of humanism.[12] Turner knew Reynolds's *Discourses* in detail, and often quoted and recommended them to fellow artists.[13] He also attended lectures by James Barry, owned a copy of Barry's *Works*, and is known to have paid careful attention to the lectures of Henry Fuseli.[14] During the first decade of his working career, especially following his election as an Associate of the Royal Academy in 1799, Turner explored a number of different aspects of history painting in a series of pictures that demonstrated his ambition to work in the highest genre of the art.[15] For these writers, the establishment and expansion of influence of the Royal Academy was to be understood within

the larger moral goals of modern society and in relation to the growth of the British empire. Each worked to some extent from a belief that modern British society was corrupt and fallen, and that the Academy might work against the decay of British morals by the effects of luxury and self-interest. Reynolds, Barry, and Fuseli all conventionally connected the fall of the arts away from ancient ideals to larger political issues of their own time, and they saw the Academy as a means to counteract this decline.[16]

A brief discussion of Sir Joshua Reynolds's *Discourses* reveals that the pursuit of pictorial unity was the guiding principle for the great artist and that this pursuit can be directly related to these social and moral issues of decline. To begin, as much as Reynolds's well-known theory of the central form can be rightly understood as a process of excluding the imperfections of nature to arrive at a higher ideal, it was also a matter of bringing together various perfections that could be found both in nature and in the work of previous masters. In his Second Discourse, for instance, Reynolds discusses a secondary phase of artistic education in which artists, having acquired a fundamental proficiency, must broaden their field of study: "Having hitherto received instructions from a particular master, he is now to consider the Art itself as his master. He must extend his capacity to more sublime and general instructions. Those perfections which lie scattered among various masters, are now united in one general idea, which is henceforth to regulate his taste, and enlarge his imagination."[17] Artistic genius, expressed in history painting, is figured as the ability to bring multiplicity together into unity. When, in the next Discourse, Reynolds turns to describe the central form itself, he admits that there may be different perfect forms for different kinds of figures, but also asserts the presence of a still higher perfection, one that unifies these types: "But I must add further, that though the most perfect forms of each of the general divisions of the human figure are ideal, and superior to any individual form of that class, yet the highest perfection of the human figure is not to be found in any one of them. It is not in the Hercules, nor in the Gladiator, nor in the Apollo; but in that form which is taken from them all... For perfect beauty in any species must combine all the characters which are beautiful in that species."[18]

Reynolds's theory of artistic development is characterized by a progress away from base, material needs towards intellectual purity, that is, from barbarism towards civilization. One of the markers of that elevated status is the ability to form varied phenomena into a unified whole, a process that was central to the production of history paintings. Reynolds is explicit about the connection between aesthetic and social hierarchies in the Ninth Discourse. He begins by noting the continued progress of the Academy, and the necessity of "Trade and its consequential riches," as a means to foster that ongoing development but then, referring specifically to the progress of empires, asserts the need for vigilance against the lure of those material concerns: "...a people whose whole attention is absorbed in those means, and who forget the end,

can aspire but little above the rank of a barbarous nation."[19] He goes on to say, in an oft-quoted passage,

Man, in his lowest state, has no pleasures but those of sense, and no wants but those of appetite; afterwards, when society is divided into different ranks, and some are appointed to labour for the support of others, those whom their superiority sets free from labour, begin to look for intellectual entertainments…As the senses, in the lowest state of nature, are necessary to direct us to our support, when that support is once secure there is danger in following them further; to him who has no rule of action but the gratification of the senses, plenty is always dangerous; it is therefore necessary to the happiness of individuals, andstill more necessary to the security of the society, that the mind should be elevated to the idea of general beauty, and the contemplation of general truth. [20]

Crucial to this project of elevating the mind for Reynolds was the ability to incorporate details into a unified whole: "The general idea constitutes real excellence. All smaller things, however perfect in their way, are to be sacrificed without mercy to the greater."[21] Smaller, subsidiary elements are considered important not for themselves, therefore, but for what they may offer to a larger, privileged, centralized composition. History painting is the elevated genre that can most achieve that formation.

For Reynolds, the material/idea dichotomy means that parts of the picture were to be imagined as physical resources to be harnessed to the good of the elevated central idea, which is in turn to be distanced from these details: "It is indisputably evident that a great part of every man's life must be employed in collecting materials for the exercise of genius. Invention, strictly speaking, is little more than a new combination of those images which have been previously gathered and deposited in the memory: nothing can come of nothing: he who has laid up no materials, can produce no combinations."[22] Turner expressed similar ideas early in his career, echoing his predecessor's belief in the importance of searching widely through nature and art to find material for composition.[23] Writing of invention—a topic dear to him—in private marginal notes to John Opie's *Lectures on Painting*, Turner mentioned the need to be "ever ready to combine what is most proper usefull and efficient, and to reject what [is] low little or absurd." He continues in terms that recall Reynolds, "But the mind, so far from being clogged in its effects, gathers and combines all the qualities of each idea to be expressed from the first impression of early youth to mature age."[24]

The process described by Reynolds is a kind of intellectual manufacture. If the idea is privileged for its very distance from materiality, then Reynolds wishes the artist to make no-thing, an idea, that is, out of something. Elizabeth Bohls finds here an analogous formation to the moral philosophy of Adam Smith and the political theory of John Locke, demonstrating that in both cases, specific, concrete details of circumstance or social relations are to be subsumed in building towards a higher, seemingly universal consensus.[25] Bohls argues that in a time of rapidly expanding individualization with the division of labor and a loss of consensus on matters of taste, the denial of particulars was

part of a broader attempt to re-inscribe the dominance of the upper classes in the midst of a breakdown in social cohesion: "For Reynolds, the detail – the representation in painting of concrete material particularity – became a symbolic threat to order in both the individual mind and the political state."[26] History painting, therefore, in its control of the detail in favor of the whole, offered a means of resisting that threat, which was itself related to the material abundance produced by empire. The degree to which Reynolds's strictures related to the themes of the growth and decline of empires brought an added layer of urgency to that project. In this view, successful history painting brings things together into ideas, and in so doing both metaphorizes and contributes to the maintenance of social status quo under the guise of creating an abstract, apparently universal subject/state, distanced from its material origins. As the embodiment of these ideas, the Royal Academy, "the ornament of the Nation," as Reynolds called it, was involved in a process of metaphorical empire building that resisted decline. As I have already discussed, Reynolds, when he comes to composition, maintains this focus on an additive process of creating unity as a means to represent the social cohesiveness that seemed so absent in modern Britain. Reynolds often stressed the process of bringing parts together into a unified whole: "Thus, though to the principal group a second or third be added, and a second and third mass of light, care must yet be taken that these subordinate actions and lights, neither each in particular, nor all together, come into any degree of competition with the principal; they should merely make a part of that whole which would be imperfect without them."[27] Fuseli was more explicit about the importance of this method of composition, which he characterized as "the formation of a striking centre into subordinate rays," that could act as a surrogate public space, uniting what was in reality disparate in a fallen, modern world.[28]

But for many, it seemed already too late to have such hopes for painting. In his final lecture Fuseli himself said,

We have now been in possession of an Academy more than half a century; all the intrinsic means of forming a style alternate at our commands…And what is the result? If we apply to our Exhibition, what does it present, in the aggregate, but a gorgeous display of varied powers, condemned, if not to the beasts, at least to the dictates of fashion and vanity? What, therefore, can be urged against the conclusion, that, as far as the public is concerned, the art is sinking, and threatens to sink still deeper, from the want of demand for great and significant works?

Fuseli tries to temper this grim outlook for the students by inspiring them to at least try to contribute to some future "gradual recovery of art": "To raise the arts to a conspicuous height may not be in our power; we shall have deserved well of posterity if we succeed in stemming their further downfall."[29] Although Fuseli delivered these words in the 1820s, John Barrell observes that by 1800, the very point at which Turner was consolidating his status as an Academician and turning his ambitions to history painting, the Academy was widely perceived to have failed in its task of creating a public art.[30]

To understand that failure and Turner's response to eighteenth-century academic art theory, it is necessary to see it in the context of a more general societal falling away that seemed imminent within the very prosperity of empire in the eighteenth century. In addition to the questions of empire and luxury already noted, we have seen that elite, oligarchic rule was being challenged in the late eighteenth and early nineteenth century.[31] Also of importance is Peter Marshall's discussion of a re-formed second British Empire in the nineteenth century, an eastern, free market-based system that arose after the decline of the North American empire, once again pointing to the interpenetration of disintegration and consolidation of empire .[32] Turner's painting can be seen to respond fundamentally to such a conception. By exploring the degree to which he violated academic theory by painting not a vision of the world being brought together into unity, but rather visions of the world falling apart by means of a formal and thematic exploration of decay and disintegration, we will see that Turner found an appropriate form for representing the perceived decay of the modern world, but in a way that still sought to achieve the previous century's demands for compositional unity.

The status of empire had direct relevance for artists and the Royal Academy. Part of the breakdown of eighteenth-century artistic models involved the increasingly unviable notion of a linkage between the interests of the painter-as-subject and those of the nation as a whole. Key to that project had been the collapsing of self-interest within greater interest, so that the painter's striving appeared to be for the general good, not his own benefit. We have seen that the painter, for Reynolds, could produce works of elevated ideals. If this allowed painting to work to preserve the state from decay, however, it could also do the same for the artist. Reynolds also writes that the artist who has mastered the grand style will not be tempted by the ephemeral status of the more materially oriented, and lucrative genres: "Such a student will disdain the humbler walks of painting, which, however, profitable, can never assure him a permanent reputation."[33] Only by history painting can the artist seek to maintain his status and name in perpetuity and so defy decline. But, again, the Royal Academy was generally considered to have failed to produce a truly public art that might offer some means of counteracting the decline of modern society. Indeed, to many it embodied the very values of self-interest and individualism that it was meant to forestall. The short-lived journal *Annals of the Fine Arts*, edited by the architect and engineer James Elmes, which directly connected itself to the moralizing tradition of the eighteenth century, was begun with the express purpose of counteracting what the editors saw as the RA's privatizing influence: "[The members of] the Royal Academy have abused their trust, and by neither properly teaching or encouraging the lofty views laid down by their Royal Founder and Patron, have rendered themselves a mere club of portrait painters, who open an annual show of their work for their own peculiar benefit, and the extension of their trade."[34] Reynolds's desired linkage between individual goals and those of the nation has broken down here, so that the artist can only engage in a personal, private

pursuit of fame. Such fame, according to Elmes and others, would do nothing to maintain the artist's name in the future, nor to forestall the decline of the state. For academic theory, in such conditions no art could be truly perfect, as it had been for a period in ancient Greece, for instance. Unable to achieve perfection, artists were forced to lower their expectations in various ways. As Barrell describes, Fuseli found a precedent for this situation in the work of Hellenistic Greek artists, who could only refine the excellence that had come before and so produce a less lofty art that could not aspire to uniting society. Importantly, however, for Fuseli, the artist in this position gained a greater sense of individual freedom of expression.[35]

These matters were not abstract to Turner. According to Ian Warrell, "… though it was not always evident to his peers, what was so extraordinary about Turner was the way that his appreciation of his own worth was coupled not only with the profound ambitions that he had for his art, but also with his patriotic hopes for the advancement of a truly national school."[36] These broader hopes were clearly spoken in Turner's official voice as Professor of Perspective at the RA. Using booming language reminiscent of Reynolds, whose name he often invoked in this forum, he concluded one lecture by taking the opposite view to Fuseli, citing a rise in patronage in the arts since the time of Wilson and charging students with the task of building on the successes of past British artists, for the glory of the Academy, and in turn of the nation:

To you therefore this institution consigns [past artists'] efforts looking forward with the hope that by your zealous guardianship to all who follow that ultimately the joint endeavors of concording activities in the pursuit of all that is meritorious and which may fix irrevocably the triple standard of the Arts in the British Empire.[37]

One suspects that Turner, who was just 32 years old at this point, was thinking as much of himself as his students when he continued, "To you therefore young gentlemen must the nation look for the further advancement of the profession. All that have toiled up the steep ascent have left in their advancement footsteps of value to succeeding assailants. You will mark them as positions in your course."[38] Turner here imagines the Royal Academy as a community in miniature, with individuals working separately but united in the goal of advancing the arts and so the British empire. Turner, who read his reviews carefully, may have been given reason to hope that he might achieve this linkage. The years of his first exhibitions at the Academy were marked by considerable praise for the as-yet unknown artist, in particular for his seascapes. Perhaps most gratifying to Turner may have been the opinion of *The Morning Post* of 3 May 1802, that he "has in our opinion more of that sublime faculty which we denominate genius than any other of the pictorial claimants, and could be another Claude or Vandevelde if he thought it expedient; but it is necessary for the dignity of the British School that he should be the father and founder of his own manner."[39] The critic describes

here a mediated individualism in which innovation is marshaled towards collective goals. The young artist is able to rival and exceed the masters of the past. He is credited with avoiding expediency, that is a fame that rested on merely replicating the past, and instead credited with the task of creating a new foundation for a specifically British manner. In so doing, he gave hope for the rise of the national school as a whole. Such reviews spoke directly to the kind of enduring fame for both artist and nation of which Reynolds had spoken, as Turner would have known.

On the other hand, in these same years, Turner's artistic innovations were connected by some critics to a larger breakdown in the British School. Sir George Beaumont, who often criticized Turner sharply, said as much in 1803 when he tied the innovations of young painters like Turner to a broader destruction of tradition and order, saying that the "harmony and modesty which distinguishes great masters is not seen, but crudeness and bravura are substituted." He further called these artists an "influenza" and concluded: "The British school is affected by it."[40] In another letter, Beaumont connected this approach to progressive politics, saying that they have "the sagacity to discover that in politics, poetry and painting all that has hitherto been done is fit only for the flames."[41] As such, laments about Turner's innovations were connected to broader concerns over the state of the British School as a whole, which were in turn rooted in a larger set of social anxieties.

But despite the optimism of *The Morning Post's* comments about Turner we have already seen that many viewers felt it was too late to harbor such hopes. David Solkin has also argued that Turner emerged in a period when artists themselves experienced a sense of belatedness, a belief that artistic perfection had already been achieved.[42] There are indications that Turner was very much aware of his position in pursuit of artistic refinement, particularity, and individuality, rather than perfection, unity, and consolidation to use Fuseli's terms. It is in this regard that we might note the oft-cited story of Turner's reaction to seeing the Altieri Claudes in May of 1799. According to Farington, Turner "was both pleased and unhappy while He viewed it [*The Sacrifice to Apollo*], – it seemed to be beyond the power of imitation."[43] In another account, the young Turner is said to have burst into tears before a Claude picture. When asked to explain his distress, he lamented, "Because I shall never be able to paint any thing like that picture."[44] Here Turner seems to understand himself as unable to achieve the perfection of previous artists. Additionally, as will be discussed in greater detail in Chapter 3, Turner's exhibition strategy at the RA reveals that he felt the need to outdo the rest of the British School to establish his own reputation, and that he also understood that he could not build his reputation and that of the nation at once.

"Massy fragments...disjoined": Turner's Shipwrecks and Destruction

I have argued that Turner's *Trafalgar* was a picture of tremendous destructive energy, both in how it realized the violence of the battle and in its undoing of the genre of contemporary history painting. This was not an isolated case. Indeed, Turner's early reputation was based in large part on scenes of implied or actual destruction, which violated the terms of history painting he had inherited. A number of early seascapes, including *The Bridgewater Sea piece, Fishermen Upon a Lee-Shore in Squally Weather* (1802, Figure 2.1) and *Calais Pier* (1803, Figure 2.2) depict ships in immediate peril of wrecking. Turner's academic pieces in these years also included scenes of the fifth (mistakenly named) and tenth plagues of Egypt. We can see a linkage between Turner's growing ability to depict destruction, and his desire to destroy tradition, and the work of other artists paintings like *The Fall of an Avalanche in the Grisons* (1810, Plate 6). This picture was undertaken in response to Philippe-Jacques de Loutherbourg's *An Avalanche or ice fall, on the alps, near the Scheideck, in the Valley of Lauterbrunnen* (1804, Figure 2.3). Loutherbourg had come to embody the sublime mode of landscape for the British art-viewing public, a style of painting also closely associated with Salvator Rosa, in which viewers were confronted with terrifying scenes of the overwhelming forces of nature. Turner's picture, however, explores the thematics of natural obliteration in ways that made the work of Rosa and de Loutherbourg look anecdotal and even absurd in comparison. In the first place, Turner eliminates the narrative details of cowering people in de Loutherbourg's foreground, replacing them with a small cottage that is dwarfed by the rock that looms threateningly over it. There is a sense that human presence has already been obliterated from the scene in favor of a vast emptiness. That emptiness is paradoxically emphasized by the fact that Turner shows the air filling with snow. Broad areas of white and grey paint applied with a palette knife give the snow a sense of solid form, so that it appears blockier and more definite than the rocks themselves, which are overwhelmed by the force and scale of the avalanche. Space in the picture contracts almost suffocatingly as it is filled with snow. Turner heightens this effect by showing only a small opening in the distance, a pink-orange section of sky, soon to be obscured completely by the avalanche.[45] But perhaps most striking is the degree to which this destructive energy is specifically marshaled in response to de Loutherbourg's picture. Turner would have seen it at the 1809 RA exhibition and again when he visited the Third Earl of Egremont in Petworth early the next year, so he would have been well aware of the elder painter's status with important collectors in a competitive marketplace.[46] Turner displayed his work at his own gallery within a year after de Loutherbourg's in the hope of attracting patrons and buyers.

2.1 Joseph Mallord William Turner, *Fishermen Upon a Lee-shore in Squally Weather*, 1802, oil on canvas. Southampton City Art Gallery, Hampshire, UK/ The Bridgeman Art Library.

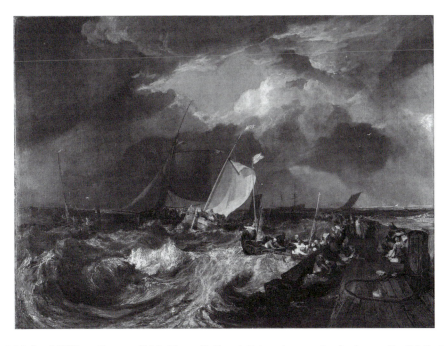

2.2 Joseph Mallord William Turner, *Calais Pier, with French Poissards preparing for Sea: an English Packet arriving*, 1803, oil on canvas, 67.75 x 94.5 in. (172 x 240 cm). National Gallery, London, Turner Bequest, 1856. Credit: © The National Gallery, London.

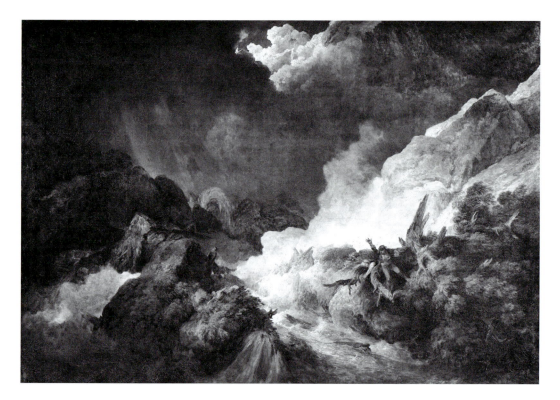

2.3 Philip James de Loutherbourg, *An avalanche or ice fall, on the alps, near the Scheideck, in the Valley of Lauterbrunnen,* exh. 1804, oil on canvas, 106.75 x 157.5 in. (271 x 400.1 cm). Petworth House, The Egremont Collection (acquired in lieu of tax by H.M.Treasury in 1957 and subsequently transferred to the National Trust). © NTPL/Derrick E. Witty.[47]

Turner's picture adopts the overall formal structure of de Loutherbourg's work, but alters it to highlight his own destructive capacity and make the elder painter's depiction of natural forces seem almost ridiculous. Indeed, various elements of the *Avalanche in the Grisons* seem to have been taken from the earlier picture in a manner that invites comparison from viewers who would have seen it recently.[48] Turner has adopted the diagonal line of the mountain in the right half of de Loutherbourg's picture, for instance, but tilted it more dramatically to emphasize the tumbling force of the snow. Similarly, where the elder painter balanced this diagonal with the downward sweep of the storm in the left distance, Turner made the rain of his storm more horizontal, implying a greater force of wind and placing it into a more violent confrontation with the line of the avalanche. That line, moreover, is formed by a jagged edge of paint that seems to cut across the very space of the canvas, like a bolt of lightning that energizes the picture's space even as it tears it apart. Finally, while de Loutherbourg left room for the energy of the avalanche and waterspout to spill out and around the islands which preserve the figures, Turner offers no such outlet. De Loutherbourg evoked nature's destructive power only to control it; Turner, by contrast, proclaims his power to align himself with a natural energy that cannot possibly be controlled or circumscribed. In this way, he reaches to the very heart of the sublime view of nature.

The most obvious difference between the two pictures is Turner's elimination of the figures. This is generally understood, quite rightly, to mark Turner's intent to place the viewer into a more immediate confrontation with the forces of nature.[49] But there is a further way to understand the relationship between the paintings and the absence of figures in Turner's work. We should first note Eric Shanes's discussion of the example of de Loutherbourg for Turner in developing the idea of decorum, or the appropriate matching of human elements to natural ones.[50] If we keep this important point in mind, then we can see that it is not just that humans and narrative are absent in the picture, but rather that the picture narrativizes the obliteration of human presence, so that the suffocating progress of the avalanche recreates the experience of the doomed occupants of the small cottage. In a sense then, Turner has turned de Loutherbourg's own strategy against him. This is a picture of obliteration in which Turner tried to visibly outdo an established master of the sublime landscape, whose work was being collected in the very circles to which the young artist sought access.

It is with this kind of de-compositional logic that we also may consider the prevalence of shipwrecks in Turner's work of this period. The shipwreck was a nearly ubiquitous subject in Romantic-era painting and poetry that played into a general cultural fascination with the sublime.[51] Interestingly, Barry Venning has shown that Turner saw the ship and the danger of wreck as a personal and professional metaphor.[52] Much later in his life, looking back on *The Bridgewater Sea piece* (1801, B&J 14) in the 1830s, Turner described it as a work that "Launched my boat."[53] Clearly, he was aware that his career's start was based in large part on these pictures of the threatened or actual destruction of sea-faring vessels. Indeed, in these early marine pictures Turner forged his reputation by developing a radical formal solution for creating unity in a picture while not repeating the compositions of previous masters; he did so while finding a form particularly appropriate to the period in which he worked. I would like to explore this development in these early years of his career in one painting in particular, *The Shipwreck* (1805, Plate 7), which focuses not on the dramatic moment of the wreck itself but rather on its aftermath and the struggle for survival in the midst of the process of disintegration.

Turner thought quite directly about the demands of such scenes early on, as he began to define his own artistic viewpoint, as revealed in his analysis of Poussin's *Winter, or The Flood* (1660–4, Figure 2.4), which he saw at the Louvre in 1802. On the one hand, Turner specifically criticizes the French artist for not giving vivid enough form to a world in chaos, and, on the other, for not sufficiently unifying his picture:

The colour of this picture impresses the subject more than the incidents, which are by no means fortunate either as to place, position, or colour, as they are separate spots untoned by the under colour that pervades the whole. The lines are defective as to the conception of a swamp'd world and the fountains of the deep being broken up. The boat on the waterfall is ill-judged and misapplied, for

the figures are placed at the wrong end to give the idea of falling. The other boat makes a parallel with the base of the picture, and the woman giving the child is unworthy [sic] the mind of Poussin, she is as unconcerned as the man floating with a small piece of board. No current or ebullition (in the water), although a waterfall is introduced to fill up the interstices of the earth—artificially, not tearing and desolating, but falling placidly in another pool…[54]

Turner mocks Poussin's inability to express the power of water in a "swamp'd world," and his failure to give a sufficiently powerful sense of downward movement to the boat and its figures. He also complains about Poussin's inability to register the emotional impact of the scene on its human participants, pointing specifically to the mother who is separated from her child. Perhaps most importantly, however, he chides Poussin for failing to bring the separate parts together into a whole. By contrast, I contend that in *The Shipwreck* Turner set out to resolve this contradiction: to adequately show, on the one hand, the details—"the fountains of the deep being broken up" and the power of water "tearing and desolating"—but to also demonstrate the ability to bring that picture back into some kind of larger compositional whole on the other.[55]

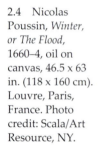

2.4 Nicolas Poussin, *Winter, or The Flood*, 1660–4, oil on canvas, 46.5 x 63 in. (118 x 160 cm). Louvre, Paris, France. Photo credit: Scala/Art Resource, NY.

This was an extremely important picture in Turner's developing career. It was the first of his paintings to be engraved for publication, a process that would benefit Turner tremendously throughout his career, and it was one of the pictures shown in his own gallery in 1805, a year in which he showed

nothing at the RA exhibition. Farington reports that this was done for an "Oeconomical motive" and given that a number of artists boycotted the RA in these years because of dissatisfaction with the placement of their pictures, something Turner himself voiced in 1804, he very likely wanted to show the work in circumstances of his own controlling.[56] Turner wrote the names of subscribers to the print on the folio opposite a sketch of a wrecked vessel in "The Shipwreck (I)" sketchbook (Figure 2.5), suggesting an early awareness of the linkage between the destruction of the ship and the creation of his reputation and fortune.

The picture is also highly unusual in Turner's oeuvre for the large number of sketches devoted to its composition, suggesting an enormous investment of time and effort in its planning. These sketches show Turner working with the individual elements of the scene—lifeboat, fishing boat, and wreck—but also moving them around in relation to each other. In doing so, he balances a desire to give a vivid immediacy to the depiction of ships at the mercy of the sea with the goal of knitting the elements together into an effective whole. In a number of wash studies (for instance, Figure 2.6) he elevated the fishing boat high above the trough of the wave to suggest the violent movement of the sea. In another (Figure 2.7), he adds the second life boat to the left, down in the trough, pointing to the perilous nature of the attempts to save survivors. In both washes he darkens the sky and water, using this tonality and the swirling circular motion across the sheet (already suggestive of the signature Turnerian vortex) to relate the parts to each other within a unified whole, however dynamic and motion-filled. In the final oil picture, Turner also took the radical step of partially blocking

2.5 Joseph Mallord William Turner, *List of subscribers*, c. 1806–7, and *Two Ships, one Sinking, and a Lifeboat: Arithmetic*, from the "Shipwreck (I)" sketchbook, c. 1805, 4.6 x 14.6 in. (11.8 x 37 cm). TB LXXXVII 2–3. © Tate, London, 2011.

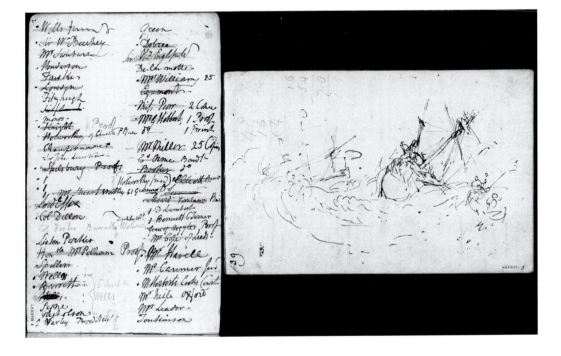

out the larger, sinking ship with the form of the fishing boat in the right foreground. This motif can be seen taking shape in the important "Calais Pier" sketchbook, a bound book of blue paper which features a number of highly detailed studies for paintings, as well as more informal sketches. In the first of these related to *The Shipwreck* (Figure 2.8), the positions of the fishing boat and lifeboat are close to the final version, but the wreck is easily visible in the left background. In another (Figure 2.9), the fishing boat is again very close to the final version, but the wreck, partially obscured, is much closer to the picture plane. The result is a chaotic central mass in which the forms of masts and yards seem to burst outward. Still another sketch (Figure 2.10) includes only the rough indication of a sail in front of the capsizing ship. In the final picture, the ship is even more completely obscured and is presented in fragmentary form with bits of sail, yards, and mast visible in small sections. By this device, Turner represented the process of disintegration itself, something further emphasized by the presence of wreckage in the foreground, which heightens the desperate struggle of the survivors by giving them only pieces to which they can cling. It is not merely that Turner was seeking to illustrate disintegration, then, but to allow it to inform the very process of composition itself. This drama is perhaps at its most terrifying, paradoxically, in the distant details of figures clinging to the lines, broken bowsprit, and falling foremast top, and isolated against the unfeeling grey sky.

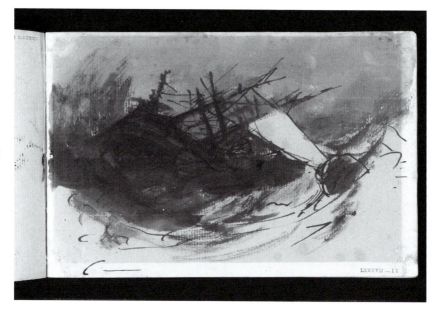

2.6 Joseph Mallord William Turner, *Study for "The Shipwreck": A Sinking Ship and a Boat in Rough Seas*, from the "Shipwreck (I)" sketchbook, c. 1805, pencil on paper, 4.6 x 7.25 in. (11.8 x 18.4 cm).TB LXXXVII 11. © Tate, London, 2011.

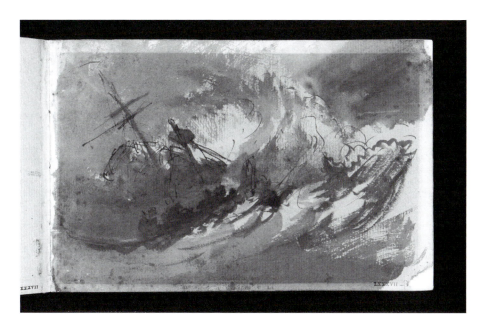

7 Joseph Mallord William Turner, *A Ship in Distress and a Smaller Boat*, from the "Shipwreck (I)" sketchbook,
 c. 1805, pencil on paper, 4.6 x 7.25 in. (11.8 x 18.4 cm). TB LXXXVII 9. © Tate, London, 2011.

8 Joseph Mallord William Turner, *Composition Study for "The Shipwreck"*, from the "Calais Pier" sketchbook,
 c. 1799–1805, chalk on blue paper, 17 x 10.7 in. (43.3 x 27.2 cm). TB LXXXI 2. © Tate, London, 2011.

2.9　Joseph Mallord William Turner, *A Large Vessel Lying on her Starboard Side in the Water, with a Small Sailing* in Front: Study for the "Shipwreck", from the "Calais Pier" sketchbook, c. 1799–1805, chalk on blue paper, 17 x 21.4 in. (43.3 x 54.4 cm). TB LXXXI 136–7. © Tate, London, 2011.

2.10　Joseph Mallord William Turner, *Study for the "Shipwreck"*, from the "Calais Pier" sketchbook, c. 1799–18 chalk on blue paper, 17 x 21.4 in. (43.3 x 54.4 cm). TB LXXXI 132–133. © Tate, London, 2011.

The radicality of Turner's painting comes not from its concentration on a smaller scene in the foreground, but rather from the way that scene blocks the wreck in the background. The use of a foreground scene as narrative focus was a common element in paintings of destruction at sea, from George Morland's *Wreckers* (1791, Figure 2.11) to de Loutherbourg's *Battle of Camperdown* (1794, Figure 1.23). In each of these cases, the smaller scene or boat in the foreground establishes key themes and issues in the work in a more human scale while also determining the structure of the pictorial space. In *The Shipwreck*, however, the placement of the smaller ship directly in front of the larger one obscures rather than clarifies the perspective space, and thus also complicates its narrative structure. In this space of breaking apart, the fates of the various parts of the narrative are separate and confused. In essence, then, it is the compositional framework of part and whole which has been undone here, broken apart by the violence of wind, rock, and current. Many of the sketches in which Turner explored this blocking motif pay particular attention to the sail of the fishing boat (Figures 2.6, 2.9, 2.10). Indeed, in the final picture (Plate 7) that sail is the formal fulcrum of the picture. On the one hand it is strikingly blank, a large swath of seemingly empty canvas that arrests the eye's movement across the swirling areas of water/paint that surround it (is there also a visual pun here in canvas/canvas?).[57] We can see Turner already thinking of the contrast of empty canvas to swirling water in one of the wash sketches (Figure 2.6), in which the sail is shown by reserving the cream white of the paper in the midst of the sepia tones. As such, it brings the non-color of the bottom of the sheet into the center of the drawing as a jutting, sharp protrusion. In the final picture, the sail is seen less obliquely, more broadly

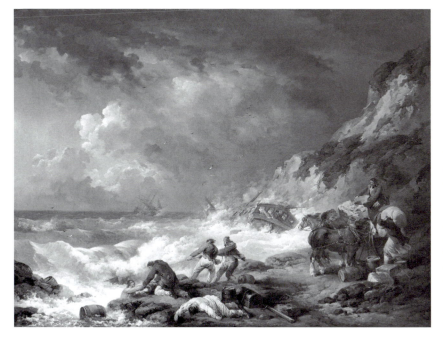

2.11 George Morland, *Wreckers*, 1791, oil on canvas, 40.875 x 54.875 in. (103.8 x 139.4 cm). Museum of Fine Arts, Boston, Bequest of William A. Coolidge, 1993.41. Photograph © 2012 Museum of Fine Arts, Boston.

and becomes a noticeably precise, almost geometric form compared with the irregular, fluid spaces around it. Like the drawing, the sail also seems to be produced by a negative action: by not painting. This seemingly non-painted, negative form sits at the very heart of the picture. It is the focal point around which the Turnerian vortex spins.

Part of the appropriateness of the solution in *The Shipwreck* stems from the fact that Turner was, I think, increasingly aware of the degree to which painting, and painting history especially, was a matter of both forming and un-forming, creating and destroying. It is significant that this dichotomy continued to play out in marine subjects, which had so much to do with British perceptions of self-identity and empire. We can further explore Turner's ongoing sense of the interlinked processes of forming and un-forming in the watercolor, *The Loss of an Indiaman* (c. 1818, Plate 8). It is interesting to note, in the first place, the persistence of these formal and thematic issues on the much smaller scale of this watercolor. As such it can be seen as a part of Turner's ongoing interest in using the medium of watercolor to speak to some of the same moral and universalizing issues as oil painting.[58] Indeed, we will see that Turner was thinking about the medium's very properties at this moment, and the degree to which they offered another link between creativity and disintegration. At first glance, this picture would seem to be very different from *The Shipwreck*, since the deck of the ship is placed in the very center of the sheet in more traditional fashion and dominates the space. Again, however, Turner creates unity out of a scene of radical decomposition. Eric Shanes, who identifies this wreck as the *Halsewell*, which went aground on the Isle of Purbeck in 1786, notes that the position of the mast at left, still in its base-block, is only possible if the rest of the ship has already broken apart. What we are seeing here, therefore, is the last moment of any kind of structural integrity for the ship as it heaves up, about to receive the final wave which will swamp it entirely.[59] While the ship is on the rise of the wave, and its deck tilts towards us to fill the space, ropes, spars, and people all fall downward, suggesting the next stage of its demise. The unity achieved here is thus contrapuntal and ephemeral: Turner creates a picture by means of destroying nearly all of the ship and by implying the subsequent dissolution of the remaining fragment.

Such a conception of the dichotomy between materiality and immateriality helps to explain the compositional complexity of the *Loss of the Indiaman*, in which form and non-form are linked together in a constant fluctuation between emergence and recession.[60] Look, for instance, at the figures along the rail at the top left of the ship. Raised up above the other figures, they are nonetheless more distant and less distinct. Those farthest away hover at the very edge of invisibility, seemingly a mere breath away from being subsumed by the indistinct swirl behind them. The larger vortex structure of the entire picture unites these figures, with their arms upraised in an apparent embrace of their incorporation into infinitude, while their more distinct shipmates in the foreground struggle against the downward pull of gravity. The picture, therefore, exists in dynamic tension between spiraling movements of up and

down, forward and back, and form and nothingness. It is worth remembering here Turner's oft-quoted quip when he heard the complaint by an American collector that his work was imprecise: "Indistinctness is my fault."[61] Turner here succinctly suggests precisely what I have been arguing: that he built his career around the forming of non-form. Suitably, not only do the ship, air, and surface of the water appear to be themselves unstable and interpenetrated by each other, but many elements of the scene are caught between appearing and disappearing, between becoming and dissolving. Moving to the right from the nearly invisible figures at the far left, consider those closer to us along the rail of the disintegrating ship. Are these figures coming into view as the ship rolls violently, or are they on the edge of being obscured by the encroaching water and wind? Neither answer is wholly satisfactory. Once the treatment of this passage is noted, it is easy to see that the picture is filled with such instances of half-hidden/half-revealed forms, or, from the painter's perspective, half-made, half un-made. Are the figures in the two hatches struggling to get out to the surface, or being plunged back in? Above the raised rail on the top of the ship, what exactly is water and what air? The ship itself is neither exactly in, nor out, of the water. And what of the faces in Turner's work? They are insistently present, but just as insistently rendered in the most basic terms. A perfect example is the face of the woman sitting on the deck, just above and to the right of the left hatch, who clutches her child desperately in her lap. This is worth noting since Turner had placed such emphasis on the failure of Poussin to register the effects of the deluge on the mother and child. Here, the pair form a stable dyadic unit at the center of the ship, but she has no more than two dots for eyes and a line for her nose. Does Turner capture a moment as the face comes into view from the swirling water and air, or is it receding into infinity? Again, neither. It is neither fully seen nor fully unseen.[62]

The ship's status as fragment at the edge of oblivion is all the more clear by contrast to the magnificent *A First-Rate Taking in Stores* (1818, Figure 2.12) exhibited as a pendant with *The Loss of an East Indiaman*, which Turner may have begun while waiting for the first wash of the *First-Rate* to dry.[63] Importantly, the *First-Rate* was central to Turner's sense of his own prowess in image-forming. It was created in a matter of a few hours, in response to his patron Walter Fawkes's challenge that he make a drawing of "ordinary dimensions" that would convey a sense of the enormity of a man'o'war. *The Loss of an East Indiaman* was likely executed in a more traditional manner,[64] but if it was indeed conceived at the same time as the *First-Rate*, then there is a powerful contrast in the pairing between the structural integrity of the one ship and the dissolution of the other that points to the ability of the artist to create both form and non-form. Once again there is even the possibility that in seeing the *Indiaman* so positioned, between states, Turner was using the boat as a metaphor for matters of life and death. On his deathbed, after all, he is said to have remarked, "So I am to become a non-entity," suggestive of the human condition perched on the edge of the non-form of death.[65]

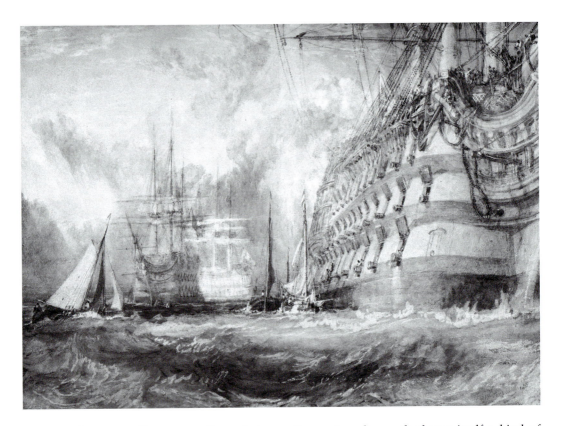

2.12 Joseph Mallord William Turner, *A First-Rate Taking in Stores*, 1818, pencil and watercolor, with scratching-out and stopping-out, 11.25 x 15.6 in. (28.6 x 39.7 cm). Trustees of the Cecil Higgins Art Gallery, Bedford.

Even more, Turner's innovative watercolor method was itself a kind of paradox of formation by destruction. Both watercolors feature subtractive processes, including stopping out and scratching out of color to reveal and roughly texture the white paper beneath. This subtractive method is reminiscent of the empty canvas in *The Shipwreck* and is visible in the *First-Rate*, for instance, in the line of frothy white waves that begins under the ship's bow at right. An eyewitness account of the artist at work on the *First-Rate* suggests that Turner's process of creation was itself a kind of fevered destruction out of which form emerged after having gone through a stage of non-form:

he began by pouring wet paint till it was saturated, he tore, he scratched, he scrubbed at it in a kind of frenzy and the whole thing was chaos – but gradually and as if by magic the lovely ship, with all its exquisite minutia, came into being and by luncheon time the drawing was taken down in triumph.[66]

As I will discuss in Chapter 3, Turner was very much aware of the performative nature of his work on the Royal Academy's Varnishing Days, responses to which frequently invoked the notion of creation "by magic." It seems to me that he responded to Fawkes's challenge precisely because it offered instance similar opportunity to reveal that his pictures were the result of a dynamic, literally fluid process of forming, un-forming, and re-forming. In describing

this process, the cited passage contrasts madness and civilization, beginning with a veritable torrent of verbs that signify an unrefined, even primitive form of destructive artistic activity: "pouring," "tore," "scratched." The clause ends with "chaos" and "frenzy," before turning after the hyphen to locate order and refinement in the "lovely ship" and its "exquisite minutiae."[67] The shift from the brutal, primal, and timeless activity of the first clause is signaled with the dual marker of temporality and propriety: the transformation has been completed "before luncheon"! The passage both evokes and attempts to police the intensity and marvel of Turner's ability to move between states of matter, all while keeping within the realm of respectability.

Inherent in the pairing of the *Indiaman* and the *First-Rate* is also a contrast between the warship at peace and the merchant ship at war with the elements.[68] But in the former, Turner's figures are placed before the awesome power of nature by human causes, namely, the ambition of empire. As already discussed, Turner's generation inherited the idea that the building of empire was in part a process of destruction, not only of the cultures brought into empire but in many cases of the values of the imperial center itself, and of the anonymous participants such as those who perish here. The picture also overlays artistic creation/destruction and imperial creation/destruction in a manner that is related to the linkage of artist and hero we have seen in *Trafalgar*. Turner's sense of the relationship of boat-building and wrecking to imperial ambition and achievement is clear from some of his poetic attempts of a few years earlier. As Andrew Wilton notes, in the "Perspective" notebook of c. 1809 that Turner made in preparation for his lectures as Professor of Perspective at the Royal Academy, there is an extended poem that meditates on the fate of Jason's *Argo*, placed now in modern Britain. Written at a point when Turner was thinking in detail about the process of artistic creation, and how to best communicate that process within the context of the body whose origins were so linked to Britain's imperial status, the poem lingers over a scene of the building of the ship in ways that speak directly, at least to the extent that any of Turner's poems manage to communicate anything directly, of the ship's ability to maintain bodily integrity in the face of the elements:

> The planks are sever'd with a Sawyer's art
> From each that proved its Counterpart
> And placed side by side alternatly [sic]
> Then crossed by pieces transversely
> Thus for the bottom that to waves unknown
> That binds the world in with a liquid zone
> Or thrown upon the hardest stony beach
> Presumtuous man a [usefull] lesson teach
> The sides are bent and turned with care
> The seams are closed with tar and Hair.[69]

The poem is powerfully evocative of a corporeal unity that is linked to an embryonic state: "binds the world in with a liquid zone." Near the beginning,

Wilton notes, Turner seems to chide Britain for its lack of pride in commercial enterprise.[70] This scolding suggests at this stage of the Napoleonic Wars a generally patriotic view of empire, based here around the metaphor of the ship, with reference to the classical *Argo* as well as the biblical ark of Noah. In a much longer, and even less coherent poem (meaning itself seemed to dissolve as Turner formed words together), penned in 1811 to accompany his series of watercolors of the southern coast of England, Turner versified specifically upon the *Halsewell* as a kind of emblem of dissolution:

> Where massy fragments seem disjoined to play
> With sportive sea nymphs in the face of day
> While the bold headlands of the seagirt shore
> Receive engulpht old ocean deepest store
> Embayed the unhappy Halswell toiled
> And all their efforts Neptune [herewith?] foild
> The deep rent ledges caught the trembling keel
> But memory draws the veil where pity soft does kneel
> And ask St. Alban why he chose to rest
> Where blades of grass seem even to feel distrest
> Twixt parching sun and raging wind
> And often but a temporary footing find
> disjointed mas[s]es breaking fast away...[71]

By making reference to St. Alban, Turner's verse addresses itself to foundational aspects of the state. St. Alban was a Christian martyr of Roman Britain and had been venerated in England since at least the fifth century. Reference to St. Alban's choice "to rest" in England allows the poem to open onto questions of national identity in the challenging natural conditions of the island nation: "Where blades of grass seem even to feel distrest..." This passage then further becomes a means to assess the status of empire in relation to those foundations: the ship becomes a doubled symbol for the potential for the glory of imperial ambition and unity and also the inevitability of decline and dissolution. The repeated invocation of the paradox implied in the phrases "massy fragments...disjoined" and "disjointed masses," indicates the degree to which these two senses are not separate but rather are mutually embedded within each other.

Composition and De-composition: Centering the Figure

As the poems indicate, *The Shipwreck* and *The Loss of an East Indiaman* belong to a period in which Turner was thinking intensely about the course of empire in ways that reveal his close familiarity with the eighteenth-century models I have described. The clearest examples of this, ones with direct relevance to ideas of British empire, are the related pictures *Dido Building Carthage* (1815, Plate 9) and *The Decline of the Carthaginian Empire* (1817, Plate 10).[72] The full title of the latter work, all fifty-one words of it, reveals Turner's allegiance to

eighteenth-century models of decline, in which it is the loss of martial spirit in the citizenry that leads to decline: *The Decline of the Carthaginian Empire - Rome being determined on the Overthrow of her Hated Rival, demanded from her such terms as might either force her into War, or ruin her by Compliance: the Enervated Carthaginians, in their Anxiety for Peace, consented to give up even their Arms and their Children.* As Kathleen Nicholson notes, Turner stayed very close in this painting to his source, Oliver Goldsmith's *A Roman History* (1769), a copy of which he owned and annotated.[73] Turner describes the luxury and resulting idleness that corrupted the city by showing some of the Carthaginians languorously reclining in fancy dress amidst scattered debris, in contrast to the simple dress and industrious activity of the earlier picture. The setting sun here functions both symbolically and visually to reinforce this theme of decline, as the golden light of the sinking orb seems to dissolve the firm outlines of the architecture, beginning the process of its ruin. According to Nicholson, Turner avoids showing ruins here; in line with eighteenth-century thinking, it is moral rather than physical decay that interested him.[74] Given this, and given my discussion of the perceived intertwining of imperial rise and fall, it is striking that Turner created this picture of decline just three years after Britain's final victory in the Napoleonic wars at Waterloo. Both Carthage and Venice, as sea-based, mercantile empires, were often cited as precedents for Britain's rise and, by extension, were seen as foreshadowing its fall. J.C. Eustace's *Classical Tour through Italy*, a copy of which Turner brought along on his first travels to Italy, compared England to Carthage in exactly these terms.[75] But more important within the context of the dynamics of forming and un-forming that I have described in Turner is the fact that Eustace describes empires as inherently fugitive:

Empire has hitherto rolled westward: when we contemplate the dominions of Great Britain, and its wide-extended power, we may without presumption imagine that it hovers over Great Britain; but it is still on the wing; and whether it be destined to retrace its steps to the East, or to continue its flight to Transatlantic regions, the days of England's glory have their number, and the period of her decline will at length arrive...[76]

Painted just a year after *The Decline of the Carthaginian Empire, The Field of Waterloo* (1818, Plate 11) is also related to ideas of the rise and fall of empire and the means by which this could be represented visually. While the subject clearly offered an opportunity to work in the same narrative and thematic vein as *The Death of General Wolfe* and even *The Battle of Trafalgar*, in which individual death leads to societal rebirth and regeneration, here the result is very different. This difference can be attributed in part to a broader difficulty in representing Waterloo. As Philip Shaw has discussed, despite the Tory trumpeting of the victory, the battle was an event of such magnitude and importance that it exceeded any of the existing modes or genres for portraying it. Shaw connects these failures of narrative to larger anxieties about the kind of state that could be produced, or confirmed, by the very victory that seemed to assure its

dominance. Meditation on the absolute destruction of the French empire, for instance, became a means of imagining the possibility of a similar fate for Britain, some version of which had only narrowly been avoided: Wellington famously insisted that the battle had been a "damned near-run thing." Shaw's account is particularly interesting in that he considers notions of statehood in terms of Lacanian psychoanalytic theory, so that representations of the nation function as a kind of infantile mirror stage in which the state can imagine a plenitude, a sense of completion that can be never be fully attained. Shaw, modifying the work of Elaine Scarry, sees the desire for war as a "deeply neurotic attempt to protect the illusion of unanimity."[77] Central to the success of this process, again working from Scarry, is the suppression of the wounded soldier, whose body, as the site of death and injury, is both the object that needs to be absorbed by state ideology and the thing that troubles its search for cohesion and unity. In one of the more sensitive discussions of Turner's *The Field of Waterloo* to date, Shaw pays particular attention to the presence of women amongst the dead soldiers, persuasively arguing that this brought the private, male experience of war into the domestic sphere. By showing the male body as vulnerable, Turner cast the project of ideology as incomplete and contingent.[78] Though Shaw does not name it as such, this works expressly against the logic of paintings such as *The Death of General Wolfe*, in which the male body is sacrificed intact, only very slightly wounded, and is thus able to symbolize the desired unity of the state.

This loss of cohesion seems to have been the starting point for the *Waterloo* picture. The battle, in its sheer scope, presented an immediate challenge to the standards of unity that were the traditional goals of literary and artistic representations of war. The Duke of Wellington, ostensibly the person most in a position to be able to supply that cohesion for the battle, was himself skeptical about any such attempt. In response to a request for help in constructing a narrative of the battle, Wellington famously said that he thought it best to "leave the battle of Waterloo as it is."[79] He believed that the battle was of such a complexity that no individual could plausibly narrate its outcome: "The history of a battle is not unlike the history of a ball. Some individuals may recollect all the little events of which the great result is the battle won or lost: but no individual can recollect the order in which, or the exact moment at which, they occurred, which makes all the difference as to their value or importance." Wellington then goes on to cast further doubt on the advisability of such a project because of the ambivalent picture of human nature it would produce: "Then the faults or the misbehaviour of some gave occasion for the distinction of others, and perhaps were the cause of material losses…Believe me that every man you see in a military uniform is not a hero; and that, although in the account given of a general action like Waterloo, many instances of individual heroism must be passed over unrelated, it is better for the general interest to leave those parts of the story untold, then to tell the whole truth." Here Wellington suggests, that while representations had

stressed heroism, the notion of a whole picture of Waterloo could challenge traditional notions of British moral superiority.[80]

Turner's response to this challenge in *Waterloo* is determined by the same issues of forming and un-forming that I have described in *The Loss of an Indiaman*, but here they are explored primarily through the figures. Additionally, Turner combines the invocation of cataclysmic destruction with a process of slow decay. Throughout the picture, an intricate intertwining of limbs and bodies suggests the loss of individual form and the creation of a single unified, emphatically dead, yet still actively decaying, body. The picture is composed, thematically and formally, of decomposition. Bodies are sinking into each other and into the ground, in a manner that recalls Byron's lines on Waterloo from the third Canto of *Childe Harold*, which Turner appended to the painting's entry in the exhibition catalog: "The earth is cover'd thick with other clay, / Which her own clay shall cover, heap'd and pent, / Rider and horse—friend, foe,—in one red burial blent."[81] The mass of bodies also evokes the description of the field four days after the battle by Major W.E. Frye, a British Army officer who travelled in Europe in the wake of the Napoleonic Wars:

This morning I went to visit the field of battle … but on arrival there the sight was too horrible to behold. I felt sick in the stomach and was obliged to return. The multitude of carcasses, the heaps of wounded men with mangled limbs unable to move, and perishing from not having their wounds dressed or from hunger… formed a spectacle I shall never forget.[82]

Indeed, taken as a whole, the picture itself, with its twisting, intricately complex forms strewn across the center of the canvas, looks not unlike an open wound, or viscera spilled out on to the ground. Turner can be found exploring a similarly gruesome arrangement of bodies in one of his studies for his 1805 picture of *The Deluge* (Figure 2.13). Another study for the same picture appears on the recto of this sheet (Figure 2.14) and is dominated by figures who struggle against the downward pull of the flood. On the verso, however, (Figure 2.13) Turner depicts a mass of dead bodies. The lines of their bodies twist and tangle together into a visceral mass spilling across the foreground. They take similar form in *Waterloo* too, as a kind of open wound in the ground and a twisted mass of guts and blood. Turner's own poetic "disjointed masses" seems all too appropriate.

Turner's process of preparation for the picture was itself fragmentary. While we saw in Chapter 1 that the success of Benjamin West and John Singleton Copley was predicated in part on the basis of their access to key actors in the events they painted, Turner had even less access here than in *Trafalgar*, for which he at least was permitted to board the ship after the battle. By contrast, he experienced Waterloo on the same terms as the thousands of British tourists who travelled to the site and collected artifacts. As Stuart Semmel has shown, this access seemed to hold the promise of a more tangible relationship to the past, but the more physically present the battle became

2.13 Joseph Mallord William Turner, *Study for "The Deluge"*, c. 1804, pen and ink, pencil and watercolor on pap
16.4 x 23.1 in. (41.6 x 58.7 cm). TB CXX XI. © Tate, London, 2011.

2.14 Joseph Mallord William Turner, *Study for "The Deluge"*, c. 1804, pen and ink, pencil and
watercolor on paper, 16.4 x 23.1 in. (41.6 x 58.7 cm). TB CXX X. © Tate, London, 2011.

through such artifacts, the more elusive history seemed since it offered only fragments that refused to cohere into a stable narrative.[83] No full-scale sketch for the picture exists, but Turner did make drawings of the battlefield in the very small-scale *Guards* sketchbook. Some of the drawings in the sketchbook (for instance, Figure 2.15) also feature single figures and bits of uniforms, helmets, and insignia, as if he were already imagining a painting composed of fragments that would exist in the absence of a living body. If Turner was to form history here, I think it was clear to him that it would have to be forged out of these fragments and out of the very loss of a connection to the events that they could not overcome. In the final painting these fragments are applied to dead bodies which are fragmentary themselves, but are knit together into an extraordinarily dense, compact structure. As such the picture certainly resonates with Linda Nochlin's argument that such a fragmentary approach to the body and history indicates something fundamentally modern about Romanticism, an aesthetic relation to the past based on "irrevocable loss, poignant regret for lost totality, a vanished wholeness."[84] But, given my previous discussion, it seems to me that for Turner the fundamental difference here lay not so much in the events themselves but in the knowledge that the aesthetic models which had succeeded for West were no longer sufficient. In this view, what is being mourned here is less the loss of historical and artistic cohesion and unity, as such, and more the loss of the conditions of production for creating the illusion of that wholeness, for the conditions that made that illusion possible.

By showing the bodies so chaotically intermingled, so completely in defiance of any kind of order, Turner evokes at once the violence of battle and its aftermath. Starting in the left foreground (detail, Plate 12), for instance, we see the flank of a dead horse catching the light above a red, blood-soaked

2.15 Joseph Mallord William Turner, *Details of Soldier's Accoutrements*, from the "Guards" sketchbook, c. 1817–8, pencil on paper, 2.7 x 4.1 in. (6.9 x 10.3 cm). TB CLXIV 25a. © Tate, London, 2011.

saddle bag and blanket. The horse's head is obscured by the body of a *cuirassier* who, lying on his back with his heavy breast plate exposed, seems to extend the horse's body. His torso is clear enough but his legs are indicated only by a few vertical strokes of white. This is because a British cavalryman, whose body extends perpendicularly out toward the center of the painting, has his legs sandwiched around those of the *cuirassier*. Following the British horseman's body down, we see that his body intersects with the torso of a French light cavalryman to our left, lying face down. One of the British soldier's cross-belts merges into the gold fabric of this figure's uniform. Where is the rest of the Frenchman's body? It must be underneath the British horseman, but the latter's body does not rise correspondingly. More noticeable is the fact that a triangular area of white seems to be part of both of their uniforms, so that they look rather like two parts of a single body. These two figures then double back on each other, as their arms limply intertwine, echoing the double-coiling of the arms of the mourning women in the center of the picture. This close tangling of bodies is given an ironic intimacy by its mirroring of the relationship of the women to each other and the babies in this central group, where it also is difficult to distinguish between various body parts.

Rather than building towards a central, climactic narrative moment, Turner's figures fall down, fall away, slide back into the earth and into seemingly infinite dispersal. But it is out of that expression of the abject dissolution of the body that the picture is formed, just like the spectacle that sickened Frye. While this mass, Byron's "other clay," is collapsing into the ground in the process of burial, it also seems to be called forth from it by the light, to be reconfigured into a single corporeal form. Turner has consolidated his figures into a powerful central grouping highlighted by the torches of the women. He does so, however, only by means of pursuing the decomposition of the body and a loss of its singularity and individual integrity. That is, compositional unity only comes by means of death here, as self is obliterated to merge with non-self. But the flames, placed into contact with the bodies on the surface of the painting, seem already to have set fire to and obliterated some of them. Seen in this way, the light that picks up the surrounding figures is a spreading fire that threatens to transform this from a burial into a pyre. Set during what would have been a very short mid-June night in northern Europe, the picture depicts bodies between states: after death, before interment.

Turner's evocation of this indeterminate state was all the more appropriate because, despite Wellington's wishes, the battle refused to be left as it was, history refused to remain comfortably past. Visiting the field more than a month after the battle, the Irish statesman and author John Croker found fragments of letters, caps, helmets, and cartridges. But he found even more gruesome reminders of battle, as he wrote in his journal: "You also could see the graves into which the dead had been thrown, sometimes singly, sometimes two or more at a time, and in many places by fifties and hundreds." He described the fields around Hougoumont, the site of Turner's picture, as broken up with graves.[85] Other visitors described the macabre sight of body parts sticking out

of the ground months after the battle. There is a sense, then, in which Turner is imaginatively uncovering the dead, even reanimating them. Are the bodies sinking into the ground or re-emerging from it?[86] This thematization of bodies in transition, between life and death, air and ground, matter and non-matter, also applies to artistic genres. At first view, as the bodies sink away into the ground, we seem to witness history painting turning into landscape, and all too literally at that.[87] But if I have said that the bodies seem to be emerging, or re-emerging from the ground, then the picture also moves in the opposite direction, from landscape to history. Once again, history painting is formed out of the ruins of its own destruction.

Turner's ambivalence about making and unmaking must be understood as part of a larger uncertainty about the battle and its consequences for empire. I have noted above that even in victory many Britons took Waterloo as a warning about the future of its empire. To elaborate, just as the growth of British empire in the East had prompted concerns about the effects of autocratic rule on British liberty, so too did many thinkers in the years after the Napoleonic Wars express concern that victory could lead to the ruin of Britain. As Byron brings Harold to the field of Waterloo—and Turner travelled to the battleground with *Childe Harold* in hand—he arrests the narrative and the reader with a literary command that refers to the grave of France, but which, given the ambivalent nature of the victory we have noted, also implied that of Britain: "Stop!—For thy tread is on an Empire's dust!"[88] Writing in this same moment, Jeremy Bentham made this point more explicitly. Bentham pointed to an increasingly repressive regime in Britain: "The plains, or heights, or whatsoever they are, of *Waterloo* — will one day be pointed to by the historian as the grave — not only of French, but of English liberties. Not of France alone, but of Britain with her, was the conquest consummated in the Netherlands. Whatsoever has been done and is doing in France, will soon be done in Britain."[89] The point is that the effects of history are never simple and one-sided. The consolidation of empire takes place only through ruins and fragmentation, and it will return to that state.

The presence of the women and children in the midst of this decomposition, standing out vertically against the horizontal pull towards the earth that has gripped the dead, functions as a thematic counterpoint to this pervasive collapse into unity by referring to the earlier part of the poem and the stanza itself, where Byron describes the soldiers attending a ball: "Last noon beheld them full of lusty life, / Last eve in Beauty's circle proudly gay."[90] It is by means of the women and the implied intercourse that produced the children that Turner recreates in part the powerful life/death contrast of the poem. But the presence of the living woman and child, and the absence of the men, also indicates Turner's inability to bring together the figural group into a more overarching unity. If Turner is able to create some kind of unified group of figures, it is a unity predicated on a prior un-forming, on disunity, dismemberment and death.

Given the sense in which this picture depicted the field of battle as both an open wound and a grave, it is perhaps not surprising that the press largely generalized its bloody specificity. Extraordinarily, the *Repository of Art* viewed *The Field of Waterloo* as an allegorical representation of war rather than a particular battle.[91] *The Examiner* was more expansive but enacted a similar generalization of the picture. Its reviewer, Leigh Hunt, began his treatment of the RA exhibition that year by dividing painting into three categories: portraiture, historical painting, and poetical painting, the last being most highly valued because of its imaginative sources and appeal. He then places Turner's work in the poetical category along with works such as Henry Howard's *Faeries* and Fuseli's *Dante in Hell*. While he acknowledges the *Waterloo*'s subject by referring to "fiery explosions," "carnage," "Ambition's charnel-house," and "slaughtered victims," Hunt is careful to avoid attributing these features to specific soldiers in a specific battle, preferring instead to describe Turner's "magical illustration of that principle of claire obscure" and his "massing and composition [which] leaves nothing for us to wish; he enlightens, he surprises, he delights."[92] This treatment of the picture speaks both to a willingness to accept Turner's method of composing by decomposition and to a desire to look and write away the specific resonances of the wounded bodies, even here in the radical *Examiner*.

Waterloo may have expressed history as a process of destruction, decay, and reformation, but in this case such a conception seems to have informed the project from the start rather than developing almost in spite of itself as in *Trafalgar*. Returning to Byron, it is interesting to note that in the stanza that immediately precedes the famous Waterloo verses, the poet expressed a condition very much like the kind of Fuselian belatedness I have attributed to Turner:

> Self-exiled Harold wanders forth again,
> With nought of hope left, but with less of gloom;
> The very knowledge that he lived in vain,
> That all was over on this side of the tomb,
> Had made Despair a smilingness assume,
> Which though't were wild,—as on the plunder'd wreck
> When mariners would madly meet their doom
> With draughts intemperate on the sinking deck,—
> Did yet inspire a cheer, which he forbore to check.[93]

There is much that Turner may have recognized in this passage, not least some sense of kinship with both Harold and Byron himself, solitary figures who had left daughters behind. But more important may have been that sense of separation, of being unmoored, an exile that was less physical for Turner than it was a matter of distance from the artistic traditions that he valued so dearly. For Byron, experience and creativity take place in the wake of loss; absence or lack is signaled through a wonderful set of reversals which are closely akin to the dual movement of rising and falling that I have described in Turner's pictures. Thus, in the condition beyond hope, there is "smilingness," and in

the midst of the wreck (note the use of this metaphor for personal dissolution), there are "draughts intemperate." One might think with this last phrase of the *Annals of the Fine Arts*'s verdict—the picture was "a drunken hubbub"—that something was out of control in *Waterloo*.[94] If Turner is able to build something out of this condition in *Waterloo*, to bring something together when "all is over this side of the tomb," it is only by means of first taking away and then building from the fragments of a world in ruins, in this case the ruin of the human body itself, and showing the loss of life, of bodily individuality and integrity, and of the familial unit of man, woman, and child.

Painting Disintegration in the 1830s

Having noted Turner's tendency to depict history by means of destruction, we can add a layer to our understanding of some of Turner's grander statements on contemporary historical events from the 1830s, such as the two pictures of *The Burning of the Houses of Lords and Commons, October 16, 1834*, paintings of 1835 (Figures 2.16 and 2.17) as well as the associated watercolors (for instance, Figures 2.18 and 2.19) and *The Fighting Temeraire, tugged to her last berth to be broken up*, 1839 (Figure 2.20). In the Parliament pictures, as in *The Decline of the Carthaginian Empire* and *The Shipwreck*, Turner resists showing the ruin, indicating instead the process of decay itself, in this case the searing power and destructive force of fire. Katherine Solender agrees with Lawrence Gowing that the Parliament paintings and watercolors represent a "climactic" moment in Turner's career, suggestive of another instance in which Turner built his art on destruction.[95] In the watercolors the buildings appear as flimsy non-forms, mere shells or stage-fronts, already eroded by the searing heat around them. In the paintings the towering fire dominates the pictorial space, rising up into the sky as it reduces the buildings back to the earth. As a way of entering into this familiar imagery from a new perspective, we might recall Reynolds's claim that the painter cannot make something out of nothing. We also might note the complex traffic in Turner's work between forms and non-forms, between, that is, "some-things" and "no-things." The fire, of course, is a non-form, a nothing, that becomes substantial here through paint; it dwarfs human achievement by reducing something, the substance of architecture, to nothing. John Canaday characterized this dual movement between form and non-form perfectly, writing about the pictures: "Water fuses with air, air and water fuse with fire, while earth, stone, and metal dissolve into them."[96] Thus, the paintings, which are formed by the fusion of non-forms, epitomize Turner's ongoing exploration of the expressive possibilities of paint and color for rendering immaterial forms such as light, air, water, and fire. In an account we will consider in depth in Chapter 3, the artist E.V. Rippingille described Turner's creation of the Cleveland version of Parliament during the 1835 British Institution Varnishing Days in terms that acknowledged Turner's ability to move between states of matter and non-matter with paint: "...the picture sent in was a mere dab of several colours, and 'without form

and void,' like chaos before the creation. Such a magician, performing his incantations in public, was an object of interest and attraction." In describing Turner as a magician (someone who makes nothing from something and vice versa), Rippingille invokes the material but unformed quality of the colors ("a mere dab"). Later he points to their transformation from material to non-material, writing that "Turner…was observed to be rolling and spreading a lump of half-transparent stuff over his picture, the size of a finger in length and thickness," thereby emphasizing the three-dimensionality of the material ("a lump of…stuff"), which is then assimilated, flattened into the imagery of the picture itself.[97]

But the movement between something and nothing goes the other way as well. As in *Carthage* and *The Shipwreck*, it is the process of something being dissolved into nothing that is the basis of Turner's formation of an image. By picturing something becoming nothing, Turner paradoxically turns the nothing, the void space of the canvas (recall the empty space of the canvas sail in *The Shipwreck*), into the something of a major painting. We can turn the screw a little further by remembering Constable's explanation, cited in the introduction, of his paintings of ordinary subjects as the making of "something out of nothing." Constable had reversed the terms of Reynolds's formulation (making no-thing out of something)—it should be no surprise that Constable's election to the RA was so long in coming—but Turner seems to have wanted to have it both ways. On the one hand, what Turner forms is, in essence, a picture of nothing: not only the formlessness of air, water, and/or fire, but also the lack, the non-form, of a ruin, the no-thing that is a process, the power of nature, the power of history. Turner, characterized so often as a

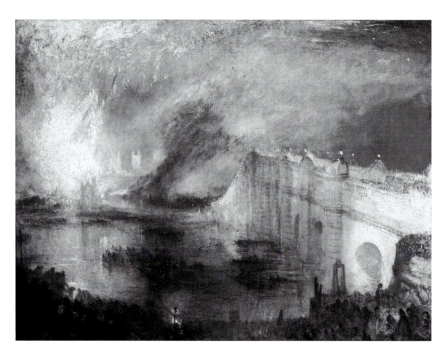

2.16 Joseph Mallord William Turner, *The Burning of the Houses of Lords and Commons*, October 16, 1834, 1834 or 1835, oil on canvas, 36.25 x 48.5 in. (92.1 x 123.2 cm), Philadelphia Museum of Art: The John Howard McFadden Collection, 1928.

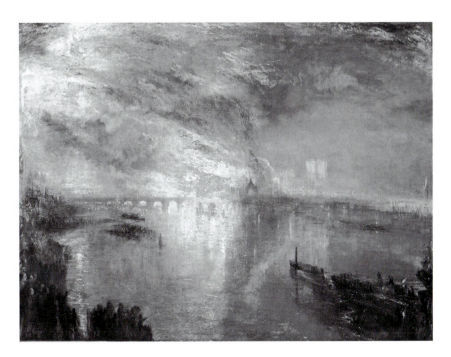

2.17 Joseph Mallord William Turner (British, 1775–1851). *The Burning of the Houses of Lords and Commons,*
16 October, 1834, 1835, oil on canvas; 92.0 x 123.2 cm The Cleveland Museum of Art.
Bequest of John L. Severance 1942.647.

2.18 Joseph Mallord William Turner, *The Burning of the Houses of Parliament,* 1834, watercolor, 9.125 x 12.75 in.
(23.2 x 32.5 cm), TB CCLXXXIII 4. © Tate, London, 2011.

2.19 Joseph Mallord William Turner, *The Burning of the Houses of Parliament*, 1834, watercolor, 9.125 x 12.75 in. (23.2 x 32.5 cm), TB CCLXXXIII 7. © Tate, London, 2011.

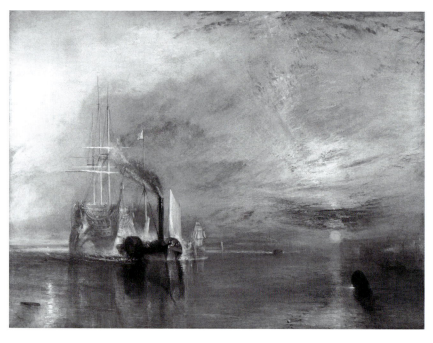

2.20 Joseph Mallord William Turner, *The Fighting Temeraire tugged to her last berth to be broken up*, 1838, oil on canvas, 35.75 x 47.9 in. (90.7 x 121.6 cm). National Gallery, London, Turner Bequest, 1856. Credit: © The National Gallery, London.

magician, takes the material form of paint and transforms it into nothing, into pure idea, into forces of nature rather than definite form. Remember, however, that Turner performed this magical act of creation for the Philadelphia *Burning of the Houses of Lords and Commons* during the Varnishing Days at the British Institute in 1835, transforming "a nearly blank canvas" (nearly nothing) into the substantial form of the finished painting. Although it did not name the Cleveland version specifically, the *Morning Herald's* review of the RA exhibition that same year clearly referenced the paintingwhen it called Turner a "fire king" and likened his works to flames that might set the room, the building, and the Academy on fire.[98] Once again, we see the connection made between Turner's artistic identity and destructive processes.

The historical charge of these transactions is determined by the fact that *The Houses of Parliament* were also suffused with a broader cultural discourse of decay. The year 1832 had witnessed the divisive passage of the first Reform Bill, but this was just one of a series of major parliamentary events of the previous few years that seemed to shake the very core of English national identity. Among these were the repeal of the Test and Corporation Acts (1827), which allowed dissenting Protestants to participate in government; Catholic Emancipation (1829); the emancipation of slaves in British colonies (1833 and gradually imposed beginning in 1834, before final enactment in 1838); and the Factory Act of 1833. In short, while we might best understand the Reform act as a means of re-inscribing aristocratic control by allying itself to the middle class at the expense of the lower class, there was also a distinct sense in these years of a broad breakdown in traditional society and English values, something the fire came to symbolize. A writer for the *Gentleman's Magazine* pointed to precisely this aspect of the fire when he wrote: "I felt as if a link would be burst asunder in my national existence, and that history of my native land was about to become, by the loss of this silent but existing witness, a dream of dimly shadowed actors and events. The very mob seemed to care little for the destruction of the other buildings, on which they vented their low and reckless jests, but the feeling of anxiety was almost universal for the preservation of the noble [Westminster] Hall."[99] While John McCoubrey has proposed an optimistic reading of the Parliament pictures, noting that Turner depicts a point after which the wind has shifted so that the beloved Westminster Hall was indeed preserved from destruction, Jack Lindsay sees the picture as "symbolically expressive of the fires of decay and violence at work in English society and liable to burst out in a general conflagration."[100] In support of this latter reading, we might note that *The Examiner* made much of the fact that the blaze had started in the fireplace of the House of Lords and, as Solender notes, was one of a number of journals that saw here the possibility of a metaphor for Parliamentary ineffectiveness, in particular in relation to the controversial and much-despised Poor Law which condemned the unemployed to the cruel conditions of workhouses.[101] *The Examiner* made no mistake about the very human causes of the fire's beginning in the Lords, as well as the insufficiency of human action to stop it once it was set in motion.[102] The relation, finally, of the destruction of Parliament to a larger sense of imperial dissolution is

clear from the similarity of the *Houses of Parliament* watercolors to Turner's contemporaneous *The Burning of Rome* (c. 1834–8, Figure 2.21). Like the House of Lords, the great columns of Rome seem like flimsy pieces of board standing out against the deep background washes of crimson, a color which Ruskin liked to note also symbolized large-scale bloodshed for Turner.

Even in *The Fighting Temeraire*, which was for Turner's contemporaries his most successful contemporary history painting, unity of form and message is created by means of death and decay. The impact of the powerfully centralized form of the old *Temeraire*, appearing for the third time in Turner's work, is predicated on our awareness of its approaching demise. Even the name contains a sense of this dual movement: "berth" puns with "birth" so that decay and growth are equally implied here. There is already a fire on her decks, as Paulson notes.[103] Is there not also an echo of the mother/child group that we have already seen held such importance for Turner, and which he depicted in the *Indiaman*, in *Waterloo* and in a number of other places as we will see below, with the smaller, newer steamship comfortably nestled beneath the older, larger war ship? The picture suggests not only the violence/peace, war/civilian contrast of the *First-Rate* and *Loss of an Indiaman*, and the *Peace – Burial and Sea* and *War: The Exile and the Rock Limpet* (both 1842, Figures 2.22 and 2.23), but also the passage of generations in cycles of growth and decay. The metaphor of the ship in the *Temeraire* is not a means of bringing together a set of prior, disparate parts, but rather of implying a future breaking up, back into parts. Turner names the British empire at its height with a certainty and unity here, but does so only in negative form, as with the sail in *The Shipwreck* again. He speaks empire by unspeaking it, names the thing by naming its demise.

2.21 Joseph Mallord William Turner, *Rome Burning*, c. 1834, pencil, watercolor and bodycolor on brown paper, 8.5 x 14.5 in. (21.6 x 36.7 cm). TB CCCLXIV 370. © Tate, London, 2011.

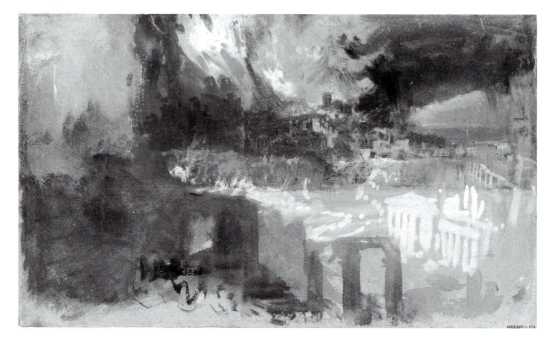

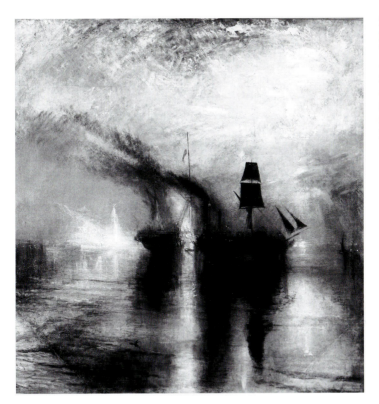

2.22 Joseph Mallord William Turner, *Peace – Burial at Sea*, 1842, oil on canvas, 34.25 x 34.125 in. (87 x 86.7 cm). © Tate, London, 2011.

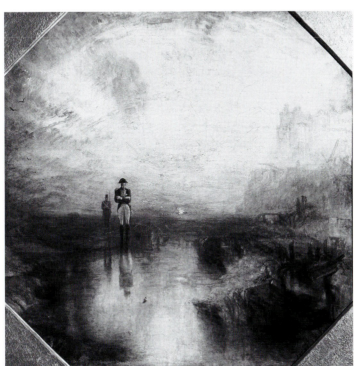

2.23 Joseph Mallord William Turner, *War – The Exile and the Rock Limpet*, 1842 oil on canvas, 31.25 x 31.25 in. (79.4 x 79.4 cm). © Tate, London, 2011.

Conclusion: The Limits of Representation

In beginning to conclude this chapter, I would like to return to the prominence of the broken family unit in *Waterloo* and note the persistence of this motif in a number of Turner's paintings of imperial decline. In *The Decline of the Carthaginian Empire*, the Carthaginians' consent to relinquish its children to Rome is specified in the title and depicted clearly along the left side of the harbor, where we see children being taken away from their parents and placed into boats. One figure, I would like to suggest, is especially significant: the woman closest to us in the foreground, who cradles a baby (detail, Figure 2.24). As I will discuss in the chapter on Venice, Turner at times linked both imperial vigor and artistic production with eroticism and procreative energy. In this regard, these details would seem consistent with Dian Kriz's characterization of the two Carthage paintings as spaces of heterotopic fantasy that allowed the male imperial viewer a symbolic visual penetration of contemporary colonial North Africa, which is masked in the garb of antiquity as a means of simultaneously preserving distance from the Other. Kriz notes that moral decline is signaled in *The Decline of the Carthaginian Empire* in part through the feminization of the pictorial space, which signaled the loss of manly virtue.[104] As both Nicholson and Kriz point out, however, Turner's stern moralism in this picture is tempered with a clear sense of sympathy for the Carthaginians. Citing a passage from Turner's preparatory drafts for the poetic attachment, Nicolson notes his reference to Carthage as the injured

2.24 Joseph Mallord William Turner, *The Decline of the Carthaginian Empire*, 1817, detail, oil on canvas, 67 x 94 in. (170.2 x 238.8 cm). © Tate, London, 2011.

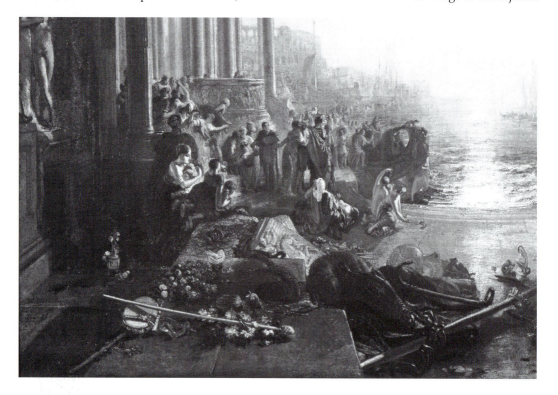

party of the aggressive Romans, and concludes that Turner, as he often did, stopped short of providing definite meaning.[105]

Without by any means disregarding Kriz's larger point, then, I would like to suggest that Turner was himself ambivalent about empire in general, something partially elaborated in his recurring use of the figure of the mother and child. The image of maternal care, and the broken dyad of mother and child, appears in a number of his works. Turner's sense of the cruelty of separation of the family, and of its relation to chaos and nihilism, is demonstrated in another early image of destruction, *The Deluge* (c. 1805, Figure 2.25). The painting features numerous scenes of mothers clinging to children. Poignantly, in the foreground, a child falls away from its mother. Only one small leg is still in contact with her body as they twist away from each other. This detail is particularly significant if we remember that Turner's criticism of Poussin's picture of the same subject centered on the earlier painter's inability to paint a world of upheaval and chaos and pointed particularly to the lack of emotion in Poussin's portrayal of the mother losing her child. Turner symbolizes that chaos, that sense of disintegration, by showing this same separation of mother and child.

In no place is the significance of mothers and children in the depiction of history more grimly clear than in the *Disaster at Sea*, an unfinished picture of c. 1833–5 (Plate 13). The painting refers, as Cecelia Powell has shown, to the disaster of 1 September 1833, when the British convict ship *Amphitrite*, bound for Botany Bay and carrying 125 women and children, ran aground off the French coast near Boulogne. All were lost. The case became a source of public outrage when it was revealed that the passengers could have been

2.25 Joseph Mallord William Turner, *The Deluge*, c. 1805, oil on canvas, 56.25 x 92.75 in. (142.9 x 235.6 cm). © Tate, London, 2011.

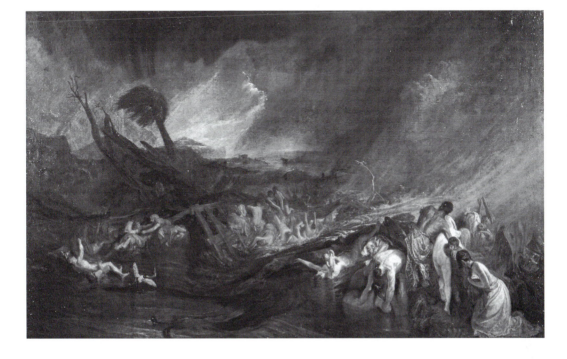

saved, but the captain refused assistance and lifeboats for fear that he would be financially liable for any prisoners who had escaped and who landed unauthorized in France.[106] In the middle of the canvas we can see a mother passing a child to another woman (detail, Plate 14). She reprises the maternal figure in the center of *The Loss of an East Indiaman*. Her face is nothing more than the roughest indication of lines, but her eyes very certainly stare out at us. Following a line diagonally down and to the right from her, we see another mother whose child is now falling. Then, in the extreme right foreground, a mother reaches for a child being carried away by the waves, reprising the vignette from *The Deluge* as well as other pictures, including both *The Loss of an East Indiaman* and *The Shipwreck,* which feature reaching figures in the foreground. Finally, at the bottom we see a woman with her head buried in her arms. It is as though we are looking at a series of events in time, as the mother successively loses control of and then mourns the child. This downward movement is produced by the wave that lifts the back of the raft upward, and we seem to have caught the last dying moments of the ship before it breaks away entirely, also similar to the *Indiaman*. Turner was evidently still trying to out-do Poussin in "the conception of a swamp'd world," not only in the immediacy of the waves that destroy the ship but in the horror of children being torn from their mothers, reprising the scene of separation in *The Decline of the Carthaginian Empire*. The *Amphitrite* places us on the edge of an abyss of unspeakable horror, and it reprises the centralized form of lit, intermingled bodies from *The Field of Waterloo*.

But, having undertaken this critique, it is as though Turner's nerve failed in the face of the unspeakable. The painting was left incomplete, with figures throughout only just barely defined against their surroundings, coming into or out of visibility at the edge of infinity. Note the figures and heads that follow a rough line between the central woman and the two figures at the mast, a reference to Géricault's *Raft of the Medusa* (1818, Figure 2.26), which Turner almost certainly saw when it was exhibited in London in 1820.[107] The figures are merged with each other; they seem only barely carved out of the bright white paint that defines the foaming water that engulfs them. Look also at the figures who curl away from the central woman in a shallow arc towards the back right corner of the wreckage. This rear portion of the ship is not under the wave that whitens the other figures, but the women here are equally, and less explicably, unclear. Immediately to the right of the line of the wave's white foam we see the stretched torso and leg of one figure, but she has no head or face in evidence. Behind her there are uncertain body parts, and further to the right is the head—one can't quite call it a face—of a body which seems to be sliding off the raft. But what should form the body is here nothing more than a blur of paint. Such application led some writers, both during and after Turner's lifetime, to conclude that he had difficulty portraying the figure.[108] Against this notion Andrew Wilton argues that such unformed, incomplete, and strange bodies are for Turner expressive of the situation they describe, deliberately mobilized to speak to a debased state of

humanity in a cruel world.[109] This is compelling, but there also seems to be something more, or less as it were, at work here: Turner, in his search for more and more extreme moments of decomposition, has come to the very limit of representability.

That limit, moreover, seems to exist precisely in the face—which is almost not a face—of the central woman holding her child. We should remember that it was hardly unusual for Turner to treat both male and female faces in such cursory fashion. Here, however, it is placed at the center of the compositional unit of the boat where it acts as far more of a fulcrum for the picture than the aft-leaning mast. Turner pushes his method of composition by decomposition to an unrecoverable limit, where it can be neither reformed nor brought back together, where it cannot be imagined as whole, even in a state of dissolution. It is in the face of this woman that Karl Kroeber's compelling account of the Romantics' use of entropy as a means of seeking and achieving plenitude breaks down with reference to Turner,[110] for in this unfinished painting there is no more complex unity that can be wrought out of this dissolution, in the manner of *The Shipwreck* or *Waterloo*. The decline here is absolute, abject even. For what would the face of that mother have held, and what might it have said to Turner and his viewers? What kind of sacrifices had been made for empire? And what were the results of that sacrifice? Not redemption, if we are to take it from *The Wreck of the Amphitrite*.

2.26 Theodore Géricault, *The Raft of the Medusa*, 1819, oil on canvas, 193.3 x 282.3 in. (491 cm x 716 cm). Louvre, Paris, France. Photo credit: Scala/Art Resource, NY.

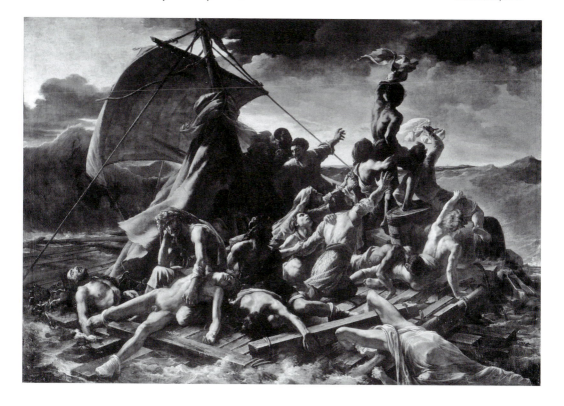

I will return to this very grim figuration of history when I consider the *Slave-ship*, a picture which is in many ways the continuation of the *Wreck of the Amphitrite* but with race and slavery as the primary issues. First, however, it is necessary to explore critical responses to Turner's painting practice to reveal how the linked processes of destruction and creation that I have described produced a deeply ambivalent response in his contemporaries.

Endnotes

1 Linda Colley, *Britons: Forging the Nation, 1707–1837*, 2nd ed. (New Haven and London: Yale University Press, 2005), pp. 38–65.

2 James Thomson, "Liberty," in J. Logie Robertson (ed.), *The Complete Poetical Works of James Thomson* (Oxford: Henry Frowde, 1908), part III, ll. 404–10, p. 351. On luxury and the state in eighteenth-century thought see John Barrell, *The Political Theory of Painting from Reynolds to Hazlitt: "The Body of the Public"* (New Haven: Yale University Press, 1986), pp. 33–9, ff; John Sekora, *Luxury: The Concept in Western Thought, Eden to Smollett* (Baltimore and London, The Johns Hopkins University Press, 1977), pp. 23–109, ff. For the defense of luxury see Sekora, pp. 110–31.

3 *Royal Magazine*, v. 4 (January 1761): p. 14.

4 David Solkin, "'Conquest, usurpation, wealth, luxury, famine': Mortimer's *banditti* and the anxieties of empire," in Tim Barringer, Geoff Quilley and Douglas Fordham (eds), *Art and the British Empire* (Manchester: Manchester University Press, 2007), pp. 136–7.

5 Peter Marshall, "Britain without America – A Second Empire," in *The Oxford History of the British Empire* (5 vols, Oxford and New York: Oxford University Press, 1998), Peter Marshall (ed.), *The Eighteenth Century*, v. 2: pp. 576–95. For more on ambivalent reactions to empire see John Barrell, *The Infection of Thomas De Quincy: A Psychopathology of Imperialism* (New Haven: Yale University Press, 1991), Nigel Leask, *British Romantic Writers and the East: Anxieties of Empire* (Cambridge: Cambridge University Press, 1992) and Alan Richardson, "Epic Ambivalence, Imperial Politics and Romantic Deflection in Williams's *Peru* and Landor's *Gebir*," in Alan Richardson and Sonia Hofkosh (eds), *Romanticism, Race and Imperial Culture* (Bloomington: Indiana University Press, 1996), pp. 265–82.

6 Adam Ferguson, *An Essay on the History of Civil Society* (Cambridge and New York: Cambridge University Press, 1995) (original 1767), p. 272; cited in Solkin, "Mortimer's *banditti*," p. 120.

7 *The Monthly Magazine*, June 1, 1818, pp. 401–2, 445.

8 Philip Shaw, *Waterloo and the Romantic Imagination* (Basingstoke: Palgrave Macmillan, 2002), p. 7.

9 J.G.A. Pocock, "Between Machiavelli and Hume: Gibbon as Civic Humanist and Philosophical Historian," in G.W. Bowersock, John Clive and Stephen R. Graubard (eds), *Edward Gibbon and the Decline and Fall of the Roman Empire* (Cambridge, MA and London: Harvard University Press, 1977), p. 104.

10 Among the most extensive are: John Gage, *J.M.W. Turner: "A Wonderful Range of Mind"* (New Haven and London: Yale University Press, 1987), pp. 49–56, 211–16; Kathleen Nicholson, *Turner's Classical Landscape: Myth and Meaning* (Princeton: Princeton University Press, 1990), pp. 89–134; Eric Shanes, *Turner's Human Landscape* (London: Heinemann), pp. 191–203; Gerald Finley, *Angel in the Sun: Turner's Vision of History* (Montreal: McGill-Queen's University Press, 1997), pp. 64–76.

11 This is reported in a review of Thornbury's book, *The Quarterly Review*, III (April 1862): p. 472.

12 In what follows, I will make reference to Barrell's powerful *The Political Theory of Painting*. Barrell uses the phrase "civic humanism" for this discourse. Andrew Hemingway, however, has objected to this usage, particularly as relates to Reynolds, in part because he thinks Barrell mistakes a practical discourse for a theoretical one. Hemingway also convincingly asserts that Barrell fails to see the possibility in the writings of many humanists, including Reynolds, of the accommodation of commerce into a model of moralizing painting ("The Political Theory of Painting without the Politics," *Art History*, 10/3 (September 1987): pp. 381–95). See also Hemingway, "Academic Theory versus Association Aesthetics: The Ideological Forms of a Conflict of Interests in the Early Nineteenth Century," *Ideas and Production*, 5 (1986): pp. 18–42. By using the phrase "academic theory" I mean to signal my broad agreement with Hemingway, but the basic point made by Barrell, that Reynolds and the others were concerned with how painting might resist the decline of the British empire, remains useful for my purposes here.

13 Turner to A. B. Johns, October 1814, in John Gage (ed.), *Collected Correspondence of J.M.W. Turner* (Oxford: Clarendon Press, 1980), p. 57.

14 See Turner to Thomas Lawrence, 15 December 1828, in Gage, *Collected Correspondence*, pp. 122–3.

15 See Leo Costello, "Confronting the Sublime," in Ian Warrell (ed.), *J.M.W. Turner*, exhibition catalog (London: Tate Publishing, 2007), pp. 39–55.

16 See Barrell, *Political Theory of Painting*, pp. 49–50, 71–3, 199–200, 261–2 ff.

17 Sir Joshua Reynolds, in Robert Wark, (ed.), *Discourses on Art* (New Haven and London: Yale University Press, for the Paul Mellon Centre for Studies in British Art, 1975), Discourse II, ll. 35–40, p. 26. (Barrell, *Political Theory of Painting*, pp. 91–2).

18 Reynolds, *Discourses on Art*, Discourse III, ll. 187–97, p. 47.

19 Reynolds, *Discourses on Art*, Discourse IX, ll. 18–21, p. 169.

20 Reynolds, *Discourses on Art*, Discourse IX, ll. 26–41, pp. 169–70.

21 Reynolds, *Discourses on Art*, Discourse IV, ll. 56–8, p. 58.

22 Reynolds, *Discourses on Art*, Discourse II, ll. 82–7, p. 27.

23 Given Hemingway's point, that Reynolds and others were concerned with the production of pictures rather than the response to them, this is not surprising, given Turner's constant preoccupation with the practical business of painting. In a private notation Turner wrote, "He that has that ruling enthusiasm which accompanies abilities cannot look superficially. Every glance is a glance for study: contemplating and defining qualities and causes, effects and incidents, and develops by practice the possibility of attaining what appears mysterious upon principle. Every look at nature is a refinement upon art: each tree and blade of grass or flower is not to him the individual tree grass or flower, but what it is in relation to the whole, its tone its contrast and its use and how far practicable…" (Barry Venning, "Turner's Annotated Books: Opie's 'Lectures on Painting' and Shee's 'Elements of Art,' (I)", *Turner Studies*, 2/1 (1982): pp. 38–9).

24 Venning, "Turner's Annotated Books (I)," p. 38.

25 Elizabeth Bohls, "Disinterestedness and denial of the particular: Locke, Adam Smith and the subject of aesthetics," in Paul Mattick (ed.), *Eighteenth-Century Aesthetics and the Reconstruction of Art* (Cambridge and New York: Cambridge University Press, 1993), p. 17.

26 Bohls, "Disinterestedness and denial of the particular," pp. 16–7.

27 Reynolds, *Discourses on Art*, Discourse IV, ll. 62–7, pp. 58–9.

28 Barrell, *Political Theory of Painting*, p. 299.

29 Henry Fuseli, *Lectures on Painting* (New York and London, Garland Publishers, 1979), reprint of Ralph Wornum (ed.), *Lectures on Painting, by the Royal Academicians* (London: Henry G. Bohn: 1848), p. 558.

30 Barrell, *Political Theory of Painting*, p. 64.

31 Colley, *Britons*, pp. 152–5.

32 Peter Marshall, "Britain without America," pp. 576–95.

33 Reynolds, *Discourses on Art*, Discourse III, ll. 282–5, p. 50.

34 *Annals of the Fine Arts*, 3/9 (1818): p. 288. For background on the *Annals* see Tom Devonshire Jones, "The Annals of the Fine Arts: James Elmes (1782–1862), architect: from youthful editor to aged gospeller," *British Art Journal*, 10/2 (Winter 2010): pp. 67–72.

35 Barrell, *Political Theory of Painting*, pp. 270–2.

36 Ian Warrell, "J.M.W. Turner and the Pursuit of Fame," in Warrell (ed.), *J.M.W. Turner*, p. 13.

37 British Library, Add. MS. 46151 H: p. 41.

38 British Library, Add. MS. 46151 H: p. 41.

39 Cited in A.J. Finberg, *The Life of J.M.W. Turner, RA*, 2nd ed., (Oxford: Clarendon Press, 1939), pp. 78–9.

40 Diary entry, 3 May 1803, in Kenneth Garlick and Angus MacIntyre (eds), 16 vols, *The Diary of Joseph Farington*, (v. VI, New Haven and London: Yale University Press for the Paul Mellon Centre for Studies in British Art, 1979), p. 2023.

41 Cited in Felicity Owen and David Blayney Brown, *Collector of Genius: A Life of Sir George Beaumont* (New Haven and London, Yale University Press for the Paul Mellon Centre for Studies in British Art, 1988), p. 144.

42 David Solkin, "Turner and the Masters," in Solkin (ed.), *Turner and the Masters*, exhibition catalog (London: Tate Publishing, 2009), pp. 18–23.

43 Diary entry, 8 May 1799, in Garlick and McIntyre (eds), *Diary of Joseph Farington*, v. 3, p. 1219. For important discussions of Turner and Claude, see Michael Kitson, "Turner and Claude," *Turner Studies*, 2/2 (1982): pp. 2–15 and Kathleen Nicholson, "Turner, Claude and the Essence of Landscape," in Solkin (ed.), *Turner and the Masters*, pp. 57–71.

44 George Jones, "Recollections of J.M.W. Turner," published in Gage (ed.), *Collected Correspondence*, p. 4.

45 At the *Turner and the Masters* research symposium at Tate Britain in January 2010, Eric Shanes forcefully emphasized the importance of Rembrandt for Turner as an example of the use of contrasting warm and cool colors. The horizontal strokes of warm peach tones of the distant sky in *Avalanche in the Grisons* are an example of how subtly Turner could deploy this lesson.

46 For the relationship between the pictures see Solkin (ed.), *Turner and the Masters*, pp. 234–5.

47 On the basis of thesis research by Olivier Lefeuvre (*Philippe-Jacques de Loutherbourg (1740–1812): Vie et Oeuvre*, Sorbonne, 2008), this picture is listed as *A Waterspout in Switzerland*, exhibited at the RA in 1809 in the *Turner and the Masters* catalog (pp. 190, 230 n.1). I am grateful to Amanda Bradley, Alison Harpur and Alastair Lang at the National Trust for information and a discussion about the dating and title of this picture.

48 At the *Turner and the Masters* symposium at Tate Britain in January 2010, Eric Shanes noted that Turner's Gallery was intended for a relatively select group of patrons and potential patrons rather than a crowd like the RA exhibition. My point remains, however, because it is very likely that such patrons would also attend the RA.

49 Andrew Wilton, *Turner and the Sublime*, exhibition catalog (London: British Museum Publications for the Art Gallery of Ontario, The Yale Center for British Art, The Trustees of the British Museum, 1980), p. 66, 68, ff., 99. For Turner's intensification of the viewer's experience, see Gerald Finley, "The Genesis of Turner's 'Landscape Sublime'", *Zeitschrift für Kunstgeschichte*, 42/2–3 (1979): pp. 145–65.

50 Shanes, *Turner's Human Landscape*, pp. 327–36.

51 For discussions of the shipwreck, see George Landow, *Images of Crisis: Literary Iconology, 1750 to Present* (Boston: Routledge and Kegan Paul, 1982) and T.S.R. Boase, "Shipwrecks in English Romantic Painting," *Journal of the Warburg and Courtauld Institutes*, 22/3–4 (July – December 1959): pp. 332–46. For a fascinating interpretation, which touches on the issues raised here, see Karl Kroeber, *British Romantic Painting* (Berkeley: University of California Press, 1986), pp. 188–92.

52 Barry Venning, "A Macabre Connoisseurship: Turner, Byron and the Apprehension of Shipwreck Subjects in Early Nineteenth-Century England," *Art History*, 8/3 (September 1985): pp. 305–7. Venning notes that Turner made frequent use of nautical metaphors in regards to painting. In 1809, Turner used the metaphor of the boat steering a course between danger on either side to recommend a union of the respective excellencies of French drawing and English coloring, making reference in the first line to William Falconer's "The Shipwreck": "Between extremes the daring vessel flies but here tho providential a middle course may be, no conclusive [accordance] can be hoped for but the union of two principles that have ever been followed…" (cited in Venning, "Turner's Annotated Books: Opie's 'Lectures on Painting' and Shee's 'Elements of Art'," *Turner Studies*, 2/2 (1983): p. 45). The metaphor of the island nation of Britain as a ship steering a dangerous course in these war-filled years is almost too obvious to be mentioned. Turner may have seen, for instance, imagery like James Gillray's *BRITANNIA between Scylla and Charybdis* (June 3, 1793), in which a small boat labeled "British Constitution" carries the allegorical figure Britannia between a Phrygian cap-topped "Rock of democracy" and a crown-like "Whirlpool of Arbitrary Power."

53 Turner to Thomas Griffith, 1 February, 1837, in Gage (ed.), *Collected Correspondence*, p. 135.

54 TB LXXII, pp. 41a–42. Cited in Finberg, *Life of J.M.W. Turner*, pp. 89–90.

55 In a talk given at a research symposium for the *Turner and the Masters* exhibition at Tate Britain in January 2010 David Blayney Brown made a similar argument about Turner's goals in his own painting of *The Deluge* (Figure 2.25) from this period and I am indebted to him for a discussion of these themes.

56 Turner's desire to show in his gallery for economic gain is noted as early as 1804. See Joseph Farington, diary entries, 21 March 1804 in Garlick and McIntyre (eds), *Diary of Farington*, v. 6, p. 2271, and 10 May 1806, in Kathleen Cave (ed.), *Diary of Joseph Farington*, v. 7, p. 2756.

57 My thanks to Professor Graham Bader at Rice for a discussion of the sail.

58 Eric Shanes, "J.M.W. Turner: The Finished Watercolor as High Art," in Shanes (ed.), *Turner: The Great Watercolors*, exhibition catalog (London: Royal Academy of Art, 2001), pp. 10–25.

59 Shanes, *The Great Watercolors*, p. 135.

60 Nicolas Flynn explores issues of form, formlessness and modernism's approach to the limits of representation in "The Last Modern Painting," *Oxford Art Journal*, 20/2 (1997): pp. 13–22. Looking specifically at late, unfinished seascapes by Turner Flynn writes, "Modernity is visible here, through this model, in these paintings, as a succession of progressively enfeebling attempts to give a name to, and conversely, to have seeing suture the wound that is reopened with every triumphant renaming…And in this schema painting illumines the limits of the representable and asks of us what we name the unnameable." (p. 14). Flynn's linkage of forming and unforming, representation and mourning and sight and abjection have significant implications also with respect to my discussions below of *The Disaster at Sea* (Plate 13) and *The Slave Ship* (Plate 30).

61 Adele Holcomb, "'Indistinctness is my fault': A Letter about Turner from C.R. Leslie to James Lenox," *Burlington Magazine*, 114: pp. 555–8. For an explanation of the confusion surrounding this quote which was sometimes given as "Indistinctness is my forte," see Andrew Wilton, "Turner and the Americans," 2002 Kurt Pantzer Lecture, subsequently published in the *Turner Society News*, 92 (December 2002): 13.

62 Of later, unfinished paintings of the sea, Nicolas Flynn writes, "…whatever is the object—a wreck, a buoy, a dolphin, a town—it is always delicately balanced at the edge of the visible, in mists of paint, confounding common-sense viewing." ("The Last Modern Painting," p. 16).

63 Shanes, *The Great Watercolors*, p. 135.

64 Andrew Loukes, "Britain at War and Peace: Markets Public and Private 1805–24," in Warrell (ed.), *J.M.W. Turner*, p. 90.

65 Helen Guiterman, "'The Great Painter': Roberts on Turner," *Turner Studies*, 9/1 (1989): pp. 2–9.

66 Eric Shanes, "Turner and the Creation of his *First-Rate* in a Few Hours: A Kind of Frenzy?", *Apollo*, CLIII/469 (March 2001): pp. 13–5.

67 See Shanes, "Turner and the Creation of his *First-rate*," p. 14, for an excellent discussion of Turner's watercolor method in the *First-rate*. Shanes cautions that the account here leaves out elements of his practice like under-drawing and stopping-out and may exaggerate aspects like the "frenzy," noting Turner's delicate handling throughout.

68 Shanes, *The Great Watercolors*, p. 135.

69 TB CVIII, "Perspectives," p. 22, transcribed in Andrew Wilton, *Painting and Poetry: Turner's* Verse Book *and his work of 1804–1812* (London; Tate Gallery, 1990), p. 164.

70 Wilton, *Painting and Poetry*, pp. 98–9. Wilton argues here against ideas that Turner held radical political beliefs, or indeed any particularly well-developed political thought at all. His very point, however—that Turner generally went along with the predominant strain of the eighteenth-century poetry he so admired— strengthens, in my view, the contention that Turner was working within inherited ideas about the course of empire.

71 TB CXXIII, "Devonshire Coast No. 1," sketchbook, pp. 56–7, transcribed in Wilton, *Painting and Poetry*, p. 171.

72 Kathleen Nicholson has argued that both pictures need to be understood as related statements within the context of Turner's sustained meditation on the fate of Carthage and its leaders, a fascination that is first manifest in *Snowstorm: Hannibal Crossing the Alps* of 1812 and lasted until the year before his death, when he created the *Marriage of Dido*. Nicholson convincingly reads these pictures within Turner's larger consideration of both the glory and futility of human ambition in the face of the overwhelming power of nature and time. (*Turner's Classical Landscape*, pp. 103–10.)

73 Nicholson, *Turner's Classical Landscape*, p. 105. Goldsmith's text was itself essentially a re-hashing of Gibbon's earlier work (Roy Porter, *Edward Gibbon: Making History* (London: Weidenfeld and Nicolson, 1988), p. 39).

74 Nicholson, *Turner's Classical Landscapes*, p. 105.

75 Gage, *"A Wonderful Range of Mind"*, p. 216.

76 J.C. Eustace, *A Classical Tour Through Italy*, 3rd ed., (3 vols, London: Mawman, 1815), v. 1, p. 23.

77 Shaw, *Waterloo and the Romantic Imagination*, p. 7.

78 Shaw, *Waterloo and the Romantic Imagination*, pp. 21–22, 28.

79 Duke of Wellington, private correspondence, 17 August 1815, published in Herbert Maxwell, *The Life of Wellington: The Restoration of the Martial Power of Great Britain* (2 vols, London: Sampson and Low, Marston and Company, 1899), v.2, p. 52. Cited in John Keegan, *The Face of Battle: A Study of Agincourt, Waterloo and the Somme* (Hammondsworth, Middlesex: Penguin Books, 1976), p. 117.

80 Duke of Wellington, private correspondence, 8 August 1815, in Maxwell, *The Life of Wellington*, v. 2, pp. 50–1.

81 Lord Byron, *Childe Harold's Pilgrimage*, H.F. Tozer (ed.), (Oxford: The Clarendon Press, 1916), Canto III,: ll. 250–2, p. 115.

82 W.E. Frye, *After Waterloo: Reminiscences of European Travel, 1815–19* (BiblioBazaar, LLC: 2008), pp. 46–7.

83 Stuart Semmel, "Reading the Tangible Past: British Tourism, Collecting, and Memory after Waterloo," *Representations*, 69 (Winter, 2000): pp. 9–37. See also Susan Pearce, "The *matériel* of war: Waterloo and its culture," in John Bonehill and Geoff Quilley (eds), *Conflicting Visions: War and visual culture in Britain and France, c. 1700–1830* (Aldershot and Burlington, VT: Ashgate Press, 2005), pp. 207–26.

84 Linda Nochlin, *The Body in Pieces: The Fragment as a Metaphor of Modernity* (London and New York: Thames & Hudson, 1994), p. 7.

85 Bernard Pool (ed.), *The Croker Papers, 1808–1857* (New York: Barnes and Noble, 1967), p. 31.

86 Turner was not alone in making the shallow graves stand for the battle itself. As Philip Shaw has discussed, the shallow mass graves at Waterloo, and the possibility of the return of the destroyed bodies, played significantly into Byron's thinking about the battle (Shaw, *Waterloo*, p. 185, ff.). Sam Smiles also notes Turner's awareness of the controversy about the use of human remains for fertilizer in the years after the Napoleonic Wars in connection with his inclusion of a skeleton in the foreground of an 1835 picture of the battlefield (*J.M.W. Turner: The Making of a Modern Artist* (Manchester and New York: Manchester University Press), pp. 21–3.

87 I am grateful to an anonymous reader for Ashgate for pointing me towards this aspect of the painting.

88 Byron, *Childe Harold's Pilgrimage*, Canto III: l. 145, p. 112.

89 Jeremy Bentham, *Plan of Parliamentary Reform, in the Form of a Catechism, with Reasons for Each Article: With an Introduction showing the Necessity of Radical, and the Inadequacy of Moderate, Reform* (1817), in *The Works of Jeremy Bentham* (11 vols, Edinburgh: William Tate, 1839), v. 10: p. 436.

90 Byron, *Childe Harold's Pilgrimage*, Canto III: ll. 244–5, p. 115. Fred G. H. Bachrach connects the juxtaposition of man and woman here to Rembrandt's *The Nightwatch* in discussing the picture as also embodying British attitudes towards the Dutch and Dutch art ("The Field of Waterloo and Beyond," *Turner Studies*, 1/2 (1981): p. 10). See also Bachrach, *Turner's Holland*, exhibition catalog (London: Tate Gallery, 1994), pp. 37–41.

91 Anonymous review, *Repository of Art*, June 1, 1818, cited in Martin Butlin and Evelyn Joll, *The Paintings of J.M.W. Turner*, 2nd edition, (2 vols., New Haven and London: Yale University Press, 1984), text volume, p. 105.

92 Leigh Hunt, RA exhibition review, *The Examiner*, 24 May 1818: p. 332.

93 Byron, *Childe Harold's Pilgrimage*, Canto III: ll. 136–44, p. 112.

94 Anonymous review, *Annals of the Fine Arts*, June 1818.

95 Katherine Solender, *Dreadful Fire! Burning of the Houses of Parliament*, exhibition catalog (Cleveland: Cleveland Museum of Art, 1984), p. 62; Sir Lawrence Gowing, *Turner: Imagination and Reality*, exhibition catalog (New York: Museum of Modern Art, 1966), p. 33.

96 John Canaday, *Mainstreams of Modern Art*, 2nd ed. (New York: Holt, Rinehart and Winston, 1981), p. 95.

97 E.V. Rippingille, "Personal Recollections of Great Artists. No. 8. – Sir Augustus W. Callcott, R.A.," *Art Journal*, 22 (April 1, 1860): p. 100.

98 Anonymous review, *Morning Herald*, May 2, 1835.

99 *The Gentlemen's Magazine*, 157 (November 1834): pp. 477–8. Cited in Solender, *Dreadful Fire!*, p. 33.

100 John McCoubrey, "Parliament on Fire: Turner's Buildings," *Art in America*, 72/11 (December 1984): pp. 112–25; Jack Lindsay, *J.M.W. Turner: His Life and Work. A Critical Biography*, (Greenwich, CT: New York Graphic Society, 1969), pp. 180–1.

101 Solender, *Dreadful Fire!*, pp. 41, 58–9.

102 *The Examiner*, October 19, 1834: p. 659.

103 Ronald Paulson, *Literary Landscape: Turner and Constable* (New Haven and London: Yale University Press, 1982), p. 96.

104 K. Dian Kriz, "Dido versus the Pirates: Turner's Carthaginian Paintings and the Sublimation of Colonial Desire," *Oxford Art Journal*, 18/1 (1995): pp. 116–32.

105 Nicholson, *Turner's Classical Landscape*, pp. 109–10. Kriz places Turner's ambivalence to the Roman conquerors within the context of post-abolition (of the slave trade in 1806) concerns over slavery, noting that the Roman's slave-taking would have been condemned by most of the painting's viewers (Kriz, "Dido versus the Pirates," p. 126).

106 Cecelia Powell, "Turner's Women: The Painted Veil," *Turner Society News*, 63 (March 1993): pp. 14–5.

107 On the *Medusa* in London, see Lee Johnson, "*The Raft of the Medusa* in London," *Burlington Magazine*, XCVI (August 1954): pp. 249–54 and Christine Riding, "Staging *The Raft of the Medusa*," *Visual Culture in Britain*, 5/2 (Winter 2004): 1–26.

108 See Ann Chumly and Ian Warrell, *Turner and the Human Figure: Studies in Contemporary Life*, exhibition catalog (London: Tate Publishing, 1990).

109 Andrew Wilton, *Turner as Draughtsman* (Aldershot and Burlington, VT: Ashgate, 2006), p. 132.

110 Karl Kroeber, *British Romantic Art*, Berkeley and London: University of California Press, 1986), p. 191–2. Kroeber's discussion of Turner's *Snowstorm: Steam-boat off a Harbour's Mouth*, is a wonderfully rich account of its use of destruction and violence as a means of breaking down previous modes of conventionalized viewing in favor of an imaginative response (pp. 189–96).

"This cross-fire of colours":
Turner and the Varnishing Days

This chapter differs from the rest of this book by concentrating primarily on critical reactions to Turner's work rather than on a particular painting or group of paintings. My interest in a particular kind of artistic and historical subjectivity elaborated in Turner's work, however, remains very much the same. Chapters 1 and 2 described a subjectivity based at some level on loss: the loss of a connection for the artist to the hero individually and to empire as a whole in *The Battle of Trafalgar*, and thus of the position of the artist as a means of creating that connection. Furthermore, we have seen that Turner, like others, envisioned himself as working in a moment of artistic belatedness, which entailed a loss of a sense of connection to artistic tradition and which corresponded in part to broader visions of imperial breakdown. Turner may well have consolidated his stature in these circumstances, as we saw in Chapter 2, but this occurred on the basis of the prior loss of certain modes of subjectivity on the one hand, and on the basis of picturing destruction on the other. This chapter seeks to build on this idea by considering Turner's relationship to the Royal Academy, specifically, and more generally to his fellow artists.[1] I will show that once again Turner's position was ambivalent, and that as he built his individual reputation there was a sense of the loss of a connection to a larger entity.

Ruskin has determined much of our sense of Turner's relationship to the Academy. In his 1859 catalogue of a Turner exhibition at Marlborough House, Ruskin was at pains to separate Turner from the traditions of academic art that had preceded him. Dividing Turner's career into stages of student-hood, maturity, and decline, Ruskin claimed that Turner only came into his full power as an artist when he managed to abandon his academic training and ambitions and look instead to the close observation of nature.[2] As one can well imagine, formalist-modernist critics, who defined important art in terms of its opposition to academicism, have generally preferred to imagine that Turner's late work "came out of nowhere" and represented a complete rejection of the taste of his contemporaries and the goals of earlier painters. But scholars who have considered Turner's interest in narrative, history, and poetry have

shown Turner to be an artist very much rooted in his time and deeply indebted to the Academic tradition.[3] In particular, they have stressed Turner's deep and abiding sense of allegiance to the Academy's founder Sir Joshua Reynolds, something I also considered in the previous chapter. Here I will build upon this work by taking the opportunity of considering accounts of Turner at work within the space of the Academy as a means of interrogating his relationship to that institution, the values it represented, and his fellow artists. At stake in my discussion of Turner's relationship to the Academy will therefore also be broader questions about the status of the individual as an agent in the nineteenth century, during a time in which the institutions that had bound society together into something at least conceivable as an organic whole were breaking down. If viewers came to think of Turner as an individual artist divided from tradition and his peers, then we need to understand this position as not simply an alienation borne of artistic difference and misunderstanding by the viewing audience, but rather as something intimately related to broader trends in British society.

In terms of individual status, the various accounts of Turner's performances on the Royal Academy and British Institution Varnishing Days, when Turner created pictures on the walls of the exhibition in just a few days, offer considerable evidence of Turner's desire to visibly transcend the Academy and his colleagues in the British School to create his own personal reputation.[4] As we will see, many of these date to the period around the early 1830s and contributed considerably to ideas of the artist's genius for both contemporaries and later viewers. I will argue, however, that we need to understand this withdrawal into individual artistic autonomy not as a mark of prescient proto-modernist genius, but rather as emerging from within the context of contemporary issues of collectivity and competition in the RA and among British artists generally. These issues were themselves related to broader concerns in Reform-era Britain. Thus, while Michael Rosenthal closes his excellent essay on Turner and the Varnishing Days by suggesting that issues of competition between painters in the RA had little relevance in the volatile years around Reform, I will show that both the performance and reception of those Days cannot be separated from the larger issues of Reform.[5] In this regard, it will be clear that while Turner's bravura performances contributed heavily to his reputation as a genius, there was also distinct concern over both the competitive nature of the Varnishing Days and the implications of that competitiveness for free-market economics in the national arena of the exhibitions. At the same time, however, within the political climate of Reform, the Varnishing Days could be portrayed by other critics as providing an unfair commercial advantage to Academicians such as Turner by blunting competition, and so were treated as a vestige of a corrupt political past. Thus, the Varnishing Days become one forum for the elaboration of larger questions about the development of British society. I am not suggesting that it was the most important one, but it does give us a compelling means to consider the

role of aesthetics in those questions and the complexity of Turner's position in relation to them.

Implicit in this account is a Foucauldian view of "Turner" as a product of various discursive operations at the intersections of aesthetic and social networks rather than a transcendent genius. However, it is also important to keep sight of Turner as a historical agent. To contextualize "Turner" as purely the product of various artistic and political interests would be at the first level to gloss over the details of individual experience, but even more to rob the individual subject of the ability to negotiate, resist, and determine, at least in part, his relation to the whole. That relation, we will see, was powerfully ambivalent. Academic theory had established a certain ideal role for the individual artist. Specifically, many writers expected or desired the Academy exhibition to be a successful totality in which individual works and their artists contributed to, rather than detracted from, a coherent expression of British painting. Because success in the arts was considered by many to be an expression of the overall health of a civilization, the Academy could ideally be made to represent the coherence of the British nation and empire. In this model, the civilization of the state produces the Academy, which produces individual artists. The success of the individual artists in turn proves the worth of the Academy, which in turn proves the worth of the state. In theory, then, artists, Academy, and state formed a kind of mutually reinforcing tautological loop, in which the identity and success of each element is assured by reference to the others. We saw in Chapter 2 that Reynolds pointed to this mutuality, saying that the artist who has indeed mastered the grand style of public history painting will also ensure his own status in perpetuity: "Such a student will disdain the humbler walks of painting, which, however profitable, can never assure him a permanent reputation."[6] This was a role that I think Turner desired to play at some level, but also felt the need to exceed. The intensity of the responses to the Varnishing Days as assertions of individuality will stem in part from this ambivalence.

Turner's assertion of individuality resulted in part from a reality that was very different than Academic discourse allowed. The Royal Academy had been marked by division and strife from its founding. By the time Turner became an Academician around the turn of the century, we have seen that the RA was already perceived to have failed in its task of creating truly public art, succumbing instead to the demands of a privatized, competitive marketplace.[7] To maintain the coherence of academic theory in the face of such challenges, certain acceptable means of releasing or discharging competitive energy from the loop of the individual painter and the Academy as a whole were necessary. With Turner, however, these issues became drastically heightened so that in his case the individual exerted its force within the loop itself, threatening to break it apart completely. I will demonstrate here how this rupture was registered in particular in responses to his competitive activity on the Varnishing Days. Two points must be made to modify this picture, however. Firstly, Turner himself was ambivalent about his own role. He seems to have

genuinely harbored hopes for the kind of symbiotic relationship between individual and whole I described by Reynolds and others in Chapter 1, even as he worked to destroy it. Secondly, not all responses to Turner's competitive behavior were negative. At stake therefore, for both Turner and the critics, were larger questions of the relationship between individuals and institutions to each other and to the state in a time of rapid political change.

"Turner…Could Outwork and Kill any Painter Alive"

Permanently established in 1809, the Varnishing Days preceded the annual Royal Academy exhibition, and were a time during which Academicians, and only Academicians, could touch up or repaint their works after they had been placed on the walls.[8] In the 1830s, Turner, assured inclusion in the exhibition as an Academician since 1802, became famous for sending in largely unfinished canvasses and completing them on the walls before amazed onlookers. These spectacles did much, both during Turner's lifetime and afterwards, to establish his reputation as a solitary, Romantic genius and *bravura* painter.[9] Indeed, William Parrott, a landscape painter who exhibited at the RA and British Institution in these years, presented a memorable portrait of the artist at work during such a performance (1846, Plate 15). As with written accounts, the Parrott portrait has the beguiling appearance of an eyewitness account of the secretive artist at work. But, of course, like any portrait, written or otherwise, it cannot be taken to be some kind of transparent account. Indeed, Parrott's picture visually reprises the many discussions of Turner's almost supernatural powers and depicts the artist as a magician or alchemist. Parrott places the artist close to his canvas and includes the pigments on the palette in his left hand. While blue and red are visible here, the area in which Turner works is aglow with bright white and gold. Turner's brush, visibly in contact with the canvas, is shown as a kind of wand, transforming base material into a radiant gold light that outshines the gilt frame.[10] As we saw in the previous chapter, the artist E.V. Rippingille also witnessed Turner at work on *The Burning of the Houses of Lords and Commons, 16th October, 1834* (1835, Figure 2.16) during the 1835 Varnishing Days of the annual exhibition of the British Institution. Again, however, we must be attentive to the rhetorical strategies at work in the description and, remembering that it was published some twenty-five years after the fact, understand that it was involved in staging a particular kind of Turner to an early Victorian audience. Rippingille invokes the same idea of Turner as a magician, something we will see frequently in what follows. To begin to shift our account from the Varnishing Days as evidence of Turner's genius, however, we should also note Rippingille's invocation of Turner's competitive, even violent attitude towards his fellow painters:

Turner who, as he boasted, could outwork and kill any painter alive, was there, and at work at his picture, before I came, having set-to at the earliest hour allowed. Indeed, it was quite necessary to make the best of his time, as the picture

when sent in was a mere dab of several colours, and "without form and void," like chaos before the creation…Such a magician, performing his incantations in public, was an object of interest and attraction…A small box of colours, a few very small brushes, and a vial or two, were at his feet, very inconveniently placed; but his short figure, stooping, enabled him to reach what he wanted very readily. Leaning forward and sideways over to the right, the left-hand metal button of his blue coat rose six inches higher than the right, and his head buried in his shoulders and held down, presented an aspect curious to all beholders…In one part of the mysterious proceedings Turner, who worked almost entirely with a palette knife, was observed to be rolling and spreading a lump of half-transparent stuff over his picture, the size of a finger in length and thickness…Presently the work was finished: Turner gathered his tools together, put them into and shut up the box, and then, with his face still turned to the wall, and at the same distance from it, went sidling off without speaking a word to anybody, and when he came to the staircase, in the centre of the room, hurried down as fast as he could. All looked with a half-wondering smile, and [painter Daniel] Maclise, who stood near, remarked, "There, that's masterly, he does not stop to look at his work; he *knows* it is done and he is off."[11]

Rippingille's account aggressively separates Turner from his peers, placing the violence of that separation into the words attributed to the artist himself: "outwork and kill." This was certainly partially the case, as we will see, but it is also necessary to consider the material conditions of that separation rather than simply attribute it to Turner's transcendent genius. The account privileges itself by both asserting Turner's reclusiveness and then offering apparently unmediated access to the reader. In this regard, the passage can be read in part as a characterization, if in negative form, of Turner's (non-)relationship with official artistic institutions and his fellow artists. The narrative is at pains to emphasize this separation, so that Turner is both physically within the official spaces of art and creatively outside of them, intensely focused yet indifferent to his surroundings. The exaggerated quality of Turner's unsociability ("his face still turned to the wall" and "without speaking a word to anybody") is only plausible given its contribution to the creation of an artistic persona that continued and refined a set of ideas that had begun during Turner's lifetime. The apparent anti-academicism of Turner's creative process during the Varnishing Days, abjuring linear drawing and studies, works very much within Ruskin's characterization of Turner's pre-eminence, encompassing at once a withdrawal from his academic background and a surpassing of both his artistic predecessors and contemporaries.

But Rippingille also alters these terms in line with emerging Victorian and modernist ideas of Turner as an artist who painted primarily from the imagination.[12] By emphasizing a Turner who worked not only inside, but in a *bravura*, improvisatory manner, without sketching and under-painting, Rippingille downplays the importance of both academic practice and natural observation to Turner. For both of these moves to be successful, Turner must seem oblivious to his surroundings, must exist in pure isolation. By means of the Varnishing Days, therefore, the notion of a transcendent individual genius, concerned with neither verisimilitude to some observed scene nor to

traditional academic practice but, rather, attuned to the qualities inherent in the picture, begins to emerge in this text. These combine with Rippingille's placement of the Varnishing Days in a competitive framework, so that Turner's performance is understood to exist in opposition to his fellow artists. This points, as does the notably violent rhetoric employed by Rippingille, towards the broader issue of competition in between artists.

Exhibition and the Growth of Competition in the Royal Academy

In a brief letter that followed an exchange of books, Martin Archer Shee, an eventual President of the RA, wrote to his friend, portraitist and fellow Royal Academician John Hoppner, in December 1805, in terms that point to the competitive environment of the RA in these years: "Whilst the two books remain, they will prove, *that in a time of much professional jealousy there were two painters, at least, who could contest without enmity and associate without suspicion.*"[13] The years of 1790–1812 were indeed unusually fractious ones in the Academy, during which both internal politics and the pressure of the broader political situation during the Napoleonic Wars led to great division amongst the Academicians, as several RA were accused of having "democratic" ideas.[14] But Shee's phrase "professional jealousy" suggests another source of controversy and it is my contention that the pressure of competition and rivalry between artists proved as divisive as any political issue.

From its inception, the Royal Academy and its members experienced a disjunction between the ostensibly disinterested stated goals of the institution and their own individual ambitions.[15] The rhetoric of the Academy privileged the former. Introducing his First Discourse in 1769, Sir Joshua Reynolds said,

Gentlemen, An Academy, in which the Polite Arts may be regularly cultivated, is at last opened among us by Royal Munificence. This must appear an event in the highest degree interesting, not only to the Artists but to the whole nation. It is indeed difficult to give any other reason, why an empire like that of BRITAIN, should so long have wanted an ornament so suitable to its greatness, than that the slow progression of things, which naturally makes elegance and refinement the last effect of opulence and power.[16]

The passage is familiar but it is worth noting three terms in particular here: "whole," "empire," and "ornament." Reynolds establishes a chain of synecdochal relationships in which artists are to be ornaments to the Academy, and the Academy is loyally to adorn the state. In this regard, Eleanor Hughes is astute in characterizing the Academy exhibition in terms of Benedict Andersen's notion of an "imagined community": a space in which the abstract form of the disparate nation can be conceived of as coherent ("whole") and seemingly finite. Discussing marine paintings, Hughes speaks of a dual identity for the works, as individual sources of meaning and narrative

and as a part of a whole. Once hung at the exhibition, she says they "could be organized in terms of a general statement concerning national identity…" "Like the page of a newspaper," she continues, "with its disparate events arranged in paragraphs and columns, the wall of the RA juxtaposes unrelated places, figures and events which the viewer imagines to be connected as a whole representing British art that year." [17]

In this view, the exhibition could become a site for the production of an illusory wholeness for the idea of the state itself. This was crucial because, as we seen, this idea of unity seemed to be more and more difficult to achieve in an ever more complex political, cultural and imperial state. It was because of the Academy's closeness to these ideas of creating unity that the presence of individual ambition and competition in the RA was so troubling. These ideas took visual form in the presentation of the annual Academy exhibitions. In 1814, Joseph Farington vocalized the need to privilege the whole over the individual in the exhibition when speaking of his duty on serving on the Hanging Committee that placed the pictures. Farington described his duty as to "act as appeared to me best for the honour of the Academy by making the finest display I could, & as far as might be consistent with this I would do the best I could for every individual Exhibitor, but I would not sacrifice the appearance of the Exhibition to gratify any man." [18] In theory, then, artists were meant to sacrifice individual concerns in favor of contributing to the production of a unified British school. This school, the Academy, could then serve as a marker for an illusory notion of the unified state at a time when the British empire was both developing and fragmenting. [19] At stake here then is not merely a question of ideals versus practical reality, but the fact that in coping with the distance between them artists and critics were negotiating a complex set of relations between individuals and institutions and institutions and the state. These relations had both practical and symbolic aspects.

Practically speaking, despite Farington's stated goals, given that the Academy exhibitions were the primary means of gaining both prestige and patronage, artists were frequently dissatisfied with the individual role allotted to their work within the display, which in turn frequently led to anger with the Hanging Committee and dissension amongst the exhibitors. The stakes were highest for the portrait painters, since this genre comprised the majority of lucrative private commissions. Especially at issue were the more expensive full-length portraits, for which there were fewer prime locations because of their larger size. [20] In 1799, Farington reports that Academician Thomas Lawrence had spoken to Sawrey Gilpin, who was on the Hanging Committee that year, about a center placement for a full-length portrait. Gilpin told Farington that other painters had complained "that Lawrence painted Colossal *figures to obtain center* [sic], by which other portraits suffered." [21] The problems with Lawrence grew more intense over the next decade. In 1801, John Hoppner refused to exhibit, according to Farington, "on acct. of Lawrence monopolizing a center place by sending Canvasses and figures of an uncommon Size." [22] These concerns continued well into the next decade. In

1814 Henry Thomson solicited Farington to urge Lawrence, on the Hanging Committee that year, to refrain from giving key placements to his own works, because of the jealousy it would incite and because there were some painters "who thought that Lawrence was rapacious to obtain the best situations."[23] A further problem was that the pictures often appeared differently once they had been placed among the rest of the works, with the brightness and intensity of colors affected by the tones of neighboring pictures. In a particularly telling case, Hoppner attempted to enact some revenge in 1806 when, as a member of the Hanging Committee, he took an adjacent painting by Thomson, the bright colors of which had made his own work appear less impressive, and moved it next to Lawrence's, who became, according to Farington, "violent" because of the effect it exerted.[24] Hoppner was forced to return the Thomson to its previous location and move his own work. The point, however, is that both the position of paintings on the wall and the effect of adjacent works were becoming means of seeking competitive advantage.

This situation resulted in constant pleas and cajoling from painters of a wide range of levels during the placement of the works. Again, Farington's description of serving on the Hanging Committee makes it clear how difficult achieving the balance between individuals and exhibition as a whole could become. On one day in April 1804, the Academician Richard Westall supplied Farington with a detailed sheet of instructions on where his paintings should be hung. Later in the same day he was approached by a certain Mrs. Noel, who applied to him for favorable placement of her single entry that year, a drawing. To emphasize the importance of her request, Mrs. Noel proceeded to detail a list of her hardships, including having been left by her husband to raise four children on the basis of what she earned as a drawing instructor, the success of which endeavor depended, in her view, upon the prominent placement of her work.[25]

On the one hand, then, artists were faced with a display environment in which they were expected to subordinate their own ambitions to those of the state. On the other hand, intrigue and favor seemed to allow certain artists an unfair advantage in a dynamic and sometimes unpredictable exhibition space. In this double bind, two options were available to Academicians seeking to control the placement of their work. The first was to remove their pictures entirely, showing them outside the official spaces of exhibition. In doing so, they were adapting a strategy pioneered by John Singleton Copley, who held four individual exhibitions of his large-scale history paintings beginning in 1781.[26] As Emily Neff has discussed, by holding the exhibition in 1784 at the same time as the Royal Academy exhibition, Copley set himself to some degree at odds with the Academy, privileging his own pursuits above the collective interest and leading to some caustic exchanges with founding member William Chambers.[27] Similarly, John Bonehill has explored Joseph Wright of Derby's 1785 exhibition in rented rooms in Covent Garden within the context of the artist's disputes with the RA. According to Bonehill, the exhibition was carefully planned and organized to show Wright's range of

formal and thematic abilities to best advantage, which allowed him to rival the work of Copley and Benjamin West and effectively compete with them for the attention of the urban viewing public.[28] Farington reports that the painter James Ward withdrew his pictures from the 1804 exhibition out of dissatisfaction with their placement,[29] and in 1805 Turner showed only in his own gallery in Harley St., which he had opened the year before. In the remaining years of the decade he often showed his works both in his gallery and at the RA and British Institution exhibitions.[30]

In these cases, the artists, either explicitly or implicitly, set themselves as individuals in opposition to the whole, privileging the viewing and potential sales of their own work over a collective effort to create the appearance of a cohesive national school in the Royal Academy. But because this took place outside of the Academy itself, such opposition could increasingly be accommodated within the symbolic rhetoric of official artistic discourse. Farington's diary for 1804, for instance, reveals that he and other Academicians like West and Henry Fuseli, could view Turner's gallery exhibition with no mention of any kind of impropriety, and his explanation of Turner's decision to exhibit alone, from a desire "to receive money," seems to find room for practical concerns outside of and alongside the official rhetoric of the Academy.[31] In this sense, individual ambition was acknowledged and tolerated, so that practical needs could be served without disturbing the symbolic appearance of a unified British school.

But if artists wanted to control the appearance of their work within the Academy exhibition itself, which remained the primary showcase for potential buyers, the other option available to them by the first decade of the nineteenth century was the Varnishing Days, during which artists could heighten colors and shift tonal balances *after* the paintings were placed, to show them to best effect. This solution, however, because it heightened the competition between individual artists, and thus challenged the idea that the Academy was primarily concerned with creating a cohesive whole, exceeded the existing symbolic means available for accommodating individual ambition. The official institution of Varnishing Days in 1809, in fact, was an attempt to cope with this competitive environment by regularizing and controlling an already rampant practice of painting inside the Academy itself, after the works had been delivered for the exhibition. The annual period of submission was a time of feverish work for artists as they prepared their paintings and around the turn of the century controversy began to develop around the late delivery of paintings.[32] It is clear from the Academy Council minutes that artists with the means to do so were using the rooms in the Academy assigned to their associates to finish paintings after they were submitted. The Varnishing Days were a response to this situation in that they provided a more equitable solution, at least for Academicians, to the need for last-minute work. When the Varnishing Days were made permanent in 1809, the motion specifically indicated that varnishing and painting after the delivery date could take place at no other time but the official Varnishing Days, and in no other location than

the exhibition room itself, and not in rooms apportioned to any officials of the Academy.[33] But the Varnishing Days had already been a part of the exhibition calendar for most of the decade. By 1808, Thomas Lawrence could write to Farington in the reasonable expectation of at least three days for varnishing, which he evidently considered crucial to his success at the exhibition.[34] The Varnishing Days thus offered a means for artists to control the appearance of their work, but because it took place within the Academy itself it produced a rupture in the ability to maintain the appearance of the Academy or British Institution exhibitions as representations of a coherent British school.

It is in this context of rising competition, and the resulting difficulty in maintaining appropriate relations between the paintings and the desired whole of the exhibition, that we should remember Rippingille's use of the term "kill" in reference to Turner's relations with his fellow Academicians. In fact, Rippingille was repeating a rhetoric of violence that had become commonplace in characterizing Turner's work on the Varnishing Days. In 1819, well before the period of Turner's most famous Varnishing Days activities in the 1830s, Farington reported a kind of chain reaction of competitive behavior: "Thomson called. – Calcott had been with him and mentioned the violent conduct of Shee respecting the arrangement of the Academy exhibition, and that in consequence Turner had made alterations injurious to the general display."[35] He later wrote that an associate had called and complained about the Varnishing Days and defended a work by Richard Cooke, which, he says, "like others suffers from the flaming colors in Turner's pictures. – He spoke of the pernicious effects arising from Painters working upon their pictures in the Exhibition..."[36] Also, in 1812 Farington had described Turner's desire to have his ambitious *Hannibal Crossing the Alps* (Figure 3.1) moved lower on the wall than its original placement: "Here [where Turner requested] it appeared to the greatest disadvantage, – a scene of confusion and injuring the effect of the whole of that part of the arrangement. We therefore determined to replace it." Turner was not mollified, however, and the controversy continued. Turner threatened to remove the work, until three days later a compromise was struck on a new position.[37] We are beginning to see a pattern in which Turner privileged his own self-interest above the interests of his fellow artists and the Academy as a whole. As such, his work represented a threat to the metaphorical relationship of painters, institution, and state that I have described.

Indeed, competitive exchanges around the appearance of work seemed to confirm long-standing fears about the possible corrupting effects of exhibition. Reynolds had recognized the value of exhibitions in exciting the ambitions of young artists, but worried that the desire to attract attention by cheap effects would undermine the kind of elevated, moral art the Academy was ostensibly intended to promote, by encouraging self-interest. He closed his Fifth Discourse to the Academy by warning that the artist:

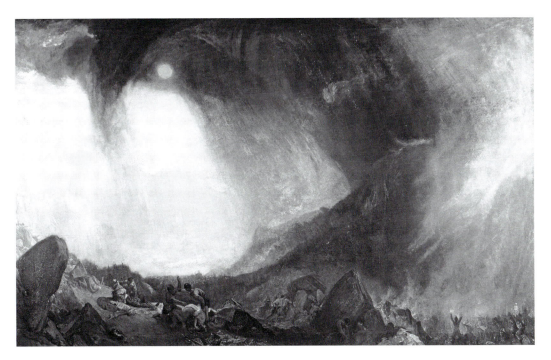

must not be tempted out of the right path by any allurement of popularity, which always accompanies the lower styles of painting. I mention this, because our Exhibitions, while they produce admirable effects by nourishing emulation and calling out genius, have also a mischievous tendency, by seducing the Painter to an ambition of pleasing indiscriminately the mixed multitude of people who resort to them.[38]

3.1 Joseph Mallord William Turner, *Snow Storm: Hannibal and his Army Crossing the Alps*, 1812, oil on canvas, 57.5 x 93.5 in. (146 x 237.5 cm). © Tate, London, 2011.

Reynolds sees the exhibitions as a point of contact between aesthetics and the broader political sphere, and expresses concern about the intrusion of a broader public—"the mixed multitude"—into the spaces of official culture.[39] Reynolds's concerns parallel those of Edmund Burke discussed in Chapter 1, about the deleterious effects of allowing an unqualified public to play a determinate role in state affairs as a whole. The key element for Burke was that a non-elite public would be able to conceive only of its self-interest rather than the interest of the nation as a whole. The intrusion of that "mixed multitude" was dangerous for Reynolds precisely because it would bring that self-interest into the Academy. This self-interest would also corrupt painters by encouraging them to consult their personal ambitions rather than prioritizing the British school as a whole.

Martin Archer Shee's *Elements of Art*, a copy of which Turner read and annotated, amplified these concerns about the dangers of excessive competitiveness in the Academy exhibition. Claiming that exhibitions may do as much harm as good, Shee sets up an oppositional relationship between the greater good and that of the individual. He notes that while the 1806 exhibition had recently brought David Wilkie to rapid public acclaim, "this advantage respects the Artist rather than the Art."[40] Exhibitions, he continues, can "excite

emulation," which is "the spur of Genius," but this can also mislead the artist towards self-interest: "if it urges in a wrong direction, and impels him to the pursuit of qualities inconsistent with the perfection of Art: if it quickens to the profitable rather than the praise-worthy: if in short, it prompts to a contention of meretricious allurements rather than of modest merit…"[41]

To clarify Shee's position, competition itself was not necessarily an evil, for it could spur the artist to great achievement if it came from the right sources and was directed toward the right goals. Indeed, the use of premiums to encourage emulation in elevated painting was one of the founding premises of the British Institution, undertaken in part because emulation was felt to be lacking at the Academy.[42] But Shee makes it clear that ambition for the attention of a paying public was another matter, for it could pervert the just spirit of competition, which the awards were meant to encourage. His use of the term "meretricious," which we will see recurs in Turner criticism, is significant in this regard. The term connotes availability for hire, as with a prostitute, or the false earning of money and when applied to painting, it implies a false or showy beauty for the purpose of allurement. Shee's usage here tellingly connects to Reynolds's concerns about exhibitions' tendency to "seducing," "tempting" and "pleasing indiscriminately." There is, therefore, a contrast here between the meretricious, which promiscuously attracts attention to itself, and the appropriately ornamental, which modestly refers its charms back to that which it adorns. Having established these gendered terms, in which a debased, material, feminine self-interest is contrasted to masculine restraint and disinterest, Shee specifically turns to the issue of rivalry between contemporaries:

The emulation excited by an exhibition is rarely influenced by general and comprehensive views: occupied with local and partial objects, it becomes a rivalry not of positive, but comparative excellence; not of the merits of the Art, but the manner of the school. Instead of contending with the great masters, we are obliged to contend with each other…The painter who is not engaged in this kind of local conflict, may enter the lists with Raphael or Rubens, with Titian or Correggio, he consults his own taste, and chooses his combatant; but he who suspends his picture in a public exhibition, must contend with those around him, and conform to the fashions of the scene in which he hopes to shine. If he would not be defeated or disregarded, he must practice the manœuvres of his competitors, and endeavour to foil them at their own weapons.[43]

By invoking "general and comprehensive views," Shee adopts the terms of trusteeship representation theory, in which elite, leisured men are able and expected to transcend "local and partial" views to think of the good of the nation as a whole. Furthermore, where Reynolds had suggested that the artist of high ideals could link his name in perpetuity to the state's and thereby secure lasting fame, here Shee argues that by following individual ambition the artist will fail to place his name alongside those of the Old Masters. Significantly, Shee also uses a series of terms and metaphors that invoke violence ("local conflict," "combatant," "defeated," "manœuvres," and "weapons") to

characterize this negative form of individually motivated artistic competition. As we will see, these terms will recur frequently in discussions of Turner, not as exclusive to him but marshaled with particular force to describe his competitive behavior.

Both Reynolds and Shee, therefore, expressed concern over the influence of a public for art that had expanded beyond the elite, aristocratic viewership that was the ideal of the eighteenth century. That new public, moreover, brought a competitive assertion of bourgeois individualism into the official spaces of culture and the nation. William Paulet Carey, writing in the 1820s as an inheritor of the academic discourse of Reynolds and Shee, warned specifically of the dangers of competition and individuality to the collective goals of the Academy. Acknowledging that the burden of creating a national art could not be borne by artists alone, Carey urged that unity be the object of both patron and painter, and, implicitly, the critic. Intra- and inter-institutional rivalries must be avoided: "We do not expect perfection in human nature, and are friendly to the correction of abuses; but we conceive that the interests of the Royal Academy, the British Institution, and the whole of the artists of the British school—and its patrons, are one. *They rest upon the same broad basis,* and whatever has a tendency to narrow that foundation to the *mistaken views, prejudices, or passions of individuals must endanger the superstructure and prove injurious to all.*"[44] In Carey's account we have the most direct statement yet of the individual as a threat to the whole: he invokes once again the "narrow" views of certain artists and patrons, contrasting them to the "broad basis" of shared interests.

Turner, Reform, and the Varnishing Days

This discussion of the Varnishing Days and their place within discourses of competitive art practice can productively shed light on reactions to Turner. Indeed, I will now show that the Varnishing Days were directly related to Reform-era political ideas expressed by writers who encompassed a spectrum of political views. To begin, we should note that Dian Kriz has convincingly argued that in characterizing landscape painters such as Turner as "native" English geniuses, critics and theorists sought to produce the image of a distinct and accomplished English national school. This image was based in large part on the assertion of the artist's unique individual creative capacities manifested through dramatic formal effects and high-key colors. According to Kriz, individuality and originality, skills valued in the growing middle-class realm of free-market competition, were important factors in the recognition of genius.[45] Robyn Hamlyn has also argued that the visibility of Turner's loose approach to the depiction of form, in which objects are rendered without the use of exact contours, was a crucial element in his reputation as a genius at the head of a distinct English school.[46] Turner's Varnishing Day performances could thus represent the English painterliness and rapid application *par*

excellence, as well as providing compelling demonstrations of his individual creative genius, a powerful typological conflation of the greatness of self and nation, but on different terms than those earlier proposed by Reynolds.[47]

Accounts of Turner's work during the Varnishing Days in the 1830s particularly stressed the performative aspect of his creation. We have already seen Rippingille's stress on Turner's absorption in the process of painting, but this is combined with a stress of the engaged activity of his work as well. With verbs like "stooping," "leaning," and "spreading," Rippingille emphasizes the moving form of the artist, while at the same time describing Turner as oblivious to almost everything about him. This combination is present in another account published after Turner's death, by the painter Sir John Gilbert, who described Turner "busily working" on *Regulus* (B&J 294) during the Varnishing Days before the 1837 British Institution exhibition:

He had—I was told—been there all morning, and seemed likely, judging by the state of the picture, to remain for the rest of the day. He was absorbed in his work, did not look around him, but kept on scumbling a lot of white into his picture—nearly all over it...He had a large palette, nothing on it but a huge lump of flake-white; he had two or three biggish hog tools to work with, and with these he was driving the white into all the hollows, and every part of the surface.[48]

Both of these accounts are products of a time in which the performative aspect of major exhibitions were often noted. Throughout the first decades of the nineteenth century, paintings were often referred to as "performances" and the exhibition rooms of the Academy and the British Institution were sometimes discussed as "theatres."[49] The performative, virtuoso quality of Turner's process, thereby became another aspect of the development of the notion of solitary Romantic genius. John Gage has noted that an increase in Turner's activities on Varnishing Days coincided with a series of concerts given in London from 1831–4 by the Italian violinist Nicolo Paganini.[50] This similarity was recognized by his contemporaries and discussed in relation to the artist's genius. In 1832, for instance, the *Morning Chronicle*, offered the following praise for the artist: "Mr. T. has six pieces of various merit, but all evincing the hand of the master, and with all of his genius a very fantastical one...[He] is a sort of Paganini, and performs wonders on a single string—is as astonishing with his chrome as Paganini is with his chromatics."[51]

But many of Turner's contemporaries were also profoundly disturbed by the very individuality that seemed so powerfully inscribed by this manner of painting. Condemnation of the practice was shared by journals of opposing political positions, though for different reasons. The concerns of Reynolds, Shee, and Carey were adapted by conservative writers, including the Reverend John Eagles, who lamented the changes wrought by Reform and was extremely hostile toward Turner.[52] Eagles, nine years Turner's junior, had been educated at Winchester and then Wadham College, Oxford and wrote art commentary for *Blackwood's Edinburgh Magazine*, a far-right conservative journal, beginning in 1833, when Turner's Varnishing Days performances

were at their most public, until his death in 1855. Eagles was a landscape water-colorist, who had been denied entry in to the Water-Colour Society in 1809.[53] In addition to his art criticism, he also translated Homeric hymns for *Blackwood's* and wrote on classical subjects, poetry, politics and current events.[54] Eagles thus claimed to have both practical experience with painting as well as the literary and historical breadth of knowledge to treat the subject of art criticism broadly, opening his views onto moral and social issues. He began his discussion of the 1835 exhibition by bemoaning a general tendency to use garish, eye-catching colors.[55] He then accused Turner in particular of seeking novelty and effect simply to maintain his temporary popularity: "Why," he asks, "for the sake of this trickery fame, will Turner persist in throwing the gauze of flimsy novelty over his genius, great as it is?" Pointing directly to self-interest, Eagles posits: "Is it that he would rest his fame on what he has done, and thus mislead, that he may have no rival in the British school hereafter?"[56] The suggestion here is that Turner used the Varnishing Days not only to overcome his rivals but also to mislead future painters and destroy the firm basis of the British school for his own benefit. This is the opposite situation to that described by Reynolds, in which the only path to personal greatness was through the glory of the national school as a whole. In 1837, Eagles continued to complain of Turner's high-key colors and dazzling effects, warning that they should be discredited, "lest younger artists of the English School…should be…[led] astray."[57] Eagles returned to this theme in his review of the 1840 Exhibition, tying Turner's waywardness and its possible effects in misdirecting art specifically to high-key colors, saying of *Neapolitan Fisher-girls Surprised Bathing by Moonlight* (B&J 388), "We at first thought the red images in the red blaze had been 'ignes fatui' knowing that Mr. Turner has so often allowed his genius to be led astray by them. This is another of the absurd school which Mr. Turner endeavours to establish."[58] Eagles's concerns are a part of a much larger discussion of the effects of individual ambition, entrepreneurship, and self-aggrandizement. Painting, therefore, is both corrupted by popular taste, as we saw with Reynolds and Shee, and itself a source of further debasement.

Indeed, the larger concern for Eagles and *Blackwood's* was the loss of traditional values amidst the commercialism and individual ambition of the rapidly changing world of Reform. Eagles connected these issues specifically to Turner's intense colors, painterly effects, and performative approach when he wrote,

But he knows to astonish is now-a-days the only way to be foremost. In our extravagant conceit for improvement and novelty, in a word, for *reforming*, whatever has been done before is to be put down as wrong. If others loved shade, we will have light. There must be universal mountebanking, political, moral, and religious—in trades, arts, and sciences.[59]

Several terms are important for understanding how this passage opens up from aesthetics onto a larger set of pressing social and political issues.

"Extravagant," first of all, is a nearly ubiquitous term enlisted to describe Turner's intense colours and *bravura* effects, sometimes even used in positive reviews. It signifies that Turner's practice had exceeded the bounds of traditional propriety, and is thus related to Eagles's discussion of Turner and novelty. "Mountebanking," from the Italian *montimbanco*, is also relevant, for the term refers to both the peddling of cheap, and perhaps deadly (like snake-oil), goods from a platform or stage, as well as sleight-of-hand or "trickery," a term that Eagles also used in reference to Turner.[60] By linking false performance and salesmanship, it impugns and conflates Turner's self-aggrandizing and deceitful entrepreneurial practice and his Varnishing Day performances. Finally, Eagles's lament over the neglect of tradition and his use of the term "reforming" tie these concerns to the broader political changes of the period around the 1832 Reform Bill. Eagles's concerns over artistic extravagance, therefore, become an opportunity to lament a loss of solid values amidst the falseness and vulgarity of rampant individualism in the early nineteenth century. It is not simply that Eagles uses a parallel with political language to make an aesthetic point more clearly, but rather that here aesthetics both reflects and influences a larger socio-political sphere. As we have seen, for Reynolds, Shee, Carey, and others, painting in its most elevated form was charged with the responsibility of contributing, either by reception or production, to a unified political public. Undoubtedly, Eagles saw the larger forces at work here as corrupting influences on the artist, but he also makes it clear that art, in its turn, was further corrupting the political public in the 1830s.

We can also understand some of the ambivalence provoked by Turner's performances by noting that the references to Turner as a magician could be double-edged, as we have already seen with Eagles. Magicians have a reputation for cheap trickery, fraudulence, and even deviltry and some reviewers suggested that Turner's magic was something unnatural at best and dangerous at worst.[61] At a time when "natural" was often indicative of, if not synonymous with "truth," the *Literary Magnet* placed Turner's self-aggrandizing practice in opposition to nature. Acknowledging Turner's considerable talent in precisely the terms described by Kriz, the *Magnet's* critic called the *Harbour of Dieppe (Changement de Domicile)* (B&J 231) of 1825, a "brilliant experiment upon colours, which displays all the magic of skill at the expence [*sic*] of all the magic of nature."[62] The *Literary Gazette*, in a typically conflicted discussion of Turner's exhibits in 1826, linked Turner's intense visual displays and magical touch to a desire to attract attention at the RA exhibition:

Mr. Turner is determined to become attractive by the violence of his powers; yet amidst all this gaud and glitter of colours, it is impossible to shut our eyes to the wonderful skill, and to the lightness and brilliancy which he has effected…Mr. Turner seems to have sworn fidelity to the *Yellow Dwarf*, if he has not identified himself with that important necromancer.[63]

This passage is remarkable for its conflation of technical skill and high-key exhibition colors with violence and sinister magic. The "Yellow Dwarf" refers to a malevolent fairy tale character who uses his occult power to attempt to marry a princess. It is also likely a jab at Turner's diminutive, portly stature and his preference for yellow tones.

A number of publications expressed concern over the brilliant effects of Turner's paintings. In discussing *The Bay of Baiae, with Apollo and the Sybil* (B&J 230), shown at the RA in 1823, *The New Monthly Magazine* first praised another artist's work as natural and then contrasted this to *The Bay of Baiae*, concluding that the latter work "is in fact a most meretricious performance, displaying infinite skill in the handling, but a most perverse taste in colouring and in general effect."[64] Interestingly, in 1832 the critic for *The Spectator* defended Turner against precisely this kind of charge, linking his magical touch directly to a true genius, that is, one still in touch with nature. The critic, who claimed to have been "riveted as by a spell" before *Childe Harold's Pilgrimage – Italy* (1832, Figure 3.2) at the RA Exhibition advised:

> Let the reader first go close up…and look at the way it is painted; and then, turning his back (as one sometimes does to the sun) till he reaches the middle of the room, look around at the streaky scrambled unintelligible chaos of colour and see what a scene has been conjured before him as if by magic…then he will see that this is no meretricious trick of art…but an imaginative vision of nature seen by the waking mind of genius…[65]

3.2 Joseph Mallord William Turner, *Childe Harold's Pilgrimage – Italy*, 1832, oil on canvas, 56 x 97.75 in. (142.2 x 248.3 cm). © Tate, London, 2011.

The critic's defense against the charge of "meretricious" painting thus takes up directly the questions of commerce and seductiveness that we have seen were central to the treatment of exhibitions in academic discourse. Even while

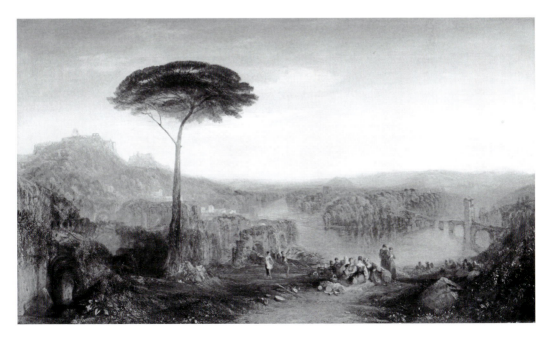

it defends Turner them, *The Spectator* acknowledges the significance of those objections.

At stake in these positions, therefore, was the status of Turner's publicly performed individual talent. In suggesting that Turner was or was not painting meretriciously, critics were implicitly treating the question of whether Turner created false effects for the purpose of drawing attention to himself at the Academy and thus reaping ill-gotten financial rewards, or whether his talent was natural, genuine, and perhaps even divinely inspired, part of a rich, coherent national artistic fabric. *The Spectator's* denial of meretriciousness in Turner gains force by its close correspondence to a well-known passage in Sir Joshua Reynolds's *Discourses* on the loose paint handling of Thomas Gainsborough:

> ...it is certain, that all those odd scratches and marks, which, on a close examination, are so observable in Gainsborough's pictures, and which even to experienced painters appear rather the effect of accident than design; this chaos, this uncouth and shapeless appearance, by a kind of magick, at a certain distance assumes form, and all the parts drop into their proper places.[66]

In the time between Sir Joshua's Discourse of 1788 and *The Spectator's* review of 1832, this kind of painting had gained considerable currency in Britain as we have seen, but had also aroused strong criticism, because this loose manner of painting could be considered morally corrupt. As Kriz's examples indicate, the question hinged in part on what view the critic took of the relationship between national character and commercialism.

With these issues in mind, we can look anew at Turner's oft-cited attack on John Constable during the 1832 Varnishing Days, in which the former placed a bright red dot on his painting *Helvoetsluys* (B&J 345) in order to make the reds in Constable's adjacent work, *The Opening of Waterloo Bridge*, seem dim. "He has been here," Constable is reported to have said afterwards, "and fired a gun."[67] Constable imagines the red dot, later formed into a buoy, as exploding violently out of Turner's painting to damage his. The conflict went back at least to the previous year, when Constable, as a member of the Hanging Committee, had removed one of Turner's paintings from a prime position and replaced it with one of his own, predictably angering Turner tremendously.[68] Exactly as Shee had feared in 1809, competition begot self-interest.[69] And once again, issues of class in the elevated cultural spaces of the state are relevant. In contrast to Turner, the London-born son of a barber, Constable was a member of a solidly Tory country family. He was associated with the connoisseur Sir George Beaumont, a member of the patrician elite and a frequent critic of Turner's, who had employed the kind of class-based vocabulary for painting style discussed by Sam Smiles, in which breaches in artistic decorum are used to register broader breakdowns in the social hierarchy.[70] In 1806, for instance, Farington reports having attended a dinner with Beaumont during which "the vicious practice of Turner and his followers was warmly exposed."[71] "Vicious," a term which recurs often in reference to Turner, should not be

taken lightly here. Rooted in "vice," when the term is applied to painting it is necessarily set in opposition to the virtuous practice of history painting in the academic theory of the eighteenth century. As John Barrell has shown, thinkers like Shaftesbury believed that pictures should actively promote public virtue as opposed to private vice.[72]

It is significant, then, that Constable robbed Turner of his brush and replaced it with a weapon. The rhetoric of violence in reference to competition in the Academy and Turner especially recurs here, with the effect of placing such practices outside the norms of polite behavior in a public space. Turner is cast as unfit for participation in the elevated arena of the Academy. This disqualification, moreover, mirrors crucial aspects of the dialogue around Reform, specifically those concerning class-based violence, which was then employed as a justification for ongoing restrictions on enfranchisement.[73] Even middle-class reformers were disinclined to see the lower classes as incapable of any political activity outside of violent physical revolt. Historian Michael Turner offers the following quote of 1819 from the liberal, pro-Reform *Manchester Gazette* as indicative of the extent to which paternalist attitudes informed respectable opinion of plebeian activism: "It must be obvious to anyone who can reason at all, that the interference of the labouring classes in political matters has almost invariably an effect contrary to that which is intended. Harsh as it may appear, we must say that poverty incapacitates for public usefulness, for the poor man has no influence otherwise than by the exertion of physical strength, to which it would be absurd as well as treasonable to have recourse…"[74]

Constable's accusation against Turner of bringing violence into the microcosm of the exhibition was by no means isolated. The *Athenæum* repeated the transformation of Turner's brush to a gun in 1837 when, in discussing *Snow-storm, Avalanche and Inundation* (B&J 371), it wrote, "[Turner] has loaded his weapon of offence with such pigments as the Quakers love, and shot a round of drab, dove-colour and dirty white, with only a patch of hot, southern-red in the foreground…"[75] Additionally, Turner's high-key, intense colors often led critics to characterize him as a kind of arsonist, suggesting that his works were like fires that threatened to engulf everything around them, including perhaps the Royal Academy itself. We should remember here the above-cited reference to Turner's "flaming colours" to describe the destructive nature of his Varnishing Days activity to the exhibition as a whole. Also, of *Shadrach, Meshach and Abednego in the Burning Fiery Furnace* (B&J 346), the *Spectator* exclaimed in 1832 that "its glare is scorching; we hope the Academy is insured…,"[76] and of the *Burning of the Houses of Lords and Commons* (Figure 2.16), the reviewer for the *Morning Herald*, while expressing pleasure at the general quality of the works on display, complained that

This very agreeable state of affairs…is glaringly invaded by some flaming canvasses of Mr. J.M.W. Turner R.A. We seriously think the Academy ought, now and then, at least, to throw a wet blanket or some such damper over either this fire King or his works; perhaps a better mode would be to exclude the latter altogether…[77]

Here, the critic points directly to the notion of the self-contained loop of mutually justifying valuation I discussed at the beginning of this chapter, which it claims Turner has invaded. My point is that the Varnishing Days were dangerous precisely because they threatened this loop from within, hence the suggestion in the *Morning Herald* that the works be placed outside the confined space of the Academy. This kind of language was not reserved exclusively for Turner. In reference to *Helvetsloeys* in 1832, for instance, Anthony Cooper suggested that a coal from George Jones's painting of *Shadrach, Meshach and Abednego* "had bounced across the room…[and] set fire to Turner's sea."[78] Yet such descriptive phrasing was most consistently and forcefully marshaled in reference to him.

Rather than merely accepting these reactions as the kind of negative commentary that is so often marshaled as evidence of modernist, innovative genius, we should understand their basis in a broader public and in a resultant individualism and competition in the RA, which was itself rooted in larger questions concerning the changing political landscape of the nation. It thus should not surprise us that some of the reactions to Turner's competitive practice were positive. The need for a nuanced understanding of these responses is made clear in one of the best-known examples of Turner's competitive behavior, the *Bridge of Sighs, Ducal Palace and Custom-House, Venice: Canaletti Painting* (1833, Plate 1). Here Turner clearly placed himself in competition with both Canaletto, whose Venetian pictures had been greatly valued by British collectors for a century, and his younger contemporary Clarkson Stanfield.[79] As we have seen, Turner includes Canaletto in the title and the picture itself, where he is shown painting in the lower left-hand corner of the canvas, with his back to the scene and with the painting in a gilt frame, an unlikely state for a canvas being worked on out of doors (detail, Plate 2). In this way, Turner shows the Italian artist painting as Turner himself would have done during the Varnishing Days, that is, in the frame and not before the motif, as Michael Rosenthal notes.[80] The picture thus functions as a sort of manifesto in which Turner proclaims his ability to work in the virtuoso manner that was increasingly prized at the time and to outdo an acknowledged master at the same time.[81] This competition was noted and the victory awarded to Turner, in tellingly commercial terms, by the *Athenæum*, whose critic downplayed the importance of Canaletto's precedent for Turner: "…the style is [Turner's] and worth Canaletti's ten times fold."[82]

Here the tautological loop of detail and whole seems intact, for Turner's victory is a triumph for the British School as a whole. If this accords with the first, positive level of competition discussed by Reynolds, Shee, and others, the press was also very much aware of the presence of a second level of competition in which Turner attacked his younger colleague, Clarkson Stanfield, who had been elected as an associate member RA the year before. According to the *Morning Chronicle* of June 6, 1833, Turner's *Bridge of Sighs* was done "in two or three days, on hearing that Stanfield was employed on a

similar subject…" Turner's competitiveness was already well-enough known for the critic to add sarcastically, "…not in the way of rivalry of course, for he is the last to admit anything of the kind, but generously, we will suppose, to give him a lesson in atmosphere and poetry."[83] Martin Butlin and Evelyn Joll are surely right when they note that since Turner had to submit the title for the catalog ahead of time, he must have already intended this subject. But there is also no denying its overall similarity to Stanfield's *Venice from the Dogana* (1833, Bowood House) a similarity which seems to demand comparison between the two manners of treating the same scene.[84] In Stanfield's work the details of the architectural forms in the background are articulated with precise, dark lines. Details in the foreground are rendered with equal precision, giving the entire work a nearly uniform clarity and polish, making Stanfield's buildings stand out sharply. By contrast, Turner's use of a loaded brush to define even the architectural details of arches and windows gives his buildings a glowing indistinctness, as if they had been softened by the moist Venetian air, so that color reveals the inter-penetration of stone and atmosphere in a highly skilful and sensually evocative manner. Indeed, as the *Morning Chronicle* somewhat ruefully acknowledged, Turner's painting seems to be an essay on how to transform a picture from a topographical record of a location into a poetic expression. By highlighting the performative quality of his creation on the Varnishing Days, Turner distanced himself even further from the younger Stanfield in a competitive marketplace.

As it was with Constable, Turner's response to Stanfield was calculated. Stanfield was in the midst of becoming known as a talented marine painter while also distancing himself from his previous, less respected field of theatre scene and panorama painting.[85] Turner seems to have wanted to emphasize the elevated quality of his own work next to that of a potential rival. And it would further appear that he was successful, for when the press compared the two, as they were generally inclined to do that year, Turner was usually awarded the victory. While the *Morning Chronicle* praised Stanfield's picture it did so in distinctly limited terms, making clear its connection to his earlier panoramas and calling it "a work of great merit, well-understood and ably executed."[86] This is very well, but it hardly gives Stanfield credit for the kind of elevated achievement of genius that was the goal of Turner. Others in the press took recourse to the rhetoric of violence to register the intensity of Turner's competitive move. *The Spectator*, for instance, compared the pictures directly, concluding that Stanfield's "is cleverly painted, but the unavoidable comparison with the same subject by Turner is fatal to it. It is to Turner's picture what mere talent is to genius."[87]

Importantly, however, W.H. Pyne, writing in *Arnold's Magazine*, did not characterize this competitive element in negative terms, though the terms he used are familiar. Invoking the violent language that recurred in reference to Turner, he wrote, "the juxtaposition brought out more glaringly the defects of Stanfield, and illustrated more strongly the fine powers of Turner. For, viewed from whatever distance, Turner's work displayed a brilliancy, breadth and

power, killing every other work in the exhibition."[88] Yet this judgment comes, we must note, at the end of an article that seeks "a just estimation of Stanfield's genius," not Turner's. Pyne comments as well on the necessity of attracting attention at exhibitions. He agrees that it is regrettable, but continues: "Still, every evil produces its own good; for, to this custom we are indebted for the production of some of the finest works of Art in the country."[89] At work here is a sensibility more willing to include arts in the increasingly capitalist, self-interested economics of the nineteenth century. This was not an unusual way of thinking. As John Barrell notes, William Hazlitt saw great art as the product of an essentially private, individual experience rather than a shared, public one.[90] Also, as both Dian Kriz and Peter Funnell have noted, there were a number of writers who spoke against the many calls for government funding of public art made by Prince Hoare, Shee, Carey, and others.[91] Kriz, in particular, discusses a persistent counter-argument to public funding which held that free-market competition represented a means of producing excellence particularly suited to the British character, as opposed to the hierarchical French model.[92] Working within this tradition, Pyne embraced the opportunity created by Turner's competitiveness because it laid bare the terms in which the painters could be compared while also allowing for an exclusively merit-based evaluation. Pyne rejected the ideas of general interest that had guided art in Britain for most of the previous century and embraced instead a Smithian position in which the general good could be insured only when individuals rigorously pursued their own best interest. In this framework, while the destructiveness of Turner's act may be acknowledged, it was in the end useful as a part of a larger social progress. Pyne concludes,

In two days, then, Turner produced that splendid work, which tended so much to obscure the merits of Stanfield's picture. And, however ill-natured or invidious such a circumstance may be considered, as personally concerning Stanfield, it cannot be denied that the public were gainers, inasmuch as they are better able to judge of the respective merits of the two, by a close examination and comparison of their paintings.[93]

If this places Turner's Varnishing Days performances in the context of middle-class individualism, they can be even more directly related to the issue of parliamentary reform. An important posthumous account of Turner's activity on the Varnishing Days provides a case in point. The account, relating to the 1807 Academy Exhibition (before the Varnishing Days were officially instituted), is the earliest example we have of Turner using this time to injure the work of a rival artist, in this case David Wilkie. Wilkie's genre scene, *The Village Politicians*, had been an enormous public and critical success the year before, and Turner himself had been unfavorably compared to Wilkie in the press.[94] According to Wilkie's biographer, Allan Cunningham, and Cunningham's son Peter, during the Varnishing Days that year Turner heightened his *A Country Blacksmith Disputing upon the Price of Iron, and the Price charged to the Butcher for Shoeing his Poney* (B&J 68) and *Sun Rising*

Through Vapour; Fisherman cleaning and selling Fish (Figure 4.14) in an effort to overpower Wilkie's exhibition piece that year, *The Blind Fiddler.* In a passage that clearly references Turner (although not by name), Cunningham senior says that Wilkie's painting,

with its staid and modest colour, was flung into eclipse by the unmitigated splendour of a neighbouring picture, hung for that purpose beside it, as some averred, and painted into its overpowering brightness, as others more bitterly said, in the *varnishing* time which belongs to academicians between the day when the pictures are sent in, and that on which the Exhibition opens.[95]

The charges, not directly asserted, but strongly implied, are dual: first against the Hanging Committee, on which Turner did not serve that year, and second against Turner himself for subsequently painting up his work once Wilkie's had been hung. Because Wilkie was not an Academician in 1807, he did not have access to his painting on the Varnishing Days and thus would have been unable to respond to Turner's actions.[96] The issue then, is not merely Turner's competitiveness, but the unfair playing field created by an exclusionary body, the Academy.

Peter Cunningham expanded on the issue in his 1853 memoir of Turner. He did so in terms that repeat the rhetoric of violence, for he called Turner's *Sun Rising through Vapour* and *A Country Blacksmith Disputing upon the Price of Iron*, the paintings which hung around Wilkie's work in 1807, "two pictures which 'killed' every other within range of their effects." He continued, "on the varnishing day set apart for the privileged body to which he belonged, Turner, it is said, reddened his sun and blew the bellows of his art on his blacksmith's forge."[97] This is another example of the rhetorical conflation of Turner's picture with what it represents, which is particularly interesting in relation to the linked destructive and creative aspects of the blacksmith's fire. While the Cunninghams's accounts are frequently cited in the Turner literature, they are usually discussed as isolated quotes.[98] But exploring their contextual position reveals that the elder Cunningham used this example to accuse the Academicians of exactly the kind of self-interest that the rhetoric of Shee and others sought to deny. Indeed, immediately prior to his account of the Wilkie/Turner episode, Cunningham suggests that Wilkie's success in 1806 had inspired great jealousy among the Academicians: "Now those who imagine that the Royal Academy is wholly composed of high-minded men of genius, who are not only generous by nature and free from envy, but proclaimed 'Esquires' by letters patent, are really gentlemen one and all, can know but little of human nature, and less of bodies corporate."[99] He then discusses service on the Hanging Committee as a role in which the Academician could choose between petty rivalry on the one hand and disinterested service to the whole on the other, in terms which recall those of Farington. The envious Academician, Cunningham says, could arrange things "to make one fine picture injure the effect of another, by a startling opposition of colour, while a generous Academician can place the whole so as

to avoid this cross-fire of colours and maintain the harmony which we look for in galleries of art."[100] The accusation, then, is clearly against self-interested Academicians in general, not just Turner.

We might also note the younger Cunningham's use of the term "privileged" with respect to the Varnishing Days. The Cunninghams' criticism of the Academy follows, in fact, in a long line of writings that portrayed it as an elitist, self-interested institution founded in the corrupt, aristocratic, pre-Reform eighteenth century. The Varnishing Days had for some time figured prominently in discussions of the Academy as a corrupt body in which the privileged members served their own interests through practices that stifled, rather than encouraged fair competition, since only Academicians were given the opportunity to touch up their works at this time, once the rest of the paintings were in place. As such, the RAs were seen as possessing an unfair advantage in the competitive marketplace of the Exhibition. In 1820, the *Annals of the Fine Arts* listed a number of injustices with respect to the Academy exhibitions, including the exclusive use of Academicians on the Hanging Committee, who could then give the best locations to themselves and their colleagues. The journal then turned to

the Varnishing Days, as they are called. When the pictures are hung up, finished or unfinished (as many of the RAs send them unfinished on purpose) the members are admitted to varnish, as it is called, when they finish *up* to the gaudy frames and colours of their adjacent pictures...This has given rise to the *'exhibition style,'* and makes these favoured members' works the most prominent. From this favour it is clear that all should be included or excluded.[101]

The *Annals* connected the tendency to garishly heighten colors to the needs of attracting attention at the exhibition, but, as opposed to Eagles, its greater concern was with the unfairness of a system in which the opportunity to appeal to the crowd was not equally afforded to all exhibitors.

These concerns continued to be voiced in the years immediately surrounding reform. In 1832, in the midst of the debate on the Reform Bill, the pro-Reform *Morning Chronicle* lashed out at the Academy in terms that struck directly at its purported concern for the general good:

It is inconceivable how men can bring themselves to believe that they are leaders of, or belong to, a 'liberal profession,' while they act with so much illiberality towards it. It may be, as corruption often is, vastly agreeable to have an advantage to...others, as in the case of four days to touch upon and varnish their own pictures, after they are sent in.[102]

These charges mirror those which had been leveled by radicals against the aristocratic elite for several decades, namely the masking of self-interest with claims of concern for the general good.[103] The degree to which issues that had once been internal to the Academy became a part of a larger political debate was made clear in 1835–6, when the House of Commons formed a Select Committee to scrutinize the Academy's institutional function and success on

the occasion of its move from Somerset House. As Holger Hoock describes, part of the issue in the Select Committee was the Academy's status as an oligarchic remnant of Old Corruption. Critics claimed that it justified its exclusionary policies by reference to its private status, but simultaneously claimed to play a public role in the nation.[104] Responding to a member of the committee, William Ewart, the radical MP for Bletchingly, said: "witnesses protested that no art society should be privileged but all left to free competition." To Ewart's question, "What do you disapprove of principally in the Royal Academy?" painter Benjamin Robert Haydon, long a critic of the Academy's failure to promote public art, answered, "Its exclusiveness, its total injustice. The body is benefited by some of the works of the most eminent men in the world, and they deny them the right of preparing pictures for the public, on which their existence depends, after they are hung up." Pointing directly to the Varnishing Days, Haydon referred to the painter John Martin: "Mr. Martin gave an extraordinary instance of their hanging a picture of his; some of the academicians dropped a quantity of varnish, and ruined the picture..."[105] Haydon introduces a subtle note of violence to the Academicians' response to Martin's challenge from outside the institution. Martin Archer Shee, now President of the Academy, was also questioned at length by the Committee over a number of allegedly unfair practices that privileged the members of the Academy. In addition to the practice of allowing only Academicians to arrange the pictures for the exhibition and thus privileging themselves, Shee was examined specifically on the matter of the Varnishing Days.[106]

Charges of using the unfair advantage of the Varnishing Days were twice directed explicitly at Turner by the liberal *Morning Chronicle*. Speaking of two of Turner's entries in 1830, the critic acknowledged that they had been completed largely "in the four or five days allowed (exclusively and, therefore, with shameless partiality to the A[ssociate] s and RAs to touch on their works, and injure as much as possible the underprivileged)."[107] The critic's use of the term "injure" invokes the violent rhetoric that I have already cited, as well as a language of social injustice. This places the reports of the 1833 Varnishing Days controversy between Turner and Stanfield in the *Morning Chronicle*, *Arnold's* and the *Spectator*, cited above, in further context. The charges were repeated in 1834 and in both cases the reviews were prefaced with attacks on the Academy as a whole.[108] In short, Turner figured as a particularly salient example of the perceived narrow, self-interested goals of the institution, even when his genius was duly acknowledged. In a somewhat astonishing move, Turner's low birth and his merit-based rise in status were forgotten or ignored as he came to stand instead for aristocratic privilege. The Varnishing Days thus became part of a larger forum on the status of fairness and competition in Britain and on the expanded participation of large segments of society in all areas of cultural experience.

Conclusion: Turner and the Academy

Turner's relationship to institutions such as the Royal Academy appears from the above to have been complex and contradictory, and a flexible and integrative model is needed to account for that complexity. It is extraordinary that Turner's activity on the Varnishing Days could stand for the dangers of excessive competition entering into the imagined community of the Royal Academy and thus the nation, while also being identified as a corrupt vestige of the aristocratic past. That these charges should have been laid at the feet of the same person, the same son of a Covent Garden barber, is further remarkable. But while my concern to this point has been primarily to discuss reactions to Turner's Varnishing Days performances, I wish to conclude this chapter by returning to the artist as a historical agent. Indeed, if I have argued that reactions to the Varnishing Days were mixed, it seems clear that Turner himself was ambivalent towards the role of the Varnishing Days as reflected in his relationships with fellow artists and the whole of the British School. The artist who boasted, according to Rippingille, that "he could outwork and kill any living painter" and who referred to himself as "the great lion of the day" clearly saw the Varnishing Days as a means of establishing his own superiority over artists like Wilkie, Constable, and Stanfield, by using the forum of the Academy, or the British Institution, to elevate himself at their expense.[109] But however much this viewpoint accords with Ruskin's and modernism's idea of Turner's greatness as measured by his distance from the Academy, no serious account of the artist can fail to acknowledge the depth of his loyalty to that institution and his fellow artists, and the extent to which he hoped to advance the cause of the British School, as his abiding affection for Reynolds and the Academy makes clear.

Turner loyally served the RA in a variety of capacities throughout his career, holding his post as Professor of Perspective from 1811 to 1828 and serving as Acting President in 1845 and 1846.[110] And while Eagles and others worried that Turner's example might lead others astray, several authors have shown that Turner saw the Varnishing Days as a genuine and important teaching opportunity and a means of informal engagement with his colleagues.[111] In noting that the Varnishing Days were abolished only after Turner's death, his fellow Academician C.R. Leslie placed their importance to Turner in collegial rather than competitive terms:

But I believe, had the Varnishing Days been abolished while Turner lived, it would almost have broken his heart. When such a measure was hinted to him, he said, "Then you will do away with the only social meetings we have, the only occasions on which we all come together in an easy unrestrained manner. When we have no varnishing days we will not know one another."[112]

It is possible of course to imagine that Leslie was trying to strategically counter the kind of accusations we have seen above, but this conforms enough with his overall attitude towards the RA to suggest that there was some substance to

the claim. Turner was a founding member of the Artists' General Benevolent Institution in 1814, an organization devoted to providing relief to needy artists and their dependents. His wills of 1829 and 1831 also prominently featured plans to fund a charity to support "Poor and Decayed Male Artists being born in England and of English parents only and lawful issue."[113] Thus, while Rippingille, writing contemporaneously, was at pains to emphasize the solitary quality of Turner's work on the Varnishing Days, for Turner they were clearly an important means of interaction with his fellow painters. He valued this collegiality very deeply. As Rosenthal notes, there is evidence of Turner using the Varnishing Days as an opportunity to mingle with colleagues and students and seems to have offered helpful advice to his colleagues as well.[114] Indeed, here the Academy seemed to function for Turner as a remnant of art-making as a pre-modern, collaborative, public activity, so that his voice joined with others, at least implicitly, in lamenting the loss of collegiality in the competitive art world from which he profited so handsomely.

Were the Varnishing Days performances that produced the blazing color of *The Burning of the Houses of Lords and Commons* the work of a visionary genius who potentially would bring the English School to divine heights of accomplishment? Or were they the product of a self-interest that threatened to spin out of control and *"endanger the superstructure and prove injurious to all"*? We are back to the categories of Homeric and Virgilian heroism, discussed in the first chapter. Was Turner building an English School or tearing it down? At stake in these questions for both Turner and his viewers were larger questions about how one conceived the relationship between the details and the whole— between individuals, institutions, and state—in a rapidly changing social, economic, and political world. The answers, moreover, were contradictory, both for Turner and for many of his viewers, and this is itself indicative of the complexity of the period more broadly. Rather than viewing the shift from an aristocratic political and cultural world to a middle-class capitalist one as direct and inevitable, we need to see it as awkward, contested, and fitful. For once, then, Turner is perhaps the ideal detail in service of the whole.

Endnotes

1 Turner's relationship to both contemporaries and predecessors was considered in depth in the important exhibition, *Turner and the Masters*, organized by David Solkin and Tate Britain, and the accompanying catalog (Solkin, (ed.), London: Tate Publishing, 2009).

2 John Ruskin, *Notes on the Turner Collection at Marlborough House* (London: Smith, Elder & Co., 1857).

3 For instance, Eric Shanes, *Turner's Human Landscape* (London: Heinemann, 1990), Kathleen Nicholson, *Turner's Classical Landscape: Myth and Meaning* (Princeton: Princeton University Press, 1990), Andrew Wilton, *Turner in his Time* (London and New York: Thames and Hudson, 2007, updated edition of 1987 original), Gerald Finley, *Angel in the Sun: Turner's Vision of History* (Montreal and London: McGill-Queen's University Press, 1999).

4 In considering accounts of Turner at work during the Varnishing Days at both the RA and the British Institution, I should be clear that I am very well aware that relations between the two institutions are complex and they are by no means interchangeable. But for the purposes of this study, I will consider them together, inasmuch as each was, in exhibiting the work of living

British artists, designed to foster a unified and accomplished school of British painting that could compete with any nation in the world. On the British Institution, see Peter Fullerton, "Patronage and Pedagogy: The British Institution in the Early Nineteenth Century," *Art History*, 5/1 (March 1982): pp. 59–72. Ann Pullan, "Public goods or private interests," in Andrew Hemingway and William Vaughan (eds), *Art in bourgeois society* (Cambridge and New York: Cambridge University Press, 1998), pp. 27–44, discusses the British Institution as a means for the patrician elite to maintain control over cultural production and reception in ways that parallel the use of philanthropy as a means of social control. She also argues (p. 40) that the BI's Old Master exhibitions were meant to check the unfettered genius and often commercially motivated fancies of artists like Turner. This relates to broader divisions between artists and connoisseurs in these years (see for instance, Andrew Hemingway, "Academic Theory versus Association Aesthetics: The Ideological Forms of a Conflict of Interests in the Early Nineteenth Century," *Ideas and Production*, 5 (1980): pp. 18–42.

5 Michael Rosenthal, "Turner Fires a Gun," in David Solkin (ed.), *Art on the Line: The Royal Academy Exhibitions at Somerset House 1780–1836*, New Haven and London: Yale University Press, 2001), p. 155.

6 Sir Joshua Reynolds, *Discourses on Art*, in Robert Wark (ed.), New Haven and London: Yale University for the Paul Mellon Centre for Studies in British Art, 1975), Discourse III: ll. 283–5, p. 50.

7 John Barrell, *The Political Theory of Panting from Reynolds to Hazlitt: "The Body of the Public"* (New Haven and London: Yale University Press, 1986), p. 64. On the Academy's origins, see Holger Hoock, *The King's Artists: The Royal Academy of Arts and the Politics of British culture, 1760–1840* (Oxford and New York: Oxford University Press, 2003), pp. 19–79. The key source on the attempt to adapt public, moral art to a privatized, commercial society is David Solkin, *Painting for Money: The Visual Arts and the Public Sphere in Eighteenth-Century Britain* (New Haven and London: Yale University Press, 1992).

8 1809 has been traditionally given as the beginning of the Varnishing Days. In fact, the practice had existed informally since the late 1790s at least, and a specific time for this purpose was established as early as 1804, as indicated by Farington. See Kenneth Garlick and Angus Macintyre (eds), *The Diary of Joseph Farington* (16 vols, New Haven and London, 1978–1998, 1979,) vol. VI: p. 2303.

9 For excellent accounts of the Varnishing Days, see John Gage, *Colour in Turner: poetry and truth* (London: Praeger, 1969), pp. 165–72; Gage, *J.M.W. Turner:"A Wonderful Range of Mind"* (New Haven and London: Yale University Press, 1987), pp. 89–94; Jack Lindsay, *J.M.W. Turner: His Life and Work, A Critical Biography* (Greenwich, CT: New York Graphic Society, 1969), pp. 257–8; Andrew Wilton, *Turner in his Time*, pp. 179–86; Anthony Bailey, *Standing in the Sun: A Life of J.M.W. Turner* (London: Sinclair-Stevenson, 1997), pp. 285–303; Martin Butlin, "Varnishing Days," in Evelyn Joll, Martin Butlin, and Luke Herrmann (eds), *The Oxford Companion to J.M.W. Turner* (Oxford: Oxford University Press, 2003), pp. 354–58. On Turner's painting methods and materials see Joyce Townsend, *Turner's Painting Technique*, exhibition catalog (London: Tate Publishing, 1993).

10 For the most important contextualization of the various figurations of Turner as genius, see K. Dian Kriz, *The Idea of the English Landscape Painter: Genius as Alibi* (New Haven and London: Yale University Press, 1997).

11 E.V. Rippingille, "Personal Recollections of Great Artists. No. 8. –Sir Augustus W. Callcott, R.A.," *Art Journal*, 22 (April 1, 1860): p. 100.

12 On Turner's Victorian reception, and in particular the move away from Ruskin, see Sam Smiles, *J.M.W. Turner: The Making of a Modern Artist* (Manchester: Manchester University Press, 2007), pp. 74–83.

13 Private correspondence, Martin Archer Shee to John Hoppner, December 7, 1805, Royal Academy Archives, James Hughes Anderdon Catalog, v. 12, item 216 (emphasis original).

14 Hoock, *The King's Artists*, pp. 180–202. The most famous episode is that of the expulsion of James Barry from the RA for both criticizing the Academy and very likely for his association with radical politics. See William Pressley, *The Life and Art of James Barry* (New Haven and London: Yale University Press, 1981), pp. 77–82, 173–85 and William Vaughan, "ⓐDavid's Brickdust' and the Rise of the British School," in Alison Yarrington and Kelvin Everest (eds), *Reflections on Revolution: Images of Romanticism* (London and New York: Routledge, 1993), pp. 134–58. For more on the situation with respect to politics and concerns over "democratic" opinion in the RA see, Hoock, *The King's Artists*, pp. 180–202, and Eric Shanes, "Dissent in Somerset House: Opposition to the Political Status-Quo within the Royal Academy around 1800," *Turner Studies*, 10/2 (Winter 1990): pp. 40–6.

15 On the controversies surrounding the Academy's founding, see Hoock, *The King's Artists*, pp. 19–23, ff.

16 Reynolds, *Discourses on Art*, Discourse I: ll. 1–9, p. 13.

17 Eleanor Hughes, "Ships of the 'line': marine paintings at the Royal Academy exhibition of 1784," in Tim Barringer, Geoff Quilley and Douglas Fordham (eds), *Art and the British Empire* (Manchester and New York: Manchester University Press, 2007), pp. 151–2.

18 Kathleen Cave (ed.), *The Diary of Joseph Farington* (16 vols, New Haven and London, 1984), v. XIII: p. 4482.

19 Peter Marshall, "Britain without America – A Second Empire," in *The Oxford History of the British Empire* (5 vols, Oxford and New York: Oxford University Press, 1998), Peter Marshall (ed.), *The Eighteenth Century*, v. 2: pp. 576–95.

20 On issues of portraiture and the RA exhibitions see Marcia Pointon, "Portrait! Portrait!! Portrait!!!" in Solkin (ed.), *Art on the Line*, pp. 93–110. On portraiture in this period more generally, see Pointon, *Hanging the head: portraiture and social formation in eighteenth-century England* (New Haven and London: Yale University 1993).

21 Kenneth Garlick and Angus Macintyre (eds), *The Diary of Joseph Farington* (16 vols, New Haven and London, 1979): v. IV, p. 1188 (emphasis original).

22 Garlick and Macintyre, *Diary of Joseph Farington,* v. IV, p. 1534.

23 Cave, *Diary of Joseph Farington,* v. XIII, p. 4482.

24 Cave, *Diary of Joseph Farington,* v. VII, p. 2538.

25 Garlick and Macintyre, *Diary of Joseph Farington,* v. VI, pp. 2292–3.

26 See William Pressley, "The Challenge of New Horizons: Copley's 'rough and perilous Asent' 'of that Mighty Mountain where the Everlasting Laurels grow'", in Emily Neff (ed.), *John Singleton Copley in England*, exhibition catalog (London: Merrell Holberson for the Museum of Fine Arts, Houston, 1995), pp. 38–43.

27 Emily Neff, "The History Theater: Production and Spectatorship in Copley's *The Death of Major Peirson*," in Neff, *Copley in England*, pp. 70–1. Neff calls Copley "a detail at odds with the whole," and I am indebted to this characterization as a means of thinking about artists and their relationships to institutions in this period.

28 John Bonehill, "Laying Siege to the Royal Academy: Wright of Derby's *View of Gibraltar* at Robin's Rooms, Covent Garden, April 1785," *Art History*, 30/4 (September 2007): pp. 521–44.

29 Garlick and Macintyre, *Diary of Joseph Farington,* v. VI, p. 2296.

30 Luke Herrmann, "Turner's Gallery and Exhibitions," in Joll, Butlin, and Herrmann, *Oxford Companion to Turner*, pp. 349–50.

31 Garlick and Macintyre, *Diary of Joseph Farington,* v. VI, p. 2271.

32 See Royal Academy Archives, Council Minutes, v. III, 1 April, 1799 for a reiteration of the deadline.

33 Royal Academy Archives, Council Minutes, v. IV, 25 March, 1809.

34 Lawrence betrays some defensiveness about the desire for Varnishing Days writing, "There is nothing disgraceful in wishing to make every exertion and improvement in one's art when it is to meet the public Eye and I am conscious of the many little things to be amended in the Pictures I have sent in." Private Correspondence, Thomas Lawrence to Joseph Farington, 16 April, 1808, Royal Academy Archives, Lawrence correspondence, v. 1, item 184.

35 Cave, *Diary of Joseph Farington,* v. XV, p. 5354–5.

36 Cave, *Diary of Joseph Farington,* v. XV, p. 5359.

37 Cave, *Diary of Joseph Farington,* v. XI, pp. 4107–10.

38 Reynolds, in *Discourses on Art*, Discourse V, ll. 416–23, p. 90.

39 For a discussion of issues of class and art viewership, see Andrew Hemingway, "Art-Exhibitions as Leisure-Class Rituals in Early Nineteenth-Century London," in Brian Allen (ed.), *Towards a Modern Art World* (New Haven and London: Yale University Press for the Paul Mellon Centre for Studies in British Art, 1995), pp. 95–108.

40 Sir Martin Archer Shee, *Elements of Art: A Poem in Six Cantos* (London: printed for William Miller by W. Bulmer and Co., 1809), pp. 296–7.

41 Shee, *Elements of Art*, p. 297.

42 *An Account of the British Institution for promoting the fine Arts in the United Kingdom* (London, 1805) p. 4.

43 Shee, *Elements of Art*, p. 299.

44 William Paulet Carey, *Desultory Exposition of an Anti-British System of Incendiary Publication… Intended to sacrifice the honor and interests of the British Institution, the Royal Academy and the whole body of the British artists and their patrons…to the passions of certain disappointed candidates for prizes, etc.* (London: Published for the author, 1819), p. 5 (emphasis original).

45 Kriz, *Idea of the English Landscape Painter*, pp. 35–40.

46 Robyn Hamlyn, "'Sword Play': Turner and the Idea of Painterliness as an English National Style," in Leslie Parris (ed.), *Exploring Late Turner* (New York: Salander-O'Reilly Galleries, 1999), pp. 117–30.

47 Turner's awareness of this issue, and his own prominence as an example of English painterliness is discussed in Barry Venning, "Turner's Annotated Books: Opie's 'Lectures on Painting' and Shee's 'Elements of Art' (II)," *Turner Studies*, 2/2 (Winter 1983): pp. 44–7.

48 Lionel Cust, "The Portraits of J.M.W. Turner," *Magazine of Art*, v. 18 (1895): 248.

49 See for instance, anonymous review, *The Sun*, May 10, 1835: p. 3, column 2.

50 Gage, *Colour in Turner*, pp. 169–70.

51 Anonymous review, *Morning Chronicle*, May 7, 1832: p. 4, column 1.

52 For a nuanced investigation of the term "conservative" in this period see James Sack, *From Jacobite to Conservative: Reaction and orthodoxy in Britain, c. 1760–1832* (Cambridge and New York: Cambridge University Press, 1993). For the conservative position on reform see especially pp. 146–55.

53 Samuel Redgrave, *A Dictionary of Artists of the English School* (London: George Bell and Sons, 1878), p. 135.

54 "Death of the Rev. John Eagles," *Blackwood's Edinburgh Magazine*, 78/482 (December 1855): pp. 757–8.

55 Rev. John Eagles, "The Sketcher No. XII," *Blackwood's Edinburgh Magazine*, 38/238 (August 1835): p. 200.

56 Eagles, "The Sketcher No. XII," p. 200.

57 Rev. John Eagles, "Royal Academy Exhibition," *Blackwood's Edinburgh Magazine*, 42/263 (September 1837): p. 335.

58 Rev. John Eagles, "Royal Academy Exhibition," *Blackwood's Edinburgh Magazine*, 48/299 (September 1840): 385.

59 Eagles, "The Sketcher No. XII," p. 200 (emphasis original). Part of this passage is noted in connection with the Varnishing Days in Barry Venning, *Turner* (London: Phaidon, 2003), p. 232.

60 My thanks to Professor Ann Christensen for a discussion of this term.

61 For a contemporary discussion of magic and the occult see Sir David Brewster, *Letters on Natural Magic, Addressed to Sir Walter Scott* (London: John Murray, 1834).

62 Anonymous review, *Literary Magnet*, 4 (1825): p. 140.

63 Anonymous review, *Literary Gazette*, 486 (May 13, 1826): p. 298.

64 Anonymous review, *The New Monthly Magazine*, 9 (1823): p. 253.

65 Anonymous review, *The Spectator*, 202 (May 12, 1832): p. 450.

66 Reynolds, *Discourses on Art*, Discourse XIV, ll. 362–7, pp. 257–8

67 C.R. Leslie, *Autobiographical Recollections* (London: John Murray, 1860), p. 135.

68 Helen Guiterman, "'The Great Painter': Roberts on Turner," *Turner Studies*, 9/1 (Summer 1989): p. 25.

69 For more on this see Rosenthal, "Turner fires a gun," pp. 148–52.

70 Sam Smiles, "'Splashers', 'Scrawlers' and 'Plasterers': British Landscape Painting and the Language of Criticism," *Turner Studies*, 10/1 (1990): 5–11.

71 Cave, *Diary of Joseph Farington*, v. VII, p. 2777.

72 Barrell, *Political Theory of Painting*, p. 29.

73 For a discussion of radicalism during the crucial years of Reform, see Michael Turner, *British Politics in an Age of Reform* (Manchester: Manchester University Press, 1999), pp. 164–77.

74 Cited in Turner, *British Politics*, p. 214.

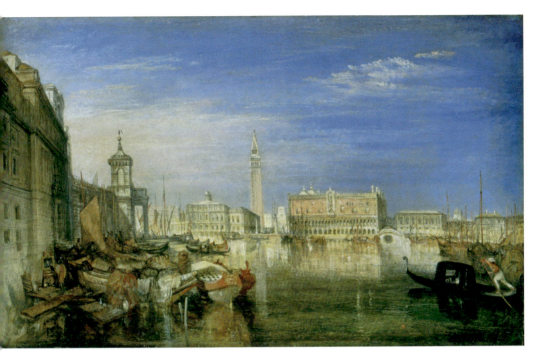

Joseph Mallord William Turner, *Bridge of Sighs, Ducal Palace and Custom-House, Venice: Canaletti Painting*, 1833, oil on panel, 20.1 x 32.1 in. (51.1 x 81.6 cm). © Tate, London, 2011.

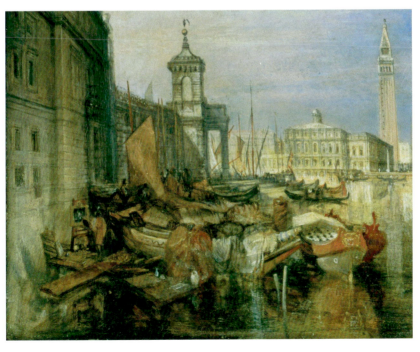

Joseph Mallord William Turner, *Bridge of Sighs, Ducal Palace and Custom-House, Venice: Canaletti Painting*, 1833, detail, oil on panel, 20.1 x 32.1 in. (51.1 x 81.6 cm). © Tate, London, 2011.

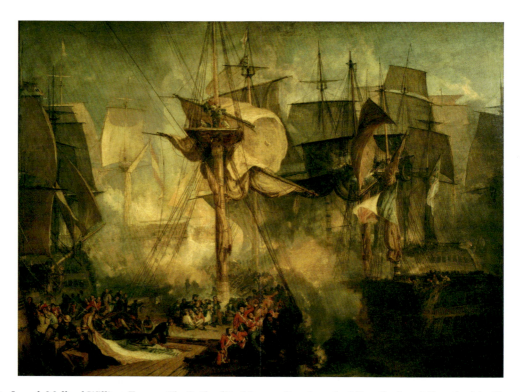

3 Joseph Mallord William Turner, *The Battle of Trafalgar, as Seen from the Mizen Starboard Shrouds of the Victory*, 1806–8, oil on canvas, 67.25 x 94 in. (171 x 239 cm). © Tate, London, 2011.

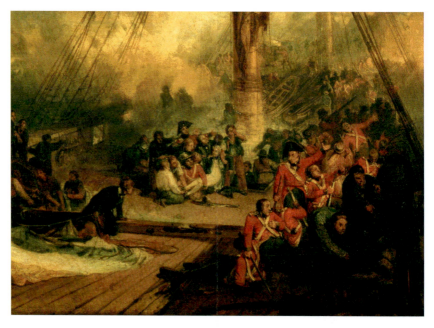

4 Joseph Mallord William Turner, *The Battle of Trafalgar, as Seen from the Mizen Starboard Shrouds of the Victory*, 1806–8, detail, oil on canvas, 67.25 x 94 in. (171 x 239 cm). © Tate, London, 2011.

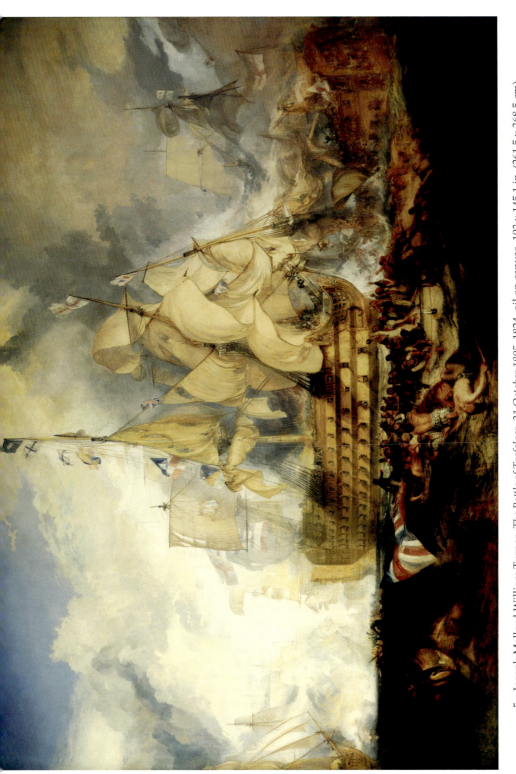

5 Joseph Mallord William Turner, *The Battle of Trafalgar, 21 October 1805*, 1824, oil on canvas, 103 x 145.1 in. (261.5 x 368.5 cm). National Maritime Museum. © National Maritime Museum, Greenwich, London.

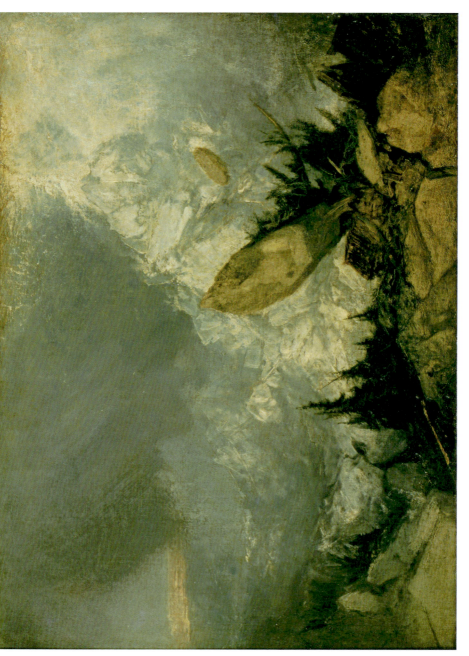

6 Joseph Mallord William Turner, *The Fall of an Avalanche in the Grisons*, 1810, oil on canvas, 35.5 x 47.25 in. (90.2 x 120 cm). © Tate, London, 2011.

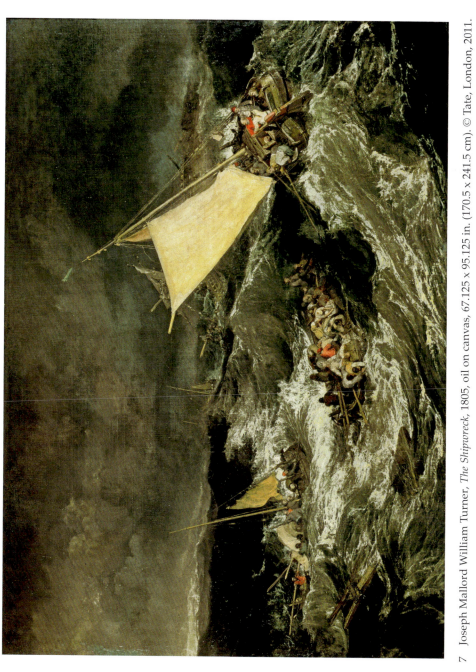

7　Joseph Mallord William Turner, *The Shipwreck*, 1805, oil on canvas, 67.125 x 95.125 in. (170.5 x 241.5 cm). © Tate, London, 2011.

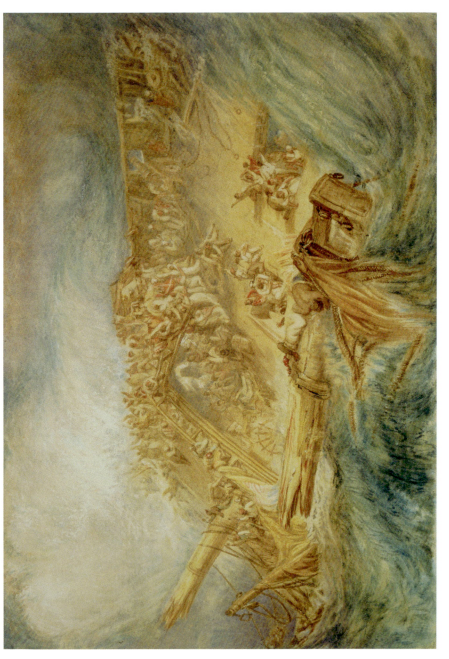

8 Joseph Mallord William Turner, *The Loss of an East Indiaman*, c. 1818, watercolor on paper, 11 x 15.6 in. (28 x 39.5 cm). Trustees of the Cecil Higgins Art Gallery, Bedford.

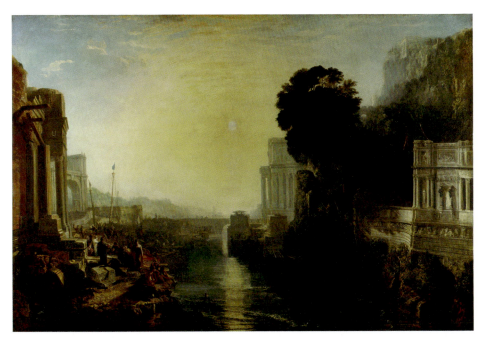

9 Joseph Mallord William Turner, *Dido Building Carthage, or The Rise of the Carthagianian Empire*, 1815, oil on canvas, 61.25 x 90.6 in. (155.5 x 230 cm). National Gallery, London, Turner Bequest, 1856. Credit: © The National Gallery, London.

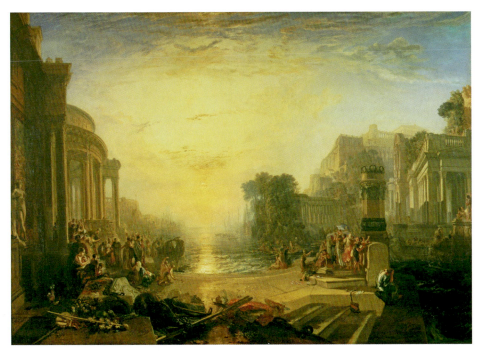

10 Joseph Mallord William Turner, *The Decline of the Carthaginian Empire*, 1817, oil on canvas, 67 x 94 in. (170.2 x 238.8 cm). © Tate, London, 2011.

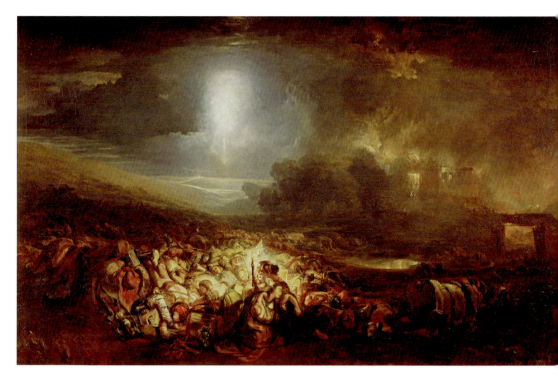

11 Joseph Mallord William Turner, *The Field of Waterloo*, 1818, oil on canvas, 58 x 94 in. (147.3 x 239 cm).
© Tate, London, 2011.

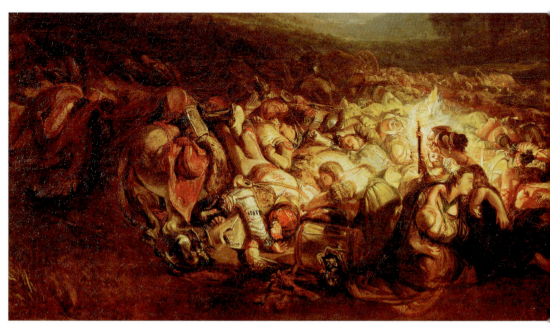

12 Joseph Mallord William Turner, *The Field of Waterloo*, detail, 1818, oil on canvas, 58 x 94 in. (147.3 x 239 cm
© Tate, London, 2011.

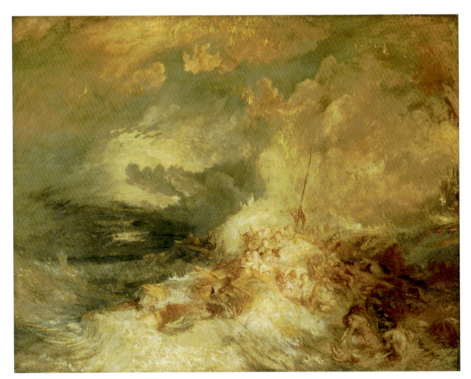

13 Joseph Mallord William Turner, *Disaster at Sea* (also known as *The Wreck of the Amphitrite*), c. 1833–35, 67.5 x 86.75 in. (171.5 x 220.5 cm). © Tate, London, 2011.

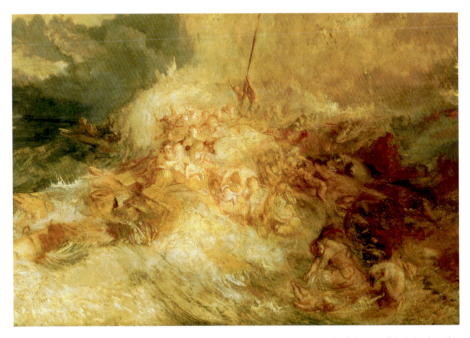

4 Joseph Mallord William Turner, *Disaster at Sea* (also known as *The Wreck of the Amphitrite*), detail, c. 1833–35, 67.5 x 86.75 in. (171.5 x 220.5 cm). © Tate, London, 2011.

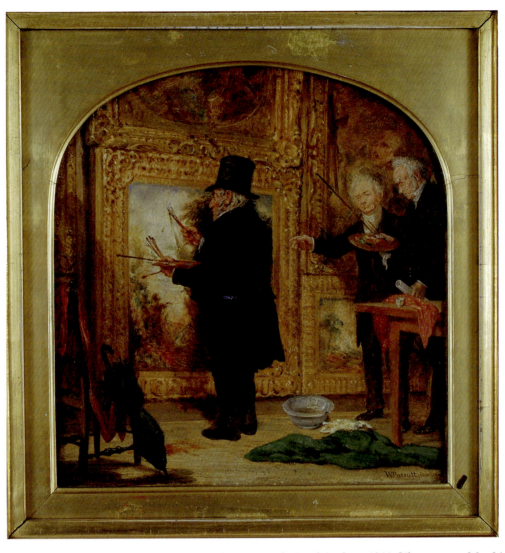

15 William Parrott, *J.M.W. Turner on the Varnishing Day at the Royal Academy*, 1846. Oil on canvas, 9.9 x 9 in. (25.1 x 22.9 cm). Collection of the Guild of St George, Museums Sheffield.

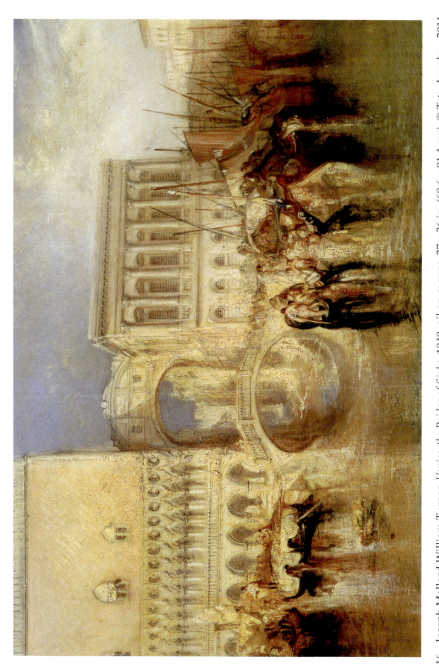

16 Joseph Mallord William Turner, *Venice, the Bridge of Sighs*, 1840, oil on canvas, 27 x 36 in. (68.6 x 91.4 cm). © Tate, London, 2011.

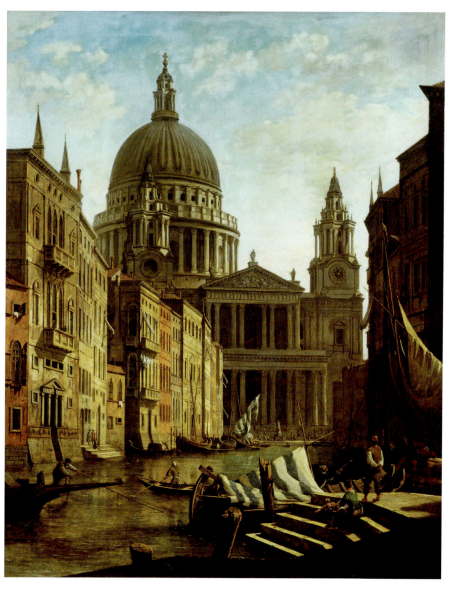

17 William Marlow, *Capriccio: St Paul's and a Venetian Canal*, c. 1795–7, oil on canvas, 51 x 41 in. (129.5 x 104.1 cm)
© Tate, London, 2011.

18 Joseph Mallord William Turner, *Venice, Storm at Sunset*, 1840, watercolour and bodycolour with pen and red ink and scratching out on paper, 8.75 x 12.6 in. (22.2 x 32.0 cm). Fitzwilliam Museum, Cambridge, UK. © Fitzwilliam Museum, Cambridge.

19 Joseph Mallord Turner, *Venice from the Laguna*, c. 1840, Watercolour, pen and ink and scraping on paper, 8.75 x 12.6 in. (22.1 x 32 cm). National Gallery of Scotland.

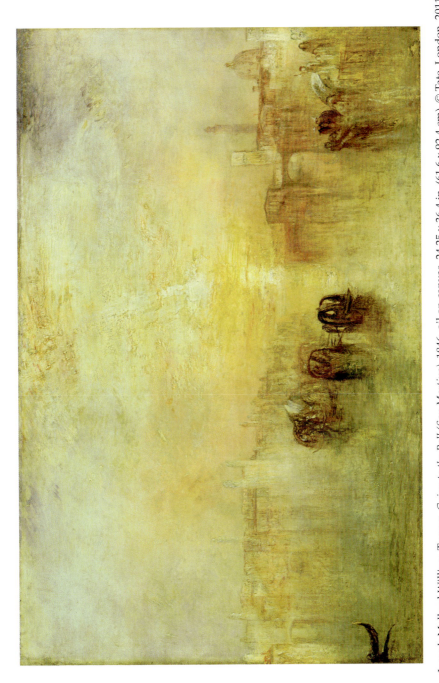

20 Joseph Mallord William Turner, *Going to the Ball (San Martino)*, 1846, oil on canvas, 24.25 x 36.4 in. (61.6 x 92.4 cm). © Tate, London, 2011.

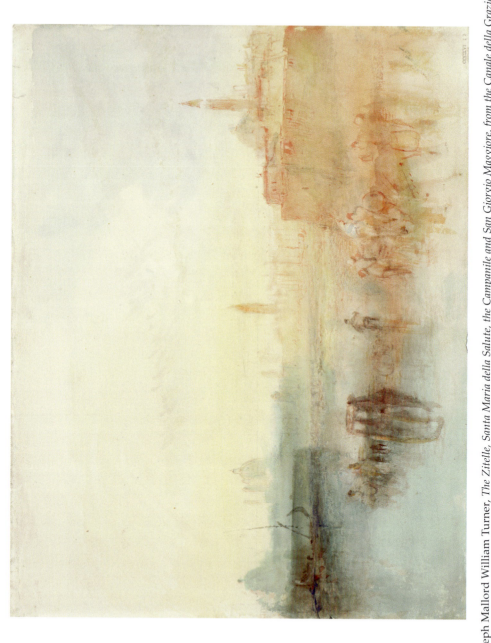

21 Joseph Mallord William Turner, *The Zitelle, Santa Maria della Salute, the Campanile and San Giorgio Maggiore, from the Canale della Grazia*, 1840, pencil and watercolor, with details added using a pen dipped in watercolor, 9.6 x 12 in. (24.3 x 30.5 cm). TB CCCXVI 19. © Tate, London, 2011.

22 Joseph Mallord William Turner, *Venice: Looking across the Lagoon at sunset*, 1840, watercolor, 9.6 x 12 in. (24.4 x 30.4 cm). TB CCCXVI 25. © Tate, London, 2011.

23 Joseph Mallord William Turner, *An Open Expanse of Water on the Lagoon, near Venice*, ca. 1840, watercolor, 9.75 x 12.1 in. (24.8 x 30.7 cm). TB CCCLXIV 332. © Tate, London, 2011.

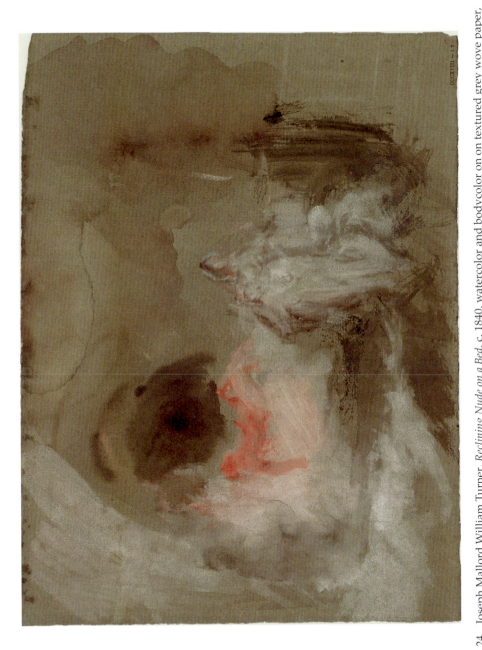

24 Joseph Mallord William Turner, *Reclining Nude on a Bed*, c. 1840, watercolor and bodycolor on on textured grey wove paper, 8.5 x 11.25 in. (21.6 x 28.4 cm). TB CCCXVIII 17. © Tate, London, 2011.

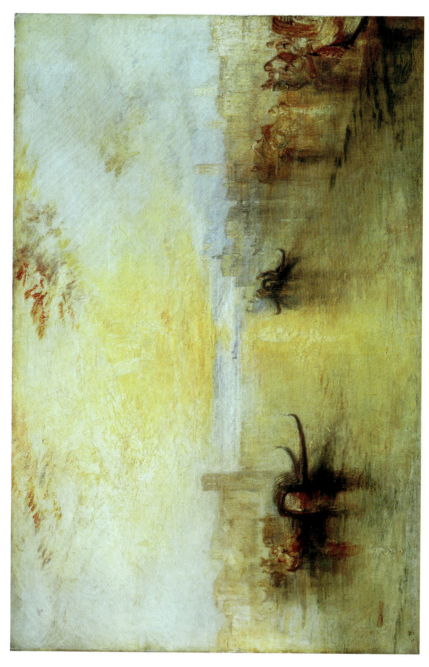

25 Joseph Mallord William Turner, *St Benedetto, looking towards Fusina*, 1843, oil on canvas, 24.5 x 36.5 in. (62.2 x 92.7 cm). © Tate, London, 2011.

26 Joseph Mallord William Turner, *Orange Sunset over the Lagoon*, 1840, bodycolor on grey paper, 7.25 x 11 in. (18.5 x 28 cm). Tate TB CCCXVIII 18. © Tate, London, 2011.

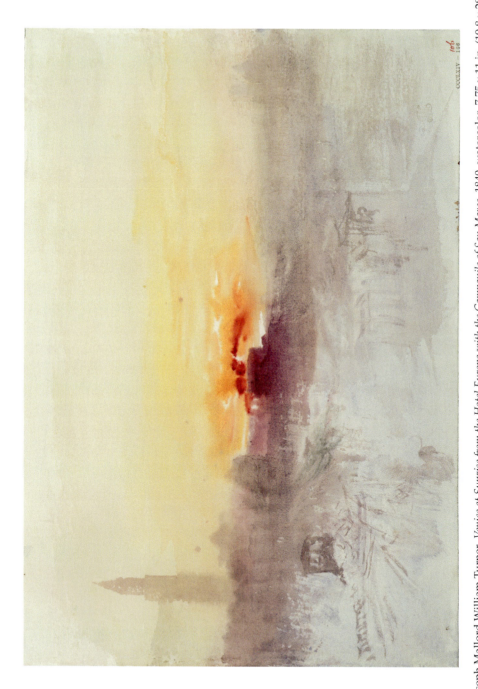

27 Joseph Mallord William Turner, *Venice at Sunrise from the Hotel Europa with the Campanile of San Marco*, 1840, watercolor, 7.75 x 11 in. (19.8 x 28 cm). TB CCCLXIV 106. © Tate, London, 2011.

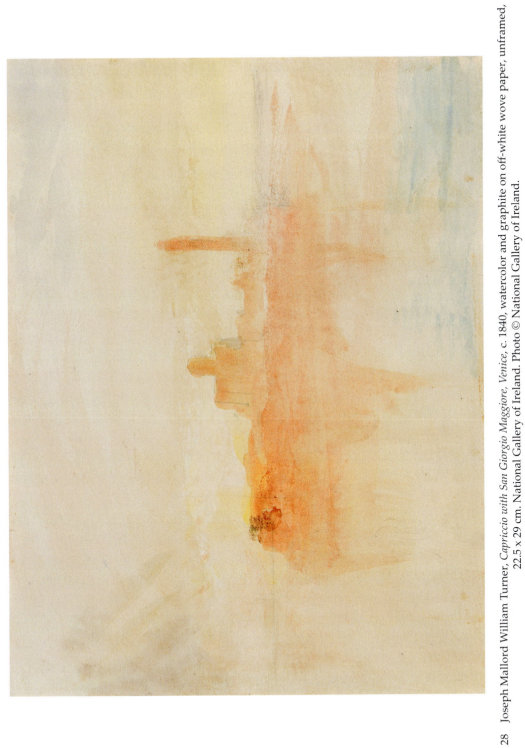

28 Joseph Mallord William Turner, *Capriccio with San Giorgio Maggiore, Venice*, c. 1840, watercolor and graphite on off-white wove paper, unframed, 22.5 x 29 cm. National Gallery of Ireland. Photo © National Gallery of Ireland.

29 Joseph Mallord William Turner, *Venice: San Giorgio Maggiore – Early Morning*, 1819, watercolor, 8.75 x 11.25 in. (22.3 x 28.7 cm). TB CLXXXI 4. © Tate, London, 2011.

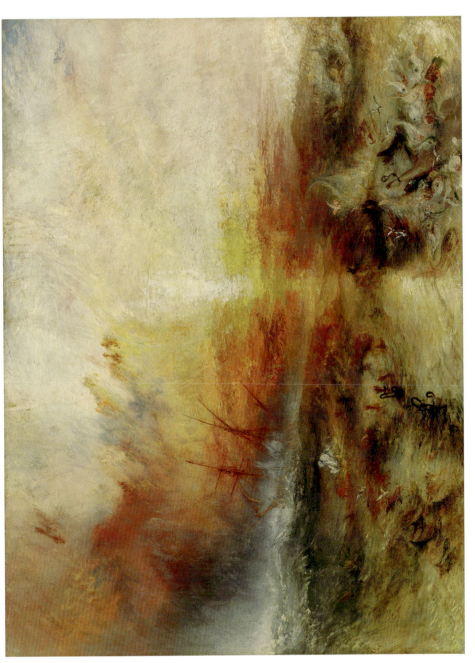

30　Joseph Mallord William Turner, *Slave Ship (Slavers Throwing Overboard the Dead or the Dying—Typhon Coming On)*, 1840, oil on canvas, 35.75 x 48.25 in. (90.8 x 122.6 cm), Museum of Fine Arts, Boston. Henry Lillie Price Fund, 99.22. Photograph © 2012 Museum of Fine Arts, Boston.

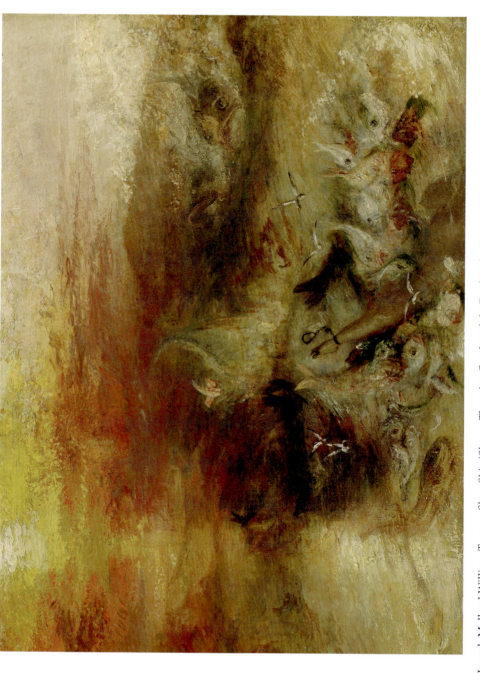

31 Joseph Mallord William Turner, *Slave Ship (Slavers Throwing Overboard the Dead or the Dying—Typhon Coming On)*, detail, 1840, oil on canvas, 35.75 x 48.25 in. (90.8 x 122.6 cm) Museum of Fine Arts, Boston. Henry Lillie Price Fund, 99.22. Photograph © 2012 Museum of Fine Arts, Boston.

75 *The Athenæum*, February 6, 1837, cited in Martin Butlin and Evelyn Joll, *The Paintings of J.M.W. Turner* (2 vols, New Haven and London: Yale University Press, 1984), text volume, p. 222.

76 *The Spectator*, 202 (12 May 1832), cited in Butlin and Joll, *Paintings of J.M.W. Turner*, text volume, p. 197.

77 *Morning Herald*, May 2, 1835, cited in Butlin and Joll, *Paintings of J.M.W. Turner*, text volume, p. 214.

78 Leslie, *Autobiographical Recollections*, p. 135.

79 See Charles Buddington (ed.), *Canaletto in England: A Venetian Artist Abroad, 1746–1755* exhibition catalog (New Haven and London: Yale University Press, 2007) and Michael Liversidge and Jane Farrington (eds), *Canaletto and England* exhibition catalog (Birmingham: Birmingham Museum and Art Gallery, 1993).

80 Rosenthal, "Turner fires a gun," p. 148.

81 Kriz, *Idea of the English Landscape Painter*, and "French glitter or English nature? Representing Englishness in landscape painting, c. 1790–1820," in Hemingway and Vaughan, *Art in Bourgeois Society*, pp. 63–83, and Hamlyn, "Sword Play".

82 *The Athenæum*, 289 (May 11, 1833): p. 298.

83 *The Morning Chronicle*, June 6, 1833: p. 3, col. 1.

84 Butlin and Joll, *Paintings of J.M.W. Turner*, text volume, pp. 200–1.

85 My thanks to Professor Robert L. Patten for pointing this out to me.

86 *The Morning Chronicle*, June 6, 1833, p. 3, col. 1.

87 *The Spectator*, 254 (May 11, 1833), cited in Butlin and Joll, *Paintings of J.M.W. Turner*, text volume, p. 201.

88 W.H. Pyne, "Clarkson Stanfield," *Arnold's Magazine*, 3/5 (February 1834): p. 409. Jerrold Ziff identified the author of this series as William Henry Pyne. For a discussion of his essay on Turner see Ziff, "William Henry Pyne, 'J.M.W. Turner, R.A.': A Neglected Critic and Essay Remembered," *Turner Studies* 6/1, (Summer 1986): pp. 18–25. Earlier, as a writer for the *Repository of Arts*, Pyne figured prominently in the development of the idea of native genius discussed by Kriz, *Idea of the English Landscape Painter*, pp. 1, 30, 62, 115).

89 Pyne, "Clarkson Stanfield," p. 405.

90 Barrell, *Political Theory of Painting*, pp. 314–38.

91 Peter Funnell, "William Hazlitt, Prince Hoare, and the Institutionalization of the British Art World," in Brian Allen, (ed.), *Towards a Modern Art World*, pp. 145–56.

92 Kriz, *Idea of the English Landscape Painter*, pp. 35–7.

93 Pyne, "Clarkson Stanfield," pp. 40–9.

94 Arthur S. Marks, "Rivalry at the Royal Academy: Wilkie, Turner and Bird," *Studies in Romanticism*, 30/3 (Fall 1981): p. 334.

95 Allan Cunningham, *The Life of Sir David Wilkie* (London: John Murray, 1843), pp. 143–4 (emphasis original).

96 We should be aware, however, that Cunningham's account was written more than thirty-five years later, after more well-documented instances of this kind of behaviour by Turner had become common knowledge. In fact, his story was disputed at the time. Arthur Marks is surely right, however, in suggesting that whatever the details may have been, something happened between Turner and Wilkie in 1807. Contemporary newspapers compared the two artists, suggesting some awareness of a rivalry, and Farington also mentions a rivalry between the two artists in 1808, and notes, interestingly, that Turner fixed the price for his *Blacksmith* based on what Wilkie had received for a similar subject (Cave (ed.), *Diary of Joseph Farington*, v. XI, p. 3255 and v. VIII, p. 3040). But in any case, the details matter less to me here than what the Cunningham's accounts may tell us about Turner's reputation for Varnishing Days competitiveness and what we may learn about the positions of the various writers in relation to them. See Marks, "Rivalry at the Royal Academy," pp. 338–9.

97 Peter Cunningham, "Memoir," in John Burnet, *Turner and his Works* (London: James Virtue, 1859), pp. 10–11.

98 For an important discussion of Allan Cunningham, which does not, however, relate to Turner, see William Vaughan, "The Englishness of British Art," *Oxford Art Journal*, 13/2 (1990) pp. 11–23.

99 Allan Cunningham, *Life of Wilkie*, p. 143.

100 Allan Cunningham, *Life of Wilkie*, p. 143.

101 *Annals of the Fine Arts*, v. 3, no.7 (1817): p. 290.

102 *The Morning Chronicle* (reprinted from *The Observer*), May 7, 1832: p. 2, col. 3.

103 Linda Colley, *Britons: Forging the Nation, 1707–1837* (New Haven and London: Yale University Press, 1992), pp. 152–5.

104 Hoock, *The King's Artists*, pp. 303–4.

105 Martin Archer Shee, Jr., *The Life of Sir Martin Archer Shee: President of the Royal Academy, F.R.S., D.C.L.* (2 vols, London: Longman, Green, Longman and Roberts, 1860), v. 2, p. 316.

106 On the Hanging Committee, see Shee, *Life of Shee*, v. 2, pp. 355–6 and on the Varnishing Days, pp. 362–3.

107 *The Morning Chronicle*, May 3, 1830: p. 3, col. 2.

108 *The Morning Chronicle*, May 26, 1834: p. 3, col. 2.

109 Walter Thornbury, *The Life of J.M.W. Turner, R.A.*, 2nd ed, (London: Hurst and Blackett, 1877), p. 239.

110 For a complete list see Joll, Butlin, and Hermann, *Oxford Companion to J.M.W. Turner*, pp. 270–2.

111 Rosenthal, "Turner fires a gun," p.146; Andrew Wilton, *Turner in his Time*, pp. 177–85; Bailey, *Standing in the Sun*, pp. 289–93.

112 Leslie, *Autobiographical Recollections*, pp. 134–5.

113 For a complete discussion of the will, see Selby Whittingham, *An Historical Account of the Will of J.M.W. Turner, R.A.* (London and Paris: J.M.W. Turner R.A. Publications, 1989); for an important account of the artistic aspects of the will see Smiles, *The Making of a Modern Artist*, pp. 33–45.

114 Rosenthal, "Turner fires a gun," p. 146.

"In Venice now":
History, Nature, and the Body of the Subject

This chapter continues, and to some degree unites, the various threads of this book by considering a number of themes in Turner's work in the 1820s, 30s and 40s. In particular, I am interested here in the way in which his work came to interrogate the relationship between the individual painter's subjectivity and the things he painted, his subjects. Especially important here will be issues of empire once again. I will show that a thematics of decline and disintegration continued to be an important aspect of these paintings, and of critical response to them. At the same time, however, I wish to argue that many of the paintings of these years reform subjectivity in relation to history by means of a different set of terms than in the tradition of history painting Turner had inherited. Thus, I will pay particular attention to questions of embodiment, both in terms of eroticism and labor as they affected Turner's conception of painting, considering especially Turner's depictions of Venice, but not exclusively. I will consider the presence of eroticism in a group of other works by Turner, for instance, at some length. Nonetheless, it will emerge that the set of issues that concern me will be particularly concentrated in the Venice pictures, thus their prominence here.

These pictures have often been treated in isolation from the rest of Turner's oeuvre, in part because the size and complexity of this group of paintings lends itself to specific consideration. The Venetian pictures constitute the largest number of works on a single topic that Turner ever undertook. Between 1833 and 1846 he exhibited twenty-five paintings of the subject, showing at least one each year with the exception of 1838 and 1839, and produced about 170 watercolors and numerous oil sketches. Additionally, Ruskin paid particular attention to the Venice subjects and thought them the finest examples of Turner's work. As Ruskin's influence, and that of the naturalism he expounded, grew in the nineteenth century, the Venetian pictures came to occupy a prominent place in the artist's reputation. Relatedly, the Venice pictures also are among the easiest to link to subsequent movements within mainstream formal modernism, including Impressionism and abstraction. Because the city lends itself to depictions of the interpenetration of light,

air, water, and heightened color effects, and because Impressionists such as Monet and Renoir painted there, the Venice pictures have been handy examples for establishing Turner as their forerunner. Additionally, the vast majority of the Venetian watercolors and all of the oils date from the last two decades of Turner's career, the period most valued by modernism. Because the Venetian pictures are confined to that period and apparently do not need to be traced back to earlier, more academic work, they can be more easily understood as the work of a visionary artist concerned with using paint to create a visual equivalent to the experience of fleeting effects of nature. As Turner's biographer, A.J. Finberg put it, "the attraction may be the subject matter; but I think it is also the way Turner treats it, for he so often succeeds in doing what the modern artists seem to want to do but fail in."[1]

For all the applicability of modernist-formalism to Turner's pictures of Venice, John Gage and a number of other Turner scholars have found this approach insufficient and have convincingly shown that any serious account of Turner's work, and the Venice pictures specifically, needs to acknowledge that "subject matter" and "the way Turner treats it" are not entirely separable. In particular, Gage has asked us to be attentive to the issue of decline in Venice and the way that this decline was understood to have relevance for the sea-based empire of England. This is clearly significant to this study, given the thematic concerns I have traced so far and I will indeed connect the Venetian pictures to the issues of decline, disintegration, and decay described in Chapter 2. It is only with this background that we can fully appreciate the significance of decline in Turner's depictions of Venice, in which he explored the relationship of societal or state decline to individual mortality. In particular, I am interested in exploring the visual means by which Turner evoked themes of decline and disintegration, through which he presents a slow process of decay rather than cataclysmic moments of destruction. This discussion touches directly on Turner's ability to create non-form with the material substance of paint, an issue raised by his contemporaries in regard to the Royal Academy's Varnishing Days. As such, the issues at stake in the Venice pictures are central to my account of Turner's approach to history, and not merely because of their apparent concern with rise and fall. In the end, the Venice pictures became a site for Turner to explore linked questions of artistic and historical subjectivity. Particularly at stake, as we will see, was the elaboration of the artist's physical, sensual relationship to the external world, a relationship that produced a very different kind of pictorial subject than the model of history painting as Turner and others would have understood it.

Before proceeding, a few brief prefatory comments should be made. Firstly, I would reiterate my comments in the introduction regarding the status of the Venice pictures as history or landscape. It is not my goal to classify or re-classify them as one or the other. I am more concerned with the implications of the pictures, whatever their primary genre, for a larger set of questions around the representation of history. Relatedly, I should note at the outset, that I will also move relatively freely in this chapter between different kinds

of depictions of Venice by Turner, looking at both finished watercolors and paintings, as well as watercolor sketches. Clearly, the differences in purpose and results for these media cannot be disregarded and they are not to be thought of as interchangeable. That said, however, one of the goals of this chapter is to use themes and ideas that Turner elaborated in the more private work of sketching to inform our account of the finished exhibition paintings, which may seem at first glance to be less conducive to the kind of analysis I wish to pursue here. In this regard, my final point is that the goal of this chapter is not to use these issues to create a fuller understanding of the Venice pictures, but rather the opposite: to incorporate the Venetian imagery into a broader account of particular themes that are crucial, in my view, to understanding Turner's historical project in the 1830s and 40s.

"That Which was Once Great...": Venice and Decline

In an important essay of 1987, John Gage argued for the relevance of themes of historical decline in Turner's depictions of Venice. Along with a 1985 exhibition catalog by Lindsay Stainton, Gage's work went against the grain of most previous treatments of these works. Indeed, many of Turner's commentators have preferred his Venetian subjects precisely because of their apparent lack of literary and narrative baggage.[2] Contemporary reviewers consistently avoided reading particular historical meaning into the pictures, preferring instead to treat them as instances of naturalism. Indeed, critics frequently praised Turner's Venetian exhibits as among his best of the 1830s and 40s because they lacked the exaggerated color and obscure themes that bothered many viewers of his work of that period. About *The Bridge of Sighs, Ducal Palace and Custom-House, Venice: Canaletti Painting* (1833, Plate 1), for instance, *The Spectator* wrote:

[Number] 109, Venice, is a most brilliant gem. The emerald waters, the bright
blue sky, and the ruddy hue of the Ducal Palace, relieved by the chaste whiteness
of the stone buildings around, combine to present a picture as bright, rich,
and harmonious in tone, as the actual scene itself. No part is overcharged or
exaggerated. Nothing in the art of painting can surpass the purity of the color. It
is a perfectly beautiful picture.[3]

The review stresses the picture's "truth" to nature, which is emphasized by the terms "chaste," "purity," and "perfectly." These terms carry gendered connotations that align with my earlier discussion of "meretricious;" they contrast specifically with the kinds of negative phrases frequently used by *The Spectator* and others, which referred to Turner's "extravagance" and suggested that by heightening his colors he had violated nature's modesty. Gendered terms here are used in criticism, as were classed terms, as a means of policing mutually reinforcing standards of aesthetic and social propriety.[4] This praise, significantly, came immediately after a general notice of the exhibition, which

regretted the effects of the low taste of the British public for painting and the lack of genius and inventiveness amidst mere "mechanical skill and dexterity." Turner was made an exception in this case, but it should be noted that his Venetian work was classed, as it often was, among the landscapes and seascapes rather than the poetic and historical pictures.[5] Again, these statements were one outlet for concerns over the growth of an English public that was thought to be too materialistic, and not enough intellectual, traits that were associated with both effeminacy in culture and middle-class dominance.

Even in fairly late pictures of Venice, critics could often find a relatively reassuring respite from the more disturbing aspects of Turner's work. About *The Dogana and Santa Maria della Salute, Venice* (Figure 4.16), of 1843, for instance, *The Times* wrote, "This is a splendid picture. It is divested of all absurdities and shows the great power of the artist, when he is content to copy nature as she is."[6] Modernist critics have also valued their apparent lack of complex historical associations and Academicism, which in their view freed the artist to explore the visual properties of the medium. Sir Lawrence Gowing's classic and considerably nuanced account of Turner as a proto-modernist, identifies Turner's experience of Venice as central to his conception of paint as capable of creating expressive forms without reference to literary narrative. Of watercolors from Turner's first visit to the city in 1819, Gowing wrote,

It may have been due to the light, but he was perhaps as much affected by the spirit of the place, which [Henry] Fuseli, whose teaching was often in his mind, called 'the birthplace and the theatre of colour.' In his drawings done at daybreak the scene is made of colour, with no other substance.[7]

It was thus that Turner, in Gowing's view, came to paint pictures that ceased to recreate an external reality, and instead foregrounded their own formal expression as equivalents for experience. Of the Cleveland *Burning of the Houses of Lords and Commons* (Figure 2.17), Gowing wrote, "It was far from descriptive; no one could forget that that the picture looked like paint...The colour and the paint itself have an intrinsic reality of their own. We recognise in them an inherent meaning extending far beyond the actual scene."[8] Even writers less concerned with the relationship of Turner to formal developments in modernist painting have been disinclined to take seriously the presence of literary or historical meaning in Turner's Venetian pictures. Margaret Plant, for instance, wonderfully evokes the natural poetics of Turner's vision of Venice by suggesting that for all of his awareness of Byron, and of Venice as a subject of decline, he had little interest in these connections. Rather, she says, there is an "eradication of (Venetian) history" at work in his pictures, for "Venice is becoming nature."[9]

Any scholar wishing to introduce historical concerns into a discussion of Turner's work in Venice must therefore contend with the weight of these responses. Another challenge is that the evidence regarding their status for Turner himself is not entirely straightforward. Turner actually spent relatively

little time in Venice, travelling there three times and staying for a total of less than four weeks, as opposed to two trips to Rome lasting nine months total.[10] The relative disregard this implies is compounded by the fact that on at least one occasion, Turner contrasted his Venetian pictures to more overtly historical work, which he valued more highly. His friend George Jones reports that after Turner sold the *Venice, the Bridge of Sighs* (1840, Plate 16), he raised the prices for subsequent Venice subjects saying, "if they will have such scraps instead of important pictures, they must pay for them."[11] This acknowledgement of a gap between public taste and "important pictures" raises the possibility that Turner painted Venice as often as he did as a means to appeal to the market and sell pictures and that some of the Venetian pictures were indeed "scraps." The period in which Turner painted Venice so consistently saw a rise in popular literature about Venice, and was a time in which Turner very consciously began painting smaller, more intimate works to appeal to the popular audience of the "Annuals." These ephemeral, sentimental volumes were increasingly popular with a bourgeois audience in the late 1820s. A number of Turner's works from this period were intended to rival artists like Jones and Thomas Stothard, whose illustrations were common in this popular genre.[12] The small scale of many of the Venice pictures further suggests that Turner undertook them at least in part to appeal to this middle-class audience. *Bridge of Sighs, Ducal Palace and Customs-House, Venice: Canaletti Painting* measures just 20.1 x 32.1 inches, as opposed to the larger size (54 x 97 inches) he used for more obviously historical Italianate pictures like *Caligula's Palace and Bridge* (1831, B&J 337) and *Childe Harold's Pilgrimage* (1832, Figure 3.2).

These issues cannot be disregarded. I will try, therefore, to acknowledge them and integrate them into an account of the pictures' treatment of decline by considering the interaction of history, nature, and painting. It is in part because of the uncertain status of some of the Venice paintings that I have paid such close attention to the watercolors as well. While many of these were highly informal works, I think it would be difficult to doubt the intensity of the engagement with Venice that Turner elaborates here. Elements of that intensity, moreover, may have found their way even into Venice pictures that Turner would have still considered "scraps."

One key means of introducing historical significance into the discussion of Turner's depictions of Venice is by connecting his work to literary treatments of Venice's decline. Undoubtedly, such resonances were familiar in Turner's cultural milieu and they frequently also resonated powerfully with ideas of contemporary British history and empire. Ruskin famously began *The Stones of Venice* (published 1851–3) by drawing a parallel between the maritime empires of Carthage, Venice, and England, and placing particular stress on contemporary Venice as a ruin, a signifier of decline:

Since first the dominion of men was asserted over the ocean, three thrones, of mark beyond all others, have, been set upon its sands: the thrones of Tyre, Venice and England. Of the First of these great powers only the memory remains; of the Second the ruin; the Third, which inherits their greatness, if it forget their example may be led through proud eminence to less pitied destruction.

Ruskin continues, "Venice is still left for our beholding in her final period of decline: a ghost upon the sands of the sea—so weak so quiet,—so bereft of all but her loveliness,…"[13] It is surely significant, as Gage notes, that Ruskin claimed in his autobiography that "My Venice, like Turner's, had been chiefly created for us by Byron."[14] The fourth Canto of the latter's *Childe Harold's Pilgrimage*, a work that Turner avidly read, opens in Venice, again invoking it as a state in decline, which is both a physical deterioration and a cultural absence:

> In Venice Tasso's echoes are no more,
> And silent rows the songless gondolier;
> Her palaces are crumbling to the shore,
> And music meets not always now the ear;[15]

Turner would have also read Wordsworth's similar sentiments dating to 1797, just after Venice had fallen to Napoleon:

> Yet shall some tribute of regret be paid
> When her long life hath reach'd its final day:
> Men are we, and must grieve when even the Shade
> Of that which once was great is pass'd away.[16]

Byron also voiced the idea that Venice's proud history of political independence made her submission first to Napoleon in 1797 and then to the Austrians in 1814 all the more painful:

> St. Mark yet sees his lion where he stood,
> Stand, but in mockery of his wither'd power,
> Over the proud Place where an Emperor sued
> And monarchs gazed and envied in the hour
> When Venice was a queen with an unequall'd dower…
>
> …Venice, lost and won,
> Her thirteen hundred years of freedom done,
> Sinks, like a sea-weed, into whence she rose![17]

It is clear, finally, that Byron also intended this statement of collapse as a corrective to British imperial confidence. Towards the end of the Venice section he suggests that Britain's inattention to Venice's plight is a sign of its own weakness:

> …and thy [i.e., Venice's] lot
> Is shameful to the nations, -- most of all,
> Albion! to thee: the Ocean queen should not
> Abandon Ocean's children; in the fall
> Of Venice think of thine, despite thy watery wall.[18]

These terms should be familiar from my discussion in Chapter 2 of the discourse of imperial decline in both eighteenth-century and post-Waterloo Britain. Byron's roots in that tradition of thinking are clear. For two centuries before Byron, Venice had served as a fluid and flexible point of comparison for developing conceptions of British empire. In the first place, Venice's status as a commercial power with wide-flung influence based on control of the seas made it a natural point of comparison for the developing English empire.[19] A myth thus developed that depicted Venice as an ideal model for Britain in its mix of democratic, aristocratic, and monarchic powers. The fact that the Venetian Republic was considered to be a "virgin" state, that is, to have remained independent and unconquered throughout its history, made that mix seem all the more important, even though by the late seventeenth century Venice's power was already perceived as waning.[20] In sum, during this period when Britain sought to understand its own growth as an empire, as historian John Eglin has commented, it is "as if the British had learned from the Venetians what to think of themselves."[21]

The dramatic fall of the Venetian Republic in 1797 and its subsequent occupation by the French and then the Austrians was therefore a profound shock to the British mentality.[22] For a nation concerned with the course of empire, still reeling from the loss of the American colonies and the French Revolution and engaged now in a major conflict with France, the sudden end of the virgin state of the Venetian Republic provided yet another opportunity for Britons to reflect upon the possibility of their own demise. The effectiveness of Venice in teaching Britons "what to think of themselves" stemmed from precisely its ability to embody familiar, reassuring traits, namely, non-Papist, mercantile, and non-despotic, while also representing the feared traits of an alterity. These latter are succinctly summarized in the opening lines of Canto IV of *Childe Harold*:

> I stood in Venice, on the Bridge of Sighs;
> A palace and a prison on each hand.[23]

Venice's decline was understood by many to have resulted from a moral laxity amidst accumulation of wealth and luxury, as evoked by Byron's "palace." Popular literature was also fascinated with the notion of Venice as a city of evil, secret nocturnal affairs and as a police state ("prison").[24]

This ambivalence is visually summarized in William Marlow's *Capriccio: St Paul's and a Venetian Canal* (c. 1795, Plate 17). More than a century of comparative thinking made it possible for Marlow to seamlessly transform this oblique southeast view down Ludgate Hill onto the monument of English Protestantism, into the watery street of the Catholic Italian city. The water suggests the maritime basis of empire and connects commerce at home to activity on the seas abroad. But the picture also seeks a contrast between the two states. Note the slight but pronounced shift in the tonalities of the buildings along the Venetian canal. Those along the left are bathed in a warm, yellow sunlight suggestive of late afternoon or sunset, thus metaphorically

referring to Venice's decline. Because it is largely in shadow, the cathedral, on the other hand, is more dimly lit in a wan grey light. The building, reaching up to the blue sky above, seems to seek a spiritual distance from the lower, physical realm of the canal, where things move with the languorous pace of a slow afternoon turning into evening.

Turner painted nothing as explicit as Marlow's picture, but it is clear that a similar interest in the implications of Venetian decline for Britain informed his pictures of the city at some level. In *Venice, from the Porch of the Madonna della Salute* (1835, Figure 4.1), the only real commercial activity visible is the movement of the gondolas that ferry tourists in the foreground. The sails of the ships in the middle ground are furled in the middle of the day, suggesting an idle fleet anchored in the harbor. Such details point to the decline of the sea-faring mercantile economy that had built Venice. Turner had travelled to Italy with a copy of J.C. Eustace's *Tour through Italy* (which included the passage cited above), that touched on the empire's westward movement and concluded that "the days of England's glory have their number, and the period of her decline will at length arrive..."[25] Gage connects this theme to Turner's 1842 oil painting of *The Sun of Venice Going to Sea* (Figure 4.2), noting, as does Lindsay Stainton, that the poetic tag Turner attached to the entry in the RA catalogue is reminiscent of lines by Turner's contemporary Percy Bysshe Shelley and the eighteenth-century poet Thomas Gray, which speak of the ephemeral nature of empire. Gage also notes the presence of luxury goods in the right foreground of *The Dogana, San Giorgio, Citella, from the Steps of the Europa* (1842, Figure 4.3), which he takes to allude to Venice's decline into wealth and moral decay.[26] Perhaps Turner's most direct elaboration of the Venice/Britain comparison is *Venice: The Dogana and San Giorgio Maggiore* (1834, Figure 4.4), a picture that was purchased from the 1834 RA exhibition by Henry McConnell, a Manchester industrialist. McConnell then commissioned Turner's *Keelman Heaving in Coals at Midnight* (1835, Figure 4.5), apparently as a pendant.[27] As Warrell notes, Turner frequently used pendants in his Venice scenes, as in other subjects, to expand the narrative significance of individual pieces.[28] Gage and others since have generally seen this pairing as a celebration of English industrialism, with fires burning into the night, contrasting with the mid-day languor of the Venetian scene.[29] Implicit in this celebration is always a warning to avoid the luxury that leads to moral decline and could ultimately doom the state to the same fate as Venice.

Turner and Venice in the 1830s

But if some of Turner's Venice pictures speak to issues of decline they do so more obliquely than Marlow or Byron had, and these connections are thus limited in their ability to attend in detail to the paintings' overall visual impact. To do this, we must be attentive to a larger set of issues at stake in the depiction of Venice for Turner in the 1830s and 40s. Among these are, as I pointed out in Chapter 2, that fact that Turner consolidated his career in the

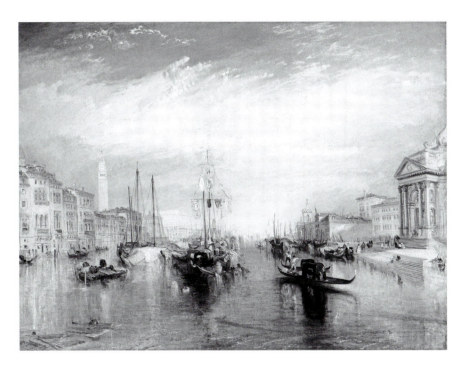

4.1 Joseph Mallord William Turner, *Venice, from the Porch of the Madonna della Salute*, ca. 1835, oil on canvas, x 48.125 in. (99.4 x 122.2 cm). Bequest of Cornelius Vanderbilt, 1899 (99.31). The Metropolitan Museum of Art, NY. © The Metropolitan Museum of Art/Art Resource, NY.

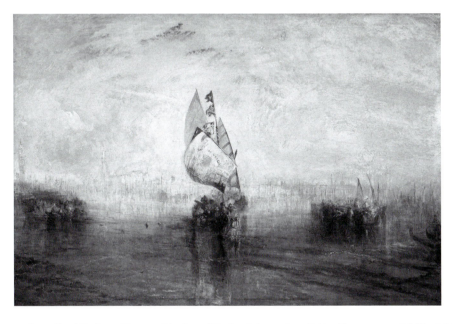

4.2 Joseph Mallord William Turner, *The Sun of Venice Going to Sea*, 1842, oil on canvas, 24.25 x 36.25 in. (61.6 x 92.1 cm). © Tate, London, 2011.

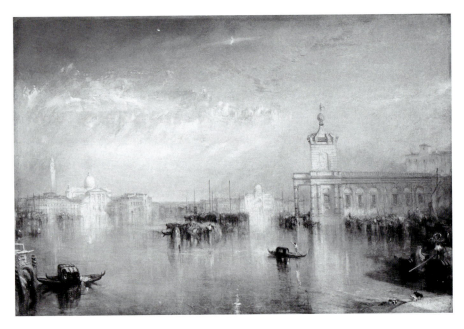

4.3　Joseph Mallord William Turner, *The Dogana, San Giorgio, Citella, from the Steps of the Europa*, 1842, oil on canvas, 24.25 x 36.5 in (61.6 x 82.7cm). © Tate, London, 2011.

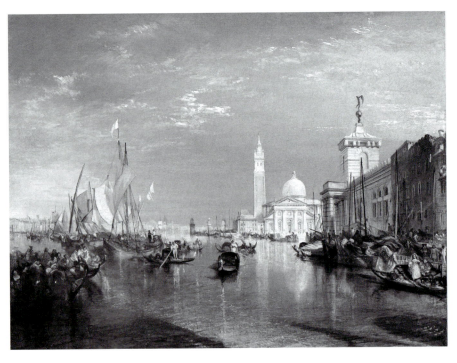

4.4　Joseph Mallord William Turner, *Venice: The Dogana and San Giorgio Maggiore*, 1834, oil on canvas, 36 x 48 in. (91.5 x 122 cm). Widener Collection, Image courtesy National Gallery of Art, Washington.

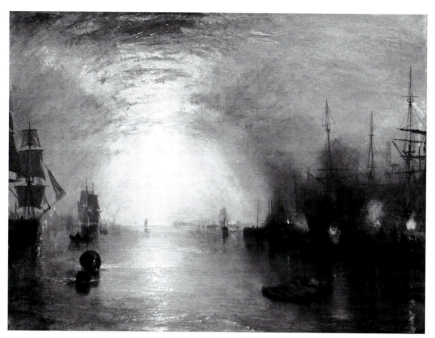

4.5 Joseph Mallord William Turner, *Keelman Heaving in Coals by Moonlight*, 1835, oil on canvas, 36.375 x 48.375 in. (92.3 x 122.8 cm). Widener Collection, Image courtesy National Gallery of Art, Washington.

first decade of the century as a painter of destruction *par excellence*, and that a number of paintings from the period immediately following Waterloo into the 1830s consistently depict empire by referring to its demise. We should add to this that the Venice pictures emerged in a period when Turner was thinking strongly about his own physical decline and mortality. He had suffered a number of losses in the late 1820s, including his close friend and patron Walter Fawkes, who died in 1825, and most seriously, his father, who passed away in 1829. The latter was a loss from which Turner never fully recovered and which made him consider his own mortality to the point that he wrote his first will just nine days later.[30] A pair of deaths in late 1829 and early 1830 also left Turner clearly thinking of his own death, as he wrote to George Jones:

Alas! Only two short months Sir Thomas [Lawrence] followed the coffin of [George] Dawe to the same place. We then were his pall-bearers. Who will do the like for me, or when, God only knows how soon. My poor father's death proved a heavy blow upon me, and has been followed by others of the same dark kind.[31]

Turner's pictures of Venice often seem to make a connection between the city's decline and human death, just as Venice was increasingly associated with individual mortality in Romantic literature.[32] In *Campo Santo* (1842, Figure 4.6), for instance, Turner took as his subject a cemetery that was recently established on the site of an ancient monastery. Having been brought into use only in 1837, the cemetery as Turner depicts it seems less a symbol of Venice's passing as a whole and more a personal reminder of the closeness of mortality to human life. The passage of the human spirit may also be figured in the reflection of the crossed sails of the ship in the foreground, which, as

Lindsay Stainton and Eric Shanes have astutely noted, are aligned with the island cemetery and resemble angel's wings.[33] *The Sun of Venice Going to Sea* (1842, Figure 4.3) repeats the theme of an outward, water-borne journey to death that we saw in *The Fighting Temeraire being tugged to its last birth*. Further indicative of mortality in this painting is the verse-tag Turner wrote for it, which identifies the looming presence of death in the sunny view. Ian Warrell suggests that the poem's pessimism contains "an echo of Byron's warning to Albion of the need for Britain as a younger, seafaring empire to avoid the fate of its ancestor."[34] As Stainton and others note, these lines are based on Shelley's *Lines Written Among the Euganean Hills*: "Fair shines the morn, and soft the zephyrs blow / Venezia's fisher spreads his painted sail so gay, / Nor heeds the demon that in grim repose / Expects his evening prey." The relevant lines from Shelley make the familiar reference to the passing of the city's power, but they personalize it by imagining its past as a ghost that threatens to haunt the modest inhabitants of the present, embodied here as a solitary fisherman:

> Sun-girt City, thou hast been
> Ocean's child, and then his queen;
> Now is come a darker day,
> And thou soon must be his prey,...
> The fisher on his watery way,
> Wandering at the close of day,
> Will spread his sail and seize his oar
> Till he pass the gloomy shore,
> Lest thy dead should, from their sleep
> Bursting o'er the starlight deep,
> Lead a rapid masque of death
> O'er the waters of his path.[35]

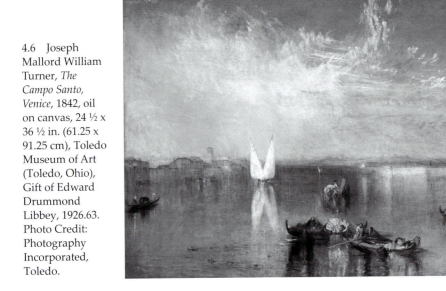

4.6 Joseph Mallord William Turner, *The Campo Santo, Venice*, 1842, oil on canvas, 24 ½ x 36 ½ in. (61.25 x 91.25 cm), Toledo Museum of Art (Toledo, Ohio), Gift of Edward Drummond Libbey, 1926.63. Photo Credit: Photography Incorporated, Toledo.

At work in these pictures, therefore, is a meditation on death and decline at individual, civic, and historical levels. This point has been made about the Venice pictures by Gage, Stainton and others, but it gains significance against the background I have discussed, in which a series of paintings, starting with *Trafalgar*, can be understood as essays on the complex relations between individuals and the state. While *Trafalgar* contrasted the rise of the state and the fall of the hero, the Venice pictures, like *Waterloo,* paralleled the decline of the individual and the state.

Interestingly, just as decline came to dominate British cultural responses to Venice so too was decline a pervasive theme in responses to Turner's career in these years. Reviewers often expressed concern about the effects of this decline on the British School as a whole, as with the writings of the Reverend Eagles discussed in Chapter 3. Even before Eagles, there was a growing concern with what critics perceived as eccentricity and "extravagance" in Turner's work. Specifically, by the 1820s a number of writers saw Turner descending into a mannered form of painting that placed a premium on artistic invention at the expense of truth to nature. To cite just one example, in 1827 critics of *Mortlake Terrace* (1827, Figure 4.7) consistently invoked a rhetoric of bodily deterioration and disease by suggesting that Turner's preference for bold hues was the result of a worsening condition of "yellow fever" or "jaundice of the eye." The critic for *John Bull* was explicit in comparing this manner of diseased painting to the more natural, "healthy" earlier work: "When we look back at the work of Turner, of some twenty or five and twenty years standing, and see nature in all her healthfulness glowing under his powerful hand, it makes us really sick as she looks in his pictures now to see so sad, so needless a falling off."[36] The opportunity to view works from an earlier point in Turner's career sometimes particularly provoked critics in the 1830s. On seeing *Apullia in Search of Apullus* (1814, Figure 4.8) on display in Turner's gallery in 1835, *The Spectator*, which was, on the whole, very circumspect in its attitude towards Turner in these years, summed up much opinion thusly: "We wish Turner would return to the sober beauty and elaborate truth of his earlier works, and cease to 'gild refined gold and paint the lily'."[37] Invoking again the rhetoric of decline, in 1842 *The Spectator* referred to seeing three earlier pictures "painted when Turner was at the zenith of his reputation when he painted nature as it is—before he became maddened with the intoxication of bright hues, and abandoned earthly form and atmospheric appearances for visionary fantasies of colour and effect."[38]

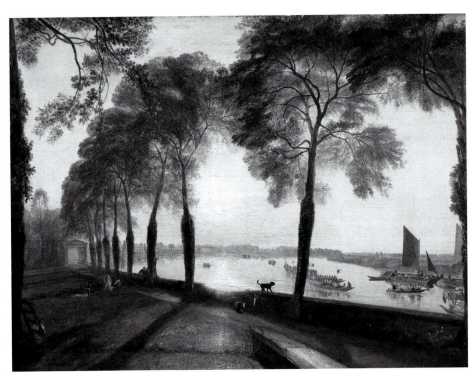

4.7 Joseph Mallord William Turner, *Mortlake Terrace*, 1827, oil on canvas, 36.25 x 48.125 in. (92.1 x 122.2 cm).
Andrew W. Mellon Collection, Image courtesy National Gallery of Art, Washington.

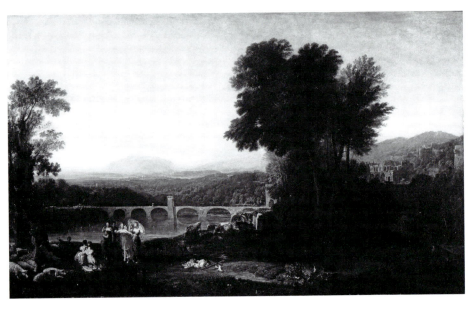

4.8 Joseph Mallord William Turner, *Appulia in Search of Appulus*, 1814, oil on canvas, 58.5 x 95 in. (148.5 x 241 cr
© Tate, London, 2011.

It is not unusual for critics to mobilize a rhetoric of decline in regard to the later work of an aging artist, and this note was sounded frequently in the 1840s. Referring to *The Dogana, San Giorgio, Citella, from the Steps of the Europa,* (1842, Figure 4.3) the *Art Union* concluded: "These Venetian pictures are now among the best this artist paints, but the present specimens are of a decayed brilliancy; we mean, they are by no means comparable with others he has within in a few years exhibited."[39] But what makes this particularly significant in Turner's case is not only its pervasiveness but the fact that such a discourse had existed for much of Turner's career already. In a review of 1820, for instance, *The Annals of the Fine Arts* already describes the progression of Turner's career as a descent into mannerism:

The earliest works…and those which he has done since…are like works by a different artist. The former, natural, simple and effective; The latter, artificial, glaring and affected…A public day at Mr. Fawkes's is a triumph to Turner; and he should really look back at some of these works and keep nearer to their truth…[40]

While reviewers of the 1840s frequently, and rather tastelessly, invoked Turner's advancing age as the cause of the decline, connecting it to his loose handling of paint and incomprehensible subject matter, this note had been sounded as early as 1806 when he had been exhibiting for less than a decade. The Academician Joseph Farington reports that Sir George Beaumont had said that Turner's pictures at the British Institution that year, such as the *Goddess of Discord choosing the Apple of Contention in the Garden of the Hesperides* (B&J 57) "appeared to him to be like the works of an *old man* who had ideas but had lost the power of execution."[41] Thus, critics in the period of Turner's Venice subjects were able to place Turner within an already elaborated but still developing model of an artist who had been in a state of decline for much of his career.

At the point when he began painting Venice, therefore, Turner was not only concerned with his own mortality and a growing discourse on a decline in his work, he also was alerted to challenges he faced from a changing public and marketplace, and from a new generation of painters like Thomas Stothard, George Jones, Richard Parkes Bonington and Clarkson Stanfield. The expansion of Turner's Varnishing Days performances in the early 1830s was very likely one response to this situation, for it allowed him to reassert his primacy in a particularly dramatic and visible way. I would like to suggest now that with Venice, Turner again revealed his ability to respond to a set of critical priorities in these crucial years.

"The Stroke of the Enchanter's Wand"

To understand Turner's response to this situation in the Venice pictures, it is useful to remember William Parrott's portrait of Turner on the Varnishing Days (Plate 15) and the discussion of Turner as a magician in Chapter 3. There,

when discussing the two pictures of *The Burning of the Houses of Lords and Commons*, I suggested that what made those Varnishing Days performances so remarkable was in part Turner's ability to make nothing, a nearly empty canvas, into something, the fully elaborated forms of a finished painting, which represent the very opposite process as fire reduces buildings to ashes and rubble. The invocation of magic made by so many viewers would have had particular significance to his depictions of Venice, which was itself often characterized as having a kind of magical appearance. Indeed, I think that in turning to the subject, Turner might have been particularly struck by the first stanza of Canto IV of *Childe Harold*: "I saw from out the wave her structures rise / As from the stroke of the enchanter's wand."[42]

For Byron, Venice could seem to rise as a vision from the hand of the artist/ author even as the city itself had already fallen into ruin. Crucial to its doing so was the depiction of the beauty of nature. The notion of Venice as a site of "enchantment" was by no means new to Byron. It informed the writing of Ann Radcliffe, whose *Mysteries of Udolpho* Turner had read. Radcliffe herself had never visited the city and had adopted her view of it from the eighteenth-century diarist and author Hester Lynch Piozzi. This notion of enchantment connects both the beauty and the perceived sinister aspects of the city (Byron's "prison" and "palace").[43] By reputation, then, Venice was perfectly matched for Turner as a painter of magic, as someone who could make visions rise on the canvas, as if from nothing.

Part of the reason for Venice's reputation as a place of magical appearances is that it was almost universally recognized as producing a greater variety and complexity of natural effects than anywhere else. Central to this were the city's ever-changing atmospheric qualities—Venice is a place where sky, sun, and water merge—and, for artists, the particular challenge to painting they constituted. It is as though Venice is in a perpetual state of "becoming" rather than "being," as Lindsay Stainton astutely put it. The representation of such fleeting and ephemeral natural effects was a growing critical priority in those years. Although it did not give Turner credit for achieving the feat in this case, *La Belle Assemblée* stated the issue clearly in its reaction to Turner's *Childe Harold's Pilgrimage—Italy* (Figure 3.2):

Let Mr. Turner recollect, that there are many exquisitely beautiful effects in nature, which art has no means of expressing; and in the particular instance before us, the ardent sun-beams, playing on such objects under the clear sky of Italy, would produce a variety of strong and dazzling tints, —but of tints ever varying and uncertain, which remain not an instant the same, are always in motion, and cannot therefore be represented by any fixed and permanent colour.[44]

In laying the issue out this way, the critic here points to another aspect of the transactions between something and nothing I have described. Specifically, the claim is made here that the something of "fixed and permanent colour" cannot possibly recreate the no-thing that is natural light and movement. Critics had often complained in these years that Turner sought to outdo nature

by creating more spectacular effects of his own. In 1828, the *Literary Gazette* warned viewers of *Dido directing the Equipment of the Fleet, or the Morning of the Carthaginian Empire* (B&J 241),

…veil your sight…or it will be overpowered by the glare of the violent colours here assembled. It is really too much for an artist to exercise so despotic a sway over the sun, as to make that glorious, and, as it has been hitherto supposed, independent luminary, act precisely in conformity to his caprice…There is scarcely a word of truth in the whole picture.[45]

In the Venice pictures, more than any others in these years, Turner seemed to align his "magical" effects with those of nature. Representing the flux of natural effects, therefore, would involve a virtuosic, even magical artistic skill on the one hand, but also an allegiance to observed nature on the other. Many critics of the 1830s and 40s evaluated Turner on precisely his ability to balance these terms. Two years later, *The Spectator* identified the same issue, but also acknowledged that the pursuit of those effects could lead to excessive mannerism:

It has been made an objection…that Turner falsifies not only actual scenes but effects of nature. This we dispute as a broad assertion; though we admit that he runs into excess, and exaggerates peculiar effects, often knowingly out of bravado, as well as unconsciously from over-excited sensation. But he seizes upon those appearances of nature, which are so transient, that he who imitates them must "catch at once the Cynthia of the minute," and "arrest evanescence" upon his canvass: and which being frequently stormy, are but seldom observed even by those who are on the look-out for the beauties in nature's ever-changing aspect.[46]

Turner's RA lectures reveal a deep awareness of the difficulty of capturing the fugitive effects of light, water, and color, as Gerald Finley notes. Speaking in an RA lecture of the effects of light when seen in glasses containing water, Turner, using an unusually effective metaphor, said that because of the "innumerable rays reflected and refracted…to define the powers of light and shade upon such changing surfaces is like picking grains of sand to measure time."[47] Finley convincingly argues that on his first visit Turner recognized Venice as an "ideal laboratory" in which to explore these effects. Lindsay Stainton connects the color lecture to the Venice watercolors as well, suggesting that Turner used the tonal subtlety of the medium as no artist had done before, "to paint the effect of Venetian buildings veiled in mist or partly dissolved by the glare of the sunlight, or seen from a distance at sunrise or sunset."[48]

It seems, then, that Turner recognized a particular challenge and opportunity in depicting Venice. Here, perhaps, was the most appropriate subject to display his "magical" powers, his "enchanter's wand": a city that had an established literary tradition as magical, dream-like, and ethereal and one that particularly involved the effects of nature most difficult to capture in a static medium. The degree to which Turner was judged to have struck the balance between magic and nature thus became an important

aspect leading to the ambivalent responses to certain Venetian works. Indeed, although many of the earlier Venetian scenes were credited with a higher degree of naturalism than other paintings, some were criticized for their liberty with effects and topography. In 1844, referring to Turner's *Approach to Venice* (Figure 4.9), *The Spectator* divided Turner's beauty from that found in nature, concluding "beautiful as it is in colour, [it] is but a vision of enchantment."[49]

It is no surprise, then, that in the two pictures in which Turner announced his foray into Venetian subjects in 1833, he worked to stake his claim to visual primacy among those artists who also represented the city. As we have seen, *Bridge of Sighs, Ducal Palace and Customs-House, Venice: Canaletti Painting* established his supremacy over both Canaletto and Stanfield, while his other exhibited Venetian oil, *Ducal Palace, Venice* (B&J 352, present whereabouts unknown) was expressly created to compare to Bonington's views, such as *The Piazzetta, Venice* (1828, Figure 4.10).[50] It was not that Turner set out to illustrate the literary city of Shakespeare, Radcliffe, and Byron, but that he sought to render visually its effects as described and evoked by those writers in a way that had never been attempted, let alone achieved, by any other painter. The key element in this effort was capturing the process of transformation in nature, "arresting evanescence," as *The Spectator* put it. It is perhaps for this reason that Turner was unique among early nineteenth-century artists in exploring views of the Lagoon in which the city itself is a distant ethereal presence.[51] This also gave Turner the opportunity to take in a broad sweep of natural effects of very different kinds. Some of the watercolors, including *Storm at Sunset* (1840, Plate 18), *Venice from the Laguna* (c. 1840, Plate 19), and *Storm at Venice* (1840, Figure 4.11), show a wide expanse of sky, which allows the artist to register subtle shifts of tone not only in the clouds and sky, but

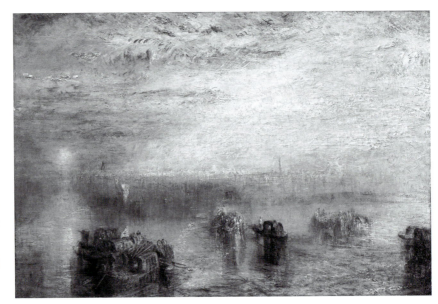

4.9 Joseph Mallord William Turner, *Approach to Venice*, 1844, oil on canvas, 24.375 x 37 in. (62 x 94 cm). Andrew W. Mellon Collection, Image courtesy National Gallery of Art, Washington.

also in the water and on the changing face of the buildings below. In *Storm at Venice*, he achieves this with broad sweeping strokes of the brush that carry the hue from the clouds across the sky. But in the *Venice from the Laguna* (Plate 19), a more finished work, Turner uses multiple layers of pigment and scratching out to give both sky and water a dappled, complex intermingling of tone that evokes changing effects without literally depicting motion in the sky. Thus, this concern with evanescence was present even in watercolors of varying degrees of finish. Later in the decade of the 1840s, oil paintings such as *Going to the Ball (St. Martino)* (1845, Plate 20), also take on much of the tonal complexity of these watercolors: Turner eschews a dominant blue in the sky in favor of yellows and oranges that fill the space of the canvas as it combines with the reflections in the water. *The Spectator* recognized this, invoking supernatural ability once again in describing its "magical effects of light and colour: the watery floor and aërial sky meet at the horizon in a gorgeous mass of orange and gold tints."[52] The skies in both pictures partake of the speckled, mottled tonality of the watercolors *Venice, Storm at Sunset* and *Venice from the Laguna*, as minute areas of color are intermingled with one another.

Turner created these subtle visual effects differently in a watercolor called *The Zitelle, Santa Maria della Salute, the Campanile and San Giorgio Maggiore, from the Canale della Grazia* (1840, Plate 21). Here he showed very few clouds in the sky, instead using the buildings to register the effect of changing light in tones that contrast warm and cool colors, moving from the blue at left through yellow to an orange at right that is shot with brown and green. As he often did, Turner made use of the receding or advancing qualities of colors to place the buildings in space, so that the receding blue pushes the Zitelle at left back while San Giorgio Maggiore at the far right springs forward in red.[53] The forms are produced out of non-form, by nothing but a light that seems to emanate from the picture itself. But by giving the scene a pervasive stillness and using the progression of subtle shades of primary colors to structure the pictorial space, Turner also gives a kind of underlying iconic solidity to the fugitive effects of a changeable

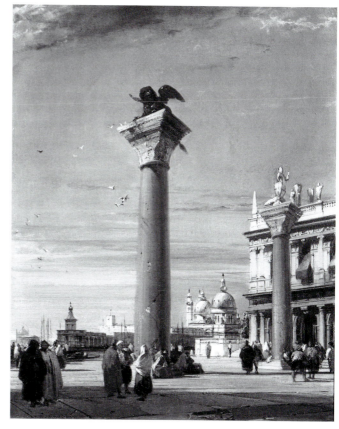

4.10 Richard Parkes Bonington, *The Piazzetta, Venice*, 1827, oil on canvas, 18 x 14.75 in. (45.7 x 37.5 cm). © Tate, London, 2011.

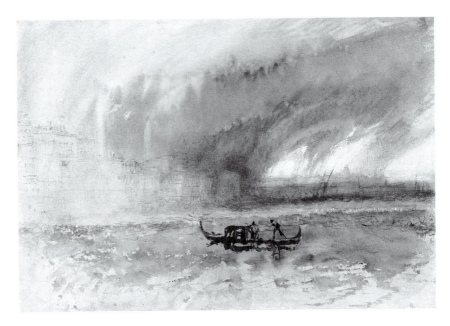

nature. This structure is the product of its formless materials rather than the negation of them. At its most successful, this approach led critics to recognize Turner in precisely the terms I have described: as a magician who could control the elements themselves, not just representing them but seeming to have the power to create and destroy them. In 1842 the *Art Union* recognized that the city's appearance was a perfect fit for these abilities, even as it invoked a linked decline in both artist and subject: "Venice was surely built to be painted by Canaletto and Turner: her greatness scarcely held out till the former had done with her. And by the time the latter has given us his aerial version there will be nothing left for anybody else to celebrate."[54] Here Turner is cast as creating an "aerial version" of the city compared to Canaletto, and his own creativity is aligned with the final destruction of the city. Where the city "held out" for Canaletto, Turner is once again in a position of belatedness able to create a vision only of a "decaying brilliancy." *The Athenaeum* went further, calling his Venice pictures of 1842 "among the loveliest, because least exaggerated pictures, which this magician (for such he is, in right of his command over the spirits of Air, Fire, and Water) has recently given us. Fairer dreams never floated past the poet's eye."[55] Successful painterly magic is cast here as the ability to harness the forces of nature, without exaggerating their effects.

Returning to the oil paintings, Turner frequently combined a sense of stillness with the depiction of changeability in nature. It is worth noting that as opposed to his many depictions of stormy seas and skies in oils, all of Turner's exhibited Venice paintings represent still waters. Also, in the majority of oils exhibited until the mid-1840s, such as *Campo Santo* (Figure 4.6) and *Venice, from the Canale della Giudecca, Chiese di S. Maria Della Salute &c* (1840, Figure 4.12) one of the defining contrasts is that of the wispy clouds—which seem to be, in

Stainton's terms, perpetually "becoming": shifting, forming and reforming—with the smooth, still surface of the water. Turner had in fact explored such surfaces throughout his career.[56] In addition to the Claudean harbor scenes, we might look at the *Harbour of Dieppe* of 1826 (Figure 4.13) as a precursor to the Venice pictures. But if we compare an early instance of a beach scene with still water, *The Sun Rising Through Vapour* (1807, Figure 4.14) to a later one, *Calais Sands, Low Water, Poissards Collecting Bait* (1830, Figure 4.15), it is possible to see not just the continuity of Turner's interest in reflections and reflective surfaces but also a growing fascination with indeterminate or liminal spaces, in which the precise borders between solid and liquid are not clear. In paintings such as *The Dogana and Santa Maria della Salute, Venice* (1843, Figure 4.16), liminality is mobilized to particular effect. We are clearly looking at a purely liquid space in the foreground. The results are similar to *Calais Sands* in that the picture appears deprived of a stable base so that the whole scene seems to float in an indeterminate space. This is particularly appropriate to Venice, which, in the work of so many writers, seemed to rise from the sea itself and float in the air. *The Dogana and Santa Maria della Salute, Venice* produces this effect because the buildings themselves are weightier and more solid than many of the more distant structures that often appear in Turner's Venice pictures, so that the usual order of gravity is reversed.[57]

4.12 Joseph Mallord William Turner, *Venice, from the Canale della Giudecca, Chiese di S. Maria Della Salute & c*, 1840, oil on canvas, 24.1 x 36.1 in. (61.2 x 91.8 cm). ©Victoria and Albert Museum, London.

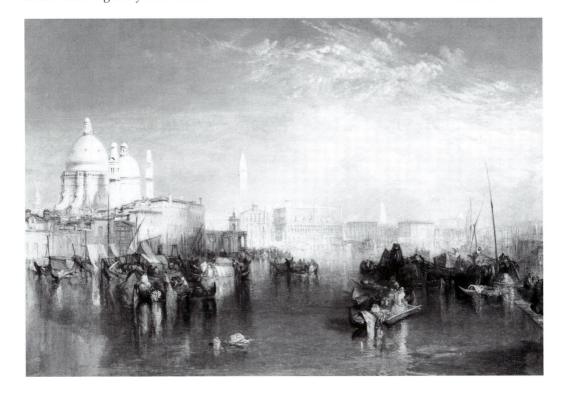

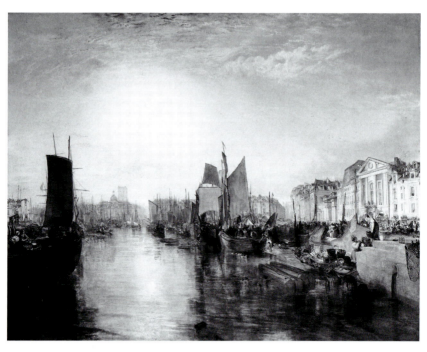

4.13 Joseph Mallord William Turner, *Harbour of Dieppe (Changement de Domicile)*, 1825, oil on canvas, 68.375 x 88.75 in. (173.7 x 225.4 cm). Copyright The Frick Collection.

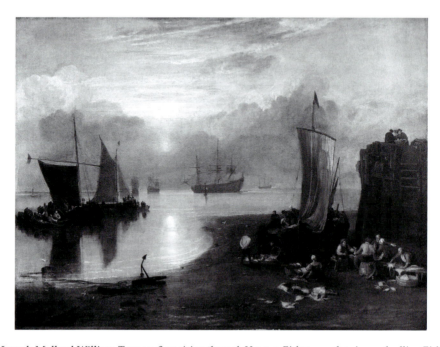

4.14 Joseph Mallord William Turner, *Sun rising through Vapour: Fishermen cleaning and selling Fish*, 1807, 52.75 x 70.75 in. (134 x 179.5 cm). National Gallery, London, Turner Bequest, 1856.
Credit: © The National Gallery, London.

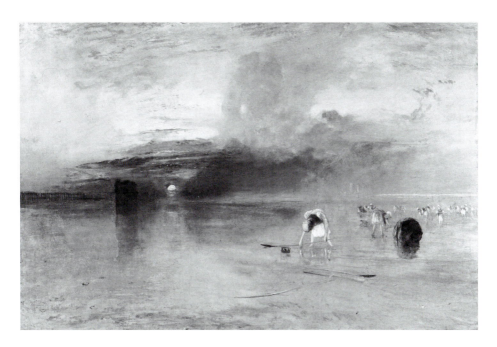

4.15 Joseph Mallord William Turner, *Calais Sands, Low Water, Poissards Collecting Bait*, 1830, oil on canvas, 28.5 x 42 in (73 x 107 cm). Bury Art Gallery+Museum, Greater Manchester, UK.

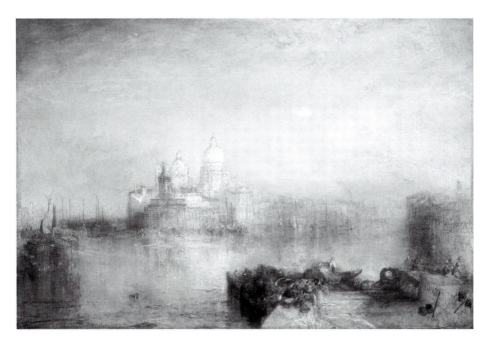

4.16 Joseph Mallord William Turner, *The Dogana and Santa Maria della Salute, Venice*, 1843, oil on canvas, 24.375 x 56. 625 in. (62 x 93 cm). Given in memory of Governor Alvan T. Fuller by The Fuller Foundation, Inc., Image courtesy National Gallery of Art, Washington.

Venice also gave Turner an opportunity to explore thematic issues of rise and fall in a format that was more oriented to the smaller-scale, more intimate interests of the public in the 1830s than pictures like *The Decline of the Carthaginian Empire*. With Venice he could powerfully reassert his own primacy as a painter of nature, while not foregoing thematic concerns. To further understand the complexity of this opportunity and its connection to intricate natural effects, it will be useful to begin with Georg Simmel's reflections on ruins:

The ruin of a building…means that where the work of art is dying other forces and forms, those of nature, have grown; and that out of what art still lives in the ruin and what nature already lives in it, there has emerged a new whole, a characteristic unit…a unity which is no longer grounded in human purposiveness but in that depth where human purposiveness and the working of non-conscious natural forces grow from their common root…[58]

What Simmel describes is a situation of contrasting movements of decay and growth in which nature is no longer the state against which and out of which the artist seeks to create a more perfect unity ("a new whole"), but instead the state to which the artist must return if such a unity is to be forged. This aesthetics of ruins understands representation to exist in the wake of perfection in a state of decay, but imagines itself producing beauty out of that very state. Certainly, in depicting a living city, Turner's depictions of Venice do not literally pair the modern city with the ruins of its ancient past, as in his 1839 pairing *Ancient Rome; Agrippina Landing with the Ashes of Germanicus* and *Modern Rome — Campo Vaccino* (B&J 378 and 379). But if we look at the Venice pictures in terms of Simmel's ideas of ruins, we can see a similar attention to a notion of the city's history narrated through time, and in this case a particular focus on its movement out of and back into nature.[59] *The Art Union* review cited above was explicit about Venice as a ruin and we have seen that both Bryon and Ruskin saw contemporary Venice as a ruin, a shell of its former glory, and Dickens saw it the same way in 1840, saying "it seemed a very wreck found drifting on the sea."[60] Many of Turner's later depictions of the city seem to invoke this same sense of a wreck or a shell. Indeed, if the buildings, boats, and people of the *Approach to Venice* seem to rise like a vision from the water, and out of the canvas, they can also be seen as falling away, refusing to cohere into definite architectural shapes.[61] As Warrell notes, in Turner's depictions of the Bacino of St. Mark's, its former commercial hub is frequently empty and still, suggesting a lack of commercial vigor.[62] In *The Dogana and Santa Maria della Salute, Venice* (Figure 4.16), this stillness combines with the richly applied paint that makes the buildings appear as if they are being eaten away by the air around them, so that Venice appears to be turning into a ruin in front of us. In *Venice — Maria della Salute* (1844, Figure 4.17), the setting sun functions both symbolically and visually to reinforce this theme of decline, as the golden light of the sinking orb seems to dissolve the firm outlines of the architecture. The building, once the seat of Venice's authority,

and the Salute in the distance, disintegrates before our very eyes, as if the moist Venetian atmosphere has softened the stone and placed it on the edge of collapse. The fact that many of the watercolors show storm-tossed waters would seem to mitigate these resonances in the smaller works, but storms have their own metaphoric resonance and it is precisely my point that these pictures are marked by a tension between the depiction of specific natural conditions and the symbolic associations they could create. Even so, some of his most temporally immediate watercolors invoke Venice as a space of desolation and emptiness. In some of his studies of the Lagoon in 1840 for instance (Plate 22), the city hovers as a ghostly presence on the horizon, which seems to be passing into nothingness with the setting sun. The docks and lines of *bricole* that stretch into the distance begin to look themselves like the remainders of some former structure. Turner depicts the process by which history—the buildings of Venice and all that they represent—falls back into landscape, that is to say into nature, a state produced not by the hand of man, but also the means by which nature and the hand of the artist work together to form a reconfigured whole.

4.17 Joseph Mallord William Turner, *Venice — Maria Della Salute*, 1844, oil on canvas, 24.1 x 36.25 in. (61.3 x 92.1 cm). © Tate, London, 2011.

Much of this is present in Byron. Consider once again the fourth canto:

Her palaces are crumbling to the shore,
And music meets not always now the ear;
Those days are gone— but Beauty still is here.
States fall, arts fade— but Nature doth not die,...[63]

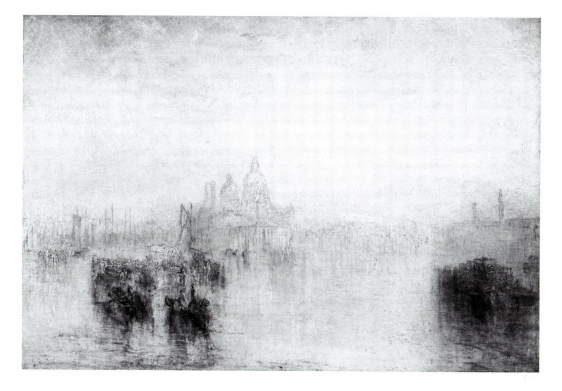

It is from a prior fall that poetry emerges, as he sees Venice rise as a vision from the sea, recalling the opening lines of the fourth canto, in which the "structures rise/As from the stroke of the enchanter's wand." Tony Tanner argues that it is Byron's goal to let poetry redeem the decay of Venice: "… out of the apparent oxymorons Byron is coaxing value from the positive beauty of manifest decline. And Nature and Art are exchanging provinces and powers."[64] We might rephrase the *Art Union's* statement that Venice was built for Turner then, to read that Venice was built and decayed so that Turner could disintegrate and rebuild it again. Venice may have declined, but what rose from the ruins was beauty, which in Turner's most successful efforts for his critics was both natural and painted. Margaret Plant captures some of this when she suggests that the late (1840s) Venice paintings "seem rather to confirm the increasing recession of history, the redundancy of historical characters and the supremacy of the environment as a spectacle governed more by nature than by man."[65] This has an undeniable explanatory quality, particularly if one compares earlier pictures like the *Bridge of Sighs, Ducal Palace and Customs-House, Venice: Canaletti Painting* (1833, Plate 1) to later ones such as *The Approach to Venice* (1844, Figure 4.9) in which the human content seems even more distant, and the city itself seems to be shrinking between the expanding masses of sky and water. The notion of a "recession from history" seems even more convincing in regard to watercolors like *Venice: Looking Across the Lagoon at Sunset* and *An Open Expanse of Water* (Plates 22 and 23), especially because it offers to account in part for the closeness of these small-scale, informal drawings to later renditions of Venice by other artists such as Monet (1908, Figure 4.18). But rather than seeing the progress towards the evocation of natural beauty as a rejection of historical narrative entirely, we can see now that for Turner the progress from history into landscape was itself a narrative, just as we saw the obliteration of human presence as a narrative in *The Avalanche in the Grisons* (Plate 6). The artist's challenge was not only to depict that process but to see it as, in some ways, the source of creativity.

It is also worth noting here that water held deep symbolic value for Turner and could be both a source of life and death. We saw in Chapter 2 his interest in the "tearing and desolating" power of water, but we also saw that it could become a means of a dissolution into an infinity that was also a re-formation. John Gage has argued for such a dual significance for water in connecting Turner's river imagery to Sir Humphry Davy's use of the river as an analogy for life. Having described smooth water as a metaphor for the progress of the mind to reason and maturity, Davy concludes:

And, above all, the sources of a river, — which may be considered as belonging to the atmosphere, — and its termination in the ocean, may be regarded as imaging the divine origin of the human mind, and its being ultimately returned to, and lost in, the Infinite and Eternal Intelligence from which it originally sprung.[66]

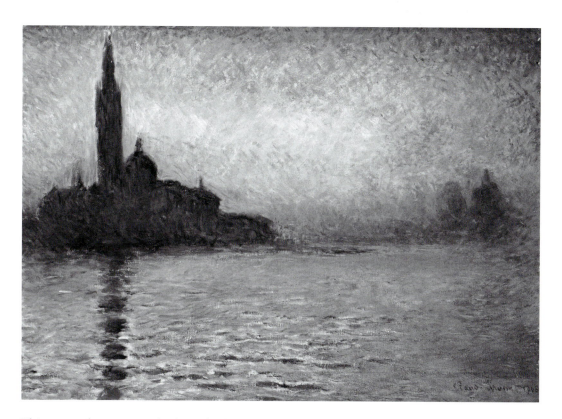

This sense of water as embodying both the dissolution and formation of life is present also in both *The Fighting Temeraire, tugged to her last berth* and *The Sun of Venice Going to Sea*, both of which indicate a water-borne progress towards both death and rebirth. Jack Lindsay explored this linkage between creativity and death with regard to Turner's relationship to his paintings, noting that he thought of them as his legitimate offspring, that is, as the product of his own sexual energy and as an extension of his physical self. But, Turner is also reported to have requested that he be buried in his painting of *Dido Building Carthage*.[67] Thus, once again creativity/birth and destruction/death are linked for Turner in a progress between states that occur literally within the space of painting.[68]

I should say at this point, however, that this notion of decline and fall in Venice risks becoming a master narrative here, and in doing so, may seem to align too closely with the critics' invocation of Turner's own decline. I do not mean to transform his entire late career into a discourse centered around decline and Venice. Indeed, it is my goal instead to situate those pictures which do concern decline within some broader themes and issues not just of his late career, but his entire oeuvre. For instance, Turner's use of smooth or slightly disturbed waters in the Venice paintings, finally, suggests in part a different form of falling away to that already charted in Chapter 2, however. Here we find neither the dramatic disintegration of *The Shipwreck* nor the crucial moment of historical failing as in *The Decline of the Carthaginian Empire*.

4.18 Claude Monet, *San Giorgio Maggiore by Twilight*, 1908, oil on canvas, 25.7 x 36.4 in.(65.2 x 92.4 cm). © National Museums of Wales/The Bridgeman Art Library.

Instead, we face a slow, steady, but irresistible decline of many centuries. This is formally registered most powerfully in the reflections which are so prominent in the oil paintings in particular. Indeed, as much as anything, it is the emphasis that Turner places on reflections that sets his Venetian pictures apart from any of his predecessors or contemporaries. In *Venice, the Bridge of Sighs* (1840, Plate 16), the foreground is filled with reflections that seem, in passages such as the mother and children closest to us, to be of equal intensity to the forms they depend upon. Comparatively, contemporary Venetian views by Bonington (Figure 4.19) and William Etty (Figure 4.20) largely eschew showing reflections at all.

Even Turner's successors in Venice, such as Thomas Moran (Figure 4.21), do not emphasize reflections to nearly the same extent. An exception is perhaps Claude Monet, of course. With Monet (Figure 4.18), the reflected color of the sunset shares much of the intensity of the sky, but it is worth noting that Monet also suppresses the reflection of San Giorgio Maggiore to emphasize the broad sweep of color and the contrast to the exaggerated length of the adjacent tower's form in the water. Turner at times did something similar, even while he retained a greater emphasis on the buildings themselves than Monet would. Recognizing the way that Monet uses the reflections to downplay perspective in the picture, and thus to organize the space into an integrated two-dimensional whole, can alert us to Turner's similar move in works like *Going to the Ball (San Martino)* (Plate 20). Indeed, while reviewers may not have liked this approach, it was identified as one of the defining aspects of Turner's Venice oils. In the 1842 review I have already cited, the

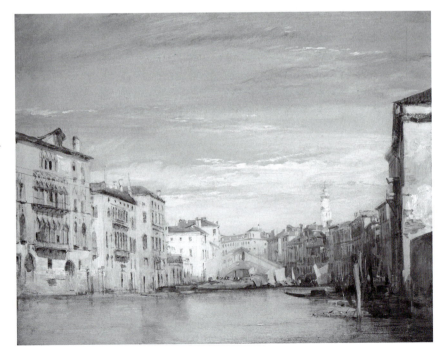

4.19 Richard Parkes Bonington, *The Grand Canal, Venice, Looking toward the Rialto*, 1826, oil on millboard, 13.875 x 17.875 in. (35.2 x 45.4 cm) AP 2009.02, Kimbell Art Museum, Ft. Worth, Texas. Photo credit: Kimbell Art Museum/Art Resource, NY.

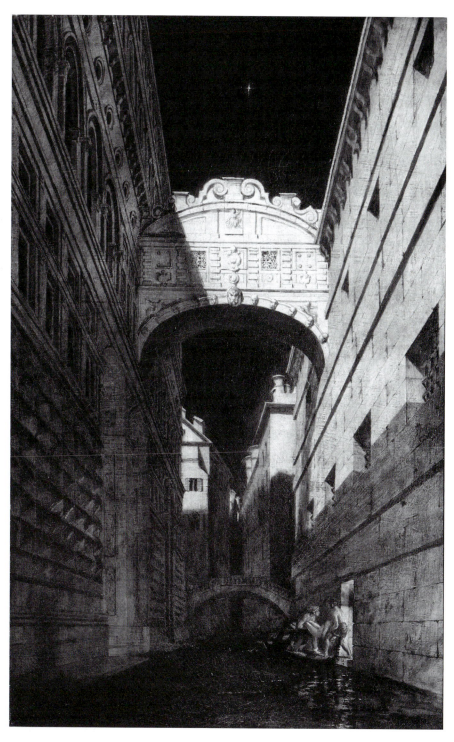

4.20 William Etty, *Bridge of Sighs*, 1833–35, oil on canvas, 31.5 x 20 in. (80 x 50.8 cm). © York Museums Trust

4.21 Thomas
Moran, *Venice*,
1913, oil on
mahogany
panel, 10.75 x
16.75 inches,
Stark Museum
of Art, Orange,
TX, 31.18.4.

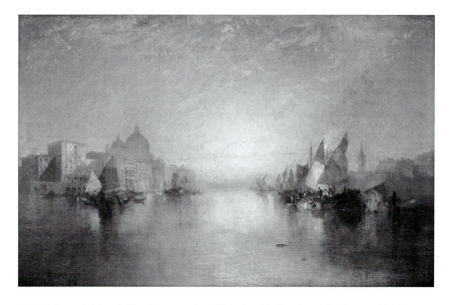

Art Union criticized *The Dogana, San Giorgio, Citella, from the Steps of the Europa* (Figure 4.3), invoking once again the rhetoric of decline in suggesting that Turner departed too much from natural appearance: "A great error in Mr. Turner's smooth water pictures is, that the reflections of colours in the water are painted as strongly as the substances themselves, a treatment which diminishes the value of objects."[69]

But where Monet eliminated objects to create a sweeping vision of two-dimensional atmosphere, Turner at times actually emphasized the reflection of solid forms. Returning to *Venice, the Bridge of Sighs* (Plate 16), look at the white highlights along the side of the prison of the Ducal Palace, both above and below the smaller Ponte della Paglia, which spans the opening of the canal between the buildings. Here the paint stands out distinctly from the canvas, causing these passages to advance even more strongly than the bridge itself, which is closer to us. But even more, Turner uses thick, scumbled paint where the building hits the water of the canal and where the reflection is drawn off to the left and downward. Some of the weighty materiality of the forms then transfers to the surface of the picture itself, where it combines with the often heavily-applied areas of paint to simultaneously emphasize both the three-dimensional solidity of the buildings and the two-dimensional surface of the picture.

These dynamics should be understood as a part of Turner's creation of an enchanted vision of the city that rises from the artist's brush. But as this vision rises, so it also falls. Indeed, it is the very process of dematerialization that Turner pictures by insisting so strongly on the similarity of objects and their reflections. Because so many of the reflections are so close to the objects—in many cases it is tellingly difficult to determine exactly where one begins and the other ends—they seem to pull the objects down, to literally "diminish the value" of what they represent, as the *Art Union* put it. The city seems to sink

downward, to be literally declining on the canvas. Consider, for instance, the reflection of the Ponte della Paglia in *Venice, the Bridge of Sighs*. There is enough continuity in the scooped curve of the reflection with the line of the bridge itself to create a complete oval. But it is a sphere that seems to be pulling apart as it is drawn downward and to the right.

A crucial part of this process for Turner, however, was the invocation of decay and decline in the very formal means by which that unity was created. What I am describing, therefore, is another very different means of reacting to the situation I have described throughout this book. Aware of the priority of decline and loss as a primary condition for painting history in the early nineteenth century, Turner sought to forge a new unity out of that very decline, even as he gave it more vivid form than any painter before him.

"In Venice Now"

Pictures such as *Venice, the Bridge of Sighs* thus cannot be understood as rejections of literary or historical narrative, nor purely in terms of their thematic resonances with decline and mortality. Instead, I have shown that an attention to fleeting, ephemeral effects of nature was a particular priority that led to Turner's concern in the pictures of Venice with the two-dimensional surface of the painting and the materiality of the paint. Yet to fully understand these paintings, to grasp the significance of the multivalent invocation of ephemerality in a picture like *The Sun of Venice Going to Sea*, one cannot simply separate Venice from the rest of Turner's oeuvre and imagine them as predecessors to Impressionism, as formalist-modernist critics have been so wont to do. Indeed, Turner's emphasis on the formal conditions of painting came not at the expense of subject matter, as pictorial modernism would have it, but from his desire to refigure the demands of history painting to the altered conditions of the early nineteenth century. It was not as an outright rejection of academicism that Turner produced the Venice pictures, but rather as a part of the desire to achieve its goals on his own terms.

One of the most astute modernist observations about Turner's paintings of Venice is Sir Lawrence Gowing's claim that by the 1830s Turner "had learned to use paint not to represent reality but to produce an equivalent for the experience of nature."[70] This registers something fundamentally important about the Venice pictures that opens onto many issues beyond formalism. I would like to explore some of them by returning to *Venice, the Bridge of Sighs*, where I have already noted the scumbled white paint that stands out along the side of the prison and carries over into the water. This treatment is used as a means to define the gradations of light and shade across the front of the buildings as well. The two most intense areas of this handling are the corners of the two buildings on either side of the canal. Turner forms the architecture by un-forming it, using the mottled application to depict the disintegrating effects of light in contrast to the shadows of the canal behind, in the case of

the Ducal Palace, and to the passing shadow that covers the right side of the prison. On that building as well, the scumbling seems to bleed across and down, so that it straddles the first window to the right of the canal and defines the right edges of the next four windows in decreasing degrees. It then is picked up in the sails of the boats in the foreground, in the clothes of the figures, and, inevitably, in their reflections. As a result, the intensely bright, scumbled paint is used both to define three-dimensional forms as well as the space of the picture (by suggesting atmospheric perspective), even as it knits together the two-dimensional surface of the canvas. In this way too it both forms and un-forms the pictured space, both creating and denying depth in the field of vision. It also carries, crucially, the intensity of the original experience, because it produces a tactile effect. That is, this handling, so characteristic of Turner, here replicates the touch of the sun on the buildings: a vivid sense of heat and energy appears to eat away at the buildings' edges. Turner is once again painting by creating transactions between materiality and nothingness. The light itself seems to become palpable even as it eats away at the stones of the buildings. This scumbled, bright paint is the means by which Turner replicates in a picture the experience of the city—its heat, its shifting light, its visionary appearance—rather than illustrating it. The tactile, physical nature of that picturing makes it clear that linked to the sense of the city as the artist's vision was a physical experience.

The nature of that physical experience—of that physicality—bears consideration, first and perhaps most obviously for its sensual, and sexual, connotations. Venice had a long-standing association in British culture as a site of sexuality and licentiousness, ideas I touched upon already in regard to the city's moral corruption and decline.[71] As that decline became more evident in the eighteenth century, and as Venice became increasingly politically irrelevant, the carnival came to define British views of the city. In terms that resonate powerfully with the themes of this book, Tony Tanner writes that "In decline and decay (*particularly* in decay and decline), falling or sinking into ruins and fragments, yet saturated with secretive sexuality – thus emanating or suggesting a heady compound of death and desire – Venice becomes for many writers what it was, in anticipation, for Byron: 'the greenest island of my imagination.'"[72] As Tanner eloquently describes, the city held both creative and destructive capacities. Byron was more comfortable with this paradox than thinkers of the previous century, and it is for this reason that I think Turner responded so powerfully to him. Eighteenth-century writers had worried about the effects of the city on male youths who visited there during the Grand Tour, encouraging them to maintain a distance from Venice's material pleasures. Margaret Doody calls this "imperial tourism," in which the British tourist was "self-consciously an observer and not a contaminated participant."[73] Sensuality was therefore at the heart of the love/hate relationship that Britons had with Venice. Clearly its wealth and physical beauty were impressive, but it literally embodied the necessary truth of the inevitable decay of both art and man.

The decline of Venice was elaborated as well in academic art theory, which marshaled itself against the immorality of Venetian materialism through its rejection of color as a basis of painting. As the primary site of the coloristic tradition of Renaissance painting, Venetian painting was consistently denigrated in academic theory. In the ongoing debate about color and line, the former stood for feminine, debased materiality, while the latter represented transcendent, masculine intellectual and spiritual qualities. This gendered conception informed the comments I cited from Reynolds and Shee in the previous chapter, in which the use of bright colors to attract attention at exhibitions was seen as "seductive" and "meretricious." Just as the imperial traveler was to remain distant from the dangerous materiality of contemporary Venice, so too was the painter to transcend Venetian color. It was on these terms that Sir Joshua Reynolds relegated the Venetians to a lower rung of the hierarchy of great art, below central Italians like Michelangelo and Raphael. Reynolds's espousal of the linear-based art of history painting was, as we saw in Chapter 2, in part intended to forestall the decay that would come with materiality and materialism. Its qualities would allow both the artist and the nation to achieve eternal fame, even after the decay of their physical being. In disqualifying Venetian art from "the nobler schools of painting," or the sublime, Reynolds pointed directly to their focus on the gratification of bodily, material pleasures. He says that in the grand style, "There is a simplicity, and I may add, severity, in the grand manner, which is, I am afraid, almost incompatible with this comparatively sensual style." Reynolds then goes on to suggest that the Venetians are at pains to dazzle viewers with the skill of their art. We have seen that Eagles and others feared the potentially contagious aspect of exactly this approach on Turner's part. Reynolds suggests that the Venetians primarily sought to be admired "the mechanism of painting," "which…the higher stile requires its followers to conceal."[74]

Turner's embrace of the physical quality of paint in passages such as those in *Venice, the Bridge of Sighs* represented an opposite approach in its foregrounding of the material quality of paint and the presence of the artist's hand. Color here seems to destroy even the possibility of line as it dissolves hard contours and makes buildings melt before our eyes. Even more, as Gowing claimed, and as contemporary critics recognized, Turner's color seems to have taken on a life of its own, to have detached itself even from nature to serve its own pictorial purposes. Thus, even as his pictures carried some of the moral overtones of eighteenth-century thought about Venice's decline, they also involved an opposite tendency, one that moved towards an immersion in sensuality. There is ample reason to believe that Turner, who, despite his abandonments of women (his mother, his illegitimate daughters) was also intensely attracted to the opposite sex, saw Venice as a space of sexual freedom. Turner made a group of watercolors from his room at the Hotel Europa during his stay in 1840. One of these (Figure 4.22) shows an adjacent rooftop, with three women who seem to respond to Turner's gaze. On the verso of the sheet is an

inscription reading, "This belongs to the Beppo Club," a reference to Byron's poem on the amorous follies of the Venetian carnival.[75] Three other drawings from Venice include references to Beppo, suggesting that Byron, whose own sexual adventures in Venice were notorious, was very much on Turner's mind in this regard as well.[76] Ian Warrell, who has explored Turner's erotic imagery extensively, suggests that it "seems unlikely to be a coincidence that so much of the extant erotica in the Turner Bequest originated during the tours to Venice."[77] Warrell also notes that this erotic charge is vividly conveyed in two sketches Turner executed in 1840, both on brown paper (Figure 4.23 and Plate 24). The first shows two women, one of them topless, leaning out of a window, flirtatiously talking with two figures below. The other sketch depicts a nude figure reclining on a bed. In both drawings the color of the female flesh stands out sharply against the earthy colors and imprecise forms that fill the rest of the sheet. The flesh is most vividly accentuated in the bright pink used to define the reclining figure, making it appear to be full of a kind of pulsing, throbbing energy indicative of rushing blood and sexual arousal.

The sensual, sometimes overtly sexual, aspect of the Venice pictures is important to note, for a discussion of decline and its relevance leaves something fundamental about the appearance of the paintings unexplained. Namely, there is a sense of excitement, of visible energy, even joy and exultation in so many of the pictures that contrasts sharply with the image of a slow decay, however beautiful. This aspect of the pictures must be accounted for. Eroticism, I think, points towards how we may do so. Turner was clearly aware of the erotic quality of Venetian colorism from an early date, as

4.22 Joseph Mallord William Turner, *Among the Chimney-pots above Venice; the Roof of the Hotel Europa, with the Campanile of San Marco*, c. 1840, gouache, pencil and watercolor on paper, 9.6 x 12 in. (24.5 x 30.6 cm). Tate TB CCCXVI 36. © Tate, London, 2011.

4.23 Joseph Mallord William Turner, *Venice: Women at a Window*, c. 1840, watercolor and body color on brown paper, 9.3 x 21.4 in. (23.6 x 31.5 cm). TB CCCXVIII 20. © Tate, London, 2011.

indicated in a draft for one of his early lectures as Professor of Perspective at the RA. Speaking of a Titian portrait Turner tellingly conflates the colors with what they depict, referring to the "softness of the female figure glowing with all the charms of color, bright, gleaming mellow, full of all the voluptuous luxury of female charms, rich, swelling and right."[78] "Full of all," "glowing with all," "voluptuous luxury," "rich, swelling": the repeated invocation of bodily plenitude and sexual arousal is unmistakable, and color is understood as the means of translating that plenitude to the canvas and communicating it to the viewer.[79]

Turner's sensual engagement with materiality is part of what makes the tactile quality of the scumbled paint of *Venice, Bridge of Sighs* (Plate 16) and the bright yellow paint that colors the sunset sky in *St. Benedetto, looking towards Fusina* (1843, Plate 25) so striking. In the latter case this intense physicality works directly against the metaphoric connotations of the setting sun and its inevitable reference to Venice's decline. It fuels the expression of immediate experience for which sexuality stood for Turner, at least in part. The searing colors of the skies in watercolors such as *Orange Sunset over the Lagoon* (1840, Plate 26) and *Venice at Sunrise from the Hotel Europa* (1840, Plate 27) burn with this energy as does the loosely defined building at the center of the *Capriccio with San Giorgio Maggiore, Venice* (Plate 28, c. 1840). The orange in these works, or the horizontal pink cloud in *Venice from the Punta della Dogana* (1840, private collection)[80], or even the subtle glow of the much earlier *Venice: San Giorgio Maggiore – Early Morning* (1819, Plate 29), are the formal equivalents of the reclining nude in the sketch on brown paper: a tonal center to the image that pulses, or even throbs, with life force. This same intensity is present in many

of the watercolors of the Houses of Parliament on fire (for instance, Figure 2.19), which points to an intriguing linkage also between sexuality, creativity and destruction. I am suggesting, then, that the eroticism in Turner's Venice pictures is to be understood not merely as the depiction or elaboration of sexual desire, but also as one sign of the intensity of the physical engagement of the artist with experience and with representation, just as we saw with the bright scumbled paint of *Venice, the Bridge of Sighs*. It is with this in mind that we might consider a note furtively scribbled early in his career in his notes for an RA lecture: "a good artist," Turner wrote, "must by all means be a concealer of his art...the artist in his picture ought to be completely hid."[81] If this seems an unlikely sentiment for Turner, it indicates the depth of his allegiance to Reynolds by repeating the idea cited above, that the hand of the artist must be obscured in the final work. The passage is also suggestive in terms of the relationship between individuality and a national style since it suggests that in the first years of his career Turner, at least officially, still gave primacy to the suppression of private goals and ambition. But Turner's phrasing here is wonderful, precisely because it implies its opposite. Firstly, it suggests that the artist is indeed physically present, and must be so, but must also be hidden. Secondly, if we read it this way, then Turner's use of "completely" suggests that the imagined physical immersion in the picture must be total and all-consuming. Once again, one thinks of Turner's request to be buried in his paintings, which is yet another manifestation of the desire to be immersed into the paintings themselves, this time by the dissolution of the body.[82]

For Turner, this sense of an immersive, eroticized entry into the space of the picture was not necessarily something that was mutually exclusive with the more typical moral themes of history painting. To explain this, as well as enter into the broader question of the place of eroticism in Turner's work, I would like to look at a picture which, not unlike the Canaletto painting, explicitly considers the relationship of the artist to empire: *Rome, from the Vatican* (1819, Figure 4.24). Here, as in the Venetian picture, the artist and his work occupy the foreground while an imperial vista opens up in the distance. *Rome, from the Vatican* is clearly an important work for Turner's overall conception of history. It has been explored in particular by Gerald Finley, who notes that it is both a "public salute" to Raphael and a "private celebration" of Turner's experience of Rome and his connection to Raphael.[83] This is significant, for it combines a personal, individual approach with a more general, national one. Turner explores this relationship by including both the public vista of Rome and Raphael's distinctly private relationship with La Fornarina, who is positioned next to a rather gentle-looking picture of the *Expulsion*.[84] As we have seen, for Reynolds the artist could achieve lasting fame for himself and his nation by eschewing sensual painting in favor of the ideal, intellectual style of history painting. By placing the eroticized Fornarina immediately before Raphael and the Renaissance city he helped immortalize, however, Turner implicitly questions the separation between sensuality and public painting. Thus La Fornarina serves as the object of desire and the inspiration for creativity, even as the *Expulsion* suggests the destructive consequences of that inspiration.

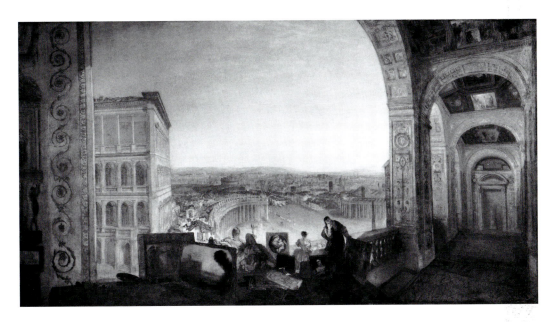

The pose Turner uses for La Fornarina is significant as well. She is shown from above and behind, with her hair swept up so that the light falls on her right shoulder and breast (detail, Figure 4.25). This pose, or some variation of it, recurs frequently in depictions of women in Turner's oeuvre and is often connected to erotic themes. Martin Butlin has linked it to Fuseli, while Selby Whittingham convincingly ties it to the French tradition, especially Watteau, and to Dutch painters like Ter Borch.[85] Its first appearance in Turner's oeuvre, however, is in the tiny Guards sketchbook of 1817–8, a year before *Rome, from the Vatican*. Here, a back-turned woman with her hair pulled up appears twice (Figures 4.26 and 4.27).[86] In the second drawing this figure is the specific object of study, as Turner pays close attention to the line of her sloping shoulders leading up her neck to the hairline. Clearly this pose resonated with Turner, for he used it again when he came to paint La Fornarina as an embodiment of the painter's desire. The ongoing connection of the pose to eroticism is particularly evident in a painting that recalls Ter Borch's amorous subjects, *Two Women with a Letter* (1830, Figure 4.28). Here Turner places the figures very close so that they seem in some ways to present two views of the same woman, whose neck and shoulders are available to the gaze but who also looks flirtatiously at the artist/viewer. The sketch for the picture focuses even more exactly on the neck and shoulders seen from behind (c. 1827–1835, Figure 4.29).[87] Here the effect is very different, as the other figure is equally absorbed in the act of reading,[88] so the artist/viewer is akin to a voyeur, able to survey the contours of the figure without her knowledge. Turner further explored the figure in relation to a more recognizable setting in a drawing of 1832 (Figure 4.30).[89] Here she appears as someone observed in more ordinary circumstances, as if she had been accidently encountered upon entering a sitting room.

4.24 Joseph Mallord William Turner, *Rome, from the Vatican. Raffaelle, Accompanied by La Fornarina, Preparing his Pictures for the Decoration of the Loggia*, 1819, oil on canvas, 69.8 x 132 in. (177.2 x 335.3 cm) © Tate, London, 2011.

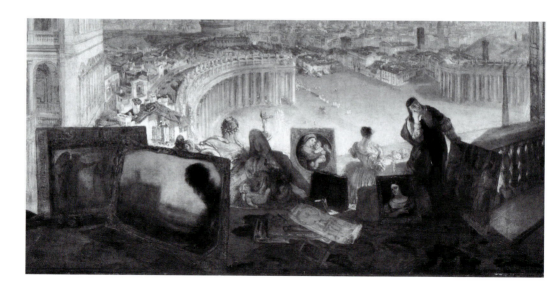

4.25 Joseph Mallord William Turner, *Rome, from the Vatican. Raffaelle, Accompanied by La Fornarina, Preparing his Pictures for the Decoration of the Loggia*, detail, 1819, oil on canvas, 69.8 x 132 in. (177.2 x 335.3 cm) © Tate, London, 2011.

4.26 Joseph Mallord William Turner, *Female Figures*, from the "Guards" sketchbook, c. 1817–8, pencil on paper, 2.7 x 4.1 in. (6.9 x 10.3 cm). TB CLXIV 6. © Tate, London, 2011.

4.27 Joseph Mallord William Turner, *Female Figures*, from the "Guards" sketchbook, c. 1817–8, pencil on paper, 2.7 x 4.1 in. (6.9 x 10.3 cm). TB CLXIV 7 © Tate, London, 2011.

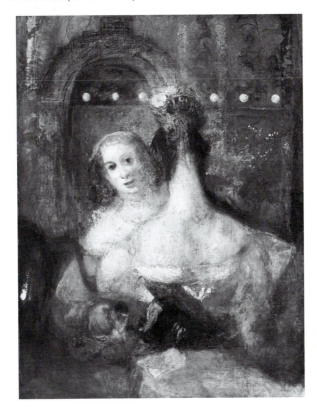

4.28 Joseph Mallord William Turner, *Two Women with a Letter*, c. 1830, oil on canvas, 48 x 36 in. (121.9 x 91.4 cm). © Tate, London, 2011.

4.29 Joseph Mallord William Turner, *Sketch for "Two Women and a Letter"*, c. 1827–35, pencil on paper, 6.3 x 7.9 in. (15.9 x 20.1 cm). TB CCCXLIV d 350 © Tate, London, 2011.

4.30 Joseph Mallord William Turner, *Sketches for "Music at East Cowes Castle"* and *"Two Women and a Letter"*, from "Seine and Paris" sketchbook, 1832, pencil on paper, 6.9 x 4.6 in. (17.4 x 11.7 cm). TB CCLIV 24. © Tate, London, 2011.

If this pose was particularly associated with desire, and, by means of *La Fornarina*, came to stand for Turner as a prompt to the artist's creative investment in his work, then it is remarkable to note its recurrence in other finished pictures from these years. Two variations occur in the amorous Shakespearian subject *What you Will!* (1822, Figure 4.31), and it is foregrounded in *Boccaccio Relating the Tale of the Bird-Cage* (1828, Figure 4.32). Here it is significant that the back-turned figure does not appear in the preparatory sketch for the painting, even though the position of the figures in the left foreground is similar. This change suggests that the figure and its pose were deployed in a relatively spontaneous manner, something associated with the physical experience of painting rather than planning a picture or drawing. But most significant is the presence of the back-turned woman no less than four times in a picture that was clearly an important one for Turner, *England - Richmond Hill, on the Prince Regent's Birthday* (Figure 4.33). This picture was exhibited the year before *Rome, from the Vatican* and was in some ways a counterpart to that picture. As Andrew Hemingway and others have discussed, Turner's pictures of the Thames Valley were deeply symbolic as depictions of the English nation.[90] In this case, as Gage notes, Turner directly incorporated a Watteau-inspired depiction of figures in the hopes of attracting royal patronage.[91] Three of these figures—the two seated women at left, and the woman at far left walking arm-in-arm with a black-clad figure—can be

4.31 Joseph Mallord William Turner, *What You Will!*, 1822, oil on canvas, 19 x 20.9 in. (48.3 x 53.1 cm). Sterling and Francine Clark Art Institute, Williamstown, USA/The Bridgeman Art Library.

4.32 Joseph Mallord William Turner, *Boccaccio Relating the Tale of the Bird-Cage*, 1830, oil on canvas, 48 x 35.4 in. (121.9 x 89.9 cm). © Tate, London, 2011.

found in Turner's copy of Watteau's *L'Isle Enchanteé*.[92] In bringing this sensual element into the picture by way of Watteau, whose association with the line of coloristic painting was very clear, Turner unites the moral concerns of history painting with those of pleasure. Furthermore, he suggests that sensuality and even erotic desire play an important role in the generative process of the artist. Taken together, the *England* and *Rome* pictures represent powerful denials of the separation between the sterner pursuit of a linear-based history painting and the coloristic tradition and, as well, the separation of idealism and sensuality.

Given this background, it is interesting that the back-turned pose does not appear in the Venetian pictures, where sensuality plays a key role. This may be because Turner felt that the associations of eroticism were already prevalent enough in the pictures not to need this form. A more comprehensive explanation may be that in the Venice works Turner was focusing on bringing this sensual bodily engagement into the act of painting in more subtle and extensive ways, especially through color and the tactile experience of paint. The notion of a bodily immersion seems to be part of the message of *Bridge of Sighs, Ducal Palace and Customs-House, Venice: Canaletti Painting* (Plate 1), which stands at the beginning of Turner's period of painting Venice. We can remember that the picture was created largely during the Varnishing Days, and that accounts of Turner at that time stressed his absolute absorption into the process of painting to the point of ignoring his surroundings. As I have said, such accounts were likely exaggerated for various strategic reasons, but the rhetoric is also suggestive of an awareness that Turner seemed to be more within the space of the painting than that of the Academy. Turner's imagined absorption into the space of the painting is further indicated by the fact that Turner includes Canaletto as his surrogate, painting under the same circumstances as Turner, with the canvas already in its frame.

4.33 Joseph Mallord William Turner, *England – Richmond Hill on the Prince Regent's Birthday*, 1819, oil on canvas, 70.9 x 131.7 in. (180 x 334.6 cm). © Tate, London, 2011.

The fact that Canaletto is shown engaged in the vigorous process of painting, the very process which Turner had publicly foregrounded during the Varnishing Days, also suggests the presence of another kind of physicality, one that may be equally important: work. While late twentieth-century scholarship has been consistently drawn to the issue of desire with respect to investigations of cultural embodiment, the idea of work has received much less attention, as Elaine Scarry points out. Work, Scarry writes, is also fundamentally about the material relation of human beings to the world around them. These themes were woven deeply into nineteenth-century life itself, and they were dominant in novels of the period, especially Hardy's.[93] In considering the idea of work for Turner, it is worth remembering that Rippingille had spoken of Turner's claim to be able to "outwork" other painters; Warrell has noted that Turner was always an "energetic and assiduous worker." Early in his career, Turner wrote privately about the importance of joining "what we call genius" with "great industry and application," and later in his career he claimed that his only secret was "damned hard work."[94] Another indication of the importance of work to him in Venice in particular comes from 1840. The sixty-five year old Turner stayed that year at the Hotel Europa with fellow artist William Callow, then twenty-eight. Callow reports that one evening while he enjoyed a cigar on a gondola he "saw in another one Turner sketching San Giorgio Maggiore, brilliantly lit up by the setting sun. I felt quite ashamed of myself idling away the time while he was hard at work so late."[95]

Individually, these references may seem anecdotal, but taken together they speak to a valuation of labor and explain a significant aspect of how these pictures posit an embodied relationship to the world for both artist and viewer that is based on the physical experience of the environment. To understand this further, it is useful to explore a brief comparison between Turner and his fellow Romanticist, Thomas Cole. Consider two paintings of the rise of empire: Cole's *Pastoral State* (1836, Figure 4.34), from the *Course of Empire* series, and Turner's *Dido Building Carthage* (1815, Plate 9). Cole's picture concentrates on agrarian pursuits, the development of science, and the emergence of religion, but no physical labor is shown except for a very small scene of boat-building relegated to the distance. Turner's seaport, on the other hand, is a hive of activity. Behind Dido are scenes of boats being unloaded and heavy materials being hauled ashore. All along the left-hand shore, stretching into the distance, bodies twist, bend, pull, and lean with the effort of physical exertion. Turner chose to depict a particular moment in Book One of the *Aeneid* that emphasizes the construction of the new city:

Aeneas found, where lately huts had been,
Marvelous buildings, gateways, cobbled ways,
And din of wagons. There the Tyrians
Were hard at work: laying courses for walls,
Rolling up stones to build the citadel,
While others picked out buildings sites and plowed
A boundary furrow...[96]

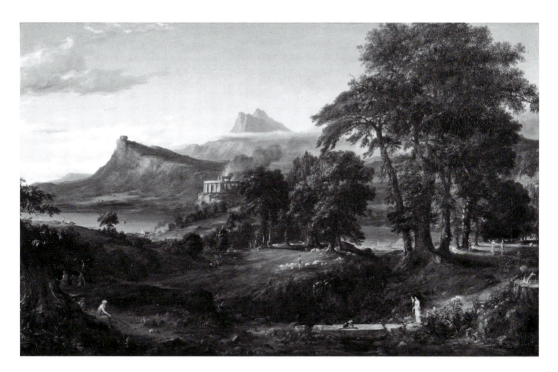

To be sure, Cole's image is a pastoral and Turner painted a number of similarly Arcadian landscapes throughout his career, but the point is that Turner stressed the physical process of the rise of empire whereas Cole suppressed it. Note the stacked logs on the right-hand shore in *Dido*, juxtaposed to the verdant green woods behind them. In a scene of ancient myth, Turner alluded to an industrialized harnessing of natural resources with a directness that we can never imagine in Cole's work. Cole was deeply ambivalent about the progress of civilization in the New World and its effect on the landscape, and so this was exactly the kind of development that he could not picture, a process that he saw as leading to the destruction rather than creation of empire. Even as he was extolling the "virgin waters" of America, as Alan Wallach and Angela Miller have discussed, Cole lamented the rampant "utilitarianism" that he thought was leading to its destruction.[97] For Cole, sensuality could only be pictured in negative terms, transformed into pleasure and luxury. His rendition of the *Consummation of Empire* (1836, Figure 4.35) is decidedly not a scene of labor; there is no representation of the means of production. Rather, he presents an elite enjoyment of the fruits and pleasures built by the invisible hand of labor.

It is instructive to remember that Cole had also almost certainly read Reynolds's *Discourses*. As we have seen, Reynolds cast the world in terms of a progress towards civilization and away from barbarism. His claims for the importance of art were based in its ability to contribute to this movement by transforming base material desires into ideas. Reynolds focused on the subject of the elite male who could maintain a distance from the materiality

4.34 Thomas Cole, *The Course of Empire: The Arcadian or Pastoral State*, 1836, oil on canvas, 39.75 x 6.75 in. (99.7 x 160.7 cm). Collection of the New-York Historical Society.

4.35 Thomas Cole, *The Course of Empire: Consummation of Empire*, 1836, oil on canvas, 51.25 x 76 in. (130.2 x 193 cm). Collection of the New-York Historical Society.

of the land and his own needs. At root then, Reynolds's outlook was of a piece with the theory of virtual representation espoused by Burke: both argued against expanded suffrage and for the continued importance of the land-owning gentleman as a bulwark against the moral decay of society. This view, in turn, was shared among Cole's Federalist patrons in the 1820s and 30s.[98] It was likely buttressed by Cole's interest in the associationist aesthetics of Archibald Alison, which legitimated the cultural authority of the landed classes by stressing a disinterested relationship to the landscape.[99] Distancing viewers from the material details of the landscape and the labor that would transform it, Cole's pictures produced the viewing conditions for the kind of disembodied, elite male subject who was central for both Reynolds and Burke by incorporating the raw, American wilderness into the accepted formulae of European landscape, whether sublime or beautiful. He signals the viewer's distance from the material, wild state of nature in pictures such as *Autumn Twilight, View of Corway Peak [Mount Chocorua], New Hampshire* (1834, Figure 4.36) by the presence of Native Americans, who he and Reynolds would have agreed lived too close to the savage state of nature to understand it in anything beyond material terms. By contrast, the viewer of *View on the Catskill, Early Autumn* (1837, Figure 4.37) maintains a distance from the landscape.

I have lingered on Cole because his work, like Turner's, unites history and landscape. But in representing an aristocratic outlook with respect to the individual and the progress of the state, Cole makes a convenient contrast

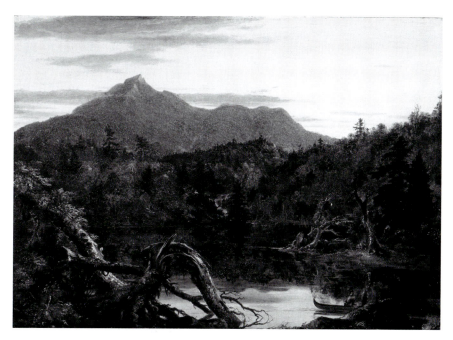

4.36 Thomas Cole, *Autumn Twilight, View of Corway Peak [Mount Chocorua], New Hampshire*, 1834, oil on canvas. 13.75 x 19.5 in. (34.9 x 49.5 cm). Collection of the New-York Historical Society.

4.37 Thomas Cole, *View on the Catskill, Early Autumn*, 1836–7, oil on canvas, 39 x 63 in. (99.1 x 160 cm). Gift in memory of Jonathan Stuges by his children, 1895 (95.13.3), The Metropolitan Museum of Art, NY. © The Metropolitan Museum of Art/Art Resource, NY.

against which we can highlight Turner's very different vision of work. It is significant in this regard to note that on the one hand there is, as John Barrell has noted, a certain resistance in many of Turner's paintings to depicting laborers as mindless automatons. [100] At the same time, there are also a number of vivid, particularized depictions of bodies at work throughout Turner's oeuvre. A small sample would include: fisherman straining to fight their way off a lee-shore (Figure 2.1); a man struggling to pull two horses against a strong Scottish wind (Figure 4.38); wreckers heaving the remains of a ship to shore (Figure 4.39); fishers bending low to collect bait in the shallows (Figure 4.15); and the leaning bodies of workers struggling to tow a barge against the current (Figure 4.40). These figures are neither incorporated into existing modes for depicting laborers nor personalized and made anecdotal or sentimental. Instead, the depiction of exertion traces a physical interaction with the natural world that is the opposite of Cole's disembodied, visual distance from the landscape. Turner persists in showing precisely the kind of activity that Cole tried to eliminate from representation. This is perhaps most clear in *Keelman Heaving in Coals by Moonlight* (Figure 4.5). The picture is remarkable in its admission not just of labor into the sphere of painting, but of industrial labor: the coalmen are highlighted against the industrial fires burning into the night. We have already seen that Turner may have used this work to connect British industriousness and industrialism to the continued viability of its empire. As such, Turner seems to suggest that the very forces that Cole and Reynolds saw as causal to the downfall of empire, namely the loss of an elite male subject who could remain sufficiently distant from the material aspect of nature, were to be its basis.

4.38 Joseph Mallord William Turner, *Borthwick Castle*, watercolor, 1818, watercolor and scratching-out, 7 x 10.375 in. (17.8 x 26.4 cm). Indianapolis Museum of Art. Gift in memory of Dr. and Mrs. Hugo O. Pantzer by their children.

4.39 Joseph Mallord William Turner, *St. Mawes, Cornwall*, ca. 1823, Watercolor and scraping out,
5 5/8 x 8 5/8 inches (14.3 x 21.9 cm). Yale Center for British Art, Paul Mellon Collection.

4.40 Joseph Mallord William Turner, *The Bridge of Meulan*, c. 1833, gouache and watercolor on paper,
5.6 x 7.6 in. (14.2 x 19.3 cm). © Tate, London, 2011.

This sense of an immersion in the physical environment of the Venice pictures is, to my mind, their defining feature. It is the only one that can fully explain the particular mixture of elements of history and naturalism, past and present, which make them so difficult to classify. While scholars such as David Laven are quite right in arguing that Turner's paintings of Venice largely ignore the contemporary city in favor of a vision of its past,[101] their pervasive naturalism often works counter to this idea: it creates a very different kind of expression, one focused on the immediacy of a present, physical experience. This is perhaps most visible in the watercolors, in which Turner often set himself the particular challenge of arresting nature at a precise moment of conditions. The pictures of sunsets (Plates 18, 22, 26), as well as the storm pictures such as *Venice, Storm at Sunset* (1840, Figure 4.11) and *Storm at Sunset* (1840, Plate 18), place the viewer before scenes that are defined by flux and changeability, in which the fluid quality of the medium matches the ephemeral world it depicts. In the latter, the solid structures of the city are distant and ethereal, while the natural world, in all its constant movement, is vividly, blazingly present. This presence is also a temporal present-ness. However much the setting sun and the storm speak metaphorically to the extinction of the Venetian empire, these meanings seem to fall away in the face of a powerfully immanent present experience, one that was not just seen but felt. Specifically in regard to work, we must note in *Storm at Venice* (Figure 4.11) the figure of the gondolier leaning forward to press his craft onward against wind and current. The same figure, which is more clearly laboring than other gondoliers which are also found in numerous paintings, recurs throughout the Venice pictures in both paintings and watercolors. It appears even more dramatically posed in *Storm at the Mouth of the Grand Canal* (1840, Figure 4.41). The leaning gondolier can also be found twice in *Santa Maria Della Salute from the Bacino* (1840, Figure 4.42), and in *The Dogana, San Giorgio, Citella, from the Steps of the Europa* (1842, Figure 4.3), *Campo Santo* (Figure 4.6), *Santa Maria della Salute, the Campanile of San Marco, the Doge's Palace and San Giorgio Maggiore, from the Giudecca Canal* (1840, Figure 4.43) in cursory, but unmistakable form again in *Ducal Palace, Dogana, with part of San Giorgio, Venice* (1841, Figure 4.44). Of course, gondoliers were a constant element in depictions of Venice by all manner of artists. But if this might lead us to dismiss this as mere staffage, it is striking when we note that in the watercolors especially the gondolier is sometimes isolated against the background of water (Figures 4.11 and 4.41, for instance), as opposed to being integrated into an overall depiction of activity and movement. The result is at least in part a focus on the interaction of the working individual with nature. This is reinforced by the fact that many of the depictions of gondoliers show them as solitary rather than interacting with passengers. This matches with the sense of intensity in the natural conditions, whether stormy or still, to give the depiction of work a meditative, almost reverent quality. In this regard, it is significant that the laboring gondolier appears also in the bottom right of the *Bridge of Sighs, Ducal Palace and Custom-House, Venice: Canaletti Painting,* (1833, Plate 1), a picture which I have already argued was central

4.41 Joseph Mallord William Turner, *Storm at the Mouth of the Grand Canal, Venice, Looking towards the Piazzetta and San Giorgio Maggiore*, c. 1840, watercolour and bodycolour, with details added using a pen dipped in watercolour, on off-white wove paper, unframed, 21.8 x 31.9 cm. National Gallery of Ireland. Photo © National Gallery of Ireland.

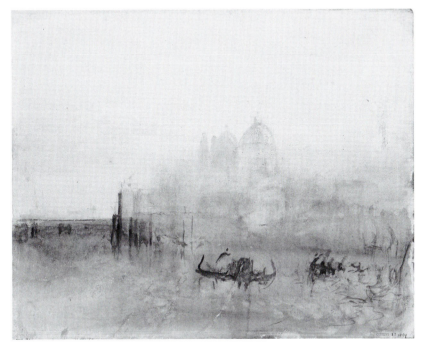

4.42 Joseph Mallord William Turner, *Santa Maria Della Salute from the Bacino*, 1840, pencil and watercolor, 9.6 x 12.1 in. (24.4 x 30.7 cm). TB CCCXVI 37. © Tate, London, 2011.

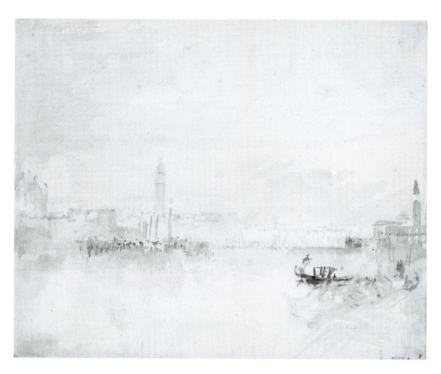

4.43 Joseph Mallord William Turner, *Santa Maria della Salute, the Campanile of San Marco, the Doge's Palace and San Giorgio Maggiore, from the Giudecca Canal,* 1840, watercolor, 9.6 x 12.1 in. (24.5 x 30.8 cm). TB CCCXVI 8.
© Tate, London, 2011.

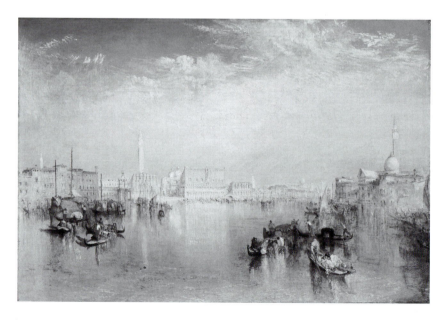

4.44 Joseph Mallord William Turner, *Ducal Palace, Dogana, with part of San Giorgio, Venice,* 1841, oil on canvas, 25 x 36.6 in. (63.5 x 93 cm). Allen Memorial Art Museum, Oberlin College, Ohio, Mrs. F.F. Prentiss Bequest, 1994

to Turner's conception of the work of painting. The diagonal form of the gondolier also reprises the working bodies in other pictures by Turner and speaks once more to a physical engagement with natural conditions that will change almost immediately, especially in cases like *Venice, Storm at Sunset*. These watercolors, it seems, are too much concerned with this ever-changing present to allow the past and future to dominate the pictorial poetics. At the same time, however, this kind of aesthetic speaks to the fleeting nature of beauty and the inevitability of change and passage in a way that re-inscribes notions of imperial rise and fall.

In the paintings, this present-tense quality is visible also in the skies, in the changing light of sunset and the shifting, wispy clouds that dance across the blue of the mid-day scenes. The subtle treatment of the skies in the Venice pictures is one reason that Ruskin thought so highly of the works, as he is particularly attentive to these upper spaces in the first volume of *Modern Painters*. At the beginning of a passage on Turner's Venetian pictures, Ruskin speaks of the clouds as "breathing" and continues: "That sky—it is a very visible infinity,—liquid, measureless, unfathomable, panting and melting through the chasms in the long fields of snow-white, flaked, slow-moving vapour, that guide the eye along their multitudinous waves down to the islanded rest of the Euganean hills."[102] The passage emphasizes mobility and change; there is the "slow-moving vapour" but also the "panting," "melting" sky. Things also shift rapidly from one material state to another, so in the "liquid" sky there is ground, for the clouds are "fields," but also gases: "vapour" eventually becomes liquid again ("multitudinous waves") before leading back to the ground of the hills. What Ruskin describes is, among other things, an attentiveness to the momentary appearances of nature, which, in turn, yields greater truths about its permanent structure: "Hence, the importance of the truth," he writes in a discussion of high clouds, "that nature never lets one of the members of even her most disciplined groups of cloud be like another."[103] For Ruskin, part of Turner's incomparable skill is his attentiveness to this infinite variation and changeability: "There is but one master," he says, "… one alone who has taken notice of the neglected upper sky; it is his peculiar and favourite field; he has watched its every modification, and given its every phase and feature; at all hours in all seasons, he has followed its passions and its changes, and laid open to the world another apocalypse of Heaven."[104]

This same sense of immediacy and instantaneousness is also visible in subtle details that seem to undercut the stillness of pictures such as *Venice: The Dogana and San Giorgio Maggiore* (1834, Figure 4.4) and *Venice, from the Porch of the Madonna della Salute* (1835, Figure 4.1). Both pictures are relatively typical of the 1830s in their assemblage of brightly-colored sets of figures posed in Shakespearian garb scattered through the fore- and middle-grounds. The former picture, as we have seen, has been considered to contrast Venetian indolence to British industriousness. But in the right foreground a long diagonal shape stretches into the water. This is the shadow of a figure striding towards the right, along the same plane as the point-of-view of the artist/

viewer. Two such shadows are visible on the water in *Venice, from the Porch of the Madonna della Salute* as well, albeit more dimly rendered. Once noticed, these shadows introduce an element of immediate temporality and movement into the lower half of the pictures that aligns with the movement implied in the clouds and sky above. This present-ness also signals a bodily presence as they act to locate the viewer more firmly on the ground before the picture, in a more definite space.

In this sense, Margaret Plant is right to connect Turner's Venetian pictures to the changes in nineteenth-century viewership described by Jonathan Crary. Although he does not discuss the Venice pictures specifically, Crary sees Turner as emblematic of the shift towards making perception "a primary object of vision." For Crary, pre-modern viewership was defined by the camera obscura, which suppressed the actual process of perception in allowing a scene to be apprehended completely and immediately in one view while maintaining a visual distance from it. Against this, however, Crary comments that "Our experience of a Turner painting is lodged amidst an inescapable temporality." Crary describes Turner's depictions of the sun as "carnal embodiment[s] of sight," in which the sun as the object of vision becomes fused with the eye itself. Crary relates such developments convincingly to broader changes in scientific understandings of sight and vision, but here the point is that he acknowledges both the temporal and bodily basis of painting that I have described in the Venice pictures.[105]

To embrace the body as a primarily physical experience of the world, one that triumphs over the intellect, is to take joy in corporeal existence. This joy of the body carries with it, however, the knowledge of the inevitability of decay and death. It is precisely this sort of dual movement that characterizes Turner's images of Venice, as they resist and lament decay while simultaneously celebrating the pleasures of life. It is in this way also that decline gains its most poignant meanings in the Venice pictures. In their embrace of color and its sensual appeal, and of work as a kind of bodily existence, the paintings ask us to take joy in the world as we work and love in it, even as they acknowledge the inevitability of national decline and individual mortality. Indeed, far beyond the erotic overtones I have described, it is in Turner's depictions of the extraordinary effects of light and color at a given moment that the greatest joy of his work resides.

It is this quality of joy in the celebration of the conditions of existence, ephemeral as they may be, that informs Ruskin's comments on Turner and Venice, which are some of his most powerful. Ruskin begins by describing the Venice of Canaletto, Prout, and Stanfield, seeking in each the sensation of being "in Venice again" and finding each wanting in some way. The relative success or failure of each is cast consistently in terms of both the joy and immediacy of Venetian light. Notice in the following passage on Canaletto's light the repeated gerunds, which convey an almost ecstatic sense of desire:

Presently…we begin to feel that it is lurid and gloomy, and that the painter, compelled by the lowness of the utmost light at his disposal to deepen the shadows, in order to get the right relation, has lost the flashing, dazzling, exulting light, which was one of our chief sources of Venetian happiness.[106]

As he comes to Turner, Ruskin's description takes on the form of an awakening, an emergence into a light that seems to consume his whole being. At the beginning of the passage, he invokes a step, a physical movement into an awakening sense of physical joy:

But let us take, with Turner, the last and greatest step of all. Thank heaven, we are in sunshine again, —and what sunshine! Not the lurid, gloomy, plague-like oppression of Canaletti, but white, flashing fulness of dazzling light, which the waves drink and the clouds breathe, bounding and burning in intensity of joy.

In the wonderful alliteration of "flashing fulness" Ruskin here captures exactly the sense of a plenitude of present-ness that I have tried to describe as defining Turner's work. Ruskin also invokes the acts of breathing and drinking, the two initial physical activities of a newborn baby. But if this step is a kind of awakening or birth, both for the viewer and for a new kind of painting, which Ruskin constantly divides from the past, it is also a death: the "last and greatest step of all." Implicit in Ruskin's response is a sense of the interlinked processes of bodily formation and dissolution. As one joins fully with the natural world through the recreated experience of painting, to achieve this unity means a complete immersion and loss of bodily singularity. Ruskin identifies the most ephemeral aspects of the picture as its most profound:

Detail after detail, thought beyond thought, you find and feel them through the radiant mystery, inexhaustible as indistinct, beautiful, but never all revealed; secret in fulness, confused in symmetry, as nature herself is to the bewildered and foiled glance, giving out that indistinctness, and through that confusion the perpetual newness of the infinite, and the beautiful.

The passage proceeds by a set of paradoxes—never all revealed/fullness, and confused/symmetry—to find form and revelation in the very flux ("indistinctness") of nature and experience. Ruskin's final phrase in this extraordinary passage captures exactly the sense of a combined temporal present-ness and physical presence within the world that I have tried to describe: "Yes, Mr. Turner, we are in Venice now."[107]

Indeed, if this chapter arrives at a familiar point for understanding Venice, namely, Ruskin and naturalism, it has also attempted to bring attention to the complexity of meaning in these, the last three words of his passage: "in Venice now." Turner places us bodily within the space of historical decline, but also in a present experience that is immediate and powerful. We need to see, however, this present-ness, this immediacy, however modern it seems, and however familiar to eyes accustomed to Impressionism it may be, not merely as a rejection of the academic tradition and contemporary tastes, but

as emerging from Turner's negotiation with them. As a result, the kind of viewing and creating that Turner posits in the Venetian pictures is one that dramatically redefines the subject of history painting. It is a question for Turner of nature as history and of an embodied, and physically and temporally present, subjective experience, a far cry from the absented, transcendent figure espoused by thinkers like Reynolds. In the final chapter we will consider the difficulty posed by the issue of slavery and abolition to this modern subject.

Endnotes

1 A.J. Finberg, *In Venice with Turner*, 1930, cited in Ian Warrell, "Epilogue: The Legacy of Turner's Venice," in Ian Warrell (ed.), *Turner and Venice*, exhibition catalog (London: Tate Publishing, 2003), p. 251.

2 John Gage, "Turner in Venice," in J.C. Eade (ed.), *Projecting the Landscape* (Canberra: Humanities Research Centre, Australian National University, 1987), pp. 72–77.

3 Anonymous review, *The Spectator*, 6/254 (May 11, 1833): p. 432.

4 Sam Smiles, "'Splashers', 'Scrawlers' and 'Plasterers': British Landscape Painting and the Language of Criticism," *Turner Studies*, 10/11 (1990): pp. 5–11.

5 Anonymous review, *The Spectator*, 6/254 (May 11, 1833): p. 432.

6 Anonymous review, *The Times*, May 9, 1843.

7 Sir Lawrence Gowing, *Turner: Imagination and Reality*, exhibition catalog (New York: Museum of Modern Art, 1966), p. 19.

8 Gowing, *Imagination and Reality*, p. 33.

9 Margaret Plant, "Venetian Journey," in Michael Lloyd (ed.), *Turner*, exhibition catalog (Canberra: National Gallery of Australia, 1996), pp. 151–55.

10 Warrell, "Turner and Venice," in Warrell (ed.), *Turner and Venice*, p. 14.

11 George Jones "A Short Memoir of Turner," in John Gage (ed.), *The Collected Correspondence of J.M.W. Turner* (Oxford: Oxford University Press, 1980), p. 5.

12 Andrew Wilton, *Turner as Draughtsman* (Aldershot and Burlington, VT: Ashgate, 2006), pp. 118–134.

13 John Ruskin, *The Stones of Venice* (2 vols., New York: John B. Alden, 1885), v. 1, p. 15.

14 John Ruskin, *Praeterita*, in E.T. Cook and Alexander Wedderburn (eds), *The Work of John Ruskin* (39 vols., London: G. Allen, New York: Longmans, Green, and Co., 1903–12), v. 25, p. 295.

15 George Gordon, Lord Byron, *Childe Harold's Pilgrimage*, H. F. Tozer (ed.), (Oxford: Clarendon Press, 1916), Canto IV, ll. 19–22, pg. 143.

16 William Wordsworth, "On the Extinction of the Venetian Republic," (1802): ll. 11–14.

17 Byron, *Childe Harold's Pilgrimage*, Canto IV, ll. 95–99, 112–4, pp. 145–6.

18 Byron, *Childe Harold's Pilgrimage*, Canto IV, ll. 149–53, p. 147.

19 John Eglin, *Venice Tranfigured: The Myth of Venice in British Culture, 1660–1797* (New York and Basingstoke: Palgrave, 2001), p. 1.

20 Eglin, *Venice Transfigured*, pp. 27–43.

21 Eglin, *Venice Transfigured*, p. 6.

22 Eglin, *Venice Transfigured*, p. 9.

23 Byron, *Childe Harold's Pilgrimage*, Canto IV, ll. 1–2, p. 143.

24 For instance, a story of 1831 in *La Belle Assembleé*, which would have been known to Turner for its art reviews, mixes a love story with historical fiction around the figure of Galileo. It begins by describing the immersive sensual experience of Venice: "The evening, by which that night had been preceded, was lovely as the loveliest evening of Italy. All was soft, and tender, and

beautiful. One of the many festivals for which Venice is famed had filled the *Piazzetta* with dance and song, and mask and spectacle: if the sigh, the gentle glance of love, the whispered note of ardent passion—of mirth and gaiety, and obstreperous laughter, that rent the very air—could be regarded as the criterion of happiness, the motley assemblage, by which the *Piazzetta* and all its avenues were crowded, must have been pronounced the happiest of earth's happy ones. But the unhallowed sounds disturbed not Galileo: by him they were unheeded and unheard." The story then shifts, however, to evocations of repressive government and nefarious night-time doings: "That night, the *Consiglio di Deici* were busy in their 'den of death;' that night — that fatal night — three of the proudest nobles of Venice were dragged from their damp and pestiferous *Pozzi*, beneath the state prison in which they had been long immured—hurried over *Il Ponte dei Sospiri*—and consigned to the sword of the executioner on the giant's stairs of *La Palazza Ducale*. Nor was this the only sacrifice of blood upon that memorable night. Six individuals, of humble birth, implicated in the crimes, real or imagined, of their superiors, were first strangled and then decapitated in succession between those antique and magnificent pillars which face the splendid palace of the Doge." ("La Piazzetta de San Marco," *La Belle Assembleé*, 13/76 (April 1831): pp. 175–6).

25 J.C. Eustace, *A Classical Tour Through Italy*, 3rd ed., (3 vols, London: Mawman, 1815), v. 1, p. 23.

26 Gage, "Turner in Venice," p. 76; Lindsay Stainton, *Turner in Venice* (London: British Museum Publications, 1985), p. 71.

27 Julian Treuherz, "The Turner Collector: Henry McConnel, Cotton Spinner," *Turner Studies*, 6/2 (Winter 1986): pp. 37–42.

28 Warrell, "Turner and Venice," pp. 22–3. Warrell notes that the picture was exhibited in 1834 along with *Wreckers – Coast of Northumberland, with a Steam-Boat assisting a Ship off Shore*, (B&J 357), "thereby juxtaposing plenitude with ruin." He also sees Byron as central here and suggests that this pairing in 1834 may have prompted to McConnell to commission his own pendant (pg. 107).

29 Ian Warrell, "Contemporary Approaches to British Art," in Warrell (ed.), *Turner and Venice*, p. 107. See also, Gerald Finley, *Angel Standing in the Sun: Turner's Vision of History* (Montreal: McGill-Queens University Press, 1997), pp. 33–6, 146–7.

30 See Anthony Bailey, *Standing in the Sun: A Life of J.M.W. Turner* (London: Pimlico, 1998), p. 260.

31 Turner to George Jones, 22 February, 1830, in Gage, *Collected Correspondence*, p. 137.

32 For a discussion of the connection between literary treatments of mortality and Venice's historical fall, see Sergio Perosa, "Literary Deaths in Venice," in Manfred Pfister and Barbara Schaff (eds), *Venetian Views, Venetian Blinds: English Fantasies of Venice* (Amsterdam and Atlanta: Rodopi, 1999), pp. 115–28. See also Werner von Koppenfels, "Sunset City – City of the Dead: Venice and the 19th-Century Apocalyptic Imagination," in Pfister and Schaff (eds), *Venetian Views*, pp. 99–114.

33 Stainton, *Turner in Venice*, p. 34; Eric Shanes, *Turner's Human Landscape* (London: Heinemann, 1990), pp. 92–4.

34 Ian Warrell, "The Bacino and the Riva della Schiavoni," in Warrell, *Turner in Venice*, p. 227. Warrell further notes that the title may pun "Sun/son," given the associations of motherhood in the related picture, which Turner entitled *The Dogana and the Madonna della Salute*. This suggests a connection to the *Temeraire*, with its invocations of a generational, water-borne journey.

35 Percy B. Shelley, *Lines Written Among the Euganean Hills*, 1818, ll. 115–8, 134–41. As Alexander Potts points out the lines also echo Thomas Gray's, "The Bard: A Pindaric Ode". See Potts, "The Romantic Work of Art," in Beth Hinderliter, William Kazen, Vared Maimon, Jaleh Mansoor and Seth McCormick, (eds), *Communities of Sense: Rethinking Aesthetics and Politics*, (Durham, NC: Duke University Press, 2009), pp. 72–3

36 Cited in Martin Butlin and Evelyn Joll, *The Paintings of J.M.W. Turner*, 2nd ed., (2 vols, New Haven and London: Yale University Press, 1984), text volume, p. 148.

37 Anonymous review, *The Spectator*, 8/356 (April 26, 1835): p. 404.

38 Anonymous review, *The Spectator*, 15/717 (March 26, 1842): p. 306.

39 Anonymous review, *Art Union*, 41 (June 1, 1842): p. 120.

40 Anonymous review, *Annals of the Fine Arts* (1820): p. 421.

41 Diary entry, April 5, 1806, in Kathryn Cave (ed.), *The Diary of Joseph Farington* (16 vols, New Haven and London: Yale University Press for the Paul Mellon Centre for Studies in British Art, 1979), v. VII, p. 2710.

42 Byron, *Childe Harold's Pilgrimage*, Canto IV, ll. 3–4, p. 143.

43 Tony Tanner, *Venice Desired* (Oxford, UK and Cambridge, MA: Blackwell, 1992), pp. 18–21.

44 Anonymous review, *La Belle Assemblée*, 15/90 (June 1832): p. 285.

45 Anonymous review, *The London Literary Gazette and Journal of Belles Lettres*, 590 (3 May 1828): p. 299.

46 Anonymous review, *The Spectator*, 6/258 (June 8, 1833): p. 529.

47 Cited in Finley, *Angel in the Sun*, p. 33.

48 Stainton, *Turner's Venice*, p. 16.

49 Anonymous review, *The Spectator* (May 11, 1844): p. 451.

50 Warrell, "Turner and Venice," p. 19.

51 Warrell, "Away from the City," in Warrell (ed.), *Turner and Venice*, p. 233.

52 Anonymous review, *The Spectator* (May 10, 1845): p. 450.

53 See Stainton, *Turner's Venice*, p. 16, ff.

54 Anonymous review, *Art Union*, 41 (June 1, 1842): p. 120.

55 Anonymous review, *The Athenaeum* (May 7, 1842).

56 For a discussion of the symbolic nature of Turner's smooth or rough waters, and of Turner's view of water generally, see John Gage, "Turner: A Watershed in Watercolor," in Lloyd (ed.), *Turner*, pp. 120–5.

57 This is also observed by Margaret Plant ("Venetian Journey," p. 160).

58 Georg Simmel, "Ruins," trans. by David Kettler, in Kurt Wolff (ed.), *Georg Simmel, 1858–1918, A Collection of Essays*, (Columbus: Ohio State University Press, 1959), p. 260.

59 Kathleen Nicholson explores these issues in regards to Turner's interest in Carthage, Rome and Greece in *Turner's Classical Landscape: Myth and Meaning* (Princeton: Princeton University Press, 1990), pp. 103–34.

60 Cited in Ian Warrell, "The Bacino and the Riva degli Schiavoni," in Warrell (ed.), *Turner and Venice*, p. 207.

61 On Shakespeare, see Ian Warrell, "From Shakespeare to Byron: Turner and the Literary Vision of Venice," in Warrell (ed.), *Turner and Venice*, pp. 69–74.

62 Warrell, *Turner and Venice*, p. 207.

63 Byron, *Childe Harold's Pilgrimage*, Canto IV, ll. 21–24, p. 143.

64 Tanner, *Venice Desired*, p. 29.

65 Plant, "Venetian Journey," p. 151 and Plant, *Venice, Fragile City 1797–1997* (New Haven and London: Yale University Press, 2003), p. 97, n. 129.

66 Cited in Gage, "Watershed in watercolor," p. 121.

67 C.R. Leslie, *Autobiographical Recollections* (London: John Murray, 1860), pp. 208–9.

68 Jack Lindsay, *J.M.W. Turner: His Life and Work* (Greenwich, CT: New York Graphic Society, 1966), pp. 92–5.

69 Anonymous review, *Art Union*, 41 (June 1, 1842): p. 120.

70 Gowing, *Imagination and Reality*, p. 32.

71 This goes back well into the sixteenth century. Interestingly the notion of Venetians as licentious and pleasure-seeking could accompany ideas of their political freedom for some writers like Sir Roger Ascham (Tanner, *Venice Desired*, p. 5), while being linked by other writers like Jean Gailhard to the repressiveness of the state (Jeanne Clegg, *Ruskin and Venice* (London: Junction Books, 1981), pp. 13–5).

72 Tanner, *Venice Desired*, p. 5

73 Margaret Doody, *The Tropic of Venice* (Philadelphia: University of Pennsylvania Press, 2007), pp. 64–5.

74 Reynolds, *Discourses on Art*, Robert Wark (ed.), (New Haven and London: Yale University Press for the Paul Mellon Centre for Studies in British Art, 1975), Discourse IV, ll. 196–215, p. 63.

75 Warrell, "Venice after Dark," in *Turner and Venice*, pp. 133–8.

76 Warrell, "Turner and Venice," in *Turner and Venice*, p. 24.

77 Ian Warrell, "Exploring the 'dark side': Ruskin and the Problem of Turner's Erotica," *British Art Journal*, 4/1 (Spring 2003): p. 26. See also Cecelia Powell, *Turner in Germany*, exhibition catalog (London: Tate Publishing, 1995).

78 British Library, Add. MS. 46151 I, p. 7.

79 Adrian Stokes, furthermore, also employed a psychoanalytic perspective in addressing Turner's sensuous handling of paint, connecting it to water and finding in both a sexual charge. See Stokes, "The Art of Turner," in *Painting and the Inner World* (London: Tavistock, 1959), pp. 47–85.

80 See Warrell, *Turner and Venice*, p. 175, illustration #185.

81 British Library, Add. MS. 46151 A, p. 19.

82 Walter Thornbury, *Life of J.M.W. Turner, R.A.*, 2nd ed, (London: Hurst and Blackett, 1877), p. 244.

83 Finley, *Angel in the Sun*, pp. 114–20.

84 Nicholson, *Turner's Classical Landscape*, p. 222.

85 Butlin and Joll, *Paintings of J.M.W. Turner*, text volume, p. 282; Selby Whittingham, "What you will; or some notes regarding the influence of Watteau on Turner and other British Artists," *Turner Studies*, 5/1 (1985): p. 19.

86 TB CLXIV 6, 7.

87 TB CCCXLIV d 350.

88 The presence of this absorptive pose points to possible connections with the terms of absorption and theatricality proposed by Michael Fried in reference to French art of the eighteenth century (*Absorption and Theatricality: Painting and Beholder in the Age of Diderot* (Chicago: University of Chicago Press, 1980).

89 TB CCLIV 24.

90 Andrew Hemingway, *Landscape Imagery and Urban Culture in Early Nineteenth-century Britain* (Cambridge and New York: Cambridge University Press, 1992), pp. 224–45; Andrew Wilton, *Painting and Poetry: Turner's Verse Book and His Work of 1804–1812* (London: Tate Gallery, 1990), pp. 98–99; David Blayney Brown, "Rule Britannia? Patriotism, Progress and the Picturesque in Turner's Britain," in Michael Lloyd (ed.), *Turner*, pp. 48–72.

91 John Gage, *J.M.W. Turner: "A Wonderful Range of Mind"* (New Haven and London: Yale University Press, 1987), p. 123.

92 TB CXLI 26a-27.

93 Elaine Scarry, *Resisting Representation* (Oxford and New York: Oxford University Press, 1994), pp. 49–90.

94 Cited in Ian Warrell, "J.M.W. Turner and the Pursuit of Fame," Ian Warrell (ed.), *J.M.W. Turner*, exhibition catalog (London: Tate Publishing, 2007), p. 14.

95 William Callow, *An Autobiography* (London: Adam and Charles Black, 1908), pp. 66–7.

96 Nicholson, *Turner's Human Landscape*, p. 105.

97 Alan Wallach, "Cole and the Aristocracy," *Arts Magazine*, 56 (November 1981): pp. 94–106; Wallach, "Thomas Cole: Landscape and the Course of American Empire," in William Truettner and Alan Wallach (eds), *Thomas Cole: Landscape into History*, exhibition catalog (New Haven and London: Yale University Press, 1994); Angela Miller, *The Empire of the Eye: Landscape Representation and American Cultural Politics, 1825–1875* (Ithaca: Cornell University Press, 1996), pp. 21–64; Miller, "Thomas Cole and Jacksonian America: The Course of Empire as a Political Allegory," *Prospects*, 14 (1990): pp. 65–92.

98 Wallach, "Cole and the Aristocracy," pp. 94, 98–9.

99 Andrew Hemingway, "Academic Theory versus Association Aesthetics: The Ideological Forms of a Conflict of Interests in the Early Nineteenth Century," *Ideas and Production*, 5 (1986): pp. 21–2.

100 John Barrell, *The Dark Side of the Landscape: The Rural Poor in English Painting, 1730–1840* (Cambridge: Cambridge University Press, 1980), pp. 154–5.

101 David Laven, "Venice under the Austrians," in Warrell (ed.), *Turner and Venice*, p. 34.

102 Ruskin, *Modern Painters*, v. 1, in Cook and Wedderburn (eds), *Work of John Ruskin*, v. 3, p. 257.

103 Ruskin, *Modern Painters*, v. 1, in Cook and Wedderburn (eds), *Work of John Ruskin*, v. 3, p. 362.

104 Ruskin, *Modern Painters*, v. 1, in Cook and Wedderburn (eds), *Work of John Ruskin*, v. 3, p. 363.

105 Jonathan Crary, *Techniques of the Observer: On Vision and Modernity in the Nineteenth Century* (Cambridge: MA and London: MIT Press, 1990), pp. 138–41.

106 Ruskin, *Modern Painters,* v. 1, in Cook and Wedderburn (eds), *Work of John Ruskin*, v. 3, p. 255.

107 Ruskin, *Modern Painters*, v. 1, p. in Cook and Wedderburn (eds), *Work of John Ruskin*, v. 3, p. 257.

The Slave Ship:
Painting/Abolition/History

If a number of the pictures over which I have lingered thus far, such as *Trafalgar* and *Waterloo*, have received comparatively little critical attention, the same cannot be said of the last picture I will consider in depth here. The challenges of *Slavers Throwing Overboard the Dead or the Dying — Typhon Coming On* (1840, Plate 30), or the *Slave Ship* as it has come to be called, are symptomatic of the broader issues facing any scholar of Turner. The painting has one of the most extensive and colorful critical histories of any of the artist's paintings, which can make it difficult to approach.[1] The title and attached verse-tag may make the general subject clear, yet scholars have attempted to discover more precise sources for the painting's rather enigmatic visual content and to fashion an interpretation that seems to fit that content from several perspectives. For instance, the *Slave Ship* has figured significantly in the work of scholars writing primarily about Turner from either an art historical or biographical approach, among them Jack Lindsay, John Gage, and John McCoubrey. The picture has been a touchstone as well for scholars concerned with broader issues in nineteenth-century culture, such as Romanticism or the shipwreck motif. The *Slave Ship* has also featured prominently in post-colonial accounts of issues of slavery and the Middle Passage (the brutal journey from Africa to the New World), in the work of Paul Gilroy, Marcus Wood, Ian Baucom and Melanie Ulz. Given the depth and sophistication of these analyses, and a number of others discussed below, it is difficult to imagine that something more could be added to the topic. By embedding the picture into the background of the previous chapters, however, and by introducing a slightly altered means of interpreting the picture's undeniably challenging imagery, it is possible to contribute further to issues within Turner studies in particular and to questions of slavery and abolition in the nineteenth century more generally.

One of the differences in the present study concerns questions of temporality, which open directly onto Turner's view of historical progress as it concerns issues as complex and difficult as slavery and abolition. To be specific, I will argue that Turner's painting shows two different moments existing simultaneously on the canvas. This kind of representation calls into

question the linear progression of historical time and lends itself to a reading which considers the interplay of past and present and places the burden of interpretation on the viewer. Out of this denial of linear progression, Turner will produce a deeply skeptical vision of history and of the possibility of adequately representing it visually. But there is still more to be said on the matter, because even as Turner seemed aware that the picture would have a broader metaphorical resonance, he was also hesitant about that process: at some level, the painting resists the incorporation of the single event into a larger typological account of slavery and abolition. Turner seemed to sense that there was an inherent violence in this type of appropriation, a violation of those deaths, of that suffering. For him, part of the business of history painting was to preserve that specificity. Turner discovered, however, that in seeking that specificity, history painting would be pushed to an un-resolvable limit of representation.

The Slave Ship and the Zong incident

To begin, we need to address some questions about Turner's source material for this painting. It will quickly become clear that the stakes in this regard with the *Slave Ship* are much greater than mere questions of art historical reference.[2] It will be useful, I believe, to consider this material in terms of a dichotomy between specificity and generality; that is, whether the reference being made in the picture is to a particular event, isolated in time, or to something which stands for a series, or a category of events. This will allow us to gauge the kind of history Turner represents, and to consider it comparatively with other accounts of slavery and abolition. The incident most frequently connected to Turner's painting is the notorious case of the slave ship *Zong* from 1781, which is recounted in Thomas Clarkson's history of the British abolition movement, originally published in 1808 but printed in a second edition in 1839, the year before the *Slave Ship* was shown at the Royal Academy exhibition.[3] As Clarkson describes it, during the Middle Passage, the captain of the *Zong*, facing a shortage of water, ordered the sick and dying slaves thrown overboard, knowing that he could collect insurance on slaves "lost at sea" but not on those who died aboard.[4] This was a crucial episode in the history of the abolition movement, because it was brought to trial in London and did much to build broader opposition to the trade. The trial was exclusively concerned with the question of insurance fraud, but it brought the cruelty of the Middle Passage to the public eye, especially because it placed the issue of treating human beings as property into such stark relief. It is worth noting that nothing in the picture or title makes specific reference to the *Zong* or Clarkson. But viewers in 1840 were likely to associate the imagery of a ship in the background and the shackled leg, hands, and chains visible in the foreground, with such a well-known episode. The act of throwing slaves overboard, moreover, is referred to directly in the verse-tag which

accompanied the entry in the Royal Academy exhibition catalog, even if the *Zong* was not named. The verses read:

> Aloft all hands, strike the top-masts and belay;
> Yon angry setting sun and fierce-edged clouds
> Declare the Typhon's coming.
> Before it sweeps your deck throw overboard
> The dead and the dying—ne'er heed their chains
> Hope, Hope, Fallacious Hope!
> Where is thy market now?

If this is a depiction of, or at least a reference to, the *Zong*, these lines expand that reference considerably to speak to larger metaphorical issues, turning the scene into a typological depiction of an event that has broader significance. The last line of the verses acknowledges the connection of the murders to questions of monetary value. In this regard, Jack Lindsay connected the picture's sense of outrage to Carlyle's contemporaneous complaints about a "cash nexus" supplanting human values.[5] Ian Baucom draws our attention to the importance of ideas of "value" in the *Zong* case, concerning as it did the matter of compensation. At stake in the trials, for Baucom, was the development of a capitalistic justice in which money can be substituted for a lost thing, as one value is exchanged for another. He also argues, however, that for the abolitionist William Wilberforce, who was in large part responsible for creating the public outcry over the case, the story of the *Zong* itself took on value as not just a set of individual murders, but also as a case that signified the evils of the trade more broadly.[6]

Indeed, art historians have generally assumed that Turner was making a larger statement about history by reference to the *Zong*. Albert Boime related the visual and thematic structure of the image to contemporary economic issues, to argue that the picture stages the struggle between the plantation system of slavery and the new forces of laissez-faire industrialism of the nineteenth century.[7] According to Boime, the painting's fiery sunset is a metaphor for the "passing of an outmoded institution [of slavery] in the context of the new industrialised state."[8] Boime's metaphorical interpretation depends upon the identification of the ship as the *Zong* because it places British participation in the slave system firmly in the past. The ship's conflict with the storm then can be made, in his account, to represent the conflict of slavery with the new industrial forces of the nineteenth century. In this sense the picture is made to represent a single moment in time, but one significant not for the specific condition of the murders which comprised it but for what they could be made to metaphorically represent: historical change, and the transition from one economic era to another.

John McCoubrey, on the other hand, argues that the *Slave Ship* does not represent the *Zong* at all, but rather the continuing involvement by the Spanish and Portuguese in the slave trade in the nineteenth century.[9] While Britain had abolished the slave trade in 1806, a number of other nations, including

Spain and Portugal, continued to engage in it in the 1830s and 40s. British warships patrolled the waters off the West Coast of Africa in an effort to stop them, but because captains were given prize money for slaves captured on the open sea but not for those still on shore or in the harbor, many captains allowed slave ships to leave the coast before pursuing them. Once the pursuit began the slavers frequently jettisoned slaves to lighten their ships as they tried to outrun the patrol. As result, the British navy was often considered complicit in the ongoing death of slaves at sea. This issue of pursuit and jettison was a highly controversial public concern in 1840. According to McCoubrey, it is precisely such a scene that Turner depicts in the *Slave Ship*. As evidence, he points to the shape of the ship, which he finds similar to those used by the Spanish and the Portuguese as slaving vessels, and the blue and white object in the water in the middle-left of the painting, which he reads as a Portuguese flag of trade that was in use in the late 1830s. Additionally, according to McCoubrey, the dogs swimming in the water to the right of the slave in the foreground are Spaniels, which may be interpreted as a Turnerian pun referencing Spain's continued involvement in the slave trade. He also connects the shackled leg in the foreground to other images of abolition in which a raised limb with broken chains was a symbol of freedom.[10] On this basis, McCoubrey interprets the *Slave Ship* as an allegory of hope for the abolition of the trade and for a period of freedom, peace, and prosperity to follow.[11] McCoubrey's case for the reference to pursuit and jettison is powerful and convincing, but his resulting total exclusion of the *Zong* as a reference in the *Slave Ship* is ultimately unnecessary and insupportable. He does not account for the reference to the "dead and dying" in the title and verse-tag, which has little to do with the jettison issue—if this is a jettison then where is the pursuer?—but which does refer to throwing sick and dead slaves overboard so that insurance could be claimed, of which the *Zong* was the most prominent example. Indeed, if the ship had indeed just left the coast it is unlikely that the slaves would already have been ill.

I wish to suggest, therefore, that we would do best not to take the picture as a literal depiction of either the *Zong* or of jettison, but instead to see it as a diachronic pictorial space which deliberately made reference to both, and that this dual referencing is central to how we should understand the picture and Turner's approach to history in 1840. The *Zong* case was made legendary by abolitionist literature and had received fresh attention in the re-issue of Clarkson's book in 1839, which included a preface decrying the role of the Royal Navy in causing jettisons.[12] The case was so well known by this time that informed members of the public may have viewed later drownings at sea, however different in their details, in terms of this earlier atrocity. Indeed, Baucom makes the trenchant point that the *Zong* became so significant precisely because it seemed to produce a genealogical type, so that any case of slaves drowning at sea came to be thought of in terms of the *Zong*.[13] The public, well informed of both the *Zong's* sordid history and the practice of

jettison, would have understood Turner's characterization as consistent with the manner in which these issues appeared in the broader culture of abolition.

One writer who acknowledges the possibility of such a diachronic reference in the painting is Jan Marsh, who accepts that the *Slave Ship* refers to the *Zong* but notes also the continuing relevance of jettison as argued by McCoubrey.[14] Marsh thus concludes: "[Turner's] picture can stand as a dramatic commentary on a long Abolitionist movement."[15] Here then is yet a different kind of account of the picture's transformations of specific incidents into a larger statement. But Marsh does not see this as a tremendously complex proclamation on the matter, suggesting instead that Turner added the drowning figure in the foreground at a late stage to tap into a contemporary patriotic and humanitarian concern.[16] In this, Marsh adopts a reading of Turner that is consistent with Ronald Paulson's notion of "Turner's graffiti," in which the artist layered literary or historical references atop a painting that was in its essence about formal relationships and the evocation of light and nature.[17] I wish to suggest instead that Turner's dual references must be understood as integral to the painting's imagery at every level rather than as a last-moment addition. By referring to the *Zong*, the *Slave Ship* points to Britain's role in the slave trade during the eighteenth century, while reference to the navy's role in jettison and pursuit points to the persistence of that involvement in the wake of abolition. Turner's multiple time references thus create a complex, diachronic history of British involvement in the slave trade that has significant consequences for the themes of this study.

It should not be surprising that Turner took such liberties with temporal details. Indeed, Eric Shanes has suggested that modern scholars are much too inclined to interpret Turner's paintings literally, in ways that preclude more subtle interpretations of his work. Shanes notes, for instance, that while Turner's contemporaries readily identified symbolic resonances in the setting sun of *The Fighting Temeraire* (1839, Figure 2.20), modern scholars have been hesitant about such interpretations because of apparent inaccuracies in the masting of the ship, details of the tug, and, most importantly, the placement of the sun, which, on the basis of the site and Turner's positioning of the ship, would appear to be setting in the east. Shanes, on the other hand, argues convincingly that the picture incorporates separate scenes (the *Temeraire's* journey from east to west up the Thames to Rotherhithe and an autumn sunset) in order to create a more poetic pictorial statement. Why should we be more inclined to accept topographical poetic license than temporal license? Indeed, if Turner was playing loose with the position of the sun, it is as much a temporal issue as a geographical one. McCoubrey himself argues that Turner took considerable topographical liberties in the *Burning of the Houses of Parliament* (Figure 2.17) now in Cleveland by exaggerating, for instance, the width of the river and by making the night scene appear to take place in bright light (to the chagrin of some viewers).[18] Turner clearly used a diachronic depiction of history in *Rome, from the Vatican* (1819, Figure 4.25), in which he shows Raphael at work in a loggia of the Vatican. The Rome that stretches

into the background, however, is that of Turner's own period, and includes Bernini's colonnade, not built until over a century after Raphael's death.

If we see the *Slave Ship* as similarly diachronic, referring to both the 1781 *Zong* incident and to the contemporary issue of pursuit and jettison, then we open up a different set of interpretive possibilities. Turner leaves these temporal references unresolved in the formal structure of the painting. As such, the painting denies the linear progression of time from the earlier period to the later, placing the two together in the same pictorial space; they negotiate and renegotiate with each other, with neither gaining precedence. This contrast of historical periods is visible in the distribution of information on the canvas. While much of the painting is devoted to the sweeping seascape and atmospheric effects, specific details are primarily concentrated in two areas: the foreground with the slaves and sea-dwellers and in the left background with the ship itself. Visually, however, these two areas of information are distinct from one another, divided by the heaving seas. Their separation is emphasized by the ambiguity created by the distance of the ship from the drowning woman in the foreground. The use of the present tense in the title and verse-tag may suggest that the action of throwing slaves overboard is happening in the present, as we look at the painting. But this connection is severed in the imagery because the ship is already some great distance from the slave. The fate of this woman—the figure is clearly female, as we will see—and that of the ship are now quite separate, an issue to which I will return shortly.

Ian Baucom's observations on temporality bear further consideration, for he comes closest to recognizing the importance of multiple time references in the *Slave Ship*. Baucom takes the painting to refer to the *Zong* incident alone, but he notes that Turner exhibited the painting along with *Rockets and Blue Lights (Close at Hand) to warn Steam-Boats of Shoal-Water* (1840, Figure 5.1), a modern subject. On this basis, Baucom understands the pairing in relation to romantic and Scottish enlightenment conceptions of history in which modernity was no longer to be understood in terms of a universally experienced, homogenized time, but rather as a fractured, locally heterogeneous temporality.[19] But, comparing Turner's account of history to Sir Walter Scott's, Baucom argues that even as Turner's pairing allows past and present to interpenetrate and fracture each other, the result of the pairing is one of "containing the massacre," by giving the viewer a choice between that past atrocity and the modernity represented by *Rocket and Blue Lights*. An awareness of the relevance of jettison and pursuit, however, denies precisely this kind of containment by refusing to make the past "only an occasion for sympathy and decent burial of the dead," as Baucom puts it.[20] For Baucom, the question in evaluating the *Slave Ship* turns on whether the *Zong* incident and the specific deaths that comprised it are to be understood in terms of some kind of exchange that could be transformed into a larger statement. Another way of stating the difference in my interpretation of the picture from his, then, is to say that it is this exchange that Turner's picture resists, both by its dual references and by separating the

slaves and the ship. If the ship is inevitably a signifier for the evils of the trade, it is distanced so dramatically from the suffering of its victims, and especially the drowning woman in the bottom right-hand corner, that it seems to exist at a different level of representation. As a result, its destruction cannot be used to redeem the suffering in the foreground any more than the atrocities it depicts be placed in the historical past.

Gender also plays a significant role here. Although rarely discussed as such in either contemporaneous or modern sources, the drowning figure in the right foreground is undeniably female. A close look (detail, Plate 31) reveals that she is on her back, as we see two breasts protruding outward, just above the near edge of the canvas. Turner's contemporaries saw her leg but either could not or chose not to see the breasts, referring only to "the leg of a negro" and "a dusky-brown leg."[21] John McCoubrey, who does identify her as a woman, notes that much early reception of the picture relies on Ruskin's description, which does not mention her sex. As McCoubrey notes, however, her bodily presence and other distasteful aspects of the scene, are displaced into Ruskin's description of the sea and waves: "a low broad heaving of the whole ocean, like the lifting of its bosom by a deep-drawn breath after the torture of the storm." Thomas Moran's engraving of the picture, actually further cuts the frame off so that the breasts are no longer visible.[22] But identifying her as a woman is crucial to an understanding of the picture that integrates the broader historical issues I have described with an account of its particular relevance for Turner. Her place within the larger scene is also critical. Where she is placed close to the viewer, the ship approaches the far edge of representation, already too far away to have a real human presence

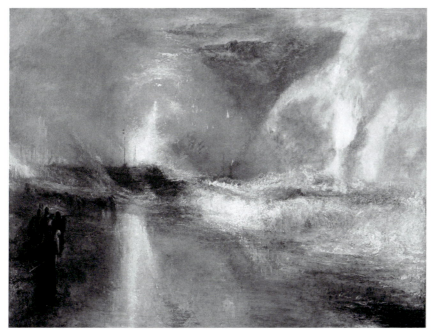

5.1 Joseph Mallord William Turner, *Rockets and Blue Lights (Close at Hand) to Warn Steamboats of Shoal Water*, 1840, oil on canvas, 36.3 x 48.1 in. (92.2 x 122.2 cm). Sterling and Francine Clark Art Institute, Williamstown, USA/ The Bridgeman Art Library.

and acts merely as a non-personified symbol of cruelty. The slave woman in the foreground occupies the opposite edge of representation: she is almost too close, as Turner cuts her head off with the edge of the canvas. If the slave ship is non-human and pure symbol, she is rather more complex: neither completely human, nor completely symbolic. It is as if Turner could not quite name her as a specific figure with individual features on the one hand, and could not bring himself to incorporate her into the space of representation where she would become an exchange value on the other. I will return to this idea at the end of this chapter, but it is important to note this dilemma, because it seems to me that the picture's odd, incomplete imagery is a product of its taking this question of representation to its limit and finding no easy resolution to the problem that limit poses, much as we saw with the representation of the female victims of *The Disaster at Sea*.

Histories of Abolition

Before returning to this, I wish to address the significance of the mode of representation that emerges from this dilemma, which I will term "dialectical history painting." This is defined precisely by the oscillation between time periods, between fore- and background, and between metaphor and singularity that I have outlined. In understanding the significance of this approach to painting history, we need to compare the *Slave Ship* to a tradition of literary and historical characterizations of abolition in which the image of a slave ship at sea with an approaching storm and figures in the water was an important metaphor. McCoubrey connects Turner's picture directly to this tradition, which in part enables his argument for its hopeful vision of abolition. In addition, scholars have connected the *Slave Ship* not only to Clarkson's account of the *Zong*, but also to some lines in James Thomson's *Summer* of 1727, a poem with which Turner was deeply familiar.[23] *Summer* was the first of a number of poems that allegorized the end of the slave trade with the wreck of a slave ship at sea in a violent storm.[24] Thomson describes a storm overtaking the slaver, which is then surrounded by hungry sharks:

> Increasing still the terrors of these storms,
> His jaws terrific armed with threefold fate,
> Here dwells the direful shark. Lured by the scent
> Of steaming crowds, of rank disease, and death,
> Behold! He rushing cuts the briny flood,
> Swift as the gale can bear the ship along;
> And from the partners of that cruel trade
> Which spoils unhappy Guinea of her sons
> Demands his share of prey—demands themselves.
> The stormy fates descend: one death involves
> Tyrants and Slaves; when straight, their mangled limbs
> Crashing at once, he dyes the purple sea
> With gore, and riots in the vengeful meal.[25]

For Thomson, the storm symbolized the Fates descending to deliver a punishing blow to slavery, so that the end of slavery is the result of divine forces expressing themselves through nature. This divine force/nature relationship has two important consequences. In the first place, it offers a model of history that establishes the action of super-human forces as the sources of political change. In Thomson's poem, as divinely ordained political change sweeps down on the ship, humans are powerless against it. Secondly, as a correlate to this view, political change appears as something linear, progressive, and inevitable. The metaphorical destruction of slavery in Thomson's poem is followed by the evocation of a peaceful and prosperous England, which now, having rid itself of the evil of slavery, lives in harmony with nature. Thomson describes this kind of harmony later in the poem, in the clearing of the skies after a storm has passed:

> As from the face of Heaven the shattered clouds
> Tumultuous rove, the interminable sky
> Sublimer swells, and o'er the world expands
> A purer azure, Nature from the storm
> Shines out afresh; and through the lightened air
> A higher lustre and a clearer calm
> Diffusive tremble;[26]

Thomson is now describing the clearing of a different storm, a thunderstorm that threatens Celadon and Amelia in Wales. But what interests me is the larger symbolic progression from an angry, vengeful nature to one of peace and calm. It is significant also that this passage shares the idea that the innocent are often destroyed by a storm: "And yet not always on the guilty head / Descends the fatal flash." This storm is followed by an evocation of the English countryside basking in the warm glow of the afternoon sun:

> The Sun has lost his rage: his downward orb
> Shoots nothing now but animated warmth
> And vital lustre; that with various ray,
> Lights up the clouds, those beauteous robes of heaven,
> Incessant rolled into romantic shapes,
> The dream of waking fancy! Broad below,
> Covered with ripening fruits, and swelling fast
> Into the perfect year, the pregnant earth
> And all her tribes rejoice.[27]

Separate though the storms are, the one that destroys the slave ship is part of a broader logic of historical progression in which, after the clearing of a storm, nature can reemerge to be described in gentle terms, the sun having "lost his rage," for instance. Thomson uses the storm to describe a tumultuous period that is followed by one of plenitude and peace. He expands the reference to say that humans can now exist in harmony with each other and with nature: "the pregnant earth and all her tribes rejoice." With nature's beneficence,

the countryside can now become prosperous and productive: "Covered with ever-ripening fruit." Thus we see in Thomson's poem an essentially linear model of history, expressed by means of natural allegory, for as the slave ship rides the seas, Britain has angered nature by engaging in the trade. After the storms which destroy both innocent and guilty, and the slave ship, nature smiles on Britain. Then, having ridded itself of the evil of the slave trade, Thomson envisions Britain aligned with the storm rather than working against it:

> Mild are thy glories too, as o'er the plans
> Of thriving peace the thoughtful sires preside—
> In genius and substantial learning, high;
> For every virtue, every worth renowned;
> Sincere, plain-hearted, hospitable, kind,
> Yet like the mustering thunder when provoked,
> The dread of tyrants and the sole resource
> Of those that under grim repression moan.[28]

In Thomson's poem, the elimination of the slave trade by a storm is a crucial moment for Britain: it can now become prosperous and bring knowledge and justice to the rest of the world. The linear model within which this occurs, as well as the invocation of Divine Will by means of natural allegory, lends a sense of inevitability to the progression. Thomson's poem was written almost eighty years before the abolition of the British slave trade in 1806, and before there was even an abolition movement as such, so it cannot be considered history, but instead part exhortation and part utopian model. But it is striking to note that the first histories of abolition that were written by the abolitionists themselves took a very similar approach.

Indeed, Thomson's poem anticipates the terms of one of the most important historical models for understanding abolition, one set by the abolitionists themselves. Clarkson's text, the same one often cited as a source for Turner's *Slave Ship*, was a key document in this tradition, and it established the tone for much of the subsequent writing about abolition. Importantly, Clarkson placed Thomson's natural allegory into an overtly Christian framework. In this model, Britain is stained by the sin of slavery but abolition acts to absolve it of sin and gain the favor of God. Clarkson's account of the *Zong* incident adopts Thomson's vengeful storm but transforms it into a Christian God's condemnation of the slave captain. According to Clarkson, Captain Collingwood claimed that he was forced to throw sick and dead slaves overboard because of a lack of water. Clarkson, however, figures the storm as divine judgment: "…as if Providence had determined to afford an unequivocal proof of the guilt, a shower of rain fell and continued for three days after the second lot of slaves had been destroyed, by means of which they might have filled many of their vessels with water, and thus prevented all necessity for the destruction of the third."[29] Clarkson thus places the abolition movement as a whole in specifically Christian terms, seeing the benevolence of the

abolitionists as the result of the guiding force of Christianity acting upon an inherent goodness in man and ultimately allowing Britain to alleviate a gross injustice.[30] Thereafter, Clarkson describes a series of Christian individuals whose contributions had led to the success of abolition. According to Howard Temperley, much of the subsequent literature on abolition has similarly viewed the movement as the disinterested activity of benevolent Christian activists.[31] In an illustration included in both editions of Clarkson's text (Figure 5.2), the author gave visual form to this conception of the history of abolition. The illustration presents the abolition movement as a series of streams and rivers, which broaden as they move downward across the page, which is organized chronologically.[32] Thus the tributary river at the left is fed by streams labelled "Leo X," "Montesquieu," "Pope," and "Thomson," among others. A similar branch on the right presents the separate, but parallel development of the Quaker anti-slavery movement. The rivers widen as they move forward in time, eventually spilling into open waters, which can be taken as the representation of the end of the slave trade and its constricting influence. By the use of this natural metaphor, Clarkson gives visual form to the same model of the history offered by Thomson in *Summer*. Abolition is presented as a linear, progressive phenomenon which flows, like a river to the sea, irresistibly forward. While he does identify many individuals they exist only within this broader historical movement. Clarkson published his volume in 1808, just two years after the slave trade had been abolished by an Act of Parliament. He represents the end of official British involvement in the trade as the crowning achievement of a series of individuals working with no other goal than to ease the suffering of their "fellow-creatures." Robin Blackburn suggests that the *Slave ship's* appearance in the context of post-emancipation

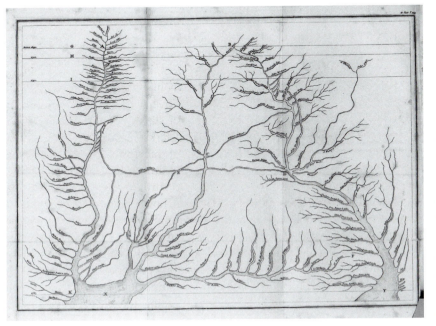

5.2 *Abolition Map*, 1808, from Thomas Clarkson, *The History of the Rise, Progress and Accomplishment of the Abolition of the African Slave-Trade by the British Parliament* (Philadelphia: James P. Parke, 1808). Source: The Library Company of Philadelphia.

abolition discourse might have produced a similar effect of cleansing the state as described by Thomson. Suggesting that the image's aesthetic qualities "redeem" the horrible deeds it depicts Blackburn concludes, "It is not, perhaps, too far-fetched to suggest that Britain's rulers could have seen in the painting not simply the slave-trader jettisoning his cargo but also a symbolic representation of their own sacrifice of slavery, in order to render the ship of state more sea-worthy in a storm."[33] I agree to the extent that I think this exactly is what abolitionists and politicians may have desired from the image, but will argue here that its fractured critical history suggests what they actually found when they looked at the picture was something quite different.

If abolition was to produce a more just world of peace and plenty, then the destruction of the slave ship by the storm—a common symbol in poetry for the eradication of slavery as McCoubrey notes—was a key moment in this progression.[34] Hugh Milligan's "*The Lovers, An African Eclogue*" of 1784, for instance, describes the aftermath of the sinking of a slaver: "Now all their fears, and tears, and sufferings cease / The Gods are good; and take their souls to peace/Guilty and guiltless now are seen no more."[35] Once again, the notion of a release from time, history, and suffering depends upon the depiction of this kind of scene, in which slavery as a whole, from the sins of the guilty to the suffering of the innocent, is wiped out in a single, apocalyptic moment. Turner refuses to offer this release. Rather than showing a storm delivering a death-blow to the whole system of slavery, Turner's portrayal of two moments, one before abolition and one well after, shows how the evils of the slave trade persisted. In 1840, as McCoubrey describes, Turner was able to see that not even emancipation in the British colonies had brought an end to the suffering, nor even to British guilt. Rather than showing the *Zong* punished by the storm and the slave trade thus wiped out, the painting points to the persistence of the slave trade in Europe and the continuing British profit in slavery by referring to the issue of jettison. Turner thus has taken Thomson's storm and divested it of its allegorical power. The slave ship may be wrecked by the storm or it may not, but in either case the evils of slavery will continue.

A crucial aspect of the lack of allegorical function in Turner's painted storm compared to Thompson's treatment is the *Slave Ship's* terrifying naturalism. As we have seen with reference to Venice, Turner paid particular attention to nature in its most changeable and fugitive forms, so that by 1840 he had developed the means to represent in paint the swirling winds and driving rain of a storm at sea. Because of this specificity, Turner's storm is less an allegorical expression of the Greco-Roman god of the storm than a natural phenomenon operating on the basis of its own properties. In Baucom's terms, there is a resistance in the painting to transforming individual elements into typological examples. In Turner's painting, moreover, the end of slavery is not so readily achieved as the Christian abolitionists had described it. History in the *Slave Ship* does not act according to such a plan and does not come to resolution in a moment of divine intervention. Instead, because the two moments Turner depicts continue to oscillate dialectically, there is no

progression of historical time and final point of release. There is no divine realm of plenty and goodness after the storm which will overtake Turner's ship, only more suffering. Turner's multiple time references acknowledge not only that the effects of slavery and the slave trade cannot be wiped out as if they never existed, but also that they cannot be represented in simplistic visual and material terms.

We can assess more clearly the significance of Turner's use of a dialectical mode of history painting by considering two aspects of abolition as a historical phenomenon. First, the model of abolition offered by Thomson and others is a vision of what historian David Brion Davis has described as an "emancipation moment": a single instant in which the effects of slavery are washed away forever. Such a conception played a crucial role in accounts of abolition, which understood the results of emancipation in terms of the Judeo-Christian idea of a deliverance from sin.[36] With such a model in mind, abolitionists such as Ralph Wardlaw could celebrate the emancipation of slaves in the British colonies in 1833 as an event that would bring immediate freedom, purge Britain from sin, and create peace and prosperity. In practice, however, the emancipation of the slaves in the British colonies was very different. A system of apprenticeship was created to smooth the transition from slave to wage labor, but unfortunately many of the evils of slavery continued under the system even after its abrupt end in 1838. Not only did the suffering of the slaves in the colonies continue to be an issue, but England itself was home to an increasingly large population of former slaves and their families who were, expectedly, very poor. Their presence raised intense debate across the city.[37] Turner, living in London in 1840, would have been in a position to see that, just as abolition in 1806 had not ended the slave trade, neither had the partial emancipation of 1833 to 1838 eliminated the ongoing issues posed by the legacy of slavery at home or abroad. In this sense, Jack Lindsay was exactly right when he concluded of the painting, "Turner is recognizing that the guilt of the slave trade was something too vast to be wiped out by any belated act of Parliament."[38]

It is also significant that Turner declined to make use of the kind of religious allegory employed by the authors whose writing influenced the *Slave Ship*. His choice becomes even more remarkable when we consider the place of abolition within the overall history of political activism in Britain. Thomas Haskell has sought to interpret the relationship between the rise of capitalism and what he refers to as the "rise of humanitarianism," a relationship based in changed sensibilities.[39] Haskell begins by describing a series of changes in human perception which he attributes to the expansion and intensification of "market discipline." As this market economy grew in scale, and became increasingly national and international rather than local, individuals were forced to change their perceptions of their relationship to the world. One of the results of this change, according to Haskell, was a new notion of the individual's causal relationship to society beyond a local level.[40] The market taught, by necessity, two lessons in particular: the worth of keeping one's

promises and the importance of attention to the remote consequences of one's actions.[41] These changes in perception were the preconditions, in Haskell's view, for a "modern humanitarian conscience" in which injustice and cruelty that take place at a distance become something that one could and should attempt to ameliorate.

At the same time Robin Blackburn has placed the humanitarian aspects of abolition within the much broader context of political and class struggles both in the metropolis and in the colonies. Of Britain he writes, "...it is well to remember that anti-slavery themes and a critique of the Atlantic slave trade had emerged in the discourse of moral philosophy, jurisprudence, social reform and political economy in late eighteenth-century Britain because they corresponded so well to middle-class anxieties and aspirations. Anti-slavery promised to tame and reshape the rampant force of commercialism and industrialism, the arrogance of the ruling class and perhaps even the waywardness of the laboring classes"[42] Blackburn says that abolition managed to create a brief alliance between the pro-Reform, middle classes, radicals and a broad popular following. For Blackburn, abolition's success in the years 1803–14 ultimately had to do with its ability to act as a "lightning conductor" for a variety of other issues.[43] Seymour Drescher has argued that the abolition and emancipation movements were ultimately the products of political mobilization on a public scale totally unprecedented in British history.[44] While Drescher acknowledges the importance of the Quaker movement in the early stages of abolition, he argues that its real success was possible only when it had become the most widespread political issue of the period and by 1792 it had galvanized large segments of the population who had previously been without political voice.[45] The next fifty years were ones of almost constant political activity. This activity can be traced directly to the mobilization that occurred in the anti-slavery movement, which provided the impetus and the very means of agitation used by subsequent generations of political activists.[46] It is thus appropriate to discuss an alternative mode of historical representation in a painting concerning abolition and slavery in Britain because this was a political issue unlike any that had come before, one which resonated in a number of different issues, and one which dramatically affected the course of British history as a whole.

It is against this historical background that we must consider the *Slave Ship's* refusal to deliver the history of abolition over to a natural allegory that placed responsibility for historical change on forces beyond human control, as in Thomson's vision of the end of slavery. In reality, abolition had been the result not of faith in higher powers to simply put matters right, but the result of political activism on an unprecedented scale. In treating this theme, it is significant that Turner mobilized the aesthetics of the sublime. He did so, I believe, because he considered it distinctly appropriate to such concerns. If we combine Haskell's discussion of the effects of an expanding market economy on modern consciousness with the issue I described in relation to *Trafalgar*, in which the individual is increasingly overwhelmed by the

scale of historical change, we can identify an important dialectical aspect of developing capitalism in the early nineteenth century. On the one hand, the growth of the market economy and the increased availability of information on a national and international level meant that the individual at the turn of the nineteenth century was increasingly aware that society existed on a scale of enormous size and complexity, a scale that threatened to overwhelm the individual. At the same time, however, according to Haskell, the demands of the market created for individuals the sense that it was both possible and morally necessary for them to create change in a community beyond the local one. This dialectic takes on the dual movement that is central to the sublime, by which the perceiver is simultaneously overawed by the sublime phenomenon and empowered by it. That is, the very forces that made the individual seem insignificant in the face of society also prompted him or her to a sense of political responsibility and activity.

This very sense of the sublime nature of individual moral responsibility and action suffuses much early abolitionist discourse, in fact, even as that discourse so frequently ascribed its success to doing God's work. In a biography of Clarkson that was published in 1839, the same year as his history of abolition, the beginning of his involvement in the movement is described as an awakening of conscience. Working on the topic of slavery for a Latin essay competition at Cambridge in 1785, Clarkson found himself overwhelmed by the scope and horror of the topic. Interestingly, this dawning awareness is described in terms that resonate with the aesthetic categories of the beautiful and the sublime: "Instead of the pleasure he had anticipated in the skilful arrangement of his materials to secure success in his literary contest, his mind was continually on the rack by the successive narration in the course of his reading of oppression most villainous and cruel." The biography then quotes Clarkson himself: "It is impossible…to imagine the anguish which the composition of this essay cost me. All the pleasure I had promised myself from the contest was exchanged for pain, by the astounding facts that were now before me."[47] In exchanging pleasure for pain, control for powerlessness, and in describing the "astounding" impact of the facts, this account shifts between the categories of beautiful and sublime, as described by Edmund Burke. The reference to torture contrasts powerfully to the previous capacity for "skilful arrangement," and transfers some of the experience of the slaves onto Clarkson himself. In doing so, it reprises the power dynamics central to Burke's exposition of the sublime in which beauty is defined as the pleasure resulting from control over something, while sublimity is the pain that comes from the lack or loss of that control. In a long section of his treatise on the sublime and beautiful devoted to power, Burke asserts that, besides the direct or mechanical suggestion of terror, "I know of nothing sublime, which is not a modification of power," and notes that the ideas of suffering and death are capable of arousing a pain that is greater than any pleasure. He goes on to say that while pleasure "follows the will," pain "is always inflicted by a power in some way superior to us." As a result, he says, "strength, violence, pain, and

terror rush in upon the mind together," analogous to Clarkson's "astounding" experience of the horrors of the slave trade, in which he himself experiences the violence of the slave trade: "his mind was continually on the rack."[48] Just as Burke's sublime subject recovers in the wake of this experience,[49] however, so too does a transformed Clarkson discover a sense of individual empowerment and responsibility: "My great desire now was to produce a work that would call forth a vigorous public effort to redress the wrongs of injured Africa."[50] Evoking again powerlessness to resist as the basis of social action of an individual ("some one"), the text describes Clarkson's work as a kind of compulsion to persist in the face of the enormity of the horror of the slave trade: "I could not divest myself of the feeling that it was the duty of some one to expose the horrors of this bloody traffic. It grew upon me from day to day, and I could no longer keep my mind at rest."[51]

This sense of duty is all the more important because Clarkson's subsequent experiences attacking the entrenched interests of the slave trade are cast in sublime terms, in which the individual confronts something drastically beyond his or her own scale. Clarkson later meditates on this purpose in terms that constantly invoke the individual nature of the work in comparison to the scale of what must be done: "He sometimes walked into the woods that he might think on it in solitude...'I felt as if I must myself undertake the great work. But innumerable difficulties presented themselves. It struck me that a young man of only twenty-four could not possess the knowledge and judgment requisite for an undertaking so important. Besides, as I had none with whom I could unite my efforts, it seemed to me so much like the fabled labours of Hercules that I imagined the soundness of my undertaking would be suspected..."[52] The text returns frequently to this sense of the enormity of his task, saying, "At times he had been almost tempted to draw back, so overwhelming did the work appear..."[53] This invocation of an overwhelming, Herculean "great work" with "innumerable difficulties" again corresponds to a crucial aspect of Burke's sublime: infinity and boundlessness, as opposed to the bounded-ness of beauty. As Burke summarizes, "...sublime objects are vast in their dimensions, beautiful ones comparatively small; beauty should be smooth and polished; the great, rugged and negligent;"[54] Later, this overwhelming quality is attributed to the vastness of the slave interest itself: "...coming in sight of Bristol, a city where he knew many individuals resided to whom the odious traffic he was attempting to abolish was a source of commercial wealth, he felt for a time dismayed at the opposition which he should be likely to encounter."[55] Seymour Drescher, himself taking recourse to the language of the sublime, notes that a sense of the implacability of the slaving interest was frequently invoked by early reformers calling Clarkson "only the last to experience a sense of awe at the unfathomable distance between individual denunciation and effective action."[56] Drescher notes that writers on slavery separated by more than a century, such as Richard Baxter and Burke himself, expressed dismay at the apparent unassailability of the slave interest.[57]

If the discourse of abolition made frequent recourse to the language of the sublime, this was clearly well-suited to Turner's work. I am suggesting, then, that there is a connection to be made between a moral imperative that takes the form of the sublime in abolitionist discourse and the aesthetic language that Turner employed to treat that subject in the *Slave Ship*. Turner had developed that aesthetic throughout his career and the fact that it was particularly centered on the reaction of a perceiving individual made it a prime means for addressing the kinds of issues raised by abolition. The direct confrontation of the viewer with overwhelming natural forces had been a crucial part of Turner's exploration of the sublime. Turner, for instance, often stripped his canvases of intermediary figures to intensify the viewer's experience of the sublime, as Andrew Wilton has described.[58] We might note here a particular structure in which small, often precisely rendered details are surrounded by much more broadly rendered passages devoted to the expression of atmosphere and natural forces. This structure is vividly clear in a picture like *Snow Storm – Steamboat off a Harbour's Mouth* of 1842 (Figure 5.3) where we see a ship surrounded by inchoate swirling forces of nature rendered so that one is unable to distinguish a place between sea and sky. Not only does the contrast in scale contribute to a sense of the sublime as the detail is overwhelmed, the difference in treatment heightens this conflict. The viewer's eye, moreover quickly moves to the inchoate surroundings, where it becomes disoriented so that the effect of the sublime is made even more direct. When the viewer's eye returns to the safety of the steam ship, that terror is displaced onto the object. This displacement gives the viewer an immediate sense of the experience of

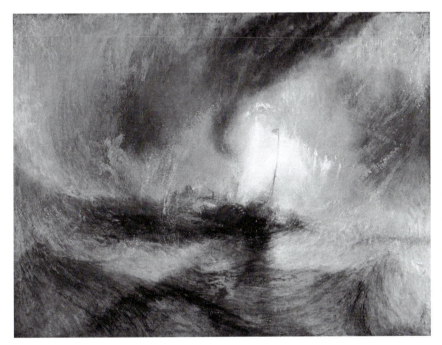

5.3 Joseph Mallord William Turner, *Snow Storm – Steamboat off a Harbour's Mouth Making Signal in Shallow Water, and Going by the Lead. The Author Was in this Storm on the Night the Ariel left Harwich*, 1842, oil on canvas, 36 x 48 in. (91.4 x 121.9 cm). © Tate, London, 2011.

the depicted event, as if they themselves were in it (the subtitle to *Snow Storm* claimed that Turner had been on that boat, in that storm).[59]

This structure is also visible in the structure of a much less chaotic picture, *War – The Exile and at the Rocket Limpet* (1842, Figure 2.23), a work that also considers recent history. *War* can be related to B.R. Haydon's painting of *Napoleon Bonaparte* of 1834 (Figure 5.4), which was disseminated throughout Britain in the form of engravings and replicas done by Haydon.[60] According to John Gage, Turner's own rather diminutive painting of Napoleon was meant to show that the grand and sublime effects of Haydon's enormous canvas could be achieved on a small scale.[61] Indeed, the fact that *War* is so small in relation to paintings like *The Battle of Trafalgar* (Plate 3) suggests that Turner was concentrating on internal relationships in the creation of the sublime rather than on the relation of the painting to the beholder. Crucial to this is

5.4 Benjamin Robert Haydon, *Napoleon Bonaparte*, 1834, 30 x 25 in. (76.2 x 63.1 cm). National Portrait Gallery London. © National Portrait Gallery, London.

the juxtaposition of the figure of the formerly all-powerful emperor with the seemingly insignificant limpet, which Turner emphasizes in the verse tag he wrote to accompany the painting in the Royal Academy exhibition catalog: "Ah! Thy tent-formed shell is like / A soldier's nightly bivouac, alone / Amidst a sea of blood — — —/— — — but you can rejoin your comrades." Napoleon's meditations on the shellfish place this detail in the realm of the metaphoric, for seeing the limpet prompts him to consider his own current situation of solitude. That state is thematized by the separation on the canvas of the three figural

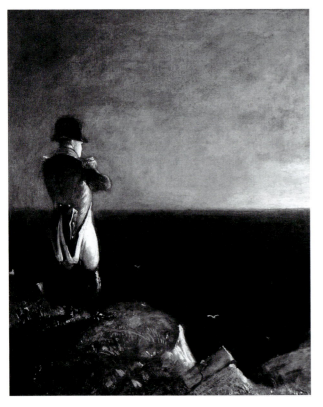

elements—the limpet, Napoleon, and his British guard—a separation emphasized by the brilliant colors which fill the negative space between the former emperor and the guard. Turner isolates the carefully delineated detail of the limpet against a vaguely defined surface of the liminal space between land and water. The limpet, whose diminutive size is drastically emphasized by means of this device, is then made to carry an enormous metaphorical weight, suggesting at once Napoleon's own former power and his current isolation in exile. The pendant to *War*, *Peace – Burial at Sea* (1842, Figure 2.22) ultimately extends these reflections by thematizing the isolation of his colleague Wilkie's death, which took place far from home. Taken together, the two pictures are meditations on the isolation of

human existence in both life and death, and the contrast between small details and sweeping natural spaces was crucial to this expression.

In many of Turner's paintings the figures or details do nothing to mitigate the perceived risk of the viewer. In the *Slave Ship* this is particularly evident, as Turner uses a seascape to strip the space of any possible place of rest and safety for the eye. Instead, the ominous swells of water and the looming storm threaten to invade the viewer's space, as Norman Bryson has noted.[62] By offering the eye no place to rest within the picture frame, thus maintaining the conflict that was the critical legacy of Burke's sublime, the viewer is drawn into the terrible scene, in which the overwhelming natural forces carry also a moral content. There is no avenue of escape from the horror and injustice of the Middle Passage, vividly rendered in this sweeping seascape. The drowning woman in the foreground is the only firm object in this area of the composition; the eye returns to it again and again, but always finds it incomplete. The sea, long an object of the sublime, is now merely a contributing factor to what we might call a kind of moral sublime with which the viewer is inescapably confronted. It is not the enmity of a metaphorical sea or storm that is responsible for the fate of the drowning woman, but the human hands who threw her there. Nature will be neither friend nor foe to her. If the atrocity is to be stopped, by implication, it must result from human action as well. By focusing the sublime so powerfully on the viewer, Turner's picture seems to place that responsibility on the beholder of the painting. Rather than using allegory to provide an easy answer and absolve the viewer of responsibility, then, Turner's painting employs the sublime to compel the viewer to grapple with a difficult issue. The painting thus emphasizes the idea that responsibility for political change rests firmly on the individual. Faith in any larger force, be it God, the government, or even mass politics, is insufficient.

Turner seems to have realized that history was being enacted in far different ways than the kind of allegorical model provided by Thomson could accommodate. As we have already seen, given an altered historical framework, Turner produced a modified pictorial structure. As with the series of pictures of destruction discussed in Chapter 2, a series which *The Slave Ship* to some degree extends, Turner both allowed this to inform the structure of the picture and addressed it directly, made it at some level the subject of the picture. There is then a doubled picturing at work here, so that picture is both about the issue of British involvement in the slave trade and abolition, and about histories and models for understanding that involvement, such as Clarkson's and Thomson's. Once again, it is my suggestion that Turner's sensitivity to the relationship between aesthetic and pictorial structure and history, meant that he found certain kinds of pictorial solutions no longer sufficient to expressing the complexity of a historical moment. Within that framework, Turner brought the dialectical aspects of the sublime into the realm of history painting. Again, while writers such as Boime would make abolition seem like distant history, this period of political activism was in many ways the legacy of the anti-

slavery movement. Turner's rejection of allegory in the *Slave Ship* is his most complete acknowledgement of the changed political nature of the nineteenth century. Seen in this way, the painting becomes a dramatic statement of the awesome power and responsibility that fall to the individual even as society threatens to overwhelm it, but which is, at the same time, its prompt to action. The result was a painting that challenged the viewer to political awareness and involvement rather than simply providing pre-determined meanings.

Gender, Race, and the Limits of Representation

At the end of Chapter 2, I suggested that in painting the *Disaster at Sea* (c. 1833–5, Plate 13) Turner came to some kind of limit of representation in his ongoing pursuit of painting by means of decomposition. I located that limit precisely in the figures of the women at the center of the painting, whose faces remained unpainted. Earlier in this chapter, I similarly suggested that Turner stopped short of representing the face of the drowning woman in the foreground of the *Slave Ship*, cutting her off with the edge of the picture. The *Slave Ship*, as Gillian Forrester notes, is related to *Disaster at Sea* because in both cases there is the question of the exchange of lives for monetary gain. We can see the *Slave Ship*, then, as one of a series of pictures about the victims of empire that includes *The Shipwreck* (Plate 7), *The Loss of an East Indiaman* (Plate 8), *The Field of Waterloo* (Plate 11), *The Decline of the Carthaginian Empire* (Plate 10), and the *Amphitrite*. Once again this is registered in violence against a woman, in this case a black woman. The battle between abolitionist and pro-slavery groups was often played out on the figure of the black woman, as Debbie Lee has discussed. Abolitionists and poets, including Southey, Cowper and, in somewhat disguised form, Wordsworth, used scenes of black women being separated from their children as a means of portraying the unnatural results of the trade and the empire-building it supported. The pro-slavery lobby, on the other hand, used tales of slave women killing their children rather than seeing them sold into slavery as evidence of the slaves' barbarism.[63]

 In the *Slave Ship* this question of imperial crimes had a deeply personal aspect for Turner. As Sam Smiles has discovered, in 1805 Turner invested in a speculation on a Jamaican cattle pen that was run entirely by slave labor, a detail that Smiles proves must have been perfectly well known to Turner at the time.[64] The scheme failed ultimately, but Turner would have been aware that several of his early patrons and customers, including Jack Fuller, the Lascelles family, William Beckford, and John Julius Angerstein had made their fortunes in the slave trade or by means of business that relied upon slave labor. Thus, we have another example of a close identification of individual/empire, but one that must have been far more uncomfortable for Turner. Any guilt held by the captains of the *Zong* and the *Amphitrite*, any guilt of the nation for the profit- and ambition-driven crimes of the slave trade, was held, in part at

least, by Turner as well. Part of the charge of the paintings, again, is that the guilt they rendered could not be effectively placed in the past.

But if this is an admission of that guilt, then what kind of admission is it? What kind of restitution does it offer for the insufficiency of parliamentary legislature? What kind of apology is this? Only one, it seems to me, that repeats the crime itself. Turner has most certainly focused on the suffering and cruelty of the slave trade by foregrounding the body of the drowning woman and refusing to incorporate her into a typological continuum. But it is a restitution that can only be made by means of destruction, not only of the ship about to face the storm but of the woman herself. It is an apology that can be made only by means of violence against the very figure whose suffering it would seek to acknowledge. The body of the slave, the material basis of Britain's imperial growth in the previous two centuries and a source, directly or indirectly, of some of Turner's own income, is only representable here as fragments: a leg and two breasts. She has already been decapitated by the edge of the picture; swarming sea creatures threaten to further disintegrate her. If I have already suggested that *Disaster at Sea* approaches a scene of abject physical and moral horror in which Turner managed, just barely, to put a face to a scene of extreme decomposition, it seems that in the *Slave Ship* Turner could not even begin to form a central figural group or to put a face on the horror he depicts.

Seen this way, the *Slave Ship* is a statement of exactly what could and could not be seen and painted, both about slavery in general and more specifically about the Middle Passage and torture.[65] Thomas Clarkson's account of the Middle Passage, which Turner would have read, takes readers through three stages of the trade for its victims: the capture in Africa, the Middle Passage, and their experience as slaves in the New World. In describing the first and last of these Clarkson uses graphic language and encourages us to visualize the horrific scenes he describes. But when he comes to the Middle Passage, Clarkson claims to find himself unfit to the task of representation:

[H]ere I must observe at once, that, as far as this part of the evil is concerned, I am at a loss to describe it. Where shall I find words to express properly their sorrow as arising from the reflection of being parted forever from their friends, relatives, and their country? Where shall I find language to paint in appropriate colours the horror of mind brought on by thoughts of their future unknown destination, of which they can augur nothing but misery from all that they have yet seen? How shall I make known their situation, while labouring under painful disease, or while struggling in the suffocating holds of their prisons, like animals inclosed in an exhausted receiver? How shall I describe their feelings as exposed to all the personal indignities, which lawless appetite or brutal passion may suggest?... Indeed every part of this subject defies my powers...[66]

The passage is notable for the relative mildness and lack of specificity concerning the conditions of the Middle Passage. Resorting to apophasis, Clarkson indicates some of the inhuman conditions aboard the ship precisely

by imagining what he cannot represent. But even in so doing, he seems unable to think in terms beyond generalized emotional responses.

Turner may well have read these words as a challenge, "to paint, in appropriate colours, the horror of mind," but it was a challenge for which the terms of success were not clear. To paint a scene from the Middle Passage, like painting the crimes of the *Zong*, would be at some level to co-opt those bodies again, to turn their deaths into something else, a mere type. But Turner himself discovered that to represent that death in all of its specificity was a painful alternative. For, if the woman in the corner of the *Slave Ship* is in some ways the companion of the central figure of the *Amphitrite*, she is also that figure's opposite. Where the white woman looks out from the edge of an abyss at the center of the earlier painting, here the black woman's look is excluded from the frame, just outside of the abyss that her body occupies. Where the *Amphitrite* brings the unsayable horror of disaster and guilt into the center of the space of representation only to show it as unrepresentable, the *Slave Ship* seems unable to either exclude or include it entirely. This act of neither fully including nor excluding was repeated by Ruskin in his discussion of the painting, which only acknowledges that this is a slave ship in a footnote.[67] The only mention of bodies—"corpses"—also comes in the footnote, but the torture of the slaves is also transposed into the turbulent, disturbing language that Ruskin uses to describe the sea and sky, as Marcus Wood convincingly argues; their blood is then transposed into the dominant crimson tones that Ruskin describes so vividly.[68]

Part of the un-nameable quality of that body, as Clarkson rather tamely suggests, must have been its suffering under repeated sexual assaults, which could not even be treated as crimes because of the black woman's objectified status as property. By fragmenting her, the figure of the woman is reduced to a series of sexualized signs, something able to be possessed, something less than human. The body of the black woman in nineteenth-century art and science came to be defined exclusively by her differential sexuality, as a marker of the black woman as a lower form of the species, as Sander Gilman has noted. This means of thought helped to justify the colonial enterprise.[69] In particular, Gilman points to the discourse around the enlarged buttocks of the Hottentot Venus, who Turner may have seen when she appeared in London in 1810 (Figure 5.5). Those buttocks appear in Turner's painting, in displaced form, in the swollen, almost absurdly rendered breasts.[70] Even more, nudity was a fundamental condition of the female slave during the Middle Passage. Women were stripped of their clothing upon entering the ship, both as a means of denying them anything that they might use for suicide and to make them sexually available to their white captors, who often chose their sexual victims during the stripping itself.[71] What would the face of such a victim have looked like for Turner? It seems that he could not put even rudimentary features on her, as he at least managed for the mother of the *Amphitrite*. And

so he placed her head and face outside of the canvas, outside the space of representation.

The face of the black slave woman could neither be seen by Turner nor allowed to see. Indeed, the only eyes that appear in the picture are those of the fish, so a blinding has taken place here.[72] In this regard, the woman is the object of the sublime described by Burke, who discusses the sublimity of darkness and blackness by means of a medical case. He describes the encounter between a black woman and a boy who had gained his vision after being blind for the first thirteen years of his life. As a part of his attempt to prove that blackness was naturally, rather than associatively, conducive to the feelings of pain and terror that are the source of the sublime, Burke writes: "…the first time that the boy saw a black object, it gave him great uneasiness; and that some time after, upon accidentally seeing a negro woman he was struck with great horror at the sight."[73] Burke is discussing a case that had been reported some time before and he has slightly altered the presentation of the facts. The physician in the case, Dr. Cheselden, had noted that "after a little Time" the boy reconciled himself to blackness, and it was only "some Months after" that the sight of the Negro woman brought the horror back.[74] On the one hand then, the black woman is an object here, equivalent with a form of nature and so not endowed with consciousness. On the other, her surprise appearance functions like the Freudian uncanny, the uncomfortable return of a repressed memory, an aspect of the story that Burke in turn represses by avoiding the interval of reconciliation.

Must not Turner's black woman have functioned in the same way to viewers surprised at her presence, her very close and visceral presence, in the midst of a beautiful, if terrifying, seascape, on the walls of the Royal Academy exhibition? Must not part of the discomfort of the picture have been, and would continue to be, its ability to prompt a return of the repressed terror of the slave trade, a horror imagined by some to have been excised from the English conscience, the repressed vision of terror and pain that the nude body

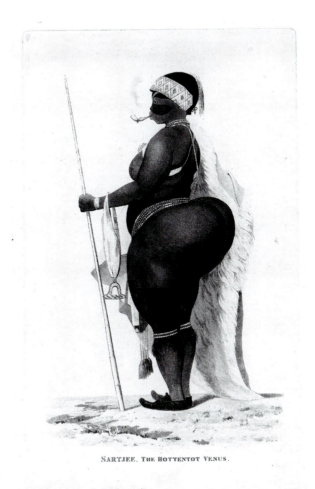

SARTJEE, THE HOTTENTOT VENUS.

5.5 Frederick Christian Lewis, *Sartjee, the Hottentot Venus*, 1810, etching and aquatint, 14.25 x 8.75 in. (36.1 x 22.3 cm). British Museum, London. © Trustees of the British Museum.

of the slave represented?[75] She is the object of the sublime here, rather than its subject. Yet even in this role she is not complete, for she is defined entirely by her skin color and sexual organs. She is, therefore, neither wholly object nor subject; she cannot fully be seen nor fully unseen. Nor, finally, can she be seen to see, for what would she have seen but the very unrepresentable scene of the Middle Passage, what Clarkson said could not be written? This is, of course, the subject of the picture, as Turner names it in the title. Yet he banishes it to the distance of the picture, again at the other edge of invisibility, about to be obscured by a storm. The fragmented body in the foreground is both the precondition and the aftermath of the crime on that ship, but not fully its present or presence. She is still the index of that horror though, lingering at the close edge of vision as the return of the repressed terror of the black woman. Neither inside nor outside the space of representation, Turner could neither banish her completely nor fully include her.

But what else could Turner have done? To show her otherwise, to make her whole, to give her exchange value and turn her into another typological example would have been to repeat the false hope of images such as David Lucas's print after Alexander Rippingille's celebratory *To the Friends of the Negro Emancipation* (1836, Figure 5.6) or the languid eroticism of Auguste Biard's *Slaves on the West Coast of Africa* (1835, Figure 5.7). Here the victims of torture are shown, but they seem to passively accept their fate rather than express real horror. The latter picture was shown at the same 1840 Royal Academy exhibition as the *Slave Ship*, and the two pictures were often compared. As McCoubrey notes, the enthusiasm of reviewers like Thackeray for Biard's piece must have stemmed in part from the fact that after condemning Turner they could still express their allegiance to abolition in praising Biard.[76] But this moral stance was enabled by the fact that the picture provided certainty regarding the viewer's own position, where Turner's did not. Biard allowed Thackeray to specifically place the picture securely on the coast of Africa. It depicted crimes that could no

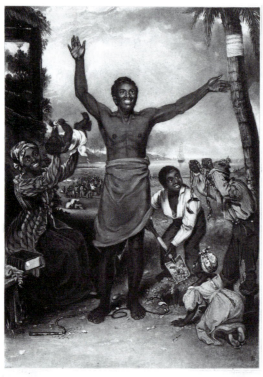

5.6 David Lucas, *To the Friends of the Negro Emancipation*, after Alexander Rippingille, 1836, aquatint, 13.9 x 9.6 in. (35.2 x 24.5 cm). National Maritime Museum. © National Maritime Museum, Greenwich, London.

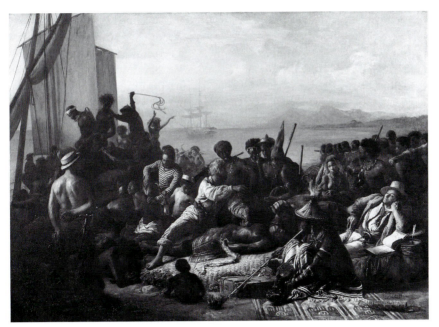

5.7 Francois Auguste Biard, *Slaves on the West Coast of Africa*, c. 1833, oil on canvas, 25.2 x 35.4 in. (64 x 90 cm). © Wilberforce House, Hull City Museums and Art Galleries, UK/ The Bridgeman Art Library.

longer be Britain's and thus allowed the viewer to experience a sense of non-reflective outrage. Turner's picture, on the other placed these crimes at sea, and enabled no such easy escape. In Biard's work, furthermore, the mute servitude of the voluptuous black women allowed a white male fantasy of erotic and commercial possession to exist alongside of a sense of righteous outrage that can be produced by imagining themselves, Britons, to be free of such sin. The blacks are suffering, certainly, but they are also passive, mute, and pose no threat of rebellion.[77]

If Turner's fragmentary, sightless woman repeats the crime of slave torture and turns the black woman into something that is all body, defined entirely by her blackness on the one hand and her sexual difference on the other, then the fragment also resists the kind of crime repeated by Biard. If she is only a fragment then she cannot be possessed completely.[78] And if the slave as a whole and rebellious subject was dangerous, Turner has at least given some sense of resistance here. Mark Twain appears to have been astute in sardonically suggesting that water appeared to have become ground, then this leg and the hands, and their chains, refuse to be buried or to remain buried.[79] While the picture is about the terror of drowning, it is also, then, about the terror of the return of the dead, much like the return of the repressed terror of Burke's example of the negro woman, much like the unburied bodies at Waterloo. This picture, like *The Field of Waterloo*, is exactly about a memory of terror and violence that will not be vanquished, that will not be placed comfortably in the past. The logic of decomposition here has been taken to an extreme, one that, it seems to me, precisely resists being reformed into some greater whole, some greater unity. The fragmentary status of the body of the drowning woman is crucial to this resistance because she is both within the

painting and outside of it. To center the image of slave torture and pain would have been to circumscribe it, to imagine that it could be healed, that it could ever have been made whole. Instead, painting here seems to acknowledge its supplementary status, its insufficiency to pay the historical debt that is at its origin.[80]

There is an important correlation with the notion of double consciousness that Paul Gilroy, adopting the idea of W.E.B. DuBois, has elaborated with respect to the space of this painting: the Black Atlantic. By this he means to suggest the space of a kind of hybrid modernity, in which the experience of slavery is central to forming the experience of both blacks and whites. Double consciousness, as discussed by Gilroy, refers to a feeling of being both in and out of society, a situation that would have been very familiar to blacks living in England at the time of this painting.[81] If, in Thomson's booming phrase, "Britons will never be slaves," the question remained after emancipation whether slaves would ever be Britons. As Peter Marshall discusses, the notion of English liberty was a defining aspect of British imperial identity. How could anyone who had so recently been enslaved qualify for the title of Briton? Against this backdrop, the figure of the black slave in Turner's *Slave Ship*, in some sense freed from the ship, is once again best understood as neither properly within nor without the painting, occupying instead a strangely constricted space of freedom. But then, the question remains, how could Britain have built an empire by means of an absolute control if such control was counter to their very defining principles? They themselves had created the uncertain status of the slave, the former slave, and the former slave-holder.

If there is anything laudable about Turner's painting, then, it is not so much its evident sense of moral outrage. It is more that this outrage comes from its own position of double consciousness, a sense of a subject who was English, white, and male, privileged to be sure, but also neither entirely within nor without of the matter of slavery and its de-structural role in imperial Britain. In fact, some of its moral outrage, it seems to me, is harnessed against the very notion that any such position could exist. A picture like Biard's, that seeks to provide that position, can only appear as a lie in the face of Turner's. I suggested earlier that in the *Slave Ship* Turner enacted a separation of the individual slave from the whole history of slavery and abolition. This separation resulted from an awareness that, at some level, the incorporation of the individual scene into a typology, the exchange value of the individual as Baucom puts it, was an act of violence itself. Even if the *Slave Ship* is not able to find an alternative mode of representation, even if it resorts to its own level of pictorial violence, the picture ultimately puts a very different kind of end to the tradition of history painting than I have described throughout this book. Not only does it suggest that the conventional terms of representation are inappropriate to the kind of history presented by questions of slavery and abolition, but it also signals a much broader skepticism. Indeed, perhaps the most modern element of the *Slave Ship* is that it prompts our suspicion of the

kind of historical representation that makes the detail fit seamlessly into a whole, that allows one historical period to flow to easily into another. In this regard, the picture's destruction of history painting is the most complete that Turner ever produced.

Endnotes

1 For sources before 1984 and a discussion of contemporary critical responses, see Martin Butlin and Evelyn Joll, *The Paintings of J.M.W. Turner*, 2nd ed., (2 vols, New Haven and London: Yale University Press, 1984), text volume: pp. 236–7. For a discussion of Ruskin's reactions to the *Slave Ship* and the painting's reception in the United States, see John McCoubrey, "Turner's Slave Ship: Abolition, Ruskin, and Reception," *Word & Image,* 14/3 (October/December, 1998): pp. 343–353; Jan Marsh, "Ruskin and Turner's *Slavers*: Patriotic, Political and Pictorial Issues," *Visual Culture in Britain,* 2/1 (2001): pp. 47–63; Eric Rosenberg, "...a flagrant falsehood": Turner's *Slave Ship* in 'the chief city of North America,' 1872–1876," unpublished manuscript; Nancy Scott, "America's First Turner: How Ruskin sold *The Slave Ship* to New York," *British Art Journal,* 10/3 (Spring 2010): pp. 69–77; Melanie Ulz, "The Guilty Ship: Memory and Cultural Denial in a Post-Abolitionist Society," in Birgit Haehnel and Melanie Ulz (eds), *Slavery in Art and Literature: Approaches to Trauma, Memory and Visuality* (Berlin: Frank and Timme, 2010), pp. 125–46. For interpretations of the painting in relation to aspects of Romantic poetry, see James A. W. Heffernan, *The Re-creation of Landscape: A Study of Wordsworth, Coleridge, Constable and Turner* (Hanover, NH and London, The University Press of New England, 1984), pp. 181–182 and James Twitchell, *Romantic Horizons: Aspects of the Sublime in English Poetry and Painting* (Columbia, MO: University of Missouri Press, 1983), pp. 101–108.

2 Melanie Ulz regards the painting as a denunciation of slave trading "in general," arguing that it took the opportunity to refer to specific historical circumstances "while at the same time making a more general, metaphorical statement against the slave trade as such." (Ulz, "The Guilty Ship," pp. 131–3).

3 This connection was first made in T.S.R. Boase, "Shipwrecks in English Romantic Painting," *Journal of the Warburg and Courtauld Institutes,* 22/3–4 (1959): pp. 341–2.

4 Thomas Clarkson, *The History of the Rise, Progress and Accomplishment of the Abolition of the Slave-trade by Act of Parliament,* 2nd ed., (London: J. W. Parker, 1839), pp. 80–81.

5 *J.M.W. Turner: His Life and Work* (Greenwich, CT: New York Graphic Society, 1966), p. 190.

6 Ian Baucom, "Specters of the Atlantic," *South Atlantic Quarterly,* 100/1 (Winter 2001): pp. 63–4, ff.

7 Albert Boime, "Turner's *Slave Ship*: The Victims of Empire," *Turner Studies,* 10/11 (1990): pp. 36, 41. Boime does note that similar incidents were reported in the press contemporaneously with Turner's painting, but only sees these as adding force of relevance to Turner's depiction of the *Zong*.

8 Boime, "Turner's *Slave Ship*," p. 40.

9 McCoubrey, "Turner's *Slave Ship*," pp. 323–334.

10 McCoubrey, "Turner's *Slave Ship*," pp. 341–45.

11 McCoubrey, "Turner's *Slave Ship*," pp. 338–45.

12 Clarkson, *Rise, Progress and Accomplishment,* pp. 5–7.

13 Baucom, "Specters of the Atlantic," pp. 72–4, ff.

14 Marsh, "Ruskin and Turner's *Slavers*," p. 48.

15 Marsh, "Ruskin and Turner's *Slavers*," p. 48.

16 Marsh, "Ruskin and Turner's *Slavers*," p. 50.

17 Ronald Paulson, *Literary Landscape: Constable and Turner* (New Haven, CT: Yale University Press, 1980), pp. 65–6.

18 John McCoubrey, "Parliament on Fire: Turner's Burnings," *Art in America,* 72/11 (December 1984): pp. 120–4.

19 Baucom, "Specters of the Atlantic," pp. 78–80.

20 Baucom, "Specters of the Atlantic," p. 80.

21 Butlin and Joll, *Paintings of J.M.W. Turner*, text volume, p. 237.

22 McCoubrey, "Turner's *Slave Ship*," pp. 338, 347–8.

23 The first scholar to connect Turner's painting to these verses was Ann Livermore, in "J.M.W. Turner's Unknown Verse-Book," *The Connoisseur Year Book* (1957): p. 80. See also Jack Lindsey, *J.M.W. Turner: His Life and Work*, pg. 161 and Andrew Wilton, *Turner and the Sublime*, exhibition catalog, (London: British Museum Publications for the Art Gallery of Ontario, The Yale Center for British Art, The Trustees of the British Museum, 1980), p. 67.

24 See also Mary Robinson's "The Negro Girl," (1800) in Alan Richardson (ed.), *Slavery, Abolition and Emancipation: Writings in the British Romantic Period* (8 vols., London: Pickering and Chatto) v. IV, pp. 260–7.

25 James Thomson, "Summer," in J. Logie Robertson (ed.), *The Complete Poetical Works of James Thomson* (Oxford: Oxford University Press, 1908), ll. 1013–1025, p. 89.

26 Thomson, "Summer," ll. 1223–1229, pp. 97–8.

27 Thomson, "Summer," ll. 1371–1379, pp. 103–4.

28 Thomson, "Summer," ll. 1471–1478, p. 107.

29 Clarkson, *Rise, Progress and Accomplishment*, p. 81.

30 Clarkson, *Rise, Progress and Accomplishment*, pp. 5–8.

31 Howard Temperley, "The Idea of Progress," in David Northrup (ed.), *The Atlantic Slave Trade* (Boston: D.C. Heath and Company, 1994), p. 193.

32 See Marcus Wood's interpretation of the map in *Blind Memory: Visual Representations of Slavery in England and America, 1780–1865* (New York: Routledge, 2000), pp. 1–6.

33 Robin Blackburn, *The Overthrow of Colonial Slavery 1776—1848* (London and New York: Verso, 1988, p. 468. Interestingly, Ulz ("The Guilty Ship," pp. 129–30, 143–5) suggests the opposite, that the painting's formal innovations were as much a part of its negative critical reactions as the subject matter. Ulz suggests that these forced viewers to confront the issues rather than offering a release from them.

34 McCoubrey, "Turner's *Slave Ship*," pp. 329–30.

35 Milligan, "The Lovers," in Richardson, *Slavery*, p. 29.

36 David Brion Davis, *The Emancipation Moment* (Gettysburg, PA: Gettysburg College, 1983), p. 8.

37 James Walvin, *Black and White: The Negro and English Society, 1555–1945* (London: Allen Lane, 1973). Walvin writes, "In the early years of the nineteenth century the black population of London was large, prominent, and the subject of heated public and private discussion." (p. 189).

38 Lindsay, *Turner: Life and Work*: p. 190. Ulz ("The Guilty Ship," pp. 144–5) concludes with a similar point, saying that in part because of the loose handling and representation of forms and its resistance to racial stereotypes, the picture refused to allow contemporary viewers an easy sense of moral superiority

39 Thomas Haskell, "Capitalism and the Origins of the Humanitarian Sensibility, I" in Thomas Bender (ed.), *The Antislavery Debate: Capitalism and Abolitionism as a Problem in Historical Interpretation* (Berkeley: University of California Press, 1992), p. 110.

40 Thomas Haskell, "Capitalism and the Origins of the Humanitarian Sensibility, II" in Bender, *The Anti-slavery Debate*, p. 148.

41 Haskell, "Capitalism and the Origins of the Humanitarian Sensibility, II" in Bender, *The Anti-slavery Debate*, p. 141.

42 Blackburn, *Overthrow of Colonial Slavery*, p. 295. See also the important work by Eric Williams, *Capitalism and Slavery* (Chapel Hill: University of North Carolina Press, 1944).

43 Blackburn, *Overthrow of Colonial Slavery*, p. 295. On British abolitionism see pp. 67–107, 131–60, 293–329, 419–72.

44 Seymour Drescher, *Capitalism and Anti-Slavery: British Mobilization in Comparative Perspective* (London: Macmillan, 1986).

45 Edward Royle and James Walvin, *English Radicals and Reformers* (Lexington, KY: University of Kentucky Press, 1982), pp. 32–5 and Drescher, *Capitalism and Anti-Slavery*, pp. 67–88.

46 Drescher, *Capitalism and Anti-Slavery*, p. 72.

47 Thomas Taylor, *A Biographical Sketch of Thomas Clarkson, M.A, with Occasional Brief Strictures on Misrepresentations of him in the Life of William Wilberforce and a Concise Historical Outline of the Abolition of Slavery* (London: Joseph Rickerby, 1839), pp. 2–3.

48 Edmund Burke, *A Philosophical Enquiry into Our Ideas of the Sublime and Beautiful*, 2ⁿᵈ ed., (London: R. and J. Dodsley, 1759), pp. 110–2.

49 See Burke, *Philosophical Enquiry*, pp. 254–8.

50 Taylor, *Thomas Clarkson*, p. 3.

51 Taylor, *Thomas Clarkson*, p. 4.

52 Taylor, *Thomas Clarkson*, pp. 13–4.

53 Taylor, *Thomas Clarkson*, p. 19.

54 Burke, *Philosophical Enquiry*, p. 237.

55 Taylor, *Thomas Clarkson*, p. 30.

56 Drescher, *Capitalism and Anti-Slavery*, p. 23.

57 Drescher, *Capitalism and Anti-Slavery*, p. 182, n. 65.

58 Wilton, *Turner and the Sublime*, p. 45.

59 My discussion here is indebted to Norman Bryson's, "Enhancement and Displacement in Turner," *The Huntington Library Quarterly* 49 (1986), pp. 47–65.

60 John McCoubrey, "War and Peace in 1842: Turner, Haydon and Wilkie," *Turner Studies*, 4/2 (1984): pp. 2–7.

61 *J.M.W. Turner à l'occasion du cinquantième anniversaire du British Council*, exhibition catalog (Paris: Ministere de la Culture, Editions de la Réunion des Musées nationaux, 1983), p. 141. See also Marcia Briggs Wallace, "J.M.W. Turner's Circular, Octagonal and Square Paintings, 1840–1846," *Arts Magazine*, 55 (April 1979): pp. 107–17; Nicholas Alfrey, "Turner and the Cult of Heroes," *Turner Studies*, 8/2 (Winter 1988): pp. 33–44; Eric Shanes, *Turner's Human Landscape* (London: Heinemann, 1990), pp. 100–6; Gerald Finley, *Angel in the Sun: Turner's Vision of History* (Montreal: McGill-Queen's University Press, 1997), pp. 109–12; Sam Smiles, *J.M.W. Turner: The Making of a Modern Artist* (Manchester: Manchester University Press, 2007), pp. 24–7.

62 Bryson, "Enhancement and Displacement," p. 54.

63 Debbie Lee, *Slavery and the Romantic Imagination* (Philadelphia: University of Pennsylvania Press, 2002), pp. 195–221.

64 Sam Smiles, "Turner and the slave trade: speculation and representation, 1805–1840," *British Art Journal*, 8/3 (Winter 2008): pp. 47–54. I am grateful to Professor Smiles for sharing this important work with me in advance of its publication.

65 Marcus Wood discusses the issue of unrepresentability in *Blind Memory*, pp. 14–77.

66 Clarkson, *History of the Rise, Progress and Accomplishment*, pp. 39–40.

67 Paul Gilroy, *The Black Atlantic: Modernity and Double Consciousness* (Cambridge: Harvard University Press, 1993), p. 14; Marcus Wood's extraordinary discussion of Ruskin's private interaction with the picture reveals Ruskin's broader awareness of the subject (*Blind Memory*, pp. 56–9).

68 Wood, *Blind Memory*, pp. 59–68.

69 Sander Gilman, "Black Bodies, White Bodies: Towards an Iconography of Female Sexuality in Late Nineteenth-Century Art, Medicine and Literature," in Amelia Jones (ed.), *The Feminism and Visual Culture Reader* (New York: Routledge, 2003), pp. 136–50.

70 Ulz ("The Guilty Ship, pp. 141–2) also connects the raised leg to the exposed legs of female dancers, suggesting that by including it here Turner critiqued male erotic fantasies and the use of aesthetic values to establish white superiority.

71 Eddie Donaghue, *Black Women/White Men: The Sexual Exploitation of Female Slaves in the Danish West Indies* (Trenton, NJ: Africa World Press, 2002), pp. 64–6. On issues of women and the slave trade see also Jennifer Lyle Morgan, "Women in Slavery and the Transatlantic Slave Trade," in Anthony Tibbles (ed.), *Transatlantic Slavery: Against Human Dignity* (Liverpool: National Museums Liverpool, Liverpool University Press, 2005), pp. 57–66.

72 Wood, *Blind Memory*, p. 72.

73 Burke, *Philosophical Enquiry*, p. 131.

74 William Cheselden, "An Account of some Observations Made by a Young Gentleman, Who Was Born Blind, or Lost his Sight so Early, That He Had no Remembrance of Ever Having Seen, and Was Couch'd Between 13 and 14 Years of Age," *Philosophical Transactions of the Royal Society*, 35/402 (1727–28): pp. 447–8.

75 Debbie Lee discusses a similar haunting by the figure of the black woman for Wordsworth, who had his own sources of guilt in his association with the trade (Lee, *Slavery and the Romantic Imagination*, pp. 204, 207, 220).

76 McCoubrey, "Turner's *Slave Ship*," p. 346.

77 Albert Boime, *The Art of Exclusion: Representing Blacks in the Nineteenth Century* (Washington and London: Smithsonian Institution Press, 1990), pp. 63–5; Wood, *Blind Memory*, pp. 43–4.

78 Ulz, ("The Guilty Ship", p. 145) ends on a similar note, emphasizing the resistance of the fragmentary body to racist stereotypes.

79 Jerrold Ziff, "'What a red rag is to a bull,'" *Turner Studies*, 3/2 (Winter 1984): p. 28.

80 Jacques Derrida, *The Truth in Painting*, trans. by Geoff Benningham and Ian MacLeod, (Chicago: University of Chicago Press, 1987).

81 Gilroy, *Black Atlantic*, p. 30.

Conclusion

This book ends where it began: with Turner's history paintings of destruction and his destruction of history painting. Only such a conception knits together some of the rather strange bedfellows that my account of Turner has produced. At first blush, *The Battle of Trafalgar* and the *Slave Ship* appear to have little to do with each other, relating at best as bookends to an account of Turner that, following Ruskin, traces Turner's growth away from the excessive narrative and academicism of his early career. There is much to support this view, it would seem. Compared to *Trafalgar*, which is literally filled with incident and form, one is struck by the starkness and pervading sense of absence in the *Slave Ship*, even in the midst of its richly painted surface. For all that I have said about the centripetal energy of *Trafalgar*, the narrative fulcrum of the Nelson group is placed relatively close to the center of the canvas, and the rest of the events on the *Victory* arrayed around it. No such centralization or hierarchy exists in the *Slave Ship*. After the eye settles on the drowning woman in the foreground, marginalized and decapitated by the edge of the canvas, one has to search for other signs of humans in the painting. The center of the canvas is dominated by non-forms: the trough of a wave and the blazing light of the sun. Almost the entire picture is given over to those elements which are precisely not things: light, air, and water, and particularly the areas where they seem to be merging together.

This last point, however, suggests the overarching connection that I have labored to demonstrate between the two pictures. There is undeniably a powerful visual difference between *Trafalgar* and the *Slave Ship*, but it is not at all clear that it must be understood in terms of the negation of the earlier work by the later, or, in other words, by a linear development of academicism to naturalism, or in terms of an approach to history that shifts from youthful patriotism to mature skepticism. This latter view is tempting because it would link unconventional painting structures to a more cynical, less naïve view of history. This would seem to confirm a certain linkage between proto-modernist pictorial practice and sophisticated historical awareness and a certain resistance to grand narratives. But in the end, this model is itself too simple to account for the kind of complexities in Turner's work that I have

elaborated here. Rather, we should note that in both pictures, both artistic creativity and imperial progress are based upon a prior loss, a death, or an absence. If *Trafalgar* is characterized by a kind of *horror vacui* that is striking in comparison to the *Slave Ship*, it was also just as much about the destruction of form, about a radical loss of integrity of ships, of bodies, of historical narratives. In this regard, the two pictures are entirely of a piece, for both thematize painting as a process of creation emerging from destruction. If we think, moreover, of the *Slave Ship* as a painted space brimming with a lushness of paint that is the very means of both representing that reduction and creating it anew, then the pictures are not necessarily opposites at all.

If it is not possible to present the development of Turner's pictorial practice and historical awareness in straightforward chronological terms, in closing, I would like to consider two related issues: first, in general terms, why did Turner approach historical representation in the manner he did? And second, to what extent can we assess which of these accounts is most correct? That is, if I have successfully argued that Turner's view of history was in many cases a skeptical one, and that he did not view the development of society in progressive terms, the question may still remain as to why this was so. Based on the above, to what extent was this skepticism ever complete? Also, if I have noted that Turner's depictions of history betray a longing for a more traditional kind of historical representation, then we might well wonder which of these most accurately represents Turner's own viewpoint. But it is not altogether clear that an answer to this question exists. I do not think that an account of Turner can, or should, reconcile this. Both positions were very real for Turner and it is their coexistence that lends such complexity to so many of the pictures. Put another way: if Turner did indeed desire to see history in progressive terms, why did skepticism so frequently surface in his pictures? In the first place, on the basis of the previous arguments, it would seem that at some level Turner knew too much about history by the time he painted the *Slave Ship* to be anything but skeptical about the grand claims of the abolitionists, for instance. From here, then, another question might be asked: about what else did Turner know too much and when did he know it?

In the first place, although Turner was not exposed to the theories of Darwin, he was deeply interested in science. Turner's considerable interest and knowledge of technological and scientific developments in the fields of architecture, meteorology, industrial production, steam power, geology, and magnetism were documented in great detail in James Hamilton's 1998 exhibition and catalog.[1] Although this scientific aspect of Turner has not entered into this book, such an awareness of the independent processes of nature would likely have increased Turner's doubt about allegorizing nature and investing it with traditional structures of meaning. This interest, moreover, would have augmented one of the key aspects of Turner's practice, his attention to the specificity and particularity of nature. Turner's interest in rendering the specific forms and processes of nature, in all of their proliferation, may well have made it difficult for him to absolutely invest those forms with

meaning and to see them as arranging themselves around man. For an object to function metaphorically, it cannot assert its independence too aggressively. Turner's constant study of nature seems to have convinced him of the infinite variety of its forms and processes, and this would have made it difficult for him to deploy metaphor and allegory at times in creating a historical landscape. Also, Turner was well aware of the dangerous aspects of nature. Indeed, he seems to have sought out nature's most dangerous conditions—storms, mountain passes, and volcanoes—and this may well have convinced him of nature's indifference to man. This interest in specificity, it should be noted, is not related to style. Turner's contemporary, the painter Frederic Edwin Church for instance, was far more precise in his renderings of individual forms than Turner ever was, even as he was interested in some of the same issues and themes. Even in the most sweeping, abstract evocations of nature, however, Turner's method was determined by his interest in rendering the many varying forms of light and atmosphere in nature.

In addition to knowing too much about nature, Turner must also have known too much about history and society. Turner's approach to British society was not dissimilar to his interest in nature. As he traveled throughout Britain and Europe he described the people and locations he saw with the same interest in precise and individual terms. Turner, I have come think, knew rather too much about the way people lived, and about the way historical change affected their lives, to be convinced by political rhetoric or to be convincing in attempts to put that rhetoric to work in history paintings. This resistance to grand narratives in favor of an awareness of particularity may connect my account to other aspects of Turner's career. Comparing the figures in Turner's *Ploughing up Turnips near Slough* and *Frosty Morning* (1813, B&J 127) to Constable's depictions of laborers at work, for instance, Barrell pointed out that Turner's pictures refuse to take recourse to the available models for showing laborers, either in terms of an idle Pastoral or as machine-like workers, as in what he calls Constable's "Georgic."[2] This reluctance to categorize rural labor suggests an awareness again that existing conventions of representation were at some level insufficient to specific aspects of social existence. Turner's somewhat anomalous social position may have had a role in the development of his skepticism about representation. As the son of a Covent Garden barber, Turner had decidedly lower-class origins. His maintenance of a thick Cockney accent throughout his life, even once his art had brought him to the upper levels of society, suggests a sort of willful refusal to dismiss his origins and associate with the members of his new milieu. Furthermore, while Turner executed a number of commissions for aristocrats, and counted the 3rd Earl of Egremont among his friends, he nonetheless remained an outsider from this highest class and would have been unlikely to adopt their political viewpoints. He also executed a number of paintings for merchants and capitalists. Given his own entrepreneurial approach, it would seem possible to identify Turner with a more typically bourgeois mentality, as we saw in the chapter on the Varnishing Days. Because of his lack of identification with any

particular class, it is perhaps not surprising that Turner's work was resistant to the adoption of a class-based political viewpoint.

Perhaps most importantly, however, if I have undermined a certain idea of Turner's progress from a more traditional, optimistic vision of history and its representation in paint, I do not think we cannot understand this awareness on Turner's part of the dialectical aspect of history as any kind of a fall or a loss of faith. Where the Civil War produced this kind of rupture for American artists, Church among them, there is no similar watershed for Turner.[3] If *Waterloo* is deeply ambivalent about war, empire, and the ability of painting to represent them, this was an ambivalence that was already present to some degree in *Trafalgar*. At the same time, however, this sense of skepticism was never absolute. However much the second *Trafalgar* picture is a product of the same destructive impulse as the earlier one, this nonetheless seems to have been marshaled, as in the earlier version, in a genuinely patriotic manner. There was no irony in Landseer's reference to Nelson as Turner's "hero." Similarly, *The Fighting Temeraire*, painted in the year before the *Slave Ship*, is undeniably successful in its booming evocation of a powerfully unified vision of national identity. Thackeray called it "as grand a painting as ever figured on the walls of any academy, or came from the easel of any painter" and likened its effect to hearing a performance of "God Save the Queen."[4] Other reviewers readily attributed patriotic qualities to the painting. The *Spectator* called the *Temeraire* "…a grand image of the last days of one of Britain's bulwarks," and suggested that "this picture ought to be purchased [by the state] for Greenwich."[5] Neither view, I am suggesting, preceded or eclipsed the other.

All of this suggests a complex relation for the individual agent, Turner, to the larger historical narratives that have come to structure our sense of Romanticism. Indeed, in sketching out a set of individual, sometimes biographical, answers above, I have not meant to over-privilege this form of art historical explanation. Indeed, this study has tried to maintain a tension throughout between Turner's choices as an individual and the material conditions which preceded, but did not determine, those choices. Thus, we should be very much aware that this sense of an overarching, structural experience of cultural loss to which Turner was both receptive and ambivalent has been taken as one of the defining features of Romanticism. I have already discussed this view in Chapter 2, with reference to the visual arts in citing Linda Nochlin's account of the predominance of fragmentation in Romanticism, but we can also note here Michael Löwy and Robert Sayre's account of the Romantic *Weltanschauung* as a "modern critique of modernity" that is rooted in the experience of loss, alienation and exile.[6] Such an account, which stresses the anti-capitalist basis of the Romantic mobilization of subjectivity, imagination, utopianism, and rejection of contemporary capitalist values, can place Turner's highly individualized response in the Varnishing Days, for instance, in further perspective. Thus, on the one hand, we can see his mobilization of genius and imaginative human response, as well as his apparent withdrawal from the Academy, described both literally, in reference to his a-social behavior, and figuratively, in his competitive response

to his peers, as embodying a Romantic response to the much-lamented commercialization of the official spaces of art.[7] As Löwy and Sayre discuss, the isolated individual is both produced by capitalism and can employ the resulting subjectivity to resist capitalism's reification. In Turner's case, as we have seen, that critique took shape within an ongoing project of maximizing the value of his work; in other words within the production of imagination as cultural capital. Thus, again, Turner's degree of resistance to modernity, to historicizing narratives, and the production of individual subjectivity for both painter and viewer is inextricable from a larger historical situation, while not being reducible to it.

In his introduction to the 1966 Turner exhibition at the Museum of Modern Art, Sir Lawrence Gowing wrote, "We cannot show the whole of Turner. It is not certain that we are yet prepared to see him whole."[8] In light of the above, then, I would offer this book as something of a positive argument in favor of this position. Questions such as patriotism or skepticism, like so much about Turner, are best recognized as productively un-resolvable. While the melancholic, looping, view of history in the *Slave Ship* is probably best compared to the work of someone like Baudelaire, Turner's embrace of a sort of Baudelairean alienation was never complete. We should not, therefore, imagine that we can or should see Turner whole. Rather, it is by seeing the individual painter as a conflicted, contradictory, ambivalent subject, as a site of heterogeneity rather than cohesion and unity, that we do the most service both to his art and the period to which he gave such complex form.

Endnotes

1 James Hamilton, *Turner and the Scientists*, exhibition catalog (London: Tate Publishing, 1998).

2 John Barrell, *The Dark Side of the Landscape: The Rural Poor in English Painting, 1730–1840* (Cambridge: Cambridge University Press, 1980), pp. 154–5. For an important discussion of *Ploughing Turnips*, see also Michele Miller, "J.M.W. Turner's *Ploughing Up Turnips, Near Slough*: the Cultivation of Cultural Dissent," *Art Bulletin*, 77/4 (December 1995): pp. 573–83.

3 Martin Christadler, "Romantic Landscape Painting in America: History as Nature, Nature as History," in Thomas W. Gaeghtgens and Heinz Ickstadt (eds), *American Icons: Transatlantic Perspectives on Eighteenth- and Nineteenth-Century American Art* (Santa Monica, CA: Getty Center for the History of Art and Humanities and Chicago: Distributed by the University of Chicago Press, 1992), pp. 93–118. Christadler characterizes Turner's political landscapes as relatively uncomplicated, seeing history as being displaced in Turner's work, "translated into the private and psychological and into new perceptions of the natural."

4 *Fraser's Magazine*, June 1839, cited in Martin Butlin and Evelyn Joll, *The Paintings of J.M.W. Turner*, 2nd ed., (2 vols., New Haven and London: Yale University Press, 1984), text volume, p. 230.

5 *The Spectator*, 11 May, 1839, cited in Butlin and Joll, *Paintings of J.M.W. Turner*, p. 230.

6 Michael Löwy and Robert Sayre, *Romanticism Against the Tide of Modernity*, trans. by Catherine Porter (Durham, NC and London: Duke University Press, 2001), p. 21. For an important discussion of the usefulness of the *Weltanschuuang* to Romanticism, see Andrew Hemingway, "Introduction: Capitalism, Nationalism and the Romantic *Weltanschuuang*," in Hemingway and Alan Wallach (eds), *Transatlantic Romanticism: An Anthology*, forthcoming. I am grateful to Dr. Hemingway for sharing the manuscript for this essay with me.

7 Löwy and Sayre, *Romanticism*, pp. 22–5, ff.

8 Sir Lawrence Gowing, *Turner: Imagination and Reality*, exhibition catalog (New York: Museum of Modern Art, 1966), p. 4.

Bibliography

Manuscript Sources

British Library, Add. MS. 46151 A.

British Library, Add. MS. 46151 F.

British Library, Add. MS. 46151 G.

British Library, Add. MS. 46151 H.

British Library, Add. MS. 46151 I.

Royal Academy Archives, James Hughes Anderdon Catalog.

Royal Academy Archives, Council Minutes, 1797–1812.

Royal Academy Archives, Sir Thomas Lawrence, correspondence.

Tate Britain, TB LXXII, Studies in the Louvre.

Tate Britain, TB CVIII, Perspectives.

Tate Britain, TB CXXIII, Devonshire Coast No. 1.

Primary Sources

NEWSPAPERS AND PERIODICALS

Annals of the Fine Arts, London.

The Artist, London.

The Art Union, London.

The Athenæum, London.

Blackwood's Edinburgh Magazine, Edinburgh.

The Examiner, London.

La Belle Assembleé, London.

The Literary Gazette, London.

The London Literary Gazette and Journal of Belles Lettres, London.

London Magazine, or, Gentleman's Monthly Intelligencer, London.

The Monthly Magazine, London.

The Morning Chronicle, London.

The Morning Herald, London.

The New Monthly Magazine, London.

The Spectator, London.

The Sun, London.

The Times, London.

The True Briton, London.

BOOKS, ESSAYS AND PAMPHLETS

An Account of the British Institution for Promoting the Fine Arts in the United Kingdom (London, 1805).

Beatty, William, *The Death of Lord Nelson* (London: T. Cadell and W. Davies, 1807).

Bentham, Jeremy, *Plan of Parliamentary Reform in the Form of a Catechism, with Reasons for each Article: With an Introduction Showing the Necessity of Radical, and the Inadequacy of Moderate, Reform*, in The Works of Jeremy Bentham (11 vols., Edinburgh: William Tait, London: Simpkin, Marshall & Co., and Dublin: John Cumming, 1838).

Brewster, Sir David, *Letters on Natural Magic, Addressed to Sir Walter Scott* (London: John Murray, 1834).

Bromley, Reverend Robert, *A History of the Fine Arts, Painting, Sculpture, and Architecture* (2 vols, New York: Garland Publishing, 1984, Original, London: Philanthropic Press, 1793).

Burke, Edmund, *A Philosophical Enquiry into Our Ideas of the Sublime and Beautiful*, 2nd ed., (London: R. and J. Dodsley, 1759).

Burke, Edmund, *Reflections on the Revolution in France and on the Proceedings in Certain Societies in London Relative to that Event* (Mineola, NY: Dover Publications, 2006 original, London: J. Dodsley, 1790).

Byron, Lord, *Childe Harold's Pilgrimage*, H. F. Tozer (ed.), (Oxford: Clarendon Press, 1916).

Carey, William Paulet, *Desultory Exposition of an Anti-British System of Incendiary Publication…Intended to sacrifice the honor and interests of the British Institution, the Royal Academy and the whole body of the British artists and their patrons…to the passions of certain disappointed candidates for prizes, etc.* (London: Published for the author, 1819).

A Catalogue Raisonée of the Pictures Now Exhibiting at the British Institution, (London, 1815).

Cheselden, William, "An Account of some Observations Made by a Young Gentleman, Who Was Born Blind, or Lost his Sight so Early, That He Had no Remembrance of Ever Having Seen, and Was Couch'd Between 13 and 14 Years of Age," *Philosophical Transactions of the Royal Society*, 35/402 (1727–28).

Clarkson, Thomas, *The History of the Rise, Progress and Accomplishment of the Abolition of the Slave-trade by Act of Parliament*, 2nd ed., (London: J. W. Parker, 1839).

Cook, E.T., and Alexander Wedderburn (eds), *The Work of John Ruskin* (39 vols., London: G. Allen, New York: Longmans, Green, and Co., 1903–12).

Cunningham, Allan, *Life of Sir David Wilkie* (London: John Murray, 1843).

Cunningham, Peter, "Memoir," in John Burnet, *Turner and his Works* (London: James Virtue, 1859).

Eustace, J.C., *A Classical Tour Through Italy*, 3rd ed., (3 vols, London: Mawman, 1815).

Farington, Joseph, *The Diary of Joseph Farington*, Garlick, Kenneth, Angus MacIntyre and Kathleen Cave (eds), (New Haven: The Paul Mellon Centre for Studies in British Art by Yale University Press, 1978–84).

Ferguson, Adam, *An Essay on the History of Civil Society* (Cambridge and New York: Cambridge University Press, 1995, original, Dublin: Boulter Grierson, 1767).

Frye, W.E., *After Waterloo: Reminiscences of European Travel, 1815–19* (BiblioBazaar, LLC: 2008).

Fuseli, Henry, *Lectures on Painting* (New York and London, Garland Publishers, 1979), reprint of Ralph Wornum (ed.), *Lectures on Painting, by the Royal Academicians* (London: Henry G. Bohn: 1848).

Galt, John, *The Life, Studies and Works of Benjamin West, Esq. President of the Royal Academy of London* (2 vols, London and Edinburgh: T. Cadell and W. Davies and W. Blackwood, 1820).

Gisborne, Thomas, *Walks in a Forest: or, Poems descriptive of Scenery and Incidents Characteristic of a Forest* (London: T. Cadell and W. Davies, 1794).

Hayley, William, *On Painting, in Two Epistles to Mr. Romney* 3rd ed. (London: J. Dodsley, 1781).

Hayley, William, *Poems and Plays* (6 vols, London: T. Cadell, 1785).

Hazlitt, William, "On Imitation," *The Examiner*, 30 (18 February, 1816): 108–9.

Hunt, Robert, "British Institution," *The Examiner*, 6 (February 7, 1808).

Jones, George, "A Short Memoir of Turner," in John Gage (ed.), *The Collected Correspondence of J.M.W. Turner* (Oxford: Oxford University Press, 1980).

Leslie, C.R., *Memoirs of the Life of John Constable, Esq., R.A., composed chiefly of his letters*, 2nd ed., (London: Longman, Brown, Green and Longmans, 1845).

Leslie, C.R., *Autobiographical Recollections* (London: John Murray, 1860).

Montagu, Edward Wortley, Reflections on the Rise and Fall of the Ancient Republicks (excerpt), in *The London Magazine, or, Gentleman's Monthly Intelligencer*, XXVIII (March 1759): 136–7.

Northcote, James, "The Progress of the Arts in Great Britain," *The Artist*, 2 (March 21, 1807).

Northcote, James, *The Life of Sir Joshua Reynolds* 2nd ed., (2 v., London: Henry Colburn, 1819).

Paine, Thomas, *Rights of Man, being an Answer to Mr. Burke's Attack on the French Revolution* (Mineola, NY: Dover Publications, 1999, original, London: J.S. Jordan, 1791).

Pool, Bernard (ed.), *The Croker Papers, 1808–1857* (New York: Barnes and Noble, 1967).

Pyne, W.H., "Clarkson Stanfield," *Arnold's Magazine*, 3/5 (February 1834).

Reynolds, Sir Joshua, *Discourses on Art*, Robert Wark (ed.), (New Haven and London: Yale University Press, 1975).

Rippingille, E.V., "Personal Recollections of Great Artists. No. 8. – Sir Augustus W. Callcott, R.A.," *Art Journal*, 22 (April 1, 1860).

Ruskin, John, *Notes on the Turner Collection at Marlborough House* (London: Smith, Elder & Co., 1857).

Ruskin, John, *The Stones of Venice* (2 vols., New York: John B. Alden, 1885).

Ruskin, John, *The Work of John Ruskin*, E.T. Cook and Alexander Wedderburn, (eds), (39 vols., London: G. Allen, New York: Longmans, Green, and Co., 1903–12).

Shee, Sir Martin Archer, *Elements of Art: A Poem in Six Cantos* (London: printed for William Miller by W. Bulmer and Co., 1809).

Shee, Martin Archer Jr., *The Life of Sir Martin Archer Shee: President of the Royal Academy, F.R.S., D.C.L.* (2 vols, London: Longman, Green, Longman and Roberts, 1860).

Taylor, Thomas, *A Biographical Sketch of Thomas Clarkson, M.A, with Occasional Brief Strictures on Misrepresentations of him in the Life of William Wilberforce and a Concise Historical Outline of the Abolition of Slavery* (London: Joseph Rickerby, 1839).

Thomson, James, *The Complete Poetical Works of James Thomson*, J. Logie Robertson (ed.), (Oxford: Henry Frowde, 1908).

Turner, J.M.W., *The Collected Correspondence of J.M.W. Turner*, John Gage (ed.), (Oxford: Oxford University Press, 1980).

Secondary Sources

Abrams, Ann Uhry, *The Valiant Hero: Benjamin West and Grand-Style History Painting* (Washington, DC: Smithsonian Institution Press, 1985).

Adkin, Mark, *The Trafalgar Companion* (London: Aurum Press, 2000).

Adorno, Theodor, and Max Horkheimer, *Dialectic of Enlightenment*, (New York: Seabury Press, 1982).

Adorno, Theodor, *Aesthetic Theory* (Minneapolis: University of Minnesota Press, 1998).

Allen, Brian (ed.), *Towards a Modern Art World* (New Haven and London: Yale University Press for the Paul Mellon Centre for the Study of British Art, 1995).

Althusser, Louis, *Lenin and Philosophy*, trans. by Ben Brewster (New York: Monthly Review Press, 1971).

Bachrach, Fred G.H., "Turner, Ruisdael and the Dutch," *Turner Studies*, 1/1 (1981): 19–30.

Bachrach, Fred G.H., "The Field of Waterloo and Beyond," *Turner Studies*, 1/2 (1981): 4–13.

Bachrach, Fred G.H., *Turner's Holland*, exhibition catalog (London: Tate Publishing, 1994).

Bailey, Anthony, *Standing in the Sun: A Life of J.M.W. Turner* (London: Sinclair-Stevenson, 1997).

Bal, Mieke, *Reading Rembrandt: Beyond the Word-Image Opposition* (Cambridge and New York: Cambridge University Press, 1991).

Barrell, John, *English Literature in History, 1730–80: An Equal, Wide Survey* (New York: St. Martin's Press, 1983).

Barrell, John, *The Dark Side of the Landscape: The Rural Poor in English Painting, 1730–1840* (Cambridge and New York: Cambridge University Press, 1983).

Barrell, John, *The Political Theory of Panting from Reynolds to Hazlitt: "The Body of the Public"* (New Haven and London: Yale University Press, 1986).

Barringer, Tim, Geoff Quilley and Douglas Fordham (eds), *Art and the British empire* (Manchester and New York: Manchester University Press, 2007).

Baucom, Ian, "Specters of the Atlantic," *South Atlantic Quarterly*, 100/1 (Winter 2001): 61–82.

Bender, Thomas (ed.), *The Anti-slavery Debate: Capitalism and Abolitionism as a Problem in Historical Interpretation* (Berkeley: University of California Press, 1992).

Benjamin, Walter, *Illuminations*, Hannah Arendt (ed.), trans. Harry Zohn (New York: Schocken Books, 1968).

Benjamin, Walter, *Reflections*, Peter Demetz (ed.), trans. Edmund Jephcott (New York: Schocken Books, 1978).

Bermingham, Ann, *Landscape and Ideology: The English Rustic Tradition, 1740–1850* (Berkeley and Los Angeles: University of California Press, 1986).

Blackburn, Robin, *The Overthrow of Colonial Slavery 1776 — 1848* (London and New York: Verso, 1988).

Boase, T.S.R. "Shipwrecks in English Romantic Painting," *Journal of the Warburg and Courtauld Institutes*, 22/3–4 (1959): 334–46.

Bohls, Elizabeth, "Disinterestedness and the Denial of the Particular: Locke, Adam Smith and the Subject of Aesthetics," in Paul Mattick (ed.), *Eighteenth-Century Aesthetics and the Reconsition of Art* (Cambridge and New York: Cambridge University Press, 1993): 16–51.

Boime, Albert, "Turner's Slave Ship: the Victims of Empire," *Turner Studies*, 10/1 (1990): 34–43.

Bonehill, John and Geoff Quilley (eds), *Conflicting Visions: War and Visual Culture in Britain and France c. 1700–1830* (Aldershot and Burlington, VT: Ashgate Press, 2005).

Bonehill, John, "Laying Siege to the Royal Academy: Wright of Derby's *View of Gibraltar* at Robin's Rooms, Covent Garden, April 1785," *Art History*, 30/4 (September 2007): 521–44.

Brennan, Teresa, *History After Lacan* (London and New York: Routledge, 1993).

Brown, David Blayney, *Turner and Byron,* exhibition catalog (London: Tate Gallery, 1992).

Brown, David Blayney, "Rule Britannia? Patriotism, Progress and the Picturesque in Turner's Britain," in Michael Lloyd (ed.), *Turner* (Canberra: National Gallery of Australia, 1996): 48–72.

Butlin, Martin and Evelyn Joll, *The Paintings of J.M.W. Turner*, 2nd ed., (2 vols, New Haven and London: Yale University Press, 1984).

Butlin, Martin, Mollie Luther and Ian Warrell, *Turner at Petworth: Patron and Painter* (London: Tate Publishing, 1992).

Bryson, Norman, "Enhancement and Displacement in Turner," *The Huntington Library Quarterly*, 49 (1986): 47–65.

Callow, William, *An Autobiography* (London: Adam and Charles Black, 1908).

Carter, Ian, "Rain, Steam and What?", *Oxford Art Journal*, 20/2 (1997): 3–12.

Chumbly, Ann and Ian Warrell, *Turner and the Human Figure: Studies of Contemporary Life*, exhibition catalog (London: Tate Publishing, 1989).

Christadler, Martin, "Romantic Landscape Painting in America: History as Nature, Nature as History," in Thomas W. Gaeghtgens and Heinz Ickstadt (eds), *American Icons: Transatlantic Perspectives on Eighteenth- and Nineteenth-Century American Art* (Santa Monica, CA: Getty Center for the History of Art and Humanities and Chicago: Distributed by the University of Chicago Press, 1992): 93–117.

Clark, T.J., *Farewell to an Idea: Episodes from a History of Modernism* (New Haven and London: Yale University Press, 1999).

Clayton, Tim and Phil Craig, *Trafalgar: The Men, The Battle, The Storm* (London: Hodder and Stoughton, 2004).

Clegg, Jeanne, *Ruskin and Venice* (London: Junction Books, 1981).

Colley, Linda, *Britons: Forging the Nation, 1707–1837*, 2nd ed.,(New Haven and London: Yale University Press, 2005).

Coolsen, T., "Phryne and the Orators: Decadence and Art in Ancient Greece and Modern Britain," *Turner Studies*, 7/2 (1986): 3–8.

Corrigan, Phillip, and Derek Sayer, *The Great Arch: English State Formation as Cultural Revolution* (Oxford: Blackwell, 1985).

Costello, Leo, "Turner's *Slaveship*: Towards a Dialectical History Painting," in Brycchan Carey, Markman Ellis and Sarah Salih (eds), *Discourses of Slavery and Abolition: Britain and Its Colonies 1660–1838* (Basingstoke and New York: Palgrave McMillan, 2004): 209–22.

Costello, Leo, Review of Andrew Wilton, *Turner as Draughtsman*, London: Ashgate, 2006, *Victorian Studies*, 49/3 (Spring 2007): 527–9.

Costello, Leo, "Confronting the Sublime," in Ian Warrell (ed.), *J.M.W. Turner*, exhibition catalog (London: Tate Publishing, 2007): 39–55.

Costello, Leo, Review of Sam Smiles, *J.M.W. Turner: The Making of a Modern Artist*, *Victorian Studies*, 51/3 (Spring 2009): 530–2.

Costello, Leo, "'This Cross-fire of Colours': J.M.W. Turner and the Varnishing Days Reconsidered," *British Art Journal*, 10/1 (Spring 2010): 56–68.

Coutu, Joan, "Legitimating the British Empire: The Monument to General Wolfe in Westminster Abbey," in John Bonehill and Geoff Quilley (eds), *Conflicting Visions: War and Visual Culture in Britain and France c. 1700–1830* (Aldershot and Burlington, VT: Ashgate Press, 2005): 61–83.

Crary, Jonathan, *Techniques of the Observer: On Vision and Modernity in the Nineteenth Century* (Cambridge: MA and London: MIT Press, 1990).

Cust, Lionel, "The Portraits of J.M.W. Turner," *Magazine of Art*, v. 18 (1895).

Daniels, Stephen, "The Implications of Industry: Turner and Leeds," *Turner Studies*, 6/1 (1986): 10–17.

Daniels, Stephen, *Fields of Vision: Landscape Imagery and Identity in England and the United States* (Cambridge: Polity Press, 1993).

Davis, David Brion, *The Problem of Slavery in the Age of Revolution, 1773–1823* (Ithaca: Cornell University Press, 1975).

Davis, David Brion, *The Emancipation Moment* (Gettysburg, PA: Gettysburg College, 1983).

de Bolla, Peter, *The Discourse of the Sublime: Readings in History, Aesthetics and the Subject* (London: Basil Blackwell, 1989).

Derrida, Jacques, *The Truth in Painting*, trans. by Geoff Benningham and Ian MacLeod (Chicago: University of Chicago Press, 1987).

Donaghue, Eddie, *Black Women/White Men: The Sexual Exploitation of Female Slaves in the Danish West Indies* (Trenton, NJ: Africa World Press, 2002).

Doody, Margaret, *The Tropic of Venice* (Philadelphia: University of Pennsylvania Press, 2007).

Drescher, Seymour, *Capitalism and Anti-slavery: British Mobilization in Comparative Perspective* (New York and Oxford: Oxford University Press, 1987).

Eglin, John, *Venice Tranfigured: The Myth of Venice in British Culture, 1660–1797* (New York and Basingstoke: Palgrave, 2001).

Favret, Mary, "Coming Home: The Public Spaces of Romantic War," *Studies in Romanticism* 33/4 (Winter 1994): 539–48.

Finberg, A. J., *The Life of J.M.W. Turner, RA*, 2nd ed., (Oxford: Clarendon Press, 1939).

Finberg, A. J., "J.M.W. Turner's Proposal for a 'Royal Progress,'" *Burlington Magazine*, v. 117 (1975): 27–35.

Finley, Gerald, "The Origins of Turner's Landscape Sublime," *Zeitschrift für Kunstgeschichte*, 42/2–3 (1979): 145–65.

Finley, Gerald, *Landscapes of Memory: Turner as Illustrator to Scott* (Berkeley: University of California Press, 1980).

Finley, Gerald, *Turner and George the Fourth in Edinburgh* (London: Tate Gallery in association with Edinburgh University Press, 1981).

Finley, Gerald, "Turner and the Steam Revolution," *Gazette des Beaux-Arts*, 126 (July/ August 1988): 19–30.

Finley, Gerald, *Angel in the Sun: Turner's Vision of History* (Montreal: McGill-Queen's University Press, 1999).

Flynn, Nicolas, "The Last Modern Art Painting," *Oxford Art Journal*, 20/2 (1997): 13–22.

Forrester, Gillian, *Turner's "Drawing Book": The Liber Studiorum*, exhibition catalog (London: Tate Publications, 1996).

Foucault, Michel, "The Subject and Power," *Critical Inquiry*, 8/4 (Summer, 1982): 777–795.

Fried, Michael, *Absorption and Theatricality: Painting and Beholder in the Age of Diderot* (Berkeley: University of California Press, 1980).

Fullerton, Peter, "Patronage and Pedagogy: The British Institution in the Early Nineteenth Century," *Art History*, 5/1 (March 1982): 59–72.

Peter Funnell, "William Hazlitt, Prince Hoare, and the Institutionalization of the British Art World," in Brian Allen (ed.), *Towards a Modern Art World* (New Haven and London: Yale University Press for the Paul Mellon Centre for the Study of British Art, 1995): 145–56.

Gage, John, "Turner and the Picturesque," *Burlington Magazine,* 107 (1965): 16–26, 75–81.

Gage, John, *Colour in Turner: Poetry and Truth,* (New York: Praeger, 1969).

Gage, John, *Turner: Rain, Steam and Speed,* (New York: Viking Press, 1972).

Gage, John, *J.M.W. Turner: "A Wonderful Range of Mind"* (New Haven: Yale University Press, 1987).

Gage, John, "Turner in Venice," in J.C. Eade (ed.), *Projecting the Landscape* (Canberra: Humanities Research Centre, Australian National University, 1987): 72–77.

Gervais, David, "The Turnerian Sublime," *The Cambridge Quarterly,* 10/3 (Winter 1981–2): 262–270.

Gervais, David, "Figures in Turner's Landscapes," *The Cambridge Quarterly,* 14/1 (Summer 1985): 20–50.

Gilroy, Paul, *The Black Atlantic: Modernity and Double Consciousness* (Cambridge: Harvard University Press, 1993).

Gowing, Lawrence, *Turner: Imagination and Reality,* exhibition catalog (New York: Museum of Modern Art, 1966).

Guiterman, Helen, "'The Great Painter': Roberts on Turner," *Turner Studies,* 9/1 (1989): 2–9.

Habermas, Jürgen, *The Structural Transformation of the Public Sphere: An Inquiry into a Category of Bourgeois Society,* trans. by Thomas Burger (Cambridge, MA: MIT Press, 1989).

Hamilton, James, *Turner and the Scientists,* exhibition catalog (London: Tate Publications, 1998).

Hamilton, James, *Turner: A Life* (New York: Random House, 2003).

Hamlyn, Robyn, "'Sword Play': Turner and the Idea of Painterliness as an English National Style," in Leslie Parris (ed.), *Exploring Late Turner* (New York: Salander-O'Reilly Galleries, 1999): 117–30.

Haskell, Thomas, "Capitalism and the Origins of the Humanitarian Sensibility," I and II, in Thomas Bender (ed.), *The Antislavery Debate: Capitalism and Abolitionism as a Problem in Historical Interpretation* (Berkeley: University of California Press, 1992):107–60.

Heffernan, James, *The Re-creation of Landscape: A Study of Wordsworth, Coleridge, Constable, and Turner* (Hanover: Published for Dartmouth College by University Press of New England, 1984).

Helsinger, Elizabeth, "Turner and the Representation of England," in W.J.T. Mitchell (ed.), *Landscape and Power,* 2nd ed., (Chicago: University of Chicago Press, 2002): 103–126.

Hemingway, Andrew, "Academic Theory versus Association Aesthetics: The Ideological Forms of a Conflict of Interests in the Early Nineteenth Century," *Ideas and Production,* 5 (1980): 18–42.

Hemingway, Andrew, "The Political Theory of Painting without the Politics," *Art History,* 10/3 (September 1987): 381–95.

Hemingway, Andrew, *Landscape Imagery and Urban Culture in Early Nineteenth-Century Britain* (Cambridge and New York: Cambridge University Press, 1992).

Hemingway, Andrew, "Art-Exhibitions as Leisure-Class Rituals in Early Nineteenth-Century London," in Brian Allen (ed.), *Towards a Modern Art World* (New Haven and London: Yale University Press for the Paul Mellon Centre for the Study of British Art, 1995): 95–107.

Hemingway, Andrew and William Vaughan (eds), *Art in Bourgeois Society* (Cambridge and New York: Cambridge University Press, 1998).

Herrmann, Luke, *Turner and Ruskin* (New York: F. A. Praeger, 1969).

Hermann, Luke, "John Landseer on Turner: Reviews of Exhibits in 1808, 1839 and 1840," *Turner Studies*, 7/1 (Summer 1987): 26–33 and 7/2 (Winter 1987): 21–8.

Holcomb, Adele, "'Indistinctness is my fault': A Letter about Turner from C.R. Leslie to James Lenox," *Burlington Magazine* 114: 555–8.

Holmes, Geoffrey and Daniel Szechi, *The Age of Oligarchy: Pre-Industrial Britain, 1723–83* (London and New York: Longman, 1996).

Hoock, Holger, *The King's Artists: The Royal Academy and the Politics of British Culture 1760–1840* (Oxford: Clarendon Press, 2003).

Hoock, Holger, "Reforming Culture: National Art Institutions in the Age of Reform," in Arthur Burns and Joanna Innes (eds), *Rethinking the Age of Reform: Britain 1780–1850* (Cambridge: Cambridge University Press, 2003): 254–270.

Hoock, Holger (ed.), *History, Commemoration and National Preoccupation: Trafalgar, 1805–2005* (Oxford and New York: Oxford University Press, 2007).

Hughes, Eleanor, "Ships of the 'Line': Marine Paintings at the Royal Academy Exhibition of 1784," in Tim Barringer, Geoff Quilley and Douglas Fordham (eds), *Art and the British Empire* (Manchester and New York: Manchester University Press, 2007): 139–52.

Hunt, John Dixon, "Wondrous Deep and Dark: Turner and the Sublime," *Georgia Review*, 30 (1976): 139–54.

J.M.W. Turner à l'occasion du cinquantième anniversaire du British Council, exhibition catalog (Paris: Ministere de la Culture, Editions de la Réunion des Musées nationaux, 1983).

Joll, Evelyn, Martin Butlin and Luke Hermann (eds), *The Oxford Companion to J.M.W. Turner* (Oxford: Oxford University Press, 2001).

Jones, Tom Devonshire, "*The Annals of the Fine Arts*: James Elmes (1782–1862), architect: from youthful editor to aged gospeller," *British Art Journal*, 10/2 (Winter 2010): 67–72.

Judge, David, *Representation: Theory and Practice in Britain* (London and New York: Routledge, 1999).

Keegan, John, *The Face of Battle: A Study of Agincourt, Waterloo and the Somme* (Hammondsworth, Middlesex: Penguin Books, 1976).

Kitson, Michael, "Turner and Claude," *Turner Studies*, 2/2 (1983): 2–15.

Kitson, Michael, "Turner and Rembrandt," *Turner Studies*, 8/1 (1988): 2–19.

Kriz, Kay Dian, "Dido Versus the Pirates: Turner's Carthaginian Paintings and the Sublimation of Colonial Desire," *Oxford Art Journal*, 18 (1995): 116–32.

Kriz, Kay Dian, *The Idea of the English Landscape Painter: Genius as Alibi in the Early Nineteenth Century* (New Haven and London: Yale University Press, 1997).

Kriz, Kay Dian, "French Glitter or English Nature? Representing Englishness in Landscape Painting, c. 1790–1820," in Andrew Hemingway and William Vaughan (eds), *Art in bourgeois society* (Cambridge and New York: Cambridge University Press, 1998): 63–83.

Kroeber, Karl, *British Romantic Painting* (Berkeley and Los Angeles: University of California Press, 1986).

Lee, Debbie, *Slavery and the Romantic Imagination* (Philadelphia: University of Pennsylvania Press, 2002).

Lindsay, Jack, *J.M.W. Turner: His Life and Work. A Critical Biography* (Greenwich, CT: New York Graphic Society, 1969).

Livermore, Ann, "J.M.W. Turner's Unknown Verse-Book," *The Connoisseur Year Book* (1957): 78–86.

Löwy, Michael and Robert Sayre, *Romanticism Against the Tide of Modernity*, trans. by Catherine Porter, (Durham, NC and London: Duke University Press, 2001).

Marks, Arthur S., "Rivalry at the Royal Academy: Wilkie, Turner and Bird," *Studies in Romanticism*, 30/3 (Fall 1981).

Marshall, Peter, "Britain without America – A Second Empire," in *The Oxford History of the British Empire* (5 vols, Oxford and New York: Oxford University Press, 1998), Peter Marshall (ed.), *The Eighteenth Century*, v. 2: 576–95.

Marsh, Jan, "Ruskin and Turner's *Slavers*: Patriotic, Political and Pictorial Issues," *Visual Culture in Britain*, 2/1 (2001): 47–63.

Maxwell, Herbert, *The Life of Wellington: The Restoration of the Martial Power of Great Britain* (2 vols, London: Sampson and Low, Marston and Company, 1899).

McCoubrey, John, "War and Peace in 1842: Turner, Haydon and Wilkie," *Turner Studies*, 4/2 (1984): 2–7.

McCoubrey, John, "Parliament on Fire: Turner's Burnings," *Art in America*, 72/11 (December 1984): 112–25.

McCoubrey, John, "Time's Railway: Turner and the Great Western," *Turner Studies*, 6/1 (1986): 33–39.

McCoubrey, John, "The Hero of A Hundred Fights: Turner, Schiller and Wellington," *Turner Studies*, 10/2 (1990): 7–11.

McCoubrey, John, "Turner's *Slave Ship*: Abolition, Ruskin and Reception," *Word and Image*, 14/4 (October/December 1998): 319–53.

McNairn, Tom, *Behold the Hero: General Wolfe and the Arts in the Eighteenth Century* (Montreal: McGill-Queen's University Press, 1997).

Miller, Angela, *The Empire of the Eye: Landscape Representation and American Cultural Politics, 1825–1875* (Ithaca: Cornell University Press, 1996).

Miller, Michele, "J.M.W. Turner's *Ploughing Up Turnips, Near Slough*: the Cultivation of Cultural Dissent," *Art Bulletin*, 77 (December 1995): 572–83.

Myrone, Martin, *Bodybuilding: Reforming Masculinities in British Art, 1750–1810* (New Haven and London: Yale University Press for the Paul Mellon Centre for Studies in British Art, 2005).

Neff, Emily Ballew (ed.), *John Singleton Copley in England*, exhibition catalog (London: Merrell Holberton for the Museum of Fine Arts, Houston, 1995).

Nicholson, Kathleen, *Turner's Classical Landscapes: Myth and Meaning* (Princeton: Princeton University Press, 1990).

Nicholson, Kathleen, "Turner, Claude and the Essence of Landscape," in David Solkin (ed.), *Turner and the Masters*, exhibition catalog (London: Tate Publishing, 2009).

Nicolson, Adam, *Seize the Fire: Heroism, Duty and the Battle of Trafalgar* (New York: HarperCollins, 2005).

Nochlin, Linda, *The Body in Pieces: The Fragment as a Metaphor of Modernity* (London and New York: Thames & Hudson, 1994).

O'Gorman, Frank, *The Long Eighteenth Century: British Political and Social History, 1688–1832* (London and New York: Arnold, 1997).

Owen, Felicity and David Blayney Brown, *Collector of Genius: A Life of Sir George Beaumont* (New Haven and London, Yale University Press for the Paul Mellon Centre for Studies in British Art, 1988).

Paulson, Ronald, *Emblem and Expression: Meaning in English Art of the Eighteenth Century*, (London: Thames and Hudson, 1975).

Paulson, Ronald, *Literary Landscape, Turner and Constable* (New Haven: Yale University Press, 1982).

Pearce, Susan, "The *matériel* of War: Waterloo and its Culture," in John Bonehill and Geoff Quilley (eds), *Conflicting Visions: War and visual culture in Britain and France, c. 1700–1830* (Aldershot and Burlington, VT: Ashgate Press, 2005): 207–26.

Plant, Margaret, "Venetian Journey," in Michael Lloyd (ed.), *Turner*, exhibition catalog (Canberra: National Gallery of Australia, 1996): 145–63.

Pocock, J.G.A., "Between Machiavelli and Hume: Gibbon as Civic Humanist and Philosophical Historian," in G.W. Bowersock, John Clive and Stephen R. Graubard (eds), *Edward Gibbon and the Decline and Fall of the Roman Empire* (Cambridge, MA and London: Harvard University Press, 1977).

Pointon, Marcia, *Hanging the Head: Portraiture and Social Formation in Eighteenth-Century England* (New Haven and London: Yale University Press, 1993).

Porter, Roy, *Edward Gibbon: Making History* (London: Weidenfeld and Nicolson, 1988).

Powell, Cecelia, "Turner's Women: The Painted Veil," *Turner Society News*, 63 (March 1993): 14–5.

Powell, Cecelia, *Turner in Germany*, exhibition catalog (London: Tate Publishing, 1995).

Prown, Jules, *John Singleton Copley* (2 vols, Cambridge, MA: published for the National Gallery of Art, Washington by Harvard University Press, 1966).

Pullan, Ann, "Public Goods or Private Interests? The British Institution in the Early Nineteenth Century," in Andrew Hemingway and William Vaughan (eds), *Art in Bourgeois Society* (Cambridge and New York: Cambridge University Press, 1998): 27–44.

Quilley, Geoff, "'All ocean is her own': the image of the sea and the identity of the maritime nation in eighteenth-century British art," in Geoffrey Cubitt (ed.), *Imagining Nations* (Manchester and New York: Manchester University Press, 1998).

Quilley, Geoff, "Missing the Boat: The Place of the Maritime in the History of British Culture," *Visual Culture in Britain*, 1/2 (2000): 79–92.

Rather, Susan, "Benjamin West, John Galt, and the Biography of 1816," *The Art Bulletin*, 86/2 (June 2004): 324–345.

Richardson, Alan (ed.), *Slavery, Abolition and Emancipation: Writings in the British Romantic Period* (8 vols., London: Pickering and Chatto).

Rodner, William, *J.M.W. Turner: Romantic Painter of the Industrial Revolution* (Berkeley and London: University of California Press, 1997).

Rosenthal, Michael, "Turner Fires a Gun," in David Solkin (ed.), *Art on the Line: The Royal Academy Exhibitions at Somerset House 1780–1836* (New Haven and London: Yale University Press, 2001): 144–55.

Royle, Edward and James Walvin, *English Radicals and Reformers* (Lexington, KY: The University Press of Kentucky, 1982).

Sack, James, *From Jacobite to Conservative: Reaction and orthodoxy in Britain, c. 1760–1832* (Cambridge and New York: Cambridge University Press, 1993).

Scarry, Elaine, *The Body in Pain* (Oxford and New York: Oxford University Press, 1987).

Scarry, Elaine, *Resisting Representation* (Oxford and New York: Oxford University Press, 1994).

Sekora, John, *Luxury: The Concept in Western Thought, Eden to Smollett* (Baltimore and London, The Johns Hopkins University Press, 1977),

Semmel, Stuart,"Reading the Tangible Past: British Tourism, Collecting and Memory after Waterloo," *Representations*, 69 (Winter, 2000): 9–37.

Shanes, Eric, *Turner's Picturesque Views in England and Wales, 1825–1838* (London: Chatto and Windus, 1980).

Shanes, Eric, *Turner's Rivers, Coasts and Harbours*, (London: Chatto and Windus, 1981).

Shanes, Eric, "Dissent in Somerset House: Opposition to the Political *Status-quo* within the Royal Academy around 1800," *Turner Studies*, 10/2 (1990): 40–6.

Shanes, Eric, *Turner's Human Landscape* (London: Heinemann, 1990).

Shanes, Eric, *Turner's England, 1810–38* (London: Cassell, 1990).

Shanes, Eric (ed.), *Turner: The Great Watercolours*, exhibition catalog (London: Royal Academy of Arts, 2000).

Shanes, Eric, "Turner and the Creation of his *First-Rate* in a Few Hours: A Kind of Frenzy?", *Apollo*, CLIII/469 (March 2001): 13–5.

Shaw, Philip, *Waterloo and the Romantic Imagination* (Basingstoke: Palgrave Macmillan, 2002).

Simmel, Georg, *Georg Simmel, 1858–1918, A Collection of Essays*, trans. by David Kettler, Kurt Wolff (ed.), (Columbus: Ohio State University Press, 1959).

Smiles, Sam, "'Splashers', 'Scrawlers' and 'Plasterers': British Landscape Painting and the Language of Criticism," *Turner Studies*, 10/1 (1990): 5–11.

Smiles, Sam, *J.M.W. Turner: The Making of a Modern Artist* (Manchester and New York: Manchester University Press, 2007).

Smiles, Sam, "Turner and the Slave Trade: Speculation and Representation, 1805–1840," *British Art Journal*, 8/3 (Winter 2008): 47–54.

Solender, Kathleen, *Dreadful Fire!: Burning of the Houses of Parliament* (Cleveland: Cleveland Museum of Art, 1984).

Solkin, David, *Richard Wilson: The Landscape of Reaction*, exhibition catalog (London: Tate Publications, 1982).

Solkin, David, *Painting for Money: The Visual Arts and the Public Sphere in Eighteenth-Century Britain* (New Haven and London: Yale University Press for the Paul Mellon Centre for Studies in British Art, 1992).

Solkin, David (ed.), *Art on the Line: The Royal Academy Exhibitions at Somerset House 1780–1836* (New Haven and London: Yale University Press, 2001).

Solkin, David, "'Conquest, Usurpation, Wealth,Luxury, Famine': Mortimer's *banditti* and the Anxieties of Empire," in Tim Barringer, Geoff Quilley and Douglas Fordham (eds), *Art and the British Empire* (Manchester: Manchester University Press, 2007): 120–38.

Solkin, David, *Painting out of the Ordinary: Modernity and the Art of Everyday Life in Early Nineteenth-Century Britain* (New Haven and London: Yale University Press for the Paul Mellon Centre for Studies in British Art, 2008).

Solkin, David (ed.), *Turner and the Masters*, exhibition catalog (London: Tate Publishing, 2009).

Stainton, Lindsay, *Turner in Venice* (London: British Museum Publications, 1985).

Stein, Richard, "Remember the Temeraire: Turner's Memorial of 1839," *Representations*, 11 (Summer 1985): 165–200.

Tanner, Tony, *Venice Desired* (Oxford, UK and Cambridge, MA: Blackwell, 1992).

Taylor, Charles, *Sources of the Self: The Making of Modern Identity* (Cambridge, MA: Harvard University Press, 1989).

Temperley, Howard, "The Idea of Progress," in David Northrup (ed.), *The Atlantic Slave-Trade* (Boston: D.C. Heath and Company, 1994).

Thompson, E.P., *The Making of the English Working Class* (New York: Random House, 1964.)

Thompson, E.P., *The Poverty of Theory & Other Essays* (London: Merlin Press, 1978).

Thornbury, Walter, *The Life of J.M.W. Turner, R.A.*, 2nd ed, (London: Hurst and Blackett, 1877).

Townsend, Joyce, *Turner's Painting Technique*, exhibition catalog (London: Tate Publishing, 1993).

Treuherz, Julian, "The Turner Collector: Henry McConnel, Cotton Spinner," *Turner Studies*, 6/2 (Winter 1986): 37–42.

Ulz, Melanie,"The Guilty Ship: Memory and Cultural Denial in a Post-Abolitionist Society," in Birgit Haehnel and Melanie Ulz (eds.), *Slavery in Art and Literature: Approaches to Trauma, Memory and Visuality* (Berlin: Frank and Timme, 2010): 125–46.

Vaughan, William, "The Englishness of British Art," *Oxford Art Journal*, 13/2 (1990): 11–23.

Venning, Barry, "Turner's Annotated Books: Opie's 'Lectures on Painting' and Shee's "Elements of Art'," (I–III), *Turner Studies*, 2/1 (1982): 36–46, 2/2 (1983): 40–9, 3/1 (1983): 33–44.

Venning, Barry, "A Macabre Connoisseurship: Turner, Byron and the Apprehension of Shipwreck Subjects in Early Nineteenth-Century England," *Art History*, 8/3 (September 1985): 303–19.

Venning, Barry, *Turner* (London: Phaidon, 2003).

Vincent, Edgar, *Nelson: Love and Fame* (New Haven and London: Yale University Press, 2003).

Wahrman, Dror, *The Making of the Modern Self: Identity and Culture in Eighteenth-Century England* (New Haven and London: Yale University Press, 2004).

Wallach, Alan, "Cole and the Aristocracy," *Arts Magazine*, 56 (November 1981): 94–106.

Wallach, Alan, "Thomas Cole: Landscape and the Course of American Empire," in William Truettner and Alan Wallach (eds), *Thomas Cole: Landscape into History*, exhibition catalog (New Haven and London: Yale University Press, Washington, D.C. : National Museum of American Art, Smithsonian Institution, 1994): 23–111.

Walvin, James, *Black and White: The Negro and English Society, 1555–1945* (London: Allen Lane, 1973).

Warrell, Ian (ed.), with Jan Morris, Cecelia Powell and David Laven, *Turner in Venice*, exhibition catalog (London: Tate Publishing, 2003).

Warrell, Ian, "Exploring the 'dark side': Ruskin and the Problem of Turner's Erotica," *British Art Journal*, 4/1 (Spring 2003): 5–46.

Warrell, Ian, (ed.), *J.M.W. Turner*, exhibition catalog (London: Tate Publishing, 2007).

White, Colin, "'His Dirge our Groans – his Monument our Praise': Official and Popular Commemoration of Nelson in 1805/6," in Holger Hoock (ed.), *History, Commemoration and National Preoccupation: Trafalgar, 1805–2005* (Oxford and New York: Oxford University Press, 2007): 23–48.

Whitley, William T., *Art in England 1821–1837* (Cambridge: Cambridge University Press, 1930).

Whittingham, Selby, "What you Will; or Some Notes Regarding the /influence of Watteau on Turner and other British Artists," I and II, *Turner Studies*, 5/1 (1985): 2–24, 5/2 (1985): 28–48 .

Whittingham, Selby, *An Historical Account of the Will of J.M.W. Turner, R.A.* (London and Paris: J.M.W. Turner R.A. Publications, 1989).

Williams, Eric, *Capitalism and Slavery* (Chapel Hill: University of North Carolina Press, 1944).

Wilson, Kathleen, *The Island Race: Englishness, Empire and Gender in the Eighteenth Century* (London and New York: Routledge, 2003).

Wilton, Andrew, *Turner and the Sublime*, exhibition catalog (London: British Museum Publications for The Art Gallery of Ontario, The Yale Center for British Art and the Trustees of the British Museum, 1980).

Wilton, Andrew, "Sublime or Ridiculous? Turner and the Historical Figure," *New Literary History*, XVI/2 (Winter 1985): 344–373.

Wilton, Andrew, *Painting and Poetry: Turner's Verse Book and His Work of 1804–1812*, exhibition catalog (London: Tate Publications, 1990).

Wilton, Andrew, "Turner and the Americans," 2002 Kurt Pantzer Lecture, subsequently published in the *Turner Society News*, 92 (December 2002): 13.

Wilton, Andrew, *Turner as Draughtsman* (Aldershot and Burlington, VT: Ashgate, 2006).

Wilton, Andrew, *Turner in his Time* (London and New York: Thames and Hudson, 2007, updated edition of 1987 original).

Wind, Edgar, "The Revolution of History Painting," *Journal of the Warburg and Courtauld Institutes*, 2/2 (October 1968).

Wood, Marcus, *Blind Memory: Visual Representations of Slavery in England and America, 1780–1865* (Manchester: Manchester University Press, 2000).

Yarrington, Alison and Kelvin Everest (eds), *Reflections on Revolution: Images of Romanticism* (London and New York: Routledge, 1993).

Ziff, Jerold, "'Backgrounds, Introduction of Architecture and Landscape': A Lecture by J.M.W. Turner," *Journal of the Warburg and Courtauld Institutes*, 26 (1963): 124–47.

Ziff, Jerrold, "Turner's First Quotations: An Examination of Intentions," *Turner Studies*, 2/1 (1982): 2–11.

Ziff, Jerold, "'What a Red Rag is to a Bull,'" *Turner Studies*, 3/2 (Winter 1984): 28.

Ziff, Jerrold, "William Henry Pyne, 'J.M.W. Turner, R.A.': A Neglected Critic and Essay Remembered," *Turner Studies* 6/1, (Summer 1986): 18–25.

Žižek, Slovaj, *The Sublime Object of Ideology* (London and New York: Verso, 1989).

Index